The MYTH of PRIMITIVISM

This book is dedicated to Paul Hiller

The MYTH of PRIMITIVISM

Perspectives on art

Edited and compiled by
SUSAN HILLER

London and New York

First published 1991
by Routledge
11 New Fetter Lane, London EC4P 4EE

Simultaneously published in the USA and Canada
by Routledge
a division of Routledge, Chapman and Hall, Inc.
29 West 35th Street, New York, NY 10001

Printed in Great Britain by
St Edmundsbury Press,
Bury St Edmunds, Suffolk

British Library Cataloguing in Publication Data
The Myth of primitivism.
1. Visual arts. Primitivism
I. Hiller, Susan
709'.04

Library of Congress Cataloging in Publication Data
The Myth of primitivism/edited and compiled
by Susan Hiller.
p. cm.
Based on seminars held at the Slade School of Art. University
College, London in 1985–86.
Includes index.
1. Art, Comparative. 2. Art, Primitive. 3. Art, Modern—
20th century. 4. Art, Primitive—Influence. I. Hiller, Susan.
N7428.5.M94 1989
709.04—dc20 89–6170

ISBN 0 415 01480 8 (hb)
 0 415 01481 6 (pb)

Contents

Illustrations

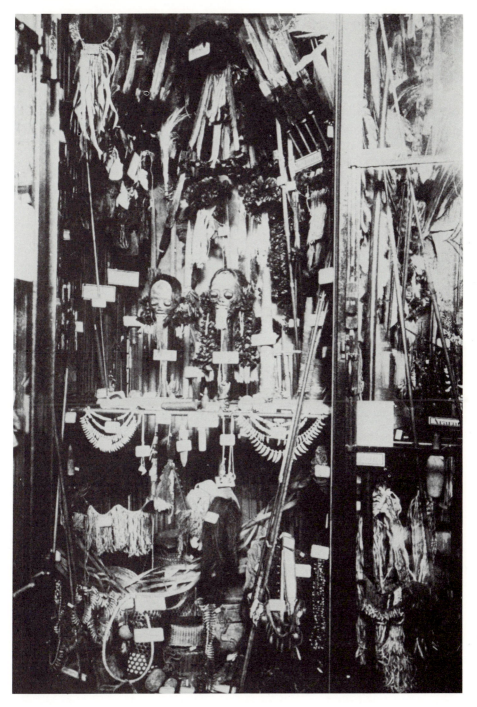

Display case, Berlin Ethnographical Museum *c*. 1910.

Editor's foreword

In its own way, this book pays homage to the beauty of the ethnographic[1] arts and to the great works of modern art that were inspired by them. Ever since 1520, when Albrecht Dürer first expressed his unaffected, astonished admiration for the intricate craftsmanship and elegant design of Mexican[2] metalwork, western artists have 'marvelled at the wonderful works of art and subtle display of ingenuity of people in far-away lands'.[3]

Those exotic, luminous fragments of a distant culture were exhibited in public only for a brief moment before being melted down and recast as coins or bullion. Since the spoils of Mexico did not appeal to sixteenth-century European tastes (apart from items in precious metals that could be converted easily into wealth), the rest of Cortés' booty was distributed to royal friends as bizarre souvenirs, which, long afterwards, sometimes found their ways into the great museums of the world.[4] In succeeding centuries, the things Dürer had described as 'all manner of curious objects for various purposes, more exquisite than any marvel',[5] would be joined by a growing horde of exotic items acquired by Europeans in other far-away societies encountered in the course of colonial expansion and conquest in the Americas, Africa, and Oceania. As time passed, many of these objects were increasingly 'appreciated', collected, displayed, and preserved. Today, the captured beauty 'we' now possess is both a legacy and a debt.

Each of us is simultaneously the beneficiary and the victim of this heritage. Western artists, in particular, are its beneficiaries because it has enriched our concept of art, increased our store of visual knowledge, and added to our repertoire of formal means. But artists are also the victims of this legacy, because we have inherited an unconscious and ambivalent involvement with the colonial transaction of defining Europe's 'others' as *primitives*, which, reciprocally, maintains an equally mythical 'western' ethnic identity. The homage offered by this book is thus a critical one that sets out to unravel the tangled web of concepts and categories called 'primitivism'.

I first began to understand the heritage of primitivism through my own experience. A long time ago, when I was doing postgraduate work in anthropology, I was so intensely moved by

the images I saw during a slide lecture on African art that I decided to become an artist.[6] My previously inchoate thoughts and feelings about anthropology as a practice and about art as a practice seemed to fall into place in one complex moment of admiration, empathy, longing, and self-awareness. I promised myself to happily abandon the writing of a doctoral thesis whose objectification of the contrariness of lived events was destined to become another complicit thread woven into the fabric of 'evidence' that would help anthropology become a 'science'. In contrast, I felt art was, above all, irrational, mysterious, numinous: the images of African sculpture I was looking at stood as a sign for all this, a sign whose meaning, strangely, was already in place awaiting my long-overdue recognition. I decided I would become not an anthropologist but an artist: I would relinquish factuality for fantasy.

The final pleasure for me that afternoon in the African art lecture was making a quick drawing of each slide image as it flashed on to the screen. Sketchy and vigorous, those little pictures inserted me neatly into a modernist tradition dating back to the turn of the century, when European artists had begun to make a practice of drawing from ethnographic models, using these exotic objects as a kind of charter of possibilities, 'a prime court of appeal against the rational, the beautiful, the normal of the West'.[7] And the pleasures of drawing bypassed words, which was wonderful, too. Words 'about' the peoples represented by the marvellous sculpture seemed redundant; the more facts, analyses, and theories I had learned, the further away I felt from any real connection with them, and what I wanted was connection, empathy, identification.

And yet. . . . What I was not then able to see is that repudiating an objectifying discourse (anthropology) in favour of a subjectifying discourse (art) does not even begin to resolve the extraordinary lived contradictions of merely *being* a subject in a culture that – to quote from a T-shirt I was given recently, which in turn paraphrases Barthes – does not allow 'a synthesis between ideology and poetry'.[8]

Leaning too far in the direction of conventional notions of poetry in the past has allowed most western artists the privilege of reproducing, intact, all the 'common-sense' stereotypes of our society about other peoples. In borrowing or appropriating visual ideas which they found in the class of foreign objects that came to be labelled 'primitive art', and by articulating their own fantasies about the meaning of the objects and about the peoples who created them, artists have been party to the erasure of the self-representations of colonized peoples in favour of a western representation of their realities. While anthropology tries to turn the peoples who are its subject-matter into objects, and

these objects into 'theory', art tries to turn the objects made by those peoples into subject-matter, and, eventually, into 'style'. Both practices maintain, intact, the basic European picture of the world as a hierarchy with 'ourselves' at the top.

The primitivistic approach to 'others' is not unambiguous or unacknowledged in either art or anthropology. It would be an oversimplification to read *The Myth of Primitivism* as an attempt to attribute *blame*, since the book itself arises out of the same cultural situation it examines. The profound inconsistencies and fractures in this cultural situation have been as truthfully represented by modern art as they can be; artists are full participants in their society and their work always expresses certain beliefs and values of that society, carrying them forward in time. But simultaneously, by ignoring, enhancing, or contesting other themes in their culture, artists are also actively involved in changing their society and in reflecting possibilities of change.

One strength of art is its reflexive truthfulness, the way it functions as a mirror to show us what we don't know that we know. The artist may not know 'the truth' either, and certainly at the time a work is produced its latent 'truthfulness' can be overlooked, misrepresented, or obscured, but retrospectively it clearly functions as a reliable witness to history, psychology, culture, and the connections between them. While the primitivizing tradition in contemporary art is a distorting mirror where ever-receding images of 'the other' appear as a set of dreams, fantasies, myths, and stereotypes, some emergent tendencies seem to me to interrogate or relativize the basic terms involved in the process by means of which the western 'self' has been constructed. I refer not to images that reflect (and thereby perpetually re-create) the category of 'the primitive' but to images that reflect *upon* such fantasies.

Although the perspectives of modernism and postmodernism(s) offer artists no guidelines to the ethics of appropriation, it is among artists that debate on this point has emerged. It is also among artists that the notion of art as a collection of objects is most strongly contested. It is artists who insist their work is *both* aesthetic (a vehicle for subjective feeling) *and* useful (an expression of cultural tendencies and values). These points form the basis of my guarded optimism.

In beginning, now, to look at the content of the self-enclosed discourse we have generated between 'ourselves' and 'the primitive', I believe we can begin to see the place where western thought has collapsed upon itself, the source of 'ourselves' as subjects in a culture dedicated to mastery of a mirage. Focusing on this mirage will undoubtedly one day come to be seen

as simply the latest version of an old myth.[9] Given our present circumstances, this seems to me to be inevitable. 'Myths are always there, even if indirectly and by hidden ways, for the good reason that they are invented by the natives themselves, searching for a parable of their own fate.'[10]

Susan Hiller
Sunset Beach, California
1988

NOTES

1 'Ethnographic', 'tribal', 'underdeveloped', 'Third World', and 'marginal' are words standing for many different, varied peoples of the world constituted by colonialism as *them* in contrast to *us* 'Europeans' or 'westerners'. 'Primitive' and 'modern' are also constructed categories deriving from a specific history. *These words should always be read as entirely problematic and as though surrounded by inverted commas/quotation marks.*

2 Most of the objects sent to the Emperor Charles V by Cortés and viewed by Dürer in Brussels in 1520 probably were the work of Mixteca-Puebla artists.

3 Excerpt from the journal of Albrecht Dürer, quoted in H.D. Disselhoff and G. Linne (1969) *The Art of Ancient America*, New York: p. 100.

4 The British Museum in London now houses three masks overlaid with mosaics of turquoise, jet, mother-of-pearl, and shell, originally given by Montezuma to Cortés, as well as a rock crystal skull and a sacrificial knife; the Ethnological Museum in Vienna contains featherwork fans, head-dresses, and shields, including a wooden shield overlaid with turquoise mosaics etc.

5 Dürer, op. cit.

6 I have spoken and written about this quite a few times. The most accessible versions are reprinted in Sarah Kent and Jackie Morreau (eds) (1985) *Women's Images of Men*, London: pp. 138–54, and in Lisa Tuttle (1988) *Heroines*, London: pp. 118–28.

7 James Clifford (October 1981) 'On ethnographic surrealism', *Comparative Studies in Society and History* 23, 4: 546.

8 This is an excerpt from the following passage in Roland Barthes (1973) *Mythologies*, trans. Annette Lavers, London: pp. 158–9:

> It seems that this is a difficulty pertaining to our times; there is as yet only one possible choice, and this choice can bear only on two equally extreme methods: either to posit a reality which is entirely permeable to history, and ideologize; or conversely, to posit a reality which is *ultimately* impenetrable, irreducible, and in this case, poeticize. In a word, I do not yet see a synthesis between ideology and poetry (by poetry I understand, in a very general way, the search for the inalienable meaning of things).

9 See the suggestion that Freud's interpretation of the Oedipus myth is simply the most recent variant of the myth, in Claude Lévi-Strauss (1963) 'The structure of myth', *Structural Anthropology*, New York: p. 217.

10 Christian Metz (Fall 1985) 'Photography and fetish', *October* 34: 90.

Acknowledgements

Most of the material in this book originated in the form of seminars on 'primitivism' presented at the Slade School of Art, University College, London in 1985–6. I formulated the concept of this weekly series in response to the interests of a number of students who had reacted strongly against the various kinds of neo-expressionism then fashionable in painting, and who were committed to investigating issues of identity – particularly ethnic and sexual identity – in their own work. This art student reaction, which I had seen at other colleges as well, met with an equally apparent art student tendency to emphasize 'essences' and 'universals' and to look for transcendental solutions in their practice. The two parties to what is a long-standing debate among western artists made works that fused and elided the themes of their encounter. What they shared was a renewed emphasis on 'history' and a revived interest in visual traits that had been re-presented in several recent major exhibitions[1] juxtaposing ethnographic art and modern art.

This emphasis and this interest provided the setting for the primitivism seminars. It became clear from the outset that the discussions would not limit themselves to defining primitivism merely as part of the history of art. The topic continually redefined itself, so that the question no longer seemed to be how to compare 'tribal' art and 'modern' art in order to find formal similarities, as in the Museum of Modern Art show, but how to decipher the colonialist and racist assumptions hidden by such a comparison. It became impossible to consider simply the history of the tendency of western artists to borrow tribal art motifs without first examining this in relationship to European intellectual history, the ethics of appropriation, and questions of power and domination. Similarly, the 'objectifying' tendencies of anthropological contributions to the seminars were queried whenever they seemed to verge on claiming 'objective', scientific authority.[2] Retrospectively, it seems to me that this deepening of a collective understanding was the direct result of my initial decision to juxtapose speakers from different disciplines.

All the seminar participants[3] (in fact, all the contributors to

this book in its present form) were intrigued enough by the possibilities of the situation to risk opening their particular fields of enquiry – whether art history, anthropology, art, or criticism – to the views of non-specialists. Some of the original participants subsequently have revised their initial contributions to take into account points that were strongly debated as the series evolved and as different perspectives interrogated each other. I added some previously published articles to make up the later collection when it became increasingly clear to me that much more than a Eurocentric examination of conscience was at stake. But there was never any intention on my part or on the part of individual authors to paper over cracks between disciplines or to cover up inconsistencies or contradictions that might emerge in reading the papers comparatively.

Indeed, my own view is that anthologies or collections organized around notions of 'theoretical consistency' – even when the theory is innovative or radical – only continue to prop up the idea that everything is known and/or knowable, one of the more geriatric assumptions of the European world-view. Surely it is past time to relinquish the quest for one totalizing, seemingly authoritative perspective in favour of a more complex, fragmented evocation that allows contradictions to emerge as spaces where new understandings can form themselves.

The contributors to this project – artists, art historians, anthropologists, and critics – share the real dangers and pleasures of stepping outside the boundaries of their specialist discourses to address an audience that will read this book for ideas that have the widest possible cultural implications *across* discourses. With this in mind, I have arranged the material thematically and, I hope, provocatively. My commentaries introducing individual sections are not straightforward summaries of each chapter, but are interpretations and speculations of my own on connections I see existing *between* chapters. In many cases my interpretation probably differs from the author's intention. This gap between intention and interpretation is where artists operate. I am optimistic enough to hope I will be forgiven by contributors for liberties taken; reading the texts themselves is, of course, the best way for readers to correct my bias in favour of their own, which need not, indeed will not, be the same as the authors' . . .

I would like to thank Slade Professor Patrick George for enabling the series of seminars to take place by providing funds and facilities; Slade faculty and staff members Ron Bowen, Monica Hutchinson, Barbara Duncan, and Murray Watson for their administrative support and encouragement; the Depart-

ment of Art and School of Art, California State University, Long Beach, California for inviting me to serve as Distinguished Visiting Professor in 1988, an appointment that gave me time to edit and shape this book into its final form, after many delays due as much to shutdowns and changes in the publishing world as to the procrastinations of writers; and the students of the Slade School of Art and the Department of Art History, University College London for their lively involvement with the seminar series and their generous contribution of ideas and criticism.

Many friends, among them some of the contributors to *The Myth of Primitivism*, have been involved with me for a long time in discussions of pertinent ideas about art which simply have been absorbed into the book, and I particularly wish to acknowledge the collaborative nature of its germination. I would also like to thank Neil Middleton and Fiona Byrne Sutton for specific helpful suggestions at an early stage. David Coxhead's close reading of my own sections of the book showed up (in the nicest possible way) some wobbles and obfuscations I've tried my best to eliminate subsequently. Helena Reckitt, Antonia Pledger, and Stephanie Horner at Routledge have been tactful and efficient co-workers on the project, patiently seeing it through to fruition. Most of all, thanks to all the individual authors and artists.

NOTES

1 Most influentially, *'Primitivism' in 20th Century Art: Affinity of the Tribal and the Modern*, at the Museum of Modern Art, New York, September 1984–January 1985, and *Lost Magic Kingdoms and Six Paper Moons*, at the Museum of Mankind, London, November 1985–October 1987.

2 See Mary Louise Pratt, 'Fieldwork in common places', in James Clifford (ed.) (1984) *Writing Culture*, Berkeley, Calif.: University of California Press, pp. 27–51, for a discussion of the history of this mode and the implications of the tension between personal narrative and impersonal description in ethnography.

3 Seminar participants were: Rasheed Araeen, Guy Brett, Lynne Cooke, Annie Coombes, Signe Howell, Anna Howells, Jill Lloyd, David Maclagan, Daniel Miller, Michael Newman, Desa Philippi, and Christina Toren.

PART I

Editor's introduction

All known human societies seem to formulate ideas of the 'other' in order to define and legitimate their own social boundaries and individual identities. The category of the 'other' includes the inhabitants of the realms of supernatural beings and monsters, the territories of real or imaginary allies and enemies, and the lands of the dead – places far from the centre of the world, where one's own land is, and one's own reality. The 'other' is always *distant* as well as *different*, and against this difference the characteristics of self and society are formed and clarified.[1] In the west, this frame of reference has been complicated by a history of expansion and conquest which inscribes the relationship between *centre* and *periphery* in economic and political terms.

The west's drive to conquer and exploit the lands of others has fused myth, history, and geography and has projected European speculations and fantasies about the 'other' on to real other peoples; primitivism and cultural colonialism are two elements in this fusion. Cultural colonialism, in Kenneth Coutts-Smith's analysis, is an ideology that extends the idea that spoils of war might include art objects along with other valuable goods as proof of conquest and territorial sovereignty, to the appropriation and incorporation into the body of European culture of 'the diverse cultures of the whole world and of all history'. The assimilation takes place on western terms. Nothing indigestible is consumed; no ideas or information that would shift or dissolve 'our' preconceptions about the makers of those 'other' cultures nourish this body.

The enlargement of European aesthetic horizons in the modern period through the importation of visual ideas originating (mainly) in Africa and the Pacific, suggests an increasing recognition by artists that the artistic resources of those lands and peoples were just as available for exploitation as their mineral and agricultural resources. Although exoticism was a theme in European art beginning in the early nineteenth century, and the anti-intellectualism and emotional intensity sought by Romantic artists were often inspired by scenes of distant, exotic cultures, the *style* of these poems or paintings was

never foreign to Europe. But in 1905, according to Vlaminck (who takes credit for being the first European to find African sculpture 'profoundly moving' and to launch its vogue as 'art'), Picasso became the first artist to appreciate 'what one could *gain* [my emphasis] from African and Oceanic arts, and he . . . gradually introduced those qualities into his paintings and in this way started a movement, the novelty of which led people to believe it was revolutionary'.[2] Vlaminck, in fact, attributes to Picasso the real 'discovery', the useful insight that African art could prove a source, a resource for western artists. This 'moment of discovery', itself mythic, binds together the imperialist conditions of possibility with the appropriative strategies of modernism.

Coutts-Smith suggests that 'subjective mental territory', the foreign land of dreams, psychopathology, fantasy, and magic, once located conceptually at the very margins of our known world, have been colonized, too, as part of the process of European expansion, absorbed into art, and brought inside the extended body of western culture for digestion. David Maclagan's question, 'Outsiders or insiders?', proposes a hall of mirrors where the art of 'endogamous primitives' is caught, ambiguously located in the ideological spaces of our culture. 'It is essential to bear in mind that the main body of this work was produced within a specific timespan – the period roughly 1880 to 1930 . . . it was "produced" in the sense of being collected, analysed, and published for the first time' during the same period as the great public ethnographic collections were first formed and later began to emphasize the aesthetic rather than the 'barbarous' values of 'primitive art.' The production of the category 'outsider art' as an artefact of our culture recalls Graeburn's definition of 'primitive art': 'The concept of primitive art is a Western one, referring to creations that we wish to call "art" made by people who in the nineteenth century were called "primitive" but in fact, were simply autonomous peoples who were overrun by the Colonial powers.'[3]

Western artists have enriched their repertoire by drawing upon the resources of a range of ethnological, archaic, or 'outsider' styles, all of which have been seen as raw, truthful, and profoundly simple, a set of projections which is the *precondition* for the validation of these exotic influences. Ethnographic art, in particular, has 'helped the (Western) artists to formulate their own aims, because they could attribute to it the very qualities they themselves sought to attain.'[4]

Daniel Miller's provocative suggestion that primitivism is *essential* to western art's self-definition because art has been given the impossible task of being a 'fragmented comment upon the nature of fragmentation' leads (again) to the '*moral* dilemma

posed by primitivism' in relation to the context in which it operates as an effect of the imperialist history of the west, 'namely racism.'

But the investigations of the Black Audio/Film Collective into the 'fictions' of British national identity 'produced through the excesses of colonial fantasy' are poised as a countermemory, a revoking of the oratorial, curatorial, art historical 'we' and 'they' of colonial discourse. This is an encounter with Europe's myth of primitivism from its 'other' side, from a place where the static, ritualized identities of myth are relinquished and its fixed map of privileged territories and positions is redrawn.

NOTES

1 See Jonathan Friedman (December 1983) 'Civilizational cycles and the history of primitivism', *Social Analysis* 14: 31–50, for a schematic analysis.
2 Quoted in Michel Leiris and Jacqueline Delange (1968) *African Art*, London: Thames & Hudson, p. 8.
3 Nelson Graburn (ed.) (1976) *Ethnic and Tourist Arts*, Berkeley, Calif.: University of California Press, p. 4.
4 Robert Goldwater (1967 [1938]) *Primitivism in Modern Art*, revised edn, New York: Random House, Vintage Books, p. 253; this remains the classic work on primitivism in art.

1 Some general observations on the problem of cultural colonialism

KENNETH COUTTS-SMITH

Traditionally, historians of culture in general and art critics in particular have tended to base their analyses and their theoretical platforms upon the assumption that art somehow represents the embodiment or the concretization of basic values and fundamental truths that exist somewhere outside of history, beyond social mutation, external to political and economic reality.

The complex of ideas that is clustered around the interrelated notions of the essential spirituality of art, the sublimity of the creative experience and the passion of genius, has served as a central nexus in the vast majority of thinking concerning matters of aesthetics since the inception of that area of enquiry as a specific discipline down to the present point in time. The validity of this position is, however, currently being severely questioned; though from the great majority of published art criticism in specialist books, in art journals, and in catalogue prefaces, it would not seem that our discipline has yet begun to take much note of a major shift in focus that is now occurring in the broad spectrum of world culture.

The present commentator himself is no longer able to accept the idea of the extra-historicity of art and the notion that artistic events take place in some manner in a continuum that is divorced from social and political dynamics. It also appears evident to him that when (in the vast majority of instances) we speak of a world-wide 'high' culture, a significant part of which is formed by the whole spectrum of the fine arts, we are actually speaking of a tradition that is largely restricted to the European cultural experience. Even a cursory glance at recent issues of the various 'international' art journals, or at museum and major exhibition catalogues, whether they emanate from Europe, from North America, Latin America, Soviet Russia, India, Japan or wherever, reveals a homogeneity of thought which fails utterly to question the Eurocentricity of most contemporary art-critical assumptions.

The two phenomena, the notion of the extra-historicity of art and the Eurocentric bias of our thinking on culture, are not

merely in a clear reciprocal relationship but would seem to be mutually dependent one upon the other. In the present writer's opinion, they would also appear to be central aspects of a total attitude towards art which cannot, in clear honesty, be defined as anything less than cultural colonialism.

These observations, however, can only serve at this point in time as a sketch outlining the problem in broad strokes and thus attempting to define the general areas in which research and analysis are indicated. This specific enquiry is currently of an extremely pressing nature for obvious moral as well as historical reasons; but the scope of the question is very wide and far-reaching, penetrating as it does into every corner and crevice of our cultural superstructure, into every assumption and belief that helps to support our identity and self-esteem, into every facet and aspect of life that we regard as justifying our individual roles and activities.

In the broadest sense, what we regard generally as culture, and specifically as art, is the continually mutating end-product of a process that is basically mythic in nature, that is to say, a process in which beliefs and asumptions gain substance, become validated. But the dynamics of culture do not only lead in this way towards the fluid identification of a collective identity within a society, they also tend towards the freezing of concepts supportive to the interests of a dominant minority within that society.[1] Ideas which are at first the products of historical necessity are thus transformed into absolutes that are cited in justification of attempts to arrest the historical process, to maintain the status quo.

The need to examine our present cultural assumptions in the light of the above contention cannot be emphasized strongly enough. It would seem that in the present majority view, there is hardly a single facet of that complex structure which we refer to as 'high' culture that is understood to remain conditional upon historic necessity; rather, the whole cultural superstructure appears to be generally regarded as constituting a self-enclosed system obedient only to the exigencies of 'art history' – a different matter altogether. The discipline of art history has never, until now (excepting in the work of isolated individuals regarded, institutionally, as tangential), been required to submit itself to the historical rigours of social and political fact, but has been nourished in the main on poetic insight and metaphysical speculation.

Art history has been, since its inception in the late Renaissance, ultimately little more than a scholarly elaboration of myths inescapably engendered by the twin concepts of the essential sublimity of the creative process (which logically defines art

as an experience located in the sphere of the ideal rather than the actual) and the centrality of style (which predicates the sequential development of an art whose central subject-matter is restricted to its confrontation with previous art rather than with real experience taking place in history).

The notion of the extra-historicity of art is, however, clearly a false one – not even, but *especially* – in terms of the class which not only defends this idea, but also raises it to an ideological imperative. The bourgeois insistence upon the idealist nature of the whole creative process can be seen to serve, on the one hand, as justifying the view held by that class that its understanding of the individualistic, competitive, and acquisitive nature of man is not a class-view but an absolute human condition, and, on the other hand, to obscure the almost total appropriation of 'high' culture as both the private property and preserve of a privileged group and as the spiritual vindication of their continuing economic and political domination.

Enough has been written elsewhere upon the question of a dominant class appropriation of cultural institutions to dispense with arguing this point in the present context: it is hoped that it will be here accepted that the possession of a broad culture and of a liberal-humanist education is not merely the privilege of the bourgeoisie but that it also comprises the structure of the code signals by which individual members of the class recognize each other and consolidate their own private identities. The institutions in which the transference and acquisition of cultural property take place are set up in such a manner as to perpetuate existing class privileges and to restrict the entry of extra-class individuals to those whose status is considered in terms of necessary recruitment, that is to say, as candidates for indoctrination into the bourgeois value system.

It might be stated that it is not our purpose here to consider the still-existing, though possibly eroding, bourgeois class dominance other than where class hegemony relates to colonialist assumptions. But this finally would be a meaningless statement since it is not possible to separate either, historically, the development of bourgeois consciousness from the development of colonialism, or socially, the bourgeois value-system from racist and imperialist assumptions of superiority. Very little that is fruitful can be achieved in attempting to think of imperialism as a phenomenon divorced from the class assumptions of capitalism; this is an error frequently made in the past by many writers concerning the internally colonialist status of the blacks in North America and elsewhere, and, more recently, in regard to the Amerindians and internally colonialized aboriginal peoples. The 'whites', as a collective and political undifferentiated mass, rather than the capitalist system which produces the alienation

requisite for racist attitudes, are seen as the oppressors.

In our present context it is absolutely crucial to recognize that the two questions of cultural colonialism and class appropriation are interrelated and interdependent; and, although space clearly precludes that this paper should attempt an analysis on these lines, it must be emphasized that the dimension of class contradiction be borne in mind throughout the remainder of this exposition.

We have intimated that culturally colonialist attitudes and assumptions permeate the whole domain of 'high' culture, and that this is nowhere more evident than across the spectrum of the fine arts. The reason for this may well be related to the reason for the apparent pre-eminence in our present culture of the visual mode in the arts over both the musical and the verbal. Up until the end of the nineteenth century it would appear that musical and verbal culture were more highly regarded than was plastic culture, which, with few significant exceptions, essentially was considered as being the province of mere artisans. Indeed, in Anglo-Saxon countries, such an attitude has persisted until very recently, whereby literature might, under certain circumstances, be considered a fit occupation for a gentleman, while, at the same time, there was something suspect, indeed disreputable, in the idea of making a career as a painter.

It is interesting to observe, over a period of time, the changing social attitudes of the European and North American middle class towards the fine arts. This process is perhaps due less to the fact that financial profit was possible in both production and speculation than to the supposition that painting (and sculpture to a lesser extent) was the art form that best objectified bourgeois ideals, since the individual picture could become property *in the absolute sense*, since it could uniquely embody both the status and the aspiration of its owner in a manner that was obviously denied to the poem, the novel, the play, or the opera.

That direct financial potential was not a factor to be taken into serious account becomes clear if one is to remember that only twice in the history of art during modern times was there a brief situation of boom and speculation in which art production and marketing could be said to approach a sufficiently high temperature of speculative potential to interest the serious investor or financier. One of these booms was in late Victorian genre painting, but this cannot in any way be considered a phenomenon of visual culture since it was, in essence, the sentimental and moralistic subject-matter exemplified by the work of such painters as Landseer and the late Millais that was at issue.

It is not possible, in this instance, to regard the art work as a cultural product designed for the consumption of a visually

literate public, nor is it possible to see the individual painting operating as a special *objet de luxe*. The whole phenomenon was more in the nature of an early construct of mass media soporific, one designed as a placebo for a restless lower-middle class and upper proletariat. The vast prices that were paid for individual works, the aura of gossip and fame, the celebrity status awarded to such artists as Watts, Alma-Tadema, Leighton and Poynter, as well as to such support-system mandarins as Ruskin, would seem to make it obvious that, if parallels were to be drawn with more recent times, then this extraordinary period should be related to the extravagance of Hollywood at its zenith, at a point where a later and only slightly more sophisticated generation of the articulate deprived were clearly persuaded to submerge their claims in a vicarious participation in constructed glamour.

The art boom, now substantially deflated, of the immediate past was a different matter altogether. It was the product of two forces: first, a direct and very lucrative dimension of speculation whereby industrial and corporative marketing techniques allied to sophisticated promotional methods were applied to the merchandizing of art, and, secondly, the recently initiated and still-ongoing 'canonization' of culture whereby the arts have, to a certain extent, been required to fill a role of secular spiritualization in the vacuum left by the demise of religion within an increasingly alienated consumer society.

It is, however, not in respect of, but rather despite these two art 'booms', both resulting from forces extraneous to art itself, that we note the progressive ascension of the fine arts from a somewhat lowly status to a position of pre-eminence among other cultural pursuits to a point whereby the word 'art' becomes synonymous with the visual experience and connotes a dimension of sublimity only previously associated with mystical and divine visitation. The hypothesis that this process represents the development of the cultural symbol-system most approriate to a society increasingly geared to profit and consumption would seem to be supported by a historical juxtaposition of the events in art during the last 150 years or so and the parallel emergence to social confidence, to political and to economic power, of the bourgeoisie.

If there is any virtue in the above line of thought, then one would expect to discover a more clearly impacted and more deeply ingrained structure of colonialist assumptions in the domain of the fine arts than in other parallel disciplines. Literature certainly in the past maintained a clear allegiance to a tradition whereby it sought to locate itself in an 'academic' stream of liberal-humanism which restricted the definition of verbal culture to the European experience; however, on the threshold of the modern period, as we shall see, it abandoned

this specific structure of collective civil value for a general structure of subjective and regional value.

The notion that culture comprises a humanizing body of values and concepts through which the *educated* both recognize each other and communicate with each other (through the common possession of a vocabulary of metaphors and historical or classical references) was an invention of the High Renaissance. There is an incontestable logic in the fact that, during the first years of evolving imperialism and condensing European identity, the emerging mercantile society should have both regarded itself as a historical and cultural nexus, and, in order to justify itself by initiating a claim upon predecessors and exemplars, should have projected value and *virtu* on to a mixed tradition that was part historical fact and part legendary construct.

The appropriation, in this manner, of a past that was an amalgam of myth and actual event was in essence the cultural dimension of a European expansionism that had its mental dimension in the developing scientific approach towards the natural world and its political and geographical dimensions in the mercantile and maritime explosion which took place at the crumbling of the Aristotelian universe. The birth of Europe was not only achieved in relationship to the twin forces of emergent science and emergent capitalism, but it was also fixated with a profound conviction of the fundamental centrality and manifest pre-eminence of the new political and social structures, and this event was accompanied from the very first by a deeply ingrained process of appropriation.

Colonialism did not appear in the modern world with the forays of Cortés into Yucatan, or with the destruction of Tenochtitlan, but with the claim of historical cozenage extended by Renaissance mercantile republicanism towards the exemplars of a dimly remembered Roman *polis* observed through the roseate lenses of political ambition and swiftly consolidating class interest.

It is from this point that we can note the development of a body of cultural property that was later to be defined as the tradition of liberal-humanism. At the beginning this represented simply the collective self-identification of a small but enormously self-confident mercantile class in Florence and elsewhere; but as time went on, the idea of 'humanism' was to be identified with civilized value itself, it was to become the prerequisite base of culture and education. In this way, the special interests of a specific class and the broad sweep of absolute cultural value were seen as synonymous. This claim upon history initiated the process of cultural mystification from which we are still suffering, and, as we may now perceive, it relied

for its continued expansion upon a process of cultural appropriation.

Culture, in the new post-Renaissance understanding, was henceforth to serve the interests of a class rather than those of the collective; as the new economic imperatives penetrated the feudal world they inexorably mutated the relationships that existed in that world, transforming the co-operative *Gemeinschaft* of the collective of Christianity into the competitive *Gesellschaft* of economic, and, later, of industrial man. Furthermore, the new concept of culture, as in the very nature of capitalism itself, demanded both a continually expanding lode of resources and a continually expanding 'market'.

In opposition to the static and genuinely 'absolute' value of feudal culture, it was in essence dynamic and relative (though, of course, it pretended claims to the absolute) and thus could only function in a condition of permanent expansion. Since its subject-matter was not *realist* in the feudal sense, that is to say, one not reflecting the existent and, internally to that society, self-evidently timeless and eternal values subscribed to by that society, but rather, was *idealist* (in that its motive was to project the poetic and the conditional, to project metaphorical allusions to a universe that did not yet exist but which might possibly be brought into being through the powers of the imagination) then, clearly, it was constrained to look outside of the general body of symbols and concepts that made up the common heritage of the society.

The culture of the feudal world, in terms of the understanding of that world, was far from a metaphysical one, for despite the totally Christian nature of its symbolism, the basic concept of the universe was of a hierarchical continuum rising vertically from the lowest peasant through the ranks of the nobility, the ranks of the church, through the pope to the empyrean, to Christ and, finally, to the Godhead. The structure of medieval thought, just like the content of medieval religious painting, was essentially one which was concerned with things as physically present in both time and space as was man and his daily mundane activities and aspirations. Paradoxically, it is with the development of pictorial realism in the purely technical sense that we first note the shift towards the depiction of a metaphysical and idealist universe.

It would not seem to be coincidental that the Medici and their successors should have chosen and reinforced the medium of the visual arts to express and confirm the justification for their vision of a new, fragmented, and competitive structure of human social relations, since this medium could perhaps best embody the dimension of subjective idealism with the notion of individual 'genius', and thus help to salve and obscure the

paradox engendered by the necessary opposition between usury and charity, between competition and co-operation, between the possession of economic power and privilege by a minority and the requisite resignation to poverty and to subservience demanded of a majority.

The new idea of the creative power of this imagination as the prime assumption within the domain of culture was, in so raising isolated and personal actions to a fundamental principle, without doubt engendered by the need to vindicate the moral ambiguity of individual economic and entrepreneurial aggression. Similarly, the claim upon precedent raised by the delineation of parallels between the fifteenth century mercantile reality and an idealized view of Roman republican virtue was conditional upon the need to legitimize a social stance that was based upon fiscal manipulation in a society that had for centuries regarded usury as a cardinal sin.

A concept of appropriation that is soon to declare itself as colonialist in nature can thus be seen to have initiated its central role in European culture from the very point of the emergence of a continental 'European' consciousness. Though the first phase of this phenomenon can be seen to have operated almost exclusively in the domain of 'history', we must be clear at this point that the force that was working in this context was far from what we understand by the concept today.

An understanding of history as a continuum of events whereby the occurrences of the past to a great extent logically preclude the patterns of the future is dependent upon the possession of accurate records or plausible speculation together with an objective analysis of the evidence. History, until the end of the eighteenth century at least, was as much, if not more, a matter of projection as it was of research and analysis; the separation between legend and fact was not accomplished until the comparatively recent past. Bishop Usher's widely accepted chronology, for example, whereby the world was understood to have been created in scriptural totality upon a specific day in February 4004 BC, or the fact that Isaac Newton was himself ultimately more interested in his theological and his historiographical speculations than in his scientific observations, demonstrates a profound ambiguity in regard to the past, existing as late as the Enlightenment. At that time it was still imperative somehow to equate the literal and revealed truth of biblical text with the virtual and observed truth of archaeological and palaeontological evidence.

Even on the threshold of romanticism we may observe William Blake alternately swinging between, on the one hand, his 'modernist' response to the injustices of industrial society and

to the revolutionary aspirations of an awakening political consciousness and, on the other, his residual, but deeply intuitive, conviction of scriptural truth and his intellectual debt to Swedenborg and Jacob Bryant; indeed, it is on the very tensions of this paradox that his poetic inspiration depended.

The Romantic period, however, was not simply the major cultural response to the developing technological dimension of the Industrial Revolution and to the emerging social dimension of class-consciousness; it also marked the shift of central emphasis in the ongoing process of appropriation from the historical domain directly to the geographical and, ultimately, to the colonial domain.

The conflict between classicism and romanticism that marked the closing decades of the eighteenth century as well as the opening ones of the nineteenth century, was not the result of simple stylistic or scholastic rivalry, it was not even primarily the expression of antagonism between the waning, closed society of post-Restoration aristocracy and the social forces unleashed by the French Revolution. Rather, it was much more the expression of the fact that a developing body of scientific knowledge had begun to render history opaque to the penetrations of capitalist appropriation. History had become, itself, a science, and, as a result, the possibility of a reinterpretation of the past in favour of an elite began to recede in the face of the increasing availability to a wider public of clear and unambiguous information.

In the light of the archaeological discoveries of Wincklemann and others, the ancient world took on the clearly defined lineaments of real life. The classical antique, revealed at last to the scrutiny of daylight, thus lost the ambiguous and problematical dimensions which alone made it malleable to the idealism of appropriation. The classical mutated into the neo-classical; and, as the distinction between legend and fact was clarified, so images in art became more archaeologically 'truthful' and progressively less and less able to support the process of mystification.

In a final and spectacular burst of historical appropriation, the French Revolution itself claimed justification from the ancient world; but the brief paganism of the divinity of Reason was soon to fade, and by the time of Napoleon we note the sudden shift of focus, first to a non-classical past, then, directly, to the double perspective of a geographical and colonial dimension balanced by the obverse invasion of purely mental territories.

Napoleon's colonial adventure into Egypt was the first one since the imperialism of the ancient world to return in triumph bearing cultural spoils as proof of conquest and territorial sover-

eignty. During earlier phases of colonialism, during the Spanish domination of Central and South America, for example, or during the British and French expansion into North America, artefacts, usually of a religious or totemic nature, were sometimes brought back to the colonizing metropolis. But it was not *cultural property* that was transported in this way as much as evidence of the spiritual and religious domination and subsequent conversion of the barbaric heathen. Conquistadors, gentlemen-adventurers, and merchants had no interest whatsoever in artefacts as cultural property, only in their possible value as precious metal. Neither did priests have any interests in such objects beyond exhibiting them as proof of their missionary zeal and as examples demonstrated before their ecclesiastical superiors of the thousands of pagan idols they had burnt and smashed in the name of the propagation of the faith.

The Napoleonic campaigns were innovative in that cultural property *was* accounted among the spoils of war; and not merely physical objects and artefacts either, but also the intangible and abstract property of artistic style. Together with the obelisks and statuary looted from the Nile valley, the victorious returning army brought back an artistic *style* that was to be rapidly adopted as the formal and official visible hallmark of the moral and political authority of empire.

At the very point when the mother lode, as it were, of the classical antique dried up as a resource for historical appropriation, a new pre-classical civilization was offered as substitute. Yet, just as a transition was being made in the matter of resources, so parallel transition was also affected in terms of needs. The Egyptian civilization, dying as it did during the classical period, turns out to be one-dimensional; there are, apparently, no decipherable records, no historic personages save a few vague shadows, no heroes, no exemplary legends, merely the single dimension of visual style.

Style alone, it quickly became apparent, cannot long fill the role now being proffered it – a radical departure, incidentally, from any previous response to visual culture, and one crucially in need of proper analysis. This new aesthetic relationship clearly places style under the constraint of consumption; without subject-matter, without a moral or exemplary dimension, there must now be initiated a process of mutation, of change, novelty, surprise.

In this way, a specific element attached to the new imperial Egyptian style becomes first isolated, then made central; it is an element that seems at first to be capable of near-infinite variety, of almost continuous mutation: the element of strangeness itself, the element of *exoticism*.

The Romantic movement now has its leitmotiv, its theme; it

is, however, to expand the search into the exotic in two essential
and different directions. One, which is our direct concern here,
is to result in the conscious attempt to appropriate and to incor-
porate into the body of European culture the diverse cultures,
not only of the whole world, but also of the whole of history. It
is here that the tacit historical appropriation that we have
attempted to define becomes a clear and overt programme of
colonial appropriation throughout the whole of world culture.
There would seem little doubt that the expanding European
military and economic imperialism from the early ninetcenth
century onwards is paralleled and echoed with a developing
structure of cultural colonialism.

The other direction taken by the Romantic movement in
general constituted a similar expansion, but one that operated
inwards, towards a 'colonization', as it were, of subjective
mental territory. As the first force can be observed as co-opting
the cultures not only of non-European peoples but also of the
vanished peoples of the past, so the second force may be seen to
launch an attempt to appropriate the whole twilight territory of
the mind, the landscapes of dreams and fantasies, the preserves
of psychology and psychopathology, the primitivism of child-
hood, the bizarre territories of superstition, magic folklore, and
the absurd.

It is not within our scope here to enter into an enquiry
concerning the subjectivist space that the arts have invaded and
which has become so firmly a characteristic of artistic modern-
ism; suffice, at this point, to briefly remark on two points. First,
during the early years of the Romantic movement, the visual
arts entered the subjectivist area with considerable vigour. In a
spectrum that might include Fuseli, John Martin and Caspar-
David Friedrich at one pole and Géricault's fascination with
abnormality at another, we could stretch out the whole wide
band of the sublime and the picaresque, particularly in terms of
landscape, and even include the gentler Wordsworthian echoes
to be found in such celebrators of the spiritual in nature as
Constable.

However, despite the dramatic intensity of the period, the
theme of mental space in painting is, after a short time, to be
almost completely abandoned until it is picked up once more, at
a later date, in a minor key by the surrealists and by various
introspective individualists such as Paul Klee. Secondly, in
considering subjectivist appropriation, we may here return to a
point that was earlier intimated concerning the relationship
between the visual arts and other creative areas of activity. A
simple glance at the events of the Romantic movement and after
will reveal that it is verbal culture in general and literature in

particular which has most consistently explored the subjectivist arena. During the Renaissance and the Baroque, literature naturally expressed the classical structure that we have defined (witness Spenser or Racine) but for some reason, perhaps partly because pre-Renaissance writing (Chaucer, Dante, Petrach, Villon, Rabelais) retained more direct links with the antique world, it never objectified Renaissance and baroque society as eloquently as did the plastic arts.

Similarly, at the point of the Romantic movement, literature, and to a comparable extent, music, was to concentrate almost exclusively on the subjectivist view of society, of the world, and of nature. This may also partly explain why present-day literature, though obviously by no means totally free of colonialist assumptions, stands in a less crucial position in this regard than do the plastic arts.[2]

As we have remarked, the subjectivist position exhibited in early nineteenth-century painting was not to hold centre stage for more than a brief period. Such subjectivism demands *content* in painting, even if it be no more than that found in Turner, for example: the flux of the individual artist's emotions in the face of nature. It was not Géricault, with his deeply humanistic response to man, who was to survive and to condition the future, but Delacroix, the flamboyant and brilliant master of style, the inaugurator of pure painting, the dynamic colourist, the anticipator of expressionist abstractionism, and the artist who, above all, defined the ideal subject-matter of painting as the *exotic*.

It was Delacroix who travelled North Africa in the wake of a colonizing embassy and, in observing the picaresque Bedouin, the harem *odalisque*, reified them into exotic and glamorous objects. He painted people as if they were guitars, and personally inaugurated the long process through which European art was to attempt to appropriate the visual culture of the whole planet into its own self-conceived 'mainstream'.

Can we here isolate an imperative within the general structure of capitalist social relations? A subjectivist artist, even if his overt motivation is that of an egoic sensibility, who desires his personality to expand to the dimensions of the universe, still observes and recognizes his fellow creatures. But if the necessities of capitalist society require art to maintain its appropriative roles in the real-time world, having lost its hegemony over the 'historical' world, then it could hardly be expected to observe and recognize *real* fellow human beings; too many contradictions could result and inhibit the process.

If the visual arts were to be about *modern life*, if painters were to anticipate Baudelaire (or at a slightly later date, to follow him), they would find themselves in a different position from the

poet and outsider who was comparatively freer from social claims. It seems plausible to envisage a situation of pretending a more profound bohemianism than is accepted as commitment, and, subsequently, avoiding conflicts by reifying the subject-matter. The logic of the situation demanded that people had to be treated as still lifes (or, more eloquently, as *nature-mortes*); the logic of the situation also revealed that the imperative towards abstractionism was inevitable.

We can note with the Barbizon painters a swing not only against the commitment to content in painting but also the first intimations of the idea of a pure painting of style. The landscape, in their hands, became the starting-point for an essay into pure visual sensibility, and was thus the initiation of a process later to be explored by some of the Impressionists to the point of negation. For the individual artist, this represented the threshold of an exciting and passionate voyage into the potential of the eye, and despite their conscious intentions (even, paradoxically, in opposition to a stated allegiance to content, to a search for rural innocence), the hegemony of style over content was inaugurated.

The later landscape painters of the pre-impressionist period were already committed to the pure visual adventure. In their conscious understanding, as well as in their visual intuition, the separation between narrative painting and pure painting was achieved. Both the creative experience and the artistic product were thrust firmly into the sphere of the absolute, and from that point onwards Europeans started to become used to thinking of 'high' culture in general and the fine arts in particular as operating in some sort of mental and moral space totally divorced from any but the most abstract and tenuous relationship with social realities.

The present world climate of thought, however, now obliges us to begin to reassess the relationships that obtain, historically, in regard to the arts; there is a current tendency to query whether it is possible for any event to take place in isolation from the social domain. If this is so, then the initial commitment to pure painting represents not merely the cultural echoes of an attempt to reify the world, but also a significant factor operating towards this end. It could be said that the *plein-airistes*, developing a commitment to style, reversed the image celebrated by such of their predecessors as Constable who envisaged a coherent and humanized landscape, and in this way projected an image of an absolute, fragmented, and dehumanized landscape.

Immersed in their narrow stylistic concerns, the individual artists, many professing liberal, humane, and even 'socialist' affiliations, nevertheless acquiesced in a restructuring of man's relationship with his environment which, ultimately, was

profitable to restricted political interests. The capitalist social relations that were consolidating at the peak of the Industrial Revolution demanded a divorce between man and his natural environment in order that the masses might better accept the artificial environment of the industrial milieu.

It is possible that an earlier stage of this process was initiated during the period of the Gothic Revival, for, with the idea of the picaresque, we can observe the first intimations of the transformation of the natural environment (the basic arena for man's presence, identity, and social interaction, the archetypal space in which man labours and humanizes the world and himself) to a product, a commodity designed to be consumed. It is capitalism, rather than the technological exigencies of the modern world, that required our present almost total alienation from natural phenomenon, and it would simply not seem plausible to regard a major cultural event, such as the process of developing abstraction in nineteenth-century landscape painting, as being socially unrelated to capitalism's achievement of this aim.

In this context, we are obliged to observe the developing hegemony of 'style' and pure painting as not merely a series of events taking place in the domain of 'art history', but as events taking place in real history, events taking place in respect of the continually mutating structure of social relations. In substituting style for content, the visual arts were suddenly launched, as we have seen, upon a process of reliance on external resources. The speed with which art, as it were, consumed landscape, eroded its stylistic potential (the rapidity of the voyage between Barbizon and, for instance, Monet's *Haystacks*) was remarkable.

Most of us are culturally and historically conditioned to regard the intense burst of activity that took place largely in Paris between the 1860s and the 1920s, to consider that period of roughly half a century which begins with the mature work of Manet and which climaxes with surrealism, constructivism, and the Bauhaus, as a peak in terms of human dignity and freedom. We usually think of this as a point where the human race compares favourably with its more common idiocies and barbarities. The only cloud that occasionally shadows this myth is a Pompidou-like French chauvinism that would claim national credit for this wonder which, in reality, belongs to the world; but that does not seem serious, since we are all, apparently, proud to claim passports to the moral citizenship of the Parisian avant-garde.

There would seem to be no question that we would have to regard this period in art as a unique and positive moment in human history if the version proposed by art history be correct;

if it really is true that a group of the most talented people that the world has ever seen congregated almost by accident and created, *in vacuo*, as it were, a dazzling perspective of images so multitudinous and so fruitful that for half a century style succeeded style, concept displaced concept, in a variety and complexity that historians and curators have hardly been able yet to begin adequately to comprehend and to classify the wealth of cultural material thus placed in our common heritage.

However, it is questionable that this is what happened. It is questionable that a great and fruitful stratum of creativity was suddenly brought to light in this manner. A doubt would appear to be raised if we are to regard the whole phenomenon of modern art in the context which we have here attempted to define; for thus we would note the centrality of *appropriation* rather than that of creation. An art structure that is rapidly expanding, both in terms of its audience and in terms of its practitioners, develops a pressing need for nourishment. And an art restricted to style, as we have seen, cannot feed from its own social and historical reality, but demands a constant supply of raw forms for its survival.

When the potential of landscape was 'consumed' some time in the 1880s, a brief foray into the twilight territory of the Parisian *demi-monde* was undertaken, but this alone did not appear to provide substantial fare. A more solid source of material was required and this was provided just at the point of most pressing need. At various levels throughout late nineteenth-century society, from the academic ethnologists and anthropologists, guardians of brand-new sciences, to the frivolity of salons and dinner tables, an awareness of extra-European culture was penetrating. Peoples in distant countries and in 'primitive' societies began to take on a substance more solid than that of the undifferentiated native. Suddenly, with the possibility of an almost apparently limitless material ripe for stylistic adoption, the vertical take-off of modern art was assured.

The process of co-option and appropriation was extraordinarily rapid and complete, beginning jointly, and perhaps hesitantly, with Degas and Whistler staking out claims on the Japanese, and with Gauguin grasping first the 'primitive' of Breton folk art, then that of Melanesia, the pattern was set. Every artist, from the most significant members of the cenacle at Le Lapin Agile to the most obscure dauber in the Place du Tertre, attempted to secure for himself some sort of cultural territory to exploit. Within thirty to forty years not one corner of non-European culture remained untouched as a source of imagery: either, geographically, the most obscure tribal totem or, temporally, the most shadowy Celtic dolman and palaeolithic cave.

Despite the ransacking of time and space, the individual artist by himself, the painter in his studio, did not, of course, personally appropriate the complete cultures of non-European space and extra-modern time. However, both by his adaptation of aspects of these cultures to contemporary idioms and by his elevation of style to an absolute principle, he was responsible for permitting the European and Eurocentric institutions of culture to consummate the appropriation totally.

For in this way was laid the justification for the process first described by Walter Benjamin in *The Work of Art in the Age of Mechanical Reproduction* and ultimately formalized by Malraux in his invidious concept of *The Museum Without Walls*, wherein the whole of known culture is placed on terms of neutral and negative institutional equality, divorced from function, divorced from meaning, divorced from human use, divorced from any social dimension whatsoever.

Any lingering doubt concerning the now almost total acceptance of this view of art, of the world-wide *bourgeoisification* of culture, may be laid to rest by visiting at random any fair-sized fine art museum *in any city in the world*.[3] Inevitably, one will there observe cultural artefacts from diverse societies and from diverse historical epochs torn out of social context and presented in a manner where the only standard of comparison or relationship is similarity or divergence of style. Further, one will see these cultural artefacts displayed peripherally to a central collection of European or Eurocentric painting (usually covering the period from the international Gothic to the latest in conceptual art).

We are so conditioned to this relationship, the central imperative of style is so ingrained in us, that the implications of the display usually escape. Only a certain type of analytical approach (such as has been attempted here) whereby art is regarded primarily from the point of view of its social role, is capable of revealing an assumption so arrogant as to stagger the mind: the assumption that the whole existing body of world culture from the very dawn of human time must be conventionally understood and appreciated *in the light of the European visual experience of the last 500 years!*

It has been the intention of this chapter to propose that it is a plausible idea to regard the assumptions of modern art and the traditions that have led up to these assumptions as being neither international in scope nor absolute in nature. On the contrary, it is suggested that the assumptions of modern art are fundamentally of a Eurocentric character and are ultimately limited to a specific world-view that is defined by the nature of the dominant class in the capitalist world.

It would seem that there is evidence to demonstrate the possibility that the fine arts have, historically, long been (though, no doubt, unwittingly) in a position of service to social interests that are inimical, both economically and politically, to their own well-being. It would also seem that the fine arts have, historically, fallen victim to a myth concerning the absolute and metaphysical nature of their activity, as a result of which their actions and products have been used to justify not merely a criminal structure of social relations but also the world-wide edifice of imperialism upon which this structure still depends.

Should this line of thought be found in any way to be a viable one, then the ramifications to the artistic community in general, and to the art critical community specifically, are enormous. We may currently observe significant factions of the academic disciplines of anthropology and sociology questioning whom they serve in terms of the conventional and accepted methodology of these sciences. Art criticism deserves to do no less than to examine the nature of its own role in this regard.

The whole question of cultural colonialism needs desperately, for obvious reasons, to be placed under scrutiny. To the best knowledge of this present commentator, this task has yet to be initiated, and this chapter may well be the first tentative attempt in this direction. The moral obligation of the European critical community to clarify its position is uncontestable. The pressing need for the Third World countries, presently struggling for economic, political, and cultural independence, to dispel the myths obscuring the true social nature of culture, goes without saying.

The scope of the question is vast, and the implications penetrate into most levels of local, regional, national, and international political relations wherever cultural differences are a significant factor or where cultural autonomy is being threatened by more forceful neighbours. The problem does not only reside primarily in the emergent Third World countries, but everywhere. One crucial area, for instance, is located in the clear policy of cultural genocide through assimilation that is currently being practised in North America and elsewhere in regard to the indigenous peoples. A subsection of this area is the ambiguous cultural activity residing in the artificial 'airport-art' constructs of Navaho jewellery and Eskimo stone-carvings, whereby bureaucratic political institutions are *inventing* art forms on behalf of subservient and internally colonized peoples.

It is not within the scope of this chapter to chart, at this point, the enormous task of analysis ahead of us. However, should some debate which might lead to the commencement of this analysis result from this thesis, then the author will feel that its primary purpose has been achieved.

NOTES

This chapter was originally a paper presented at the Association internationale des critiques d'art (AICA) congress in Lisbon in 1976. It was published in Artery *(1976) and* Black Phoenix *(1983) and I have included it in this book because of its influence on the work of several other contributors. This version, very slightly abridged, is published with kind permission of the executors of the estate of the late author.*

1 Roland Barthes speaks of myth as being 'depoliticised speech' (Barthes (1972) *Mythologies*, London: p. 142). I am using the word 'mythic' here in an analogous manner. See also 'myth is a type of speech . . . a mode of signification . . . an inflexion . . . it transforms history into nature' (ibid., p. 109).

2 Naturally, the very subjectivist bias of the mainstream of the literature of the last 100 years or so (e.g. since Rimbaud's *Lettre de Voyant* of 1871) seems to justify the bourgeois contention that extreme individualism and competitiveness are the 'natural human condition'; thus, in turn, appearing to vindicate a political and economic system that accords priority to competition over cooperation.

3 We should clearly remark here that this would be at the present time with the obvious exception of China. It remains to be seen what forms the art institutions of that country will take in the future. In this context, it is perhaps as well to emphasize here that this *does not except* Soviet Russia and other eastern European socialist countries who remain European chauvinists in this regard.

The phrase 'fine art museum' has been used in this paragraph. It is possible to remark here upon a tendency that is occasionally observable in certain so-called ethnographic or anthropological museums where cultural artefacts are displayed as if they were 'art', defining them minimally in a social context. The bourgeois assumptions concerning culture are very insidious indeed.

2 Outsiders or insiders?

DAVID MACLAGAN

Leopards break into the temple and drink the sacrificial vessels dry; this is repeated again and again; finally one can predict it in advance, and it becomes a part of the ceremony. (F. Kafka, **Parables and Paradoxes**, New York: Schocken, 1961)

If 'primitivism' is a myth that seems to haunt European culture from the outside, 'outsider' art is something like an image of the primitive *within*.

'Outsider art' (or 'Art Brut') is a term that has been current only since the Second World War. The work included under this rubric falls into three broad categories: work produced by the inmates of psychiatric asylums, usually with the diagnostic label 'psychotic'; work resulting from the practice of some form of automatism, usually under the aegis of spiritualism; and work that, through some combination of formal originality and social marginality, seems to owe nothing to conventional culture. All three categories share certain features which could be said to be definitory of outsider art: the work is created without any normal 'professional' preparation, and its intentionality is either perverse or nonconformist, or else is effectively absent – as in the case of works resulting from automatic processes. It is essential to bear in mind that the main body of this work was produced within a specific time-span – the period roughly 1880 to 1930; it was 'produced' in the sense of being made, because much of the work dates from this period and we have very little reliable evidence as to whether any comparable work was produced earlier; and it was 'produced' in the sense of being collected, analysed, and published for the first time during the same period. The latter can be seen as a gradual process of cultural digestion, whereby work that was judged discordant or peculiar, coming as it did from persons excommunicated from society by being assigned (or perversely adopting) the deviant roles of 'madman' or 'eccentric', was at first given a negative qualification as 'psychotic' or 'crazy', but was later given a more positive value, as 'original' or 'inspired'.

Like the concept of the 'primitive', this notion of the originality – and consequent lack of origins – of outsider art is prob-

lematic: these so-called 'outsiders' are in fact discovered *within* the boundaries of the culture from which they are supposed to be independent; in effect, they are treated as *endogenous primitives*. But influences from their cultural matrix are, in fact, present from the start and form, as I shall argue, a crucial focus in certain kinds of outsider art: in any case, once these images have been discovered and promoted, they re-enter the cultural domain; and once this publicity barrier is breached, the feedback between outsider art and the culture at large becomes too complex for the original notion of 'outsider' to be workable.

The standard definition of outsider art depends upon a notion of utter originality: Dubuffet, for example, described it as an artistic creativity 'glowing in its pure state, free of all the compromises that adulterate its mechanisms in the productions of professionals'.[1] This pursuit of the 'original' has for a long time been a distinctive feature of European culture: it is one term in the dialectic between 'individual' (personalized, subjective) and 'collective' (public, socially responsible) forms of expression that has been a motive force in the history of art since the Renaissance, and that reaches a crisis-point with the emergence of a modernist avant-garde, in many forms of which the two poles can no longer be held together, or are recast in a new form. This conflict is vividly illustrated in surrealism, which showed a fascination with individual nonconformity whilst simultaneously promoting collective and anonymous forms of creativity (such as automatic writing). Because of this history, the rhetoric of originality seems to point towards the unique and the personal: but not every work that appears 'original' in the context of European fine art conventions is *ipso facto* 'individual' – this is, of course, another of the key factors to be taken into account in trying to understand the role of 'primitivism' in modern art. On the contrary, many works that challenge these conventions, or in some way seem to disobey them are *constitutionally* anonymous; the categories of psychosis or automatism entail an erasure or obliteration of the subject; yet many of the works that exemplify these are valued purely for their peculiarity and eccentricity. It is one of the paradoxes of outsider art that it is defined *from the outside*: it is people from within the art world, however avant-garde, who collect and classify it as such. The label that is literally stamped on works in the Collection de L'Art Brut is a form of *appellation contrôlée*; and the idea of a self-appointed outsider is somewhat problematic.[2]

None the less, a great deal of outsider art appears to be created in a kind of indifference to or detachment from such factors as commercial reward, critical approval, or even local encouragement. This appearance may be deceptive: in some cases the

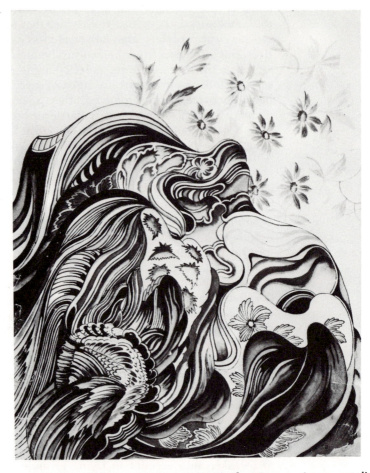

2.1 In most of this anonymous patient's drawings an 'ornamental' upsurge invades some more conventional motif (in some cases a figurative one) (*Le Voyageur Français, Composition aux Fleurs* 61.5 × 49.5 cm: Collection de L'Art Brut, Lausanne).

question of 'success' is incorporated into the work; for example, in Adolf Wölfli's plans for the printing and distribution of his books, and his elaborate, fugal calculation of the compound interest accruing from their imaginary sales. The problem is that the ideology behind the promotion of outsider art conceals the fact that both in its form and in its content it functions as a 'negative' or reversed version of the aesthetic criteria of conventional art, and forms of parody or sacrilege are intimately dependent upon the idioms which they subvert. In the case of outsider art this may be as much to do with the motives for its 'discovery' as for those of its creation in the first place. Typical

features which reflect traditional criteria – only, like all reflections, in an inverted form – are: outsiders create in apparent indifference to the reception of their work;[3] they have no professional preparation, or can be supposed to have abandoned it in the course of their psychosis; their work often uses 'base' materials and is equally crude in its subject-matter (frank sexuality, for example); their work is alleged to show no signs of normal intentionality or of 'progress' in its development;[4] and finally, they are usually either anonymous, or else do not claim any personal responsibility for their work.[5]

These characteristics might disqualify the *authors* of outsider art from being artists in the conventional sense, but they would not necessarily affect the status of the work itself: one of the many philosophical problems raised by 'psychotic' art is whether we might treat something as a work of art when it was the work of someone who had forfeited so many of the normal characteristics of being an artist. There is also the question of how far work that has been created by people labelled 'psychotic' (or indeed any other outcast label) is *ipso facto* psychotic itself; or the converse question, whether one can legitimately deduce from the peculiarity of the work a corresponding psychological deformation of the person who made it. There is always a danger in making too facile a connection between the work and its creator: 'deviant' work might be created by someone with no diagnosable features of psychological or social deviance. This challenges our assumption that work must, consciously or unconsciously, be the personal 'expression' of the individual who made it. Howard Becker has warned that

> Treating a person as though he were generally rather than specifically deviant produces a self-fulfilling prophecy. It sets in motion several mechanisms which conspire to shape the person in the image people have of him. In the first place, one tends to be cut off, after being identified as deviant, from participation in more conventional groups, even though the specific consequences of the particular deviant activity might never of themselves have caused the isolation had there not also been the public knowledge and reaction to it.[6]

But, whatever the connection, or lack of connection, between such work and the psychology of its creators, there are also intrinsic features of the works themselves that amount to a negative 'mould' of many of the features of conventional art: patterning or ornamental processes overflow and swamp the image; order or structure does not appear to serve any obviously intelligible purpose; where symbols appear to be used, they are opaque or confused; and if objects are represented, they are arbitrarily distorted or fragmented. These formal features were

2.2 Detail from the *Palais Idéal*. Built over a long period (1879–1912) by the postman Ferdinand Cheval after his retirement (Le Facteur Cheval, *Palais Idéal*, Hauterives: photograph Simon Pugh).

first systematically described by Hans Prinzhorn in his cele-
brated book *Artistry of the Mentally Ill*, first published in 1922.[7]
Prinzhorn had trained as an art historian before he became a
psychotherapist, and it could be said that his work effectively
translates *aesthetic* criteria into a *psychiatric* symptomatology.[8]
Certainly the 'rules' which are thus honoured in their breach
add up to most of the key ingredients of the post-Renaissance
figurative tradition: for example, that 'decorative' or 'abstract'
motifs must be subordinate to a central figurative theme. But
the most crucial precondition of all is that a figurative work
should, properly, be legible on two levels at once: it must
represent scenes in forms that are *recognizable*; and it must
symbolize ideas and feelings through a visual rhetoric that is, to
a reasonable extent, *understandable*. The coherent interlocking
of these two levels of the figurative – so coherent that it is
difficult to disentangle them – is the *sine qua non* of the artist's
ability to convey his or her intention successfully.

Such figurative art is fascinated by the perceptible, and this
has resulted in some rich and marvellous work, but at a price:
the hidden cost of the figurative artist's phantasmagoric power
has been a tacit disqualification of the non-visible; or rather, a
privileging of those forms in which the non-visible could best be
rendered visible. In particular, all that we might subsume under
the title of an 'inner world' – fantasy, dream, or imagination
– suffers a kind of repression, whereby it is allowed no reality of
its own, but has to speak, ventriloquially as it were, by borrow-
ing (at an undisclosed rate of interest) imagery that is couched in
terms of the external, perceptible world. Its very 'inner-ness' is
thus reinforced, at the same time as its reality is presumed to be
derivative or second-hand.[9]

An art that abandoned this figurative apparatus would have
to emigrate to a territory where most of the cardinal points by
which the landmarks of intention could be located were missing
or askew. Hence Prinzhorn saw the convergence between the
'difficulty' of modern art and 'schizophrenic configuration' as a
result of the former's aiming at a 'liberation from the com-
pulsion of external appearances . . . so complete that all con-
figuration should deal only with pure psychic qualities.[10]
This programme, which Prinzhorn, for all his sympathy with
modern art, found 'extravagant, grandiose and often com-
pulsively distorted', was, in its pictorial results, almost indis-
tinguishable from schizophrenic pictures that reflected a
comparable withdrawal from the representation of external
reality. The only effective difference that Prinzhorn could find,
in the end, was between the artist's relatively rational and
conscious decisions and the compulsive, automatic, or almost
instinctual production of the psychotic. Of the latter he wrote:

These works really emerged from autonomous personalities who carried out the mission of an anonymous force, who were independent of external reality, indebted to no-one and sufficient solely unto themselves. The innate primeval process of configuration ran its course, far from the external world, without plan, but by necessity, like all natural processes.[11]

The knot is thus tied that links together 'abstraction', automatism, and an instinctual, unsublimated creativity. Abstraction, even when it was associated with an attempt to find a new way of depicting 'pure psychic qualities', was all too easy to diagnose as a symptom of withdrawal from a 'reality' identified with the perceptible world: at least Prinzhorn did not, like so many of his psychiatric contemporaries, try to dismiss the more puzzling features of modernism as evidence of some psychopathology. Automatism, with all its uncertainties about where the 'message' is coming from and to whom it might be addressed, is open to the charge that 'normal' indicators of development, in which stylistic and psychological change are expected to mirror each other, are missing, so that the work remains static, monotonous, or unresponsive. This fails the demand for 'progress' in an artist's work, for evidence of some *motivated* evolution. Thus Morgenthaler wrote of Wölfli – quite unjustly, in fact – that he

lives off the excess of the psychic capital he possessed at the start of his illness, without being capable of acquiring anything new since this period. . . . That is why one cannot really talk of progress in relation to his drawings, or of a perfecting due to his personality widening or deepening.[12]

It should be noticed that the attempt to find evidence symptomatic of *mental* disorder in the *formal* dis-order of a picture depends on a curious application of representational conventions: such diagnoses depend on the assumption that patients with no demonstrable artistic training in drawing should – particularly where the human body is concerned – naturally and immediately conform to these conventions, so that any distortion in the picture can be read as indicating a corresponding distortion in the perception or thinking of the patient.[13]

If the convergence between modern art and psychotic art had been a chance coincidence before Prinzhorn's book was published – and I shall argue that it was not – it could never again be one afterwards: for both his book, and Walter Morgenthaler's pioneering study of the psychotic artist Adolf Wölfli,[14] were potent influences on a number of significant writers and artists. Max Ernst took a copy of Prinzhorn with him when he went to Paris in 1922 and a good many surrealists saw

2.3 This drawing by 'Emmanuel' is in fact a negative alphabet, almost overwhelmed by its 'decorative' matrix ('Emmanuel', *dessin no. 2* 50 × 65 cm: Collection de L'Art Brut, Lausanne).

it; Alfred Kubin is known to have been impressed by his visit to the Heidelberg collection (the basis of Prinzhorn's book) in the same year; and Paul Klee is on record as leafing through the book, exclaiming 'That's a good Klee!'[15] Morgenthaler's book was enthusiastically commented upon by Rainer-Maria Rilke:

> Wölfli's case will be an immense help in gaining further knowledge concerning the sources of creativity: he contributes to the strange and yet growing realisation that many pathological symptoms (as suggested by Morgenthaler) should be furthered, since they stimulate the rhythm nature adapts to win back what has become estranged.[16]

This process continues today: the idiom of New Figuration, for example, owes much to the invisible chapter in the history of art that is constituted by 'psychotic art'.

This feedback of psychotic imagery into the mainstream, or at least the avant-garde, of culture was accelerated by surrealism's deliberate promotion of imagery that was delirious, hallucinatory, or otherwise irrational. The surrealists' hijacking of the

techniques of psychoanalytic investigation of the unconscious
– free association and the interpretative strategies used to
decipher its results – were in aid of purposes quite contrary to
those for which they had been devised by Freud: they sought
to contradict the superiority of the Reality Principle and to over-
whelm its authority through the multiplication of texts and
images that ignored the conventional boundaries between art
and madness. André Breton's identification of the 'real function-
ing of thought' with 'pure psychic automatism'[17] was the result
of several years of group experimentation with automatist
techniques, and two aspects of this are relevant in this context:
first, the relinquishment of all intentionality (except, of course,
the decision not to intend) in automatism; and second, the
absence of the normal criteria for authorship – some texts were
written collectively, and, in any case, a writer could disclaim
personal responsiblility for a text of which he or she was merely
the transmitter. A kind of artificial innocence was thus
achieved, to which the work of 'mad' persons could readily be
assimilated: for Breton and many other surrealists the madman
was disconnected from society and immune from its values – in
effect, an outsider.[18]

Ironically, many of the early surrealist attempts to reproduce
'unconscious' imagery remained faithful to a figurative idiom,
to the realization of the fantastic in terms of a perceptible
reality, and hence to the traditional translation of the visionary
into the visible. In practice, the early surrealist artists found
themselves torn between two incompatible visionary schemes
derived from the 'unconscious': on the one hand, there was the
free-range flow of automatic or mediumnistic drawing, that
meandered through a no-man's land between the figurative and
the non-representational; on the other hand, there was the deep
figurative structure proposed by Freud, that employed an
apparatus of visual rhetoric (including puns, elisions, and con-
densations) which depended upon a minimum degree of
representation. Surrealist objects or pictures could, rather labo-
riously, provide illustrations of what amounted to a psycho-
analytic iconography. The typical surrealist image defined by
Reverdy as the 'bringing together of two more or less separate
realities'[19] has obvious points in common with the typical
dream-image as described by Freud: in effect, both are like
visual conundrums, striking yet enigmatic, legible yet not
understandable; but whereas Freud saw the pictorialization of
unconscious thoughts as a process to be unravelled and demysti-
fied by analysis, the surrealists insisted that the mystery of the
image was inviolable. In particular, the work of Salvador Dali
had the effect of reinforcing the dependence of imagination on a
perceptual translation: however perverse and 'subjective' the

2.4 Johann Hauser, undated drawing (from Leo Navratil (1978) *Schizophrenie et Art*, Paris, Editions Complexe).

nature of his fantasy seemed, it was conveyed by much the same conventions as more properly sublimated fantasies had been in traditional art.

Something of the surrealist attitude towards psychotic art is carried over, after the Second World War, into the new notion of 'Art Brut' (or 'raw' art) – indeed, Breton was one of the founding members of the Compagnie de L'Art Brut set up on Dubuffet's initiative in 1948. In the texts concerning what eventually became the Collection de l'Art Brut, one senses a tone at once dogmatic and protective; as if outsider art were an endangered species that, once captured, had to be kept in a special environment in order for it to survive. There seemed to be several dangers, as far as the 'purity' of Art Brut was concerned: first, there was the risk that it would, in being made public, become contaminated by the very culture it was supposed to be independent of; second, there was the threat that increasing social pressures towards conformity, transmitted by the organs of mass culture, would eliminate the marginal and the eccentric; and finally, since so much (about half) Art Brut came from unsupervised patients in old-fashioned asylums, there was the fear that normative psychiatric practices, and quite particularly the emergence of 'art therapy', would blunt its originality.[20] The resultant stance of Art Brut connoisseurs is

2.5 Simon Lewty, detail from *Preparations for Their Arrival* (1983) reproduced courtesy of the artist: photograph John Wright.

full of defensive paradoxes: the work is rescued from obscurity and (re)introduced into the general culture, but elaborate steps are taken to try to control the manner of its insertion; for example, the collection, although it functions in almost every way like a museum, is not called such, and for a long time was jealously kept private – even today no work from it can be shown in any other context.

We are now in a position to look more critically at the 'originality' of outsider art. Whilst it is true that a great deal of such work is, by definition, anomalous and exceptional, it does nevertheless arise from a context, or a number of contexts, that cannot be eliminated from culture. Even Dubuffet had to admit that 'It would be right to think of "Art Brut" more as a pole, as a

wind that blows more or less strongly, and which is often not the only wind to blow.'[21] First of all, no matter how solitary or confined, a person cannot be completely insulated from the world: he or she is brought up in some kind of milieu, even if he or she subsequently rejects or forgets it; even in the asylum people have memories and souvenirs (in the form of newspapers, magazines, etc.) of the outside world. The circumstances of confinement may even intensify this: books and other printed matter are both the pathetic medium for such vicarious contact *and* the symbols of cultural authority – no wonder they are so often re-created. And part of this world, however diffuse or subliminal, has some idea of what 'art' is. In some cases there is clearly an assertion – persistent, inflamed, sometimes

frantic – of what is, in terms of traditional artistic conventions, inferior or subordinate. For instance, under the heading of 'decoration' lies a whole range of visual discourse whose symbolic value is often diluted in our culture (here again, outsider art has features in common with primitive art):[22] there are the elaborate 'doodles' of certain automatist drawings – for example, the lovely looping line of Laure Pigeon; and there is the eruptive force of ornamental upsurges – for example, the decorative excesses of *Le Voyageur Français* (see Figure 2.1).

Underlying these extravagant excursions is a more radical, 'proto' form of elaboration that upsets conventional rhetoric, in which the ornamental is only a processed and degraded version of 'organic' forms such as bodies or plants: this is a continuous metamorphic elision *between* forms, that establishes a kind of indefinite and radical exchange between animal, vegetable, and mineral realms – for example, in the detail of the Facteur Cheval's *Palais Idéal* (see Figure 2.2), or in Raphael Lonné's drawings. This free-range 'metadoodling', which is often linked to automatic or otherwise dissociated performance, has profound implications for how we imagine unconscious processes: for what is revealed here is not a 'picture' in any straightforwardly representational sense, nor even a 'Gestalt' in perceptual terms, but a kind of 'flux'[23] or the sort of 'chaotic' and multivalent image that Anton Ehrenzweig proposed as characteristic of primary process.[24] The complex, radically metaphoric nature of this imagery – which questions the conventional definition of 'image' – suggests that the 'conditions of representability' Freud wrote of, which determine what unconscious thoughts can be turned into pictures, and how, may *in themselves* by their figurative bias screen out more than any process of secondary revision. The work of outsiders, especially that belonging to the 'Golden Age' between 1880 and 1920, seems to revolve around this issue so persistently, at times almost desperately, that it hardly seems accidental. Is it just a coincidence that during the same period there is a 'crisis' of representation that is evident not only in science, philosophy, and literature, but in those forms of visual art associated with the rise of modernism?

It is in a psychiatric context that the collision is most abrupt, between conventional aesthetic criteria, masquerading as clinical diagnoses, and works that in one way or another are 'outside' the pale established by those norms. Again and again such work is (dis)qualified as the result of incompetence, inability, or collapse: yet certain of these works have a clearly *strategic* method in their madness; but their discourse is devious, a kind of ironic dumbshow, destined – if not designed – to be overlooked or misunderstood. An obvious example is the drawing made by Dr Leo Navratil's patient Johann Hauser in

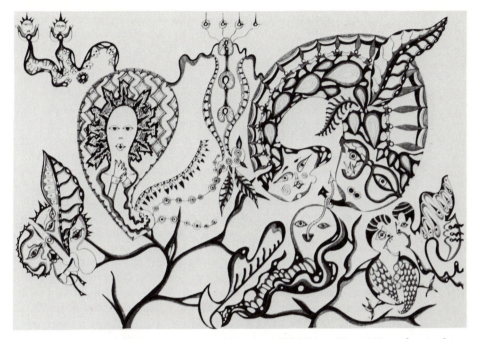

2.6 Valerie Potter, drawing 9/7/82 21 × 30 cm (Outsider Archive, London).

response to a reproduction of a Boucher nude: when first published,[25] this was described as evidence of Hauser's 'innate constructive *apraxia*' and as a sample of his manic creativity (see Figure 2.4). Yet the picture is clearly a savage transcription of the sentimentalized eroticism of the Boucher into violent and sarcastic form; bearing in mind that Hauser, however well treated, is confined, and that the resultant (sexual) frustration is exacerbated during his 'high' periods, it is not difficult to imagine a motive for the brutality of his response.

Subversive or ironic modes of discourse are, by nature, unverifiable: they are, along with a certain sustained form of metaphor, extremely vulnerable to misunderstanding if they appear without the normal 'frame' or 'label'.[26] But such a stepping-back is itself a capitulation to the conventional framework. Certain extreme forms of irony, or texts that collapse together the literal and the metaphoric, cannot be translated without being compromised, or without losing their point at the very moment that it is made explicit. The problem is compounded by the fact that it is impossible always to distinguish between deliberate – and therefore critical – deformations of convention, and those that are the result of a bad fit between a person's experience and the available framework. Nor is it

simply a matter of 'communicating' something in one form or another, for – as any artist knows – what can be said changes according to how one says it, and the one does not necessarily come before the other.

An overlap between what might be called the 'psychotic style' and artistic licence is, since the successive waves of publication of outsider art, almost inevitable. Simon Lewty's work, for example, comes from a context that seems to be largely 'artistic', in that he has the stylistic self-consciousness that professional art training implants; yet the striking coincidence between his style, and especially its linguistic inventions, and the neologisms of certain psychotic works is the result of a mysterious convergence rather than of conscious imitation.[27] (See Figure 2.5.) Valerie Potter's work on the other hand (see Figure 2.6) is rooted in experiences that can only be called psychotic; but it is elaborated in a way that transcends any merely psychopathological expla- nation and is certainly not 'unconscious' in any simple sense.

Modernism tried to wrench outsider art loose from any con- text – cultural, social, or psychological – in terms of which it might have been possible to situate it, and declared it 'free', so that it could be used, like 'primitive art', for its own currency. There is a danger that post-modernism, in its more critical self- consciousness, will lean too far in the opposite direction. Craig Owens has written that

> It is precisely at the legislative frontier between what can be represented and what cannot that the postmodernist oper- ation is being staged – not in order to transcend represen- tation, but in order to expose that system of power that authorizes certain representations while blocking, prohibit- ing, or invalidating others.[28]

If outsider art of the kind I have been talking about here were co-opted into this enterprise too abruptly, then it would be made to seem more explicitly critical than it is. In reality, its messages have usually to be read between the lines. Above all, we must not forget the real psychological cost of some of these images: if there is something like a 'deconstruction' of conven- tional pictorial discourse going on here, it is a problem in which the subject – not just as an identifiable author or agent, but as a self with some sort of boundary – may be dissolved in the pro- cess of its solution.[29]

NOTES

1 Jean Dubuffet 1976, *Introduction to Collection de L'Art Brut*, Lausanne: Collection de L'Art Brut; my translation.
2 However, because of the infiltration of outsider art into the culture at large – for which it is itself partly responsible – the collection

has recently had to admit work that is 'second-generation' outsider art (see, for example, the Rosemary Koczÿ exhibition, February–June 1985).

3 Roger Cardinal, for example, writes: 'Outsiders create their works in a spirit of indifference towards, if not plain ignorance of, the public world of art. Instinctive and independent, they appear to tackle the business of making art as if it had never existed before they came along.' R. Cardinal (1979) Catalogue to *Outsiders* exhibition, London: Arts Council, p. 21.

4 Prinzhorn, for example, sees the 'complete autistic isolation and the gruesome solipsism which far exceed the limits of psychopathological alienation' as the crucial features that distinguish the psychotic creator from even the most isolated artist (Hans Prinzhorn (1972 [1922]) *Artistry of the Mentally Ill*, New York: Springer Verlag. See also Morgenthaler's comment on Wölfli.

5 The most striking examples are of artists who shelter under the umbrella of spiritualism – a group activity – but who practise in isolation: Laure Pigeon and Raphael Lonné are two examples.

6 Howard Becker (1963) *Outsiders: Studies in the sociology of deviance*, New York: Free Press, pp. 33–4; quoted in Bruce Jackson (1978) 'Deviance as success: the double inversion of stigmatised roles', in Barbara Babcock (ed.) *The Reversible World: Symbolic Inversion in Art & Society*, Ithaca, NY: Cornell University Press.

7 Hans Prinzhorn (1922) *Bildnerei der Geisteskranken*, Berlin; English translation, *Artistry of the Mentally Ill* (n. 4).

8 This is an argument I have developed elsewhere: see D. Maclagan (1983) 'Methodical madness', in *Spring*.

9 A more detailed version of these points is in my (1989) 'Fantasy and the Figurative', in T. Dalley and A. Gilroy (eds) *Pictures at an Exhibition*, London: Routledge.

10 Prinzhorn, *Artistry of the Mentally Ill*, p. 272.

11 ibid.

12 W. Morgenthaler (1921) *Ein Geisteskranker als Kunstler*; French translation in (1964) *Cahiers de L'Art Brut* no. 2, Paris.

13 A. Bader and L. Navratil (1976) *Zwischen Wahn und Wirklichkeit, Kunst-Psychose-Kreativitat*, Frankfurt: Bucher– Verlag, pp. 65–75.

14 Morgenthaler's monograph, which is lavishly illustrated, names Wölfli, and even reproduces photographs of him. For a French translation, see n. 12.

15 Stefanie Poley (1980) 'Prinzhorns Buch "Die Bildnerei der Geisteskranken" und seine Wirkung in der Modernen Kunst', in Hans Gerke and Inge Jarchov (eds) *Die Prinzhornsammlung*, Konigstein: Athenaum Verlag, pp. 58–63.

16 R.-M. Rilke, letter of 10 September 1921, to Lou-Andreas Salome (who recommended Morgenthaler's book to Freud).

17 André Breton (1962 [1924]) *Premier Manifeste du Surréalisme*, Paris: Jean-Jacques Pauvert, p. 40.

18 The slogan 'Every individual act is anti-social' appears in the 'Lettre aux Médecins-Chefs des Asiles de Fous' (probably written by Theodor Fraenkel and not Antonin Artaud) in (1925) *La Révolution Surréaliste*, no. 3.

19 Breton, *Premier Manifeste*, p. 34.

20 The latter is a particularly unjust accusation, for art therapists struggle to maintain their art rooms as oases of freedom in what are otherwise totally institutional settings.
21 Dubuffet, *Introduction to Art Brut*.
22 The connection between the rudimentary status of ornament and 'primitive', unsophisticated art forms goes back to the turn of the century. See Françoise Will-Levaillant (1980) 'L'Analyse des dessins d'aliénés et de mediums en France avant le Surréalisme', in *Revue de L'Art* 50:34.
23 The notion of flux appears throughout Gilles Deleuze and Félix Guattari (1975) *L'Anti-Oedipe*, Paris: Editions de Minuit; for example, pp. 289–90.
24 Anton Ehrenzweig (1965) *The Psychoanalysis of Artistic Vision and Hearing*, New York: Braziller, pp. 33–4.
25 Leo Navratil (1978) *Schizophrénie et Art*, Paris: Editions Complexe, pp. 94–5.
26 Bateson, for example, insists that problems arise when 'metacommunicational' statements are not made: but this depends upon a pre-existing destinction between literal and metaphoric which does not always obtain. See Gregory Bateson (1972) *Steps Towards an Ecology of Mind*, New York: Ballantine, pp. 421–2.
27 Simon Lewty, personal communication.
28 Craig Owens (1985) 'Feminists & post-modernism', in *Postmodern Culture*, London, Pluto Press, p. 59.
29 See Louis Sass's valuable article (Summer 1987) 'Introspection, schizophrenia, and the fragmentation of self', in *Representations* 19.

BIBLIO-
GRAPHY

Babcock, Barbara (ed.) (1978) *The Reversible World, Symbolic Inversion in Art & Society*, Ithaca, NY: Cornell University Press.
Bader, Alfred and Leo Navratil (1976) *Zwischen Wahn und Wirklichkeit, Kunst–Psychose–Kreativitat*, Frankfurt: Bucher–Verlag.
Bateson, Gregory (1972) *Steps Towards an Ecology of Mino*, New York: Ballantine.
Bihalji-Merin, Otto (1971) *Modern Primitives*, London: Thames & Hudson.
Billig, Otto and B. G. Burton–Bradley (1978) *The Painted Message*, New York: Wiley.
Cardinal, Roger (1972) *Outsider Art*, London: Studio Vista.
Cardinal, Roger (1979) 'Singular visions', in catalogue to *Outsiders* exhibition, London: Arts Council.
Deleuze, G. and Guattari, F. (1975) *Anti-Oedipe*, Paris: Editions de Minuit.
Dubuffet, Jean (1976) *Introduction to Collection de L'Art Brut*, Lausanne: Collection de L'Art Brut.
Ehrenzweig, Anton (1965) *The Psychoanalysis of Artistic Vision and Hearing*, New York: Braziller.
Forster, Hal (ed.) (1985) *Postmodern Culture*, London: Pluto Press.
Gerke, Hans and Inge Jarchov (eds) (1980) *Die Prinzhornsammlung*, Konigstein: Athenaum.
Maclagan, David (April 1979) 'Missing, presumed lost', *Artscribe* 17: 22–7.

Maclagan, David (December 1981) 'Methodical madness', *Artscribe* 32: 36–44.

Maclagan, David (1981) 'Inspiration or madness: the case of Adolf Wölfli', *Art Monthly* 45: 3–7.

Maclagan, David (May 1982) 'Creativity, cultivated & wild', *Inscape*: 10–13.

Maclagan, David (1983) 'Methodical madness', *Spring*, Texas: 3–11.

Maclagan, David (1989) 'Fantasy and the Figurative', in T. Dalley and A. Gilroy (eds) *Pictures at an Exhibition*, London: Routledge.

Maclagan, David (1990) 'Solitude and communication: beyond the doodle', *Raw Vision* 3.

Melly, George (1986) *It's All Writ Out For You, the Life & Work of Scottie Wilson*, London: Thames & Hudson.

Meredieu, Florence de (1984) *Antonin Artaud: Portraits & Gris-gris*; Paris: Blusson.

Morgenthaler, Walter (1964 [1921]) *Ein Geisteskranker als Kunstler*, French translation in *Cahiers de L'Art Brut 2*, Paris.

Navratil, Leo (1978) *Schizophrénie et Art*, Paris: Editions Complexe.

Plokker, J.H. (1962) *Artistic Self-Expression in Mental Disease*, London: Chas Skilton.

Prinzhorn, Hans (1972) *Artistry of the Mentally Ill*, New York: Springer Verlag.

Schmidt, Georg, Hans Steck, and Alfred Bader (1961) *Though This Be Madness*, London: Thames & Hudson.

Spoerri, Elka and Jurgen Glaesemer (eds) (1976) *Adolf Wölfli catalogue*, Berne: Adolf Wölfli Foundation.

Thevoz, Michel (1976) *Art Brut*, London: Academy Editions.

Thevoz, Michel (1978) *Le Langage de la Rupture*, Paris: Presses Universitaires de France.

Will-Levaillant, F. (1980) 'L'analyse des dessins d'aliénes et de mediums en France avant le surréalisme', *Revue de l'Art* 50.

3 Primitive art and the necessity of primitivism to art

DANIEL MILLER

INTRODUCTION

This chapter[1] is divided into two main sections: in the first, I want to argue for the *necessity* of primitivism to art. That is, primitivism is not simply an idea picked up from time to time by particular artists, but is integral to what art is, and indeed the two terms, 'primitivism' and 'art', may best be understood in relation to one another. It will be suggested that this is so because our concept of 'art' is based upon several contradictory premises, and that primitivism is central to these definitional paradoxes. Secondly it will be suggested that most of what is termed 'primitive art' is an equally contradictory construction, consisting of artefacts produced by peoples without a concept of primitivism for peoples who utilize those artefacts to objectify this concept. In the second section of this chapter, examples will be given of how primitive art is constructed as an assemblage of objects in relation to primitivism, outside of which it has no meaning.

A premise of this chapter is that the concept of art may be subject to the critique of relativism, in that it stems from no essentialist foundation – that is, no absolute quality of the world – but has become an established perspective through particular cultural and historical conditions. This premiss is supported by historical works which indicate how the particular evocations of the current concept of art arose. An example is the semantic history of Williams (1958: 48–64) who has shown how a series of interrelated terms such as art, genius, aesthetics, and culture, developed their modern connotations. These terms refer mainly to an assumption as to the qualitatively superior products of an individual (until recently, usually male) genius, who has the privileged capacity to produce authentic cultural forms. Williams argues that, previously, these same terms tended to refer to characteristic dispositions and qualities which anyone might hold.

A series of histories of high and popular culture follow in broader terms the means by which a relatively socially homogeneous, though regionally heterogeneous, European culture transformed to become socially divided, but spatially united. This commences with a division into an opposing culture of elites and the popular mass (Burke 1978), and then develops that specific form of production for elites which detached itself as an aesthetic medium of value from the traditional constraints of the value both of any particular materials (e.g. the paint itself) and the contractual obligations of the painter (Baxandall 1972). Some artists, such as Dürer, continued to work in both the new fields of fine art and mass commercial print-making (Mukerji 1983: 60–5). Recent historical research has emphasized the use of gender differentiation to accentuate these divisions (e.g., Parker and Pollock 1981). Eventually, the point is reached today where even the individual work of art is subordinate to the major category under which we experience art, that is, as pertaining to named artists and their oeuvres, or, as Baudrillard (1981: 102–12) argues, it is the signature that produces and defines art. To generalize from these histories, it appears there was a time when activities such as entertainment, painting, and architecture were not perceived as qualitatively very different in their nature from, for example, cooking, parenting, or shoemaking. In so far as certain activities shared an element whose aura was to persist into the formation of the category art, it was their religious associations which constructed certain icons as referential to a transcendent truth.

The implications of these historical perspectives are either that people in former times were not capable of perceiving something we now understand about the special nature of art, or that our experience of the aesthetic dimension is historically contingent and entirely dependent upon a whole series of other historical changes which make our perception distinct from these earlier periods. Since anthropology might have been an alternative route to this same relativistic point, I will draw the latter conclusion here.

The broader historical context for the rise of 'high art' may be taken as the general move towards increasing abstraction and differentiation which are subsumed under the notion of modernity, a process associated with the 'early modern' period of European history; that is, the fifteenth and sixteenth centuries. The increasing division of labour and general structural differentiation which followed have been characterized by most of the classic sociologists such as Durkheim, Tonnies, and Weber (see especially Simmel (1978)). The separation and definition of art and aesthetics as something different and particular may be understood as coincident with the development of a plethora of

distinct and abstract areas of interest, including those which came to be termed politics, kinship, or economics, within a general increase in the division of labour. There is, however, an important difference between art and all these other new particular domains, and this is that art appears to have been given, as its brief, the challenge of confronting the nature of modernity itself, and providing both moral commentary and alternative perspectives on that problem.

Art takes its concern with transcending the fragmented nature of contemporary life partly from religion and partly from the general Romantic tradition, focused upon the notion of totality, which was also generated within the historical process of modernity. That structural differentiation should prompt a critical response devoted to developing holistic images is hardly surprising. My argument is that these large-scale historical changes provide the basis for the development of the contemporary category of art, and remain its major legitimation irrespective of the particular intents of particular artists.

THE PARADOXICAL FOUNDATIONS OF ART

The problem for art is that it itself developed within precisely the same tradition and framework it was seeking to criticize. As shown by Williams, art simultaneously moved from being a quality of all things, from which perspective this critical vision might appear more plausible, to become the task of very particular peoples and very particular media which were conventionally established with the specific aim of realizing these objectives. Being so specific, however, art has developed within a position from which it is difficult for it to claim to represent the perspective of totality.

Art has become extremely specialized, a supreme example of the very fragmentation it was created to oppose. This is the initial paradox, from which develops a wide spectrum of contradictions generated by art in almost every sphere within which it interacts with the world. For example, in the nineteenth century when aesthetics initially opposed the machine as agent of differentiation and thereby fragmentation, art became identified with a specialist mode of hand-made and non-utilitarian products. This defeated William Morris's attempts to reunite the art and crafts, since the desire to involve workers in non-alienated production became the basis for establishing an exclusive and expensive sign of privilege in consumption. Art's alternative was then to identify with and, indeed, reify the machine-made as the futuristic image for society. This had some equally unfortunate consequences, at least in architecture, and supported a technocratic ideology in political and economic

domains which would finally exclude art altogether. A third strategy has been art's attempt to move against its own abstract nature and produce what it considers populist. Examples of this, ranging from Brecht to Warhol, have not only failed in their purpose, but generally have marked major stages in moving art one more notch into the esoteric and unpopular. The attempt to embody fragmentation often employed in 'modern' art as a weapon against the normative consensus leads again to what is often viewed as simply incomprehensible and alien forms by the mass population with the effect on social differentiation documented in considerable detail by Bourdieu (1984).

The same conflict between totality and specialization underlies art's extraordinary relationship with money. The two are clearly extremely close, both in reference to the vast sums commanded by works of art, and to the determination of art to define itself in opposition to monetary values. This is understandable given the parallels between the nature of the two media. Money is the other domain which has as its historical task the problem of abstracting itself from all particular things in order to comment on (in this case, in the sense of evaluate) all things. Money is, then, a mode of abstraction and transcendence. Money's material forms have become conventional abstractions which allowed it to be as flexible as possible. Similarly, art, in its search for transcendence, has successively repudiated most of the concrete forms, such as expensive materials, which might have grounded it in some particular evaluative medium, which makes it a highly suitable candidate for free exchange, a task which is simplified if the artist is dead *or* the form is abstract. In this regard, the final demand has been to remove art from any even apparently essentialist evaluative principle, which would include aesthetics. If there ever was a universal criterion for beauty, modern art has undoubtedly managed to escape it. This raises a problem for the role of art as moral and critical commentary upon modern life, which is threatened by the amoral and quantitative qualities of money. The result has been art's continual origin myth of bohemian asceticism and the search for alternative sources of value.

Art's moral claims run into similar contradictions, as found in the continual tension in its history between art as moral guide dealing directly with fragmentation, and art's autonomy leading to the perennial art for art's sake movements which are themselves symptomatic of fragmentation. Much art today would claim to be radical or socialist, identified with some struggle for liberation or some social critique. Yet to the non-believer the claim of, for example, a documentary film to contain such critical efficacy may seem to be reduced by precisely the degree to which it is regarded as artistic, inevitably

distancing it from its own content and from the objective conditions to which it is supposedly addressed. The claimed 'radicalism' of art is currently often associated with similarly abstract and esoteric academia expressed in terms such as 'deconstruction', 'myth', and 'discourse' which present parallel ambiguities although they may be clearer as to their nihilistic implications (see Anderson 1983: 32–55 for a critique).

Distancing as the prime mode by which art relates to the world has been enshrined in aesthetic theories at least since the writings of Kant. Its implications for the social meaning of art provide the final example of the structures generated by its paradoxical foundation. These have been brought out most clearly by the anthropologist Bourdieu, in his recent work *Distinction* (1984: 28–65), an extensive attempt to follow art into society and examine its precise implications for social interaction and hierarchy. Bourdieu's study of the relationship between aesthetics and 'taste' indicated how the aesthetic mode involving a particular outlook upon the world which is associated with a contemplative, distanced abstraction from the sensuality or immediacy of things is countered by a popular 'anti-Kantian' perspective based on the immediate, the sensual, the entertaining, and the content of cultural forms. Here the totalizing abstractions of art become transformed into a central mechanism of social differentiation to re-emerge as class.

To summarize, what has been presented here is clearly not intended as a description or comprehension of the work of all particular artists or works of art. In so far, however, as these are evaluated against the larger category of art, they become involved in the paradoxical foundations of that category. It has been argued that many of the major observable attributes of modern art – its high prices, its abandonment of representation and realism, its association with morality but also autonomy, its self-critical mode, and its relation to social class – are not coincidental, but may all be related to the central, definitional paradox of art as a fragmented comment upon the nature of fragmentation. In a sense it may be implied that art represents a historical mistake. Since the writing of Hegel's *Phenomenology of Spirit* it has been apparent that the contradictions of modernity may best be faced through equally complex responses (as found in some social transformations of consumer culture; see Miller 1987: 178–217). Art, however, attempts a short cut based on the immediacy of the experience of individual self-expression, and as such it rests on the Romantic illusion that the ultimate solution to complexity lies in simplicity.

PRIMITIVISM AND ORIENTALISM

The argument that primitivism is integral to the notion of art itself, is based upon this same paradoxical foundation for art. Primitivism stands for that aspect of the Romantic movement which is based on the assumption that there exists a form of humanity which is integral, is cohesive, and works as a totality. Since this totality is always defined as a critical opposite to the present, it is always a representation of a primitive 'other'. It is in this sense that all the strategies to be described in this section may be considered primitivist. It follows that all works of art are primitivist irrespective of whether they, as individual works, are seeking to express a totalizing or fragmented image. It is precisely the qualities which define them as art works which constitute them as primitivist. They would cease being primitivist only if they were no longer regarded as art.

There is a variety of strategies by which art may determine the genres through which it finds expression. The most important divide is between attempts to characterize the fragmented nature of modernity itself, and the attempt to represent other worlds as models for totality. From the latter, the most obvious route, and the one, which in a sense, signifies the foundation of art as a modern movement, is, ironically, its tendency to look backwards to the image of a world lost, to the idea that there was once an integrated, cohesive, social totality which can be located historically. The Renaissance is generally characterized in relation to a new perspective on the past, art emerging alongside antiquarianism (Rowe 1965). The classical period was thus recognized as distinct from the present, and as embodying characteristic qualities, such as a sense of harmony and beauty, which could be seen as absent from the present. Forms of neo-classicism become a common mode in art thereafter. An alternative version that flourished during the British Industrial Revolution was the Pre-Raphaelite movement, oriented towards a more specific unity of art and craft, said to be characteristic of the medieval period. It follows from the previous argument that the claim to a past which exhibited less structural differentiation than the present is not unreasonable (though not a past without contradiction), but that this is best understood in terms of the wider historical canvas of social and cultural development, and may not be resurrected merely by significant imagery.

The second possibility for art in its search for cohesive totalities is to face in the opposite direction, towards the future, putting its faith in technological change, and the Humpty-Dumpty claims of new technologies, from the printing press to the computer, that they will somehow put us back together

again. Futurist or modernist movements have been particularly influential when associated with political visions of a future reunification organized around the concept of a social totality, as in the romantic vision of communism. These two strategies, that of modernism and the appeal to a Utopianism based on some historical period, derive their full meaning only in relation to each other (for an example of which, see Miller 1984).

The concept of totality has been central to the development of critical perspectives on modernity especially in western Marxism (Jay 1984). Lukács (1971), for example, argued that a perception of totality was fundamental to the proletariat's ability to comprehend their true historical position, no longer mystified by the reified and fragmented world of commodities, and subjected to the overly rationalist, positivist, and quantitative perspectives that go with them. Lukács favoured realism in art (Lukács 1973: 277–307), but others on the left (e.g. Bloch and Brecht) took the complementary position embraced by critical modernism which saw art's task as directly representing through its own fragmented forms the nature of the present order of society, which was taken to be an artificial closure within a fragmented reality, a repressive homogenization rendered in the interests of certain groups. This was the consensus which art was supposed to challenge (Jameson 1977 surveys the internal arguments within this group).

A third alternative is to examine or portray the child as an earlier state, a naive, simple expression of unfragmented consciousness, which also tends to be related to a psychological primitivism, or a Jungian archetype. This is often related to 'folk' and 'naive' genres. Closely associated with this is a theme that often emerges in psychoanalysis of the heroic unconscious, a reservoir of disorder and creativity held up against the controlled and barren arena of consciousness. Most essentialist approaches to aesthetics are founded upon such claims to prior authenticity involved in the very mechanisms of being.

Primitivism may be used as a term to describe both a general and a specific movement in art. As noted above, it may encompass all these strategies, through which the primitive stands for the projection of a simple totality on other worlds. There is, however, a more specific definition which may be developed here as the fourth alternative, which employs as a reference point other contemporary societies, where spatial distance has been conflated with temporal distance so that they appear to us as present visages of our own pasts. This conflation of time and space is the fundamental defining quality of the primitivist conception (Fabian 1983) as defined in this narrower sense, which will be used from now on.

Primitivism, in its narrower sense, consists of the projection of

social self-definition as a structure composed of being and other-
ness. It is a specific example of a phenomenon which is by no
means limited to contemporary populations, and although its
particular form is resonant with the experience of colonialism it
is not, as such, merely a product of colonialism. The anthro-
pologist Friedman (1983) has argued that primitivism must be
understood as one example of a more general tendency for most
peoples to have images of themselves as inhabiting a cultural
centre with the outside populated by wild, unnatural, and semi-
human species (the classic example is Herodotus's description of
peoples with heads below their shoulders, living outside the
Greek world). This may form part of a rejection of the world
lying outside the boundary (the realm of the dead, the uncon-
scious, hell etc.), or the basis of an incorporative mode, allowing
empires to extend their rule as superiors over their subhuman
neighbours.

Contemporary western societies have, it has been argued,
increasingly conflated mythical images with real peoples living
on their geographic and – increasingly economic – periphery.
Friedman divides this conception rather differently, into an
evolutionism which associates the other with our own past, and
a primitivism which attempts a positive evaluation of the other
as our equals, or our moral superiors. Anthropology itself,
derived, in part, from the same Romantic tradition as art, has as
its task the location of essential human nature, pivoted upon
comparable conflicts between relativism and universalism.
Ethnography, during the period of functionalism (approxi-
mately 1920s to 1950s), presented society as an 'organic' unity,
and this tendency towards romantic and holistic images has con-
tinued in various forms of anthropological social theory, includ-
ing structuralism. Contemporary ethnographies, however,
especially those influenced by Marxism, have shown that most
societies are often better considered in terms of contradiction,
conflicts of interest, issues of power, forms of alienation, and
competing cosmologies. This does not mean rejecting general-
ization based upon the impact of the massive division of labour
and quantitative increase in material culture represented by
industrialization and the modernist philosophies of capitalism
and socialism. It has already been argued that such societies are
both more differentiated and have stronger pressures towards
both abstraction and specificity than most non-industrial
societies.

To comprehend the specific nature of primitivism it seems
sensible to start with those societies that generated this concept.
Primitivism may be investigated as a form of ideology. In as
much as different groups in society have an ability to construct
the world around them, they tend to do so in accordance with

the perspective which emerges from their relative objective positions in the world. The material world around us is therefore likely differentially to reflect the relevant perspectives of those groups who have the power to construct cultural forms. Since meaning is often defined through oppositions, dominant groups may often be found not only to construct material representations of their own interests, but also to project models of those which they define themselves in opposition to (e.g. Miller 1984). As such, ideology as a methodological device need not be restricted to class societies. It demonstrates how, without any notion of conspiracy, it is possible to account for the observable dominance of certain images over others in a given society.

An example of the operation of ideology is the concept of orientalism as developed by Said (1978) who investigates in considerable detail the manner by which the Occident constructed the form of the Orient as an oppositional image. As Said makes clear, one result of this is that in so far as the Occident actually deals with the Orient it assumes that reality to be an actual expression of the model it has constructed of it, and treats it accordingly. On occasion, however, the relationship is reciprocal as illustrated by a case taken from textile history. There exists in such studies a set of designs known as the oriental style, which comprises large blooms with curvilinear stems in rich brocades, silks, and other textiles (Figure 3.1). Large collections of such chintz are held by museums around the world and this led to an interesting debate amongst museum workers as to where these materials came from. That is, was the oriental style originally Persian, Chinese, Indian, or from elsewhere? Through research it becomes clear that these materials come from India, but are in no simple sense an Indian style.

When Indian cloth was first exported to Europe it was an awesome material since it represented a far greater sophistication in dyeing techniques and other decorative means than existed in Europe at that time. Unfortunately, however, the kind of design which appealed to Mughal courtiers was not that desired by British ladies. Some notice of this displeasure was transmitted back to India, which had developed a marketing and manufacturing system parallel to the European *verlag* or putting-out system (Kriedte *et al.* 1981) which was remarkably sensitive to the differences in consumer desire between traditional Indian markets such as China or South-East Asia. What the British required of this cloth was not direct copies of British designs, but rather something that fitted their image of what the Indians should have been making for themselves, and was thus both exotic and tasteful. Through a series of cycles carried over an immense distance and with some confusion at both ends, a satisfactory design did arise, which is what the

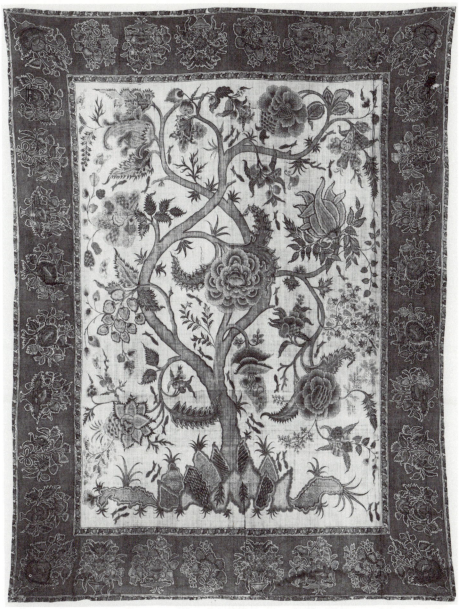

3.1 The 'oriental style', Palampore, India (Coromandel Coast), late
seventeenth or early eighteenth century (reproduced from J. Irwin and
K. Brett (1970) *Origins of Chintz*, London: HMSO, by kind permission
of the Victoria and Albert Museum, London).

oriental style represents (Irwin and Brett 1970).

Clearly then the oriental style is not properly an Indian design, though made in India, nor yet a British design, though the idea for it came from Britain. It is a design which has meaning only as an expression of the relationship between the two societies. It may be said therefore to be an objectification in material form of the concept of orientalism. On the one hand we have an immensely fluid relationship comparable to Laing's models of 'what I think that you think I think' etc., and yet this same hermeneutic cycle produces an increasingly fixed material text. Furthermore, it is a series of objects which may develop first, to mediate between each society's image of the other, and then may obtain a certain autonomy, until eventually we are left with discussions not of British–Indian relations but merely of the oriental style of cloth in itself.

To generalize from this example, there is a process by which objects as objectifications come to fix as material forms, images of the relationship between societies, in which one society produces for the other an image that society has of itself. Given time, the image may often be assimilated and act as a powerful element in the self-conception of that same society, since the process is always a 'two-way' force. As a process, this is by no means new. Different variants of what have been termed 'centre–periphery' relations may have pertained in many of the early states (Rowlands *et al.* 1987). For example, ancient Mesopotamian society appears to have constructed the development of settlements on its own periphery in eastern Iran, where the local population was engaged in making 'exotic' items for consumption in the core region (Kohl 1979). Indian erotic ivories have turned up on classical sites in Italy, and the concept of 'prestige goods' has had an important place in archaeological theories about the development of complex societies (e.g. Friedman and Rowlands 1977).

PRIMITIVE ART AS PRIMITIVISM

If the example of the oriental style is used as a model for the study of primitivism then it has to encounter the paradoxical foundations of art. Art, which is valued as the most esoteric, sophisticated, and fragmented part of our culture, has to construct itself with respect to totalizing images of the essential, unreflective, and ultimately simple nature of things. In constructing itself as ideology art will always tend to control, as far as possible, the image of that which it defines itself in opposition to. Thus art will attempt, from time to time, to enter, represent, and define popular culture, kitsch, folk traditions, and also the representations made by other societies. The

problem here is that by definition such things should not be the direct product of artists, or at least not only of them. Although art may produce its own primitivisms and neo-primitivisms, as genres these are always legitimated in part by reference to what is seen as authentically primitive, and must be therefore the product of those peoples designated genuinely primitive. For this reason, although the understanding of the concept of primitivism must begin with the countries which regard themselves as the cultural core, the study of its products must begin with the countries they regard as peripheral.

The first 'moment' in the material construction of primitivism is always one of selection and distorted representation. In the first instance the peoples concerned have no concept of primitivism or art to objectify, but there are a number of strategies which those who have such concepts may employ short of encouraging full production. Exemplary analyses of this phenomenon have been made by Bernard Smith (1960) and Partha Mitter (1977). The former has shown how sets of representations of the Pacific, such as the drawings from Cook's voyages, were transformed into what could best illustrate the arguments about noble savages or cannibalistic barbarians which were raging in Britain at the time. Although Cook's voyages are a classic example of a scientific project collecting material from societies with no prior contact with Europeans, the selectivity of vision makes Hodges's original paintings made during the voyages and the successive copies of these, fine examples of primitivism as a process of the recontextualization of images. Mitter illustrates how certain features of South Asian deities were successively emphasized according to the development of similar arguments.

Much of what is termed primitive art is not, however, merely the product of a selection, but as with the oriental style of cloth, it is the material result of one people's understanding of what they think another society perceives them to be. It is only through this transformative process that a more developed construction of primitivism can occur. The evidence depends on the area concerned. Many of the items which influenced European artists in the period 1900–20 were from areas of coastal West Africa which are documented as making ivories for Portuguese consumption some five centuries earlier (Donne 1978, Ben-Amos 1980: 25–9). There is abundant evidence for faking and for the taking-over of production or the direction of production of primitive art by Europeans. Gathercole (1978: 282) provides the exotic example of Maori 'flutes', which turn out to be overcarved Tibetan thigh-bone trumpets. Indeed, many complete genres were established through European intervention such as Inuit (Eskimo) soapstone carving around 1949 (Graburn 1976: 39–55), or at least as a result of European

contact as with argilitte carving on the American north-west coast around 1820 (Kaufman 1976).

The rapidity with which a society may develop material culture specifically for export has been revealed by examples of peoples with whom contact with Europeans was established quite recently, and where this process may therefore still be observed, as in the upper Sepik valley of New Guinea with whom significant interaction did not occur until after 1945 (Abramson 1976). Such evidence appears to indicate that a large number of peoples may have transformed aspects of their material production in response to missionary, explorer, and later colonial and commercial contacts. This should not surprise us, since it is only a reflection of the wider observation that certain societies may have changed very swiftly after colonial contact. Thus, for example, archaeologists have partly debunked what had been taken as the image of 'pristine' pre-contact Maori society, by showing that the situation recorded by early ethnographers was, in fact, the result of rather swift changes following initial European contact (Groube 1972).

It follows from the above cases that the general collection of objects which have been labelled 'primitive art' might be a useful resource in understanding the concept of primitivism in the light of whose image they were collected, selected, and in many cases produced. The point at issue is not the inauthentic nature of primitive art, or museum collections. Often such claims to 'authenticity' are themselves, based on the illusion that such societies did not change and were isolated prior to colonialism, allowing them to be characterized as 'pristine'. Alternatively objects are seen as authentic because they come from a society without internal division, in which each object is expressive of that society as a totality, or of an original spirituality true to itself and the materials it employs in representation. Although non-industrial or pre-capitalist societies may exhibit certain specific differences from industrial or capitalist societies, there are no *a priori* grounds for supposing them to be less subject to change or internal contradiction or social oppression except through the assumption that they must conform to our own primitivist images defined through oppositional self-definition.

What is implied, however, by the evidence for selection and change in the objects which are used to portray primitive art, is that there are specific questions about the nature of primitivism which might be put to these syncretic and selected forms. These queries divide into two main types. First there is the question of describing those changes in the material culture which appear to have taken place in many different areas of the world and which might suggest, therefore, the form taken by the material representation of the universalistic nature of primitivism. Secondly,

there may be competing pressures to keep such materials diverse and distinctive so as to represent the sometimes contradictory attributes of the primitive.

Certain parallel, if superficial, changes are evident. For two years I worked as an employee for the Museum of the Solomon Islands in the South Pacific, one of whose tasks was to promote the continued manufacture of 'traditional' items through their sale in the museum shop. Although the museum would not sponsor all contemporary carvings made by local craftsmen for sale to tourists, such as those of lions (in the South Pacific!), few of the museum's items were exactly those which Solomon Islanders might anyway have made for themselves. The items for sale tended to be smaller and often employed materials which had not previously been used. The most popular of these new materials was ebony with a shiny black finish (Figure 3.2). A similar change has been noted in West Africa by Ben-Amos (1976: 322), who terms ebony the distinguishing mark of modern Benin carving, while New Guinea shields are increasingly expected to have a black background on which the motifs are carved. If one reflects on what materials are most immediately associated with the Chinese, Inuit (Eskimo), or Aztecs, that is jade, ivory, and soapstone, there is a clear relation between racial typologies and associated artefacts. Many other shifts are equally superficial, and have been documented by Graburn (1976: 9–21). These include miniaturization, dustability, and other matters of convenience in materials taken home by tourists. The larger museums, by contrast, tend to impress by commissioning the construction of the most monumental of canoes, men's houses, and suchlike.

3.2 Miniature ebony 'tourist' version of a canoe prow 'guardian spirit' figure from the western Solomon Islands.

More significant may be generalities in the nature of the representation. This can only be impressionistic from such a vast range, but there is some evidence for two related shifts; the first is from geometric to more naturalistic forms, as documented, for example, in aboriginal bark paintings (Morphy 1977). This move is not, however, to a pure naturalism. The sculptural figures tend towards various kinds of distortion, for example, anthropomorphic figures with exaggerated limbs or sexual organs, while geometric forms tend to shift from symmetry to assymmetry. Often the geometric becomes the infilling for naturalistic design, since there appears a kind of *horror vacui*. The primitive should fill out the entire object being worked and not leave distinct breaks between plain space and decorated section, since this would be an abstraction of the design as design, a characteristic of non-primitive art (examples of these changes may be found in Graburn 1976). The requirements of ethnographic museums, private collectors, and tourists will differ according to the images they have of the societies concerned.

The desire for a degree of naturalism may be linked to the need for cross-cultural semanticity. A form that is designed to be opaque to the females or non-initiates of the group is likely to be even more opaque on the Parisian Left Bank, or in the Metropolitan Museum of Fine Art, and most people like to think they have some idea as to what it is that is being represented in the piece they are examining or have bought. It is the degree and forms of distortion from this naturalism which perhaps come closest to the more universalistic features of primitivism itself. Whether pure or barbaric, noble or cruel, these figures have to embody their opposition to the inauthentic, fragmented, and individualistic world of industrial modernity.

For this purpose the ideal primitive object retains some element which suggests anthropomorphism, but not as an abstracted naturalistic representation of apparent humanity, but rather with features which indicate that the object contains within itself a reference to its own transcendental quality. For example, primitive art is seen as often containing some indication of a supra-human form with which it is associated. A 'good' piece of primitive art will often contain, therefore, a mixture of human and animal attributes with the idea that primitives tend towards an animistic conception of the universe. Equally a degree of distortion is taken as an indication that the primitive has not fully divorced the human from the spiritual or magical, and that these figures are representative of some ancestral form which transcends the mere human, and which embodies also a notion of society as *supra* aligned to myth and religion. Thus an ambiguous naturalism is identified with the supernatural.

Typical of our romantic conception of the primitive is the idea that there is no individual interest, that individuality as we know it is solely a modern form, that in the natural condition humankind tends to the collective. This idea of the non-dualism of the primitive has a long history in anthropology from Levy-Bruhl to Lévi-Strauss, and is equally strong in the post-structuralist traditions of Derrida, Barthes, Lacan, and Foucault, who condemn all concern for the individual as bourgeois ideology. Clearly this refusal even to consider the possibility of a highly individualistic society outside of industrial or capitalist culture may be simply another variant of our construction of the other as oppositional.

Ideas from structuralism have been incorporated into the anthropology of art to express how primitive art objects embody multivalent or polysemic qualities; by standing simultaneously for almost every area of life and thought, they were seen to exemplify the totalizing process (Bateson 1973, Forge 1973). This approach follows in the tradition of Mauss (1970) writing on 'the gift' as total prestation, thereby providing a foundation for studying objects as constitutive of social relations and ultimately of society itself as totality, in contrast to the prevailing images of capitalist social fragmentation. In different ways, the primitive image is held as a reservoir of the non-alienated. This primitive totality should appear a naive, unreflective form. If a more sophisticated totality based on abstraction is required, the art of societies designated as philosophical, such as Japan, China, or India, will be appealed to.

Complementary to these universalistic tendencies is the use of primitive art as a means for accomplishing the diverse tasks to which the concept of primitivism has always been subject. Ideas of simplicity and unfragmented totality are compatible with a large range of both positive and negative attributes. The image of primitivism in a sense has to be as diverse as our self-image to which it is created in opposition. Between the representations of Hobbes and Rousseau, from the ignorant barbarian to the noble savage, there is a wide variety of possible 'others'. The romantic conservatism which seeks a site of cohesion in the distant present, is complemented by that romantic modernism which sees the plurality of other societies as the reservoir for divergent and creative humanity to be set against the repressive orders enshrined here. The products of particular societies are used to emphasize particular primitivist attributes. For example, the supposed relationship between the primitive and the child may be objectified in the bold bright animals or anthropomorphic figures popular in some South and Central American textiles. There is also the simple desire for spatial reference, such that we should be able to tell a Kenyan object from a Tahitian. Objects

may be integrated on the one hand as fine art, showing the creativity of the individual tribal artist, or on the other as directly signifying the collectivist and holistic vision of tribal society which has been lost in industrial society.

It would be quite wrong, however, as in some of the recent critiques of postmodernism, to mistake diversity or pluralism for superficiality or lack of intensity of meaning; rather it is a mark of the complexity of the concept of primitivism as material objectification. A fascinating study by Graburn (1978) of American students' reactions to ethnographic exhibitions showed that there were clear limits as to what items labelled 'primitive art' were supposed to designate. Objects that were ambiguous with the category 'folk art' were taken as an immediate sign of inauthenticity by visitors to the exhibition. Bourdieu (1984) has shown how tightly structured these matters of taste remain within a mass consumer culture. A dismissal of consumer culture as mere pastiche (Jameson 1984) indicates only a failure to comprehend it in its specificity as against a romantic appeal to authentic art.

There is a marked convergence, then, between the demands of primitivism and the material base of its construction. Primitivism wants to enshrine both a universalistic and coherent image but is faced with a multitude of versions of this image. The primitive art which objectifies it, whether the product of European selection or of specific production for the outsider, is, however, the product of an equally diverse array of peoples and regions which can be allocated the task of exemplifying certain aspects of this overarching concept without appearing self-contradictory. Thus the apparent unity of primitive art in an exhibition under that title becomes a triumphant proof of its genuine nature, when the diverse themes produced in varied materials and regions are reunited within one gallery. Primitivism is thereby able to discover none other than itself! The catalogue to the exhibition held at the Museum of Modern Art in New York (Rubin 1984) provides abundant examples of the absurd claims made for such objects as legitimizing their integration into both tribal and fine art categories, for example 'The New Guinea object has, however, the mordant and truly hallucinatory quality of a work whose creator really believes in monsters' (ibid: 58).

Meaning is always dependent upon the variability of its context, and this is continually changing. The contemporary context of primitive art is a world where most societies have been radically affected by missions, colonial powers, and economic world-systems. Almost all societies have come to perceive themselves within the terms of the nation-state. As such, most will seek to promote a national art, alongside stamps, flags, and his-

tories, the required paraphernalia of national self-consciousness. This is particularly significant when countries were formed by colonial authorities within arbitrary boundaries and have been left with the task of forging a national image from often competing ethnic groups. A new national art may be preferable to the invidious selection of the products of one particular ethnic group. Internationally known genres of primitive art may also be useful in gaining a presence for some very small countries for whom even to have been heard of is important if one's interests are to be considered in the vast international forums of contemporary politics. In many cases, the objects come to stand for the larger settler society; Maori art is now identified with and often made by non-Maori New Zealanders, standing as symbol for that country (Mead 1976). With developing industrialization, such artefacts may be enmeshed in the familiar confrontations of modernity and 'custom', and collected by urban elites. Through these processes, objects originally developed in order to comprise a concept of primitivism generated elsewhere may become the subject once again of locally based strategies and needs (see especially Jules-Rosette 1984 for several African examples, but also Spooner 1986 for the more problematic case of the Turkmen carpet).

Alongside the production of primitive art as primitivism, there has always been a primitivist art which is directly produced by artists and writers as a genre within the dominant ideology. The orientalism studied by Said (1978) is such a genre. The colonial period was festooned with images of these other worlds popularized through figures such as Kipling, Mark Twain, Melville, and Robert Louis Stevenson. Museums and junk shops provided materials which could be used to bring the concept into view or even into the home. Modern technology has provided for increasingly sophisticated versions of these representations, which have become both more dynamic and more flexible than those which peripheral peoples further from the loci of concept development can create, and for this reason primitive art as the objectification of primitivism has itself become increasingly redundant.

An example of this process may be taken from primitivism's close link to modernism. One of the most popular genres of modernism is science fiction, which is able to establish distance in time and space through which ideas of modernity can be expressed as comments upon present-day society. By locating imagined peoples on distant planets and in other eras, the constraints (limited though they are) posed by the existence of real peoples in other countries as the focus of imaginative fantasy are removed. Indeed, ironically, the limits of high technology can be used to extend the form and detail of our objectifications of

images of simplicity and essential human nature.

A recent high point in the traditions of both primitivism and orientalism is the film *Return of the Jedi*. The film is basically divided into three elements, a battle over the futuristic hi-tech headquarters of the evil emperor, the rescue of certain key figures from the court of Jabba the Hutt, which provides orientalist imagery, and the interaction with the Iwoks, who are quintessential primitives. The episode with Jabba begins with a view of his settlement, two saucer-topped buildings, one squat, the other tall, evocative of mosque and minaret and seen over a desert landscape. The Jabba of Hutt is a pyramidical lump of fat who is first encountered smoking a hookah, while fanned by a mechanical palm leaf. He has grotesques based on courtesans and belly-dancers perform in front of him, keeps the heroine, enmeshed in a revealing gold fretwork bikini, on a chain at his lap, and presides over fawning and terrified courtiers. Underneath is a torture chamber and pit where monsters devour his foes.

As an oriental figure the Jabba manages to capture the ancient stereotypes of the fat Ottoman potentate and the greedy Jew together with the cruelty of the Ayatollah Khomeini; the film uses technology to exaggerate each feature beyond the point that real peoples – and perhaps more significantly, earlier films in this genre – could possibly be used to embody. First, there are the possibilities of extreme expression. Thus, jowls overflowing on to the body become a complete absence of neck. The cruelty is extended in the action of devouring live screaming creatures kept in a bowl at his side. Furthermore, the orientalist image has been merged with parallel expressions of evil including attributes of the ogres in fairy-tales, or the reptilian monsters of horror films. At the end of this sequence it is the heroine's discovery of a neck, which up to that point had been invisible in the image, that allows her to strangle him with her chain, exploiting this 'human' frailty to accomplish his doom.

Later on, we move to a creature who is similarly more primitive than the image projected upon any actual peoples, that is, the teddy bear. These short brown bears with the classic plastic orange eyes and squat nose stand for the link between the child and social ontogeny. Their purity and innocence as a quasi-humanity not entirely separated from nature are represented by their anthropomorphic qualities. The teddy bear is also a passive toy, which often acts as a 'transitional object' (Winnicott 1974) in the construction of identity. These live in a generic jungle, in tree-houses, they hunt with stone-tipped spears and arrows, and wear simple skins. They have witch-doctors with animal tooth necklaces and half-skulls worn on their heads, who carry fetishes and immediately recognize the

high-tech android as their own deity, They sit communally by the fireside listening to stories told with exaggerated gestures, and represent the moral purity of an innocence which the hero and heroine need to enlist to combat the forces of evil. Once again, there is exaggeration but also syncratism. Thus, there are echoes of the curious but frightened squirrel in the park or the pet who must be reassured and tamed, of monkeys, of acrobats, and of the high cranial ridge of primitive hominids.

The *Return of the Jedi* thereby continues the popular version of a genre which is sanctified in the museums and galleries of primitive and exotic arts in all the self-assertive 'civilized' countries of the world, the compilation of complex images objectifying the varied characteristic features of the 'other'. It does so in a manner which again indicates the close symmetry between the images of primitivism and modernism. The complex technology used in making these images is immediately transferable both to commerce, on the one hand, and futuristic high art on the other; for example, there is an exchange of personnel and ideas between the audio division of Lucas's film studios and Boulez's academy for modernist music at IRCAM in Paris.[2]

To conclude, I have attempted to show that the phenomena of primitivism, as of art in general, are particular forms of the general process by which a society uses techniques of projection and introjection to construct itself as a self-conscious and self-defined category, that is, the use of material culture as objectification (Miller 1987). These specific projects are the product of a powerful romantic tradition founded in the paradoxical task of using one increasingly fragmented aspect of modern culture to characterize the problem of fragmentation. The particular moral dilemma posed by primitivism is a result of the context within which it operates, that of racism. Whereas it used to be common to regard the peoples living beyond one's boundaries as wild, fantastic, and mythical, in our positivistic, rationalist world we tend rather to incorporate the image of real peoples for our construction of the other, and furthermore we are much more likely to actually encounter such peoples, either down the road personally, or cross-nationally in contexts ranging from tourism to economic dominance.

In these circumstances, two alternative scenarios for primitivism in art arise. It can be argued that primitivism is an aid to the formation of images of Us and the Other, which promote and refine negative and derogatory stereotypes, to produce a stronger indictment of other peoples whom we are thereby the more likely to oppress when we encounter them, or in its positive aspect produces romantic images of nobility which lead to an equally unrealistic set of expectations. The alternative argument would suggest that the construction of images of non-Us is an

inevitable concomitant of social self-definition and the further we can push the images away from real peoples on to science fiction, art, or fantasy the better. In this argument the vicarious and largely inconsequential nature of art is to its advantage.

NOTES

1 I would like to acknowledge comments from the following people during the preparation of this chapter: Jill Lloyd, Brian Moeran, Allen Abramson, Anne Kemperdick, Georgie Born, and Susan Hiller.
2 Personal communication, Georgie Born.

BIBLIO-
GRAPHY

Abramson, J. (1976) 'Style change in an Upper Sepik contact situation', in N. Graburn (ed.) *Ethnic and Tourist Arts*, Berkeley, Calif.: University of California Press, pp. 249–65.

Anderson, P. (1983) *In The Tracks of Historical Materialism*, London: New Left Books.

Bateson, G. (1973) 'Style, grace and information in primitive art', in A. Forge (ed.) *Primitive Art and Society*, Oxford: Oxford University Press, pp. 235–55.

Baudrillard, J. (1981) *For a Critique of the Political Economy of the Sign*, St Louis, Miss.: Telos Press.

Baxandall, M. (1972) *Painting and Experience in Fifteenth-Century Italy*, Oxford University Press.

Ben-Amos, P. (1976) ' "A la Recherche du Temps Perdu": on being an ebony carver in Benin', in N. Graburn (ed.) *Ethnic and Tourist Arts*, Berkeley, Calif.: University of California Press, pp. 320–33.

Ben-Amos, P. (1980) *The Art of Benin*, London: Thames & Hudson.

Bourdieu, P. (1984) *Distinction*, London: Routledge & Kegan Paul.

Burke, P. (1978) *Popular Culture in Early Modern Europe*, London: Temple Smith.

Donne, J. (1978) 'African art and the Paris studios 1905–20', in M. Greenhalgh and V. Megaw (eds) *Art in Society*, London: Duckworth, pp. 105–20.

Fabian, J. (1983) *Time and the Other: How Anthropology Makes its Object*, New York: Columbia University Press.

Forge, A. (1973) 'Introduction', in A. Forge (ed.) *Primitive Art and Society*, Oxford: Oxford University Press, pp. xxiii–xxii.

Friedman, J. (1983) 'Civilisational cycles and the history of primitivism', *Social Analysis* 14: 31–52.

Friedman, J. and Rowlands, M. (1977) 'Notes towards an epigenetic model of the evolution of "civilisation" ', in J. Friedman and M. Rowlands (eds) *The Evolution of Social Systems*, London: Duckworth.

Gathercole, P. (1978) 'Obstacles to the study of Maori carving: the collector, the connoisseur and the faker', in M. Greenhalgh and V. Megaw (eds) *Art in Society*, London: Duckworth, pp. 275–88.

Graburn, N. (ed.) (1976) *Ethnic and Tourist Arts*, Berkeley, Calif.: University of California Press.

Graburn, N. (1978) 'I like things to look more different than that stuff did', in M. Greenhalgh and V. Megaw (eds) *Art in Society*, London: Duckworth, pp. 51–70.

Groube, L. (1972) 'The hazards of anthropology', in M. Spriggs (ed.) *Archaeology and Anthropology*, Oxford: British Archaeological Reports 19, pp. 69–90.

Irwin, J. and Brett, K. (1970) *Origins of Chintz*, London: HMSO.

Jameson, F. (1977) 'Reflections in conclusion', in *Aesthetics and Politics*, London: New Left Books, pp. 196–213.

Jameson, F. (1984) 'Postmodernism, or the cultural logic of late capitalism', *New Left Review* 184: 53–92.

Jay, M. (1984) *Marxism and Totality*, Berkeley, Calif.: University of California Press.

Jules-Rosette, B. (1984) *The Messages of Tourist Art*, New York: Plenum Press.

Kaufmann, C. (1976) 'Functional aspects of Haida agrillite carvings', in N. Graburn (ed.) *Ethnic and Tourist Arts*, Berkeley, Calif.: University of California Press, pp. 56–69.

Kohl, P. (1979) 'The "world-economy" of West Asia in the third millennium BC', in M. Taddei (ed.) *South Asian Archaeology 1977*, Naples: Instituto Universitario Orientale.

Kriedte, P. Medick, H., and Schlumbohm, J. (1981) *Industrialisation Before Industrialisation*, Cambridge University Press.

Lukács, G. (1971) 'Reification and the consciousness of the proletariat', in *History and Class Consciousness*, London: Merlin Press.

Lukács, G. (1973) *Marxism and Human Liberation*, New York: Delta.

Mauss, M. (1970) *The Gift*, London: Cohen & West.

Mead, S. (1976) 'The production of native art and craft objects in contemporary New Zealand society', in N. Graburn (ed.) *Ethnic and Tourist Arts*, Berkeley: University of California Press, pp. 285–98.

Miller, D. (1984) 'Modernism and suburbia as material ideology', in D. Miller and C. Tilley (eds) *Ideology, Power and Prehistory*, Cambridge University Press, pp. 37–49.

Miller, D. (1987) *Material Culture and Mass Consumption*, Oxford: Basil Blackwell.

Mitter, P. (1977) *Much Maligned Monsters: European Reactions to Indian Art*, Oxford: Clarendon Press.

Mukerji, C. (1983) *From Graven Images*, New York: Columbia University Press, pp. 198–204.

Parker, R. and Pollock, G. (1981) *Old Mistresses*, London: Routledge & Kegan Paul.

Rowe J. (1965) 'The Renaissance foundations of anthropology', *American Anthropologist* 67: 1–20.

Rowlands, M., Larsen, M., and Khristiansen, K. (eds) (1987) *Centre and Periphery in the Ancient World*, Cambridge University Press.

Rubin, W. (ed.) (1984) *Primitivism in Twentieth-Century Art*, Boston, Mass.: Little, Brown.

Said, E. (1978) *Orientalism*, New York: Random House.

Simmel, G. (1978) *The Philosophy of Money*, London: Routledge & Kegan Paul.

Smith, B. (1960) *European Vision and the South Pacific 1768–1850*.

Spooner, B. (1986) 'Weavers and dealers: the authenticity of an oriental carpet', in A. Appadurai (ed.) *The Social Life of Things*, Cambridge University Press.

Williams, R. (1958) *Culture and Society 1780–1950*, Harmondsworth: Penguin.

Winnicott, D. (1974) *Playing and Reality*, Harmondsworth: Penguin.

4 Expeditions: on race and nation

BLACK AUDIO/FILM COLLECTIVE

NOUGHT: THE MOMENT

August 1891

Picture me there, a dazed missionary, listening to those dream-tellers. Listening and wondering, listening and wandering, with one foot in the grave.

We await classification; we are not traders, not raiders, therefore, he cannot get at us, cannot 'place' us. The only category he can conceive is that of 'the people who live by doing nothing'.

He is a withered old man, disconcerted, scrutinous, quizzing incredulously, with one foot in the grave.

ONE: . . . AND THE ARCHIVE

Expeditions is an engagement with the mythologies around which national identity is secured. The central concern is to investigate the fictions of national character as they are produced through the excesses of colonial fantasy.

Expeditions follows the operations of colonial discourse in its living-death throes (Thatcher's 'swamping' speech), its moments of transmutation (Gaitskell's hopes for the new Commonwealth), and its morbid multiple births — Amritsar, Liverpool 1919, Bahia 1808, South Africa 1951, London 1981.

It is a poem on remembrance, and the art of forgetting anew.

TWO: NAMING THE MOMENT

Expeditions prioritizes archival reading. A kind of returning to the source, privileging archival moments as instances whereby we can grind the tempo of colonial discourse almost to a halt, paring its parts down into a genealogy of colonial narratives. An inventory of such moments might include the following:

(1) The zoological/Cuvierial moment. Best exemplified in the classi-ficatory works of the French biologist Cuvier, Thomas Carlyle's 'Discourse on the Nigger Question', and the speeches and writings of Enoch Powell on race.

(2) The eugenic/Darwinist moment, in which the two necessary exam-ples are Edward Long's **Two Vol. History of Jamaica**, and the statistician Francis Galton's pronouncements on selection of character.

(3) The evangelical/expeditionary moment. Consider here the 'Mis-sionary Research Series' published during the 1880s, and the eve of 1601, when Queen Elizabeth I signed and sealed the charter of the East India Company which raised the curtain for Britain's Indian Empire.

(4) The millenarian/redemptionist moment, in which we turn our atten-tion to the writings of the abolitionist society: Wilberforce and Sharpe, particularly, and the memoirs of Captain Crow of the **Kitty Amelia**, 'the last English slaver to sail legally'.

BEGIN
NING
TO
GROW
OBSO
LETE

THREE: YOU WILL BE MINE

1882

Twilight over the Niger, a remembrance: 'My dream, as a child, was to colour the map of Africa red.' Sir George Taubman Goldie, standing before the Niger, which he liked to think of as his own.

He sees us reading. He awakes as from a nightmare to discover that the whole of his past experiences have returned. And even as he lapsed into half-sleep, we recorded and transcribed his fantasies. He sees us reading.

Colonial discourse is an anxious rhetoric. And this anxiety is precisely to do with its negation of its pretensions to civility. This ambivalence perpetually performs a displacing, splitting function — just when we thought the European was a creature of Enlightenment, we discover him to be a barbarian.

1889

Dr D. Crawford, FRGS, traveller for twenty-two years without a break, in the long grass of Central Africa, looks at a photograph of an African with her hands cut off. The good doctor pauses. With slow unshakable resolve he says, 'It is not the hands that steal, but the heart.'

In looking at colonial discourse through specific moments, it is possible to identify key rhetorics through which notions of a national character are defined and reworked. Rhetorics of becoming, rhetorics of loss . . .

In the settlement of Virginia, begun by Sir Walter Ralegh, established by Lord de la Mere . . . these attempts completely failed. Nearly half the colony was destroyed by savages . . . and famine. The rest, consumed and worn down by fatigue . . . deserted the colony and returned home . . . in despair . . .

. . . there we can see colonial discourse as the supreme overinvestment in the minimal demand. It simply states, 'I want you.'

. . . then again, the circulations of power and authority with which that demand is made are always excessive: 'I want your body; your soil; your labour; your soul; your love.' A conflation of land and flesh, fear and desire.

AND HIS STORIES'

FOUR: THINKING BLACK

'Remember, **you** are the stranger.'

January 1900

Frederick Lugard, the 'father of Nigeria', begins his governing of the new colony: 'The vast majority of the inhabitants were not only completely unaware that they had been allocated to Britain, but were ignorant of its very existence.'

Expeditions looks at how colonial discourse builds an orature of identification between social subjects and narratives. Between myth parading as essence, and essence parading as national character, is the oratorial 'We' and 'They' of nationhood's discourse of colonial mastery: **Thinking Black**.

In **Thinking Black**, the Portuguese can invest in distilling a specific rum, aptly called 'Nigger Killer', for export to Africa.

In **Thinking Black**, a nineteenth-century ethnographer sits by the window of his Bloomsbury study. On his desk, photographs of two African women. He scribbles across one, 'A typical mop head-dress', across the other, 'Mere barbarism disgusts — it is the unnatural union of savagery and civilization that is ugly and painful.'

In **Thinking Black** the illustrator/writer of 'The ABC of Baby Patriots' reaches the ninth letter: ' "I" is for India, Our land in the East, where everyone goes to shoot tigers and feast.' Reaching letter 23, a baby patriot reads: ' "W" is the word of an Englishman true: when given, it means what he says he'll do.'

The father of Nigeria continues with flat surety: 'They cannot know who they are, or what they are.'

to be
FOUND OUT

FIVE: BEYOND THE SEA: A NEW BRITAIN

The delirium of becoming: a moment caught between myth and history.

What we need to ask is, what regime of truth governs these sentiments?

Now known as Konga Vantu, Dr D. Crawford, FRGS, author of **Thinking Black**, gives the game away. Having stood for twenty-two years in what he calls 'the malarial mouth of the Congo', Doctor Crawford has this to say about the native:

Take the Negro now, and watch a curious thing. I mean that hard, impersonal stare of those bottomless-eyed natives, not the intense, penetrating thing of Europe. You might be something worked on tapestry or painted on a china cup, so impersonally does he look at you.

The good doctor has discovered himself and, consequently, England.

There, in that monster mouth of the Congo. Yawning seven miles wide and vomiting its dirty contents into the blue Atlantic. There, I say, you see the sad and symbolic story of the decadence on the west coast of Africa. For the fearful fact has to be faced that all things European degenerate in central Africa—European provisions go bad, European fruits, European dogs degenerate. So too, European men and women.

The grace of unbecoming: between force and meaning, a moment, caught.

SIX: DO NARRATIVES DIE?

Signs of Empire and **Images of Nationality** trace the conglomerate of signs which structure national identity, in their transformation from old chains of signification, to the geopolitical indiscretions which organize contemporary subjectivities. New jokes are spoken through old; old fictions are reborn as morbid truths.

1981

London. QC Sir Ronald Bell (RIP) hisses quietly on the BBC **Panorama** studio set. On the screen behind him, film footage of civil disorder in 1980s Britain. His lips part in a smile to the camera and the rotting teeth belong to Sir Patrick Lugard. They gesture in ghostly unison to the screen:

> If you look at their faces . . . I think they don't know who they are, or what they are. And really, what you're asking me is how the hell one gives them the kind of sense of belonging young Englishmen have.

I'm sitting in my front room. I look at his face on the screen. His face looks back at me. Seeing only partial presence, I am reminded of Fanon's words

> Not only must the black person be black: s/he must be black in relation to the white man.

August 1891

They don't know who they are, or what they are . . .

The desert stretches before the missionary. He continues to sit and listen to the wind whistling through the sand. 'Through them, we know what we are not, and therefore what we are is always unstable.'

He sees dancing figures as the sands eat into him. 'What is this, if not the desert turning poet?'

PART II

Editor's introduction

The concept of the 'primitive' in European thought begins with an interest in discovering the origins of human society; this leads to proposals of evolutionary models of social development which position the west as the most advanced instance. To conform to this model, distant societies whose pasts are as long as our own are imagined to be unevolved, static, natural (organic), and simple. By making the assumption that the cultures of peoples designated 'primitive', 'marginal', or 'underdeveloped' are virtually changeless, it becomes possible to see them as typical of what has been lost or superseded by 'us' in our supposedly more rapid evolution at the centre. Societies geographically distant from Europe (located at the centre of its own myth) come to be seen as temporally distant, that is, typical of earlier stages in human development. In this way, the far-away is transformed into the long-ago.

For modern western artists, the evolutionary model that assumes the further back one goes in time the simpler things become (and the simpler, the more profoundly unified) and the primitivist fantasy that the far-away is the same as the long-ago, have been major investments. 'One's position', as Guy Brett emphasizes, 'is always a product of the historical process.' The chapters in this section of *The Myth of Primitivism* reveal an additional theme visible within the myth once its intricate historical links with racism, imperialism, evolutionism, and nostalgia are excavated, and that is the disquieting relationship between primitivism as an ideological construct and a mythic modernism, progressive, universal, and homogeneous.

Jill Lloyd examines in depth the 'ethnographic' still lifes of Emil Nolde, unmasking a series of contradictions, discrepancies, and gaps which these paintings depict, and because of which they have been marginalized within the discourse of modernism presented as a 'unitary, revolutionary phenomenon' instead of the 'forward- *and* backward-looking' tendency it in fact was. This mythic modernism has a symbiotic relationship with primitivism, and dismantles itself as soon as the myth of primitivism is dismantled. 'Modernism' can then be seen as an ideological construct, like 'the primitive' which modernism situates oppositionally.

Guy Brett points to something of this sort when he reveals that 'having identified so strongly with the formation of modern art in this century, and the ongoing explorations of the avant-garde', he has also 'identified with the myth of primitivism'. Yet there is value in 'some of those expressions of early twentieth-century art in which the primitive and the modern are most closely entwined' and 'one feels the sharpest sense of the internal contradictions of western society. . . . But for this to become clear one has to recall the period before 'modernism' became part of official western culture and power, an instrument of state policy – when it stood against the consensus. And also, we need to investigate a notion of the primitivist impulse broader than that suggested by the . . . fixation on Picasso's discovery of African masks.'

In the modern period, the arts of Europe's 'others' enlarged western concepts of what art is, the many forms it can assume, and the diverse roles it can play. But however much or little ethnographic art truly has provided a source for western artists, and however much or little it still functions as a charter of difference and opposition, it always does so as a sign whose meanings are already in place before they are deciphered.

Perhaps relocating the 'primitive' *within* the 'modern' as a site of need and desire, while recognizing it as a category produced by a specific history, can begin to free fantasy from its projection on to real other peoples who have been burdened conceptually by the west with essentialist, timeless attributes. With the dissolution of the myth that disguises the enabling historical and political conditions of artistic primitivism, it might then become possible to envisage an idea of art widened even further by what Foucault called 'the inexhaustible treasure-hoard of experience and concepts, and above all, a perpetual principle of dissatisfaction, of calling into question, of criticism and contestation of what may seem in other respects to be established' filed under 'ethnography'.[1]

Lynne Cooke investigates this redemptive potential in her chapter, emphasizing that 'recourse to primitivist imagery can no longer be an innocent act' on the part of artists once its character as a social construct is known. Artistic primitivism in European and American art of the 1980s is not 'a simple, unproblematic concept, whether construed in psychological terms of otherness or as the material expression of alternative social possibilities. Although purporting to concretize notions of difference, otherness, and alternatives, primitivism is more aptly seen as a case of enantiosis. . . .[2] It is the achievement of the 1980s that the critical mythification of primitivism is at last being explored in contemporary art.'

Less optimistically, speaking from a perspective that engages

both with the relationship between primitivism and modernism, and with the issue of the status and representation of peoples who have been labelled 'primitive', Rasheed Araeen explores a disturbing 'return' of primitivism in its classic form of a refusal to recognize difference except in the fixed stereotypes of myth. The idea that the creative expressions of black artists in a multicultural society are realizable only 'within the limits of their traditional cultures' enables the 'primitive' to appear '*within* western metropolises, no longer a Freudian unconscious, but physically present within the dominant culture as AN EXOTIC, with all the paraphernalia of grotesque sensuality and vulgar entertainments . . .'

NOTES
1 Michel Foucault (1970) *The Order of Things*, New York: Vintage Books, p. 373.
2 *enantiosis*: a shape exactly the same as another except that right and left are exchanged.

5 Emil Nolde's 'ethnographic' still lifes: primitivism, tradition, and modernity

JILL LLOYD

Modernism is unique as compared to the artistic attitudes of past societies in its essentially critical posture, and its primitivism was to be consistent with this.[1]

Much has been said in recent years about the misrepresentation of non-European cultures in exhibitions and essays about primitivism.[2] Less attention has been paid to an underlying cause of this failure, which has to do with an unsatisfactory representation of European art itself – namely the history of modernism. The tendency to define modernism narrowly, from the viewpoint of mainstream French aesthetics, and to represent it as a unitary, revolutionary phenomenon, excluding all conservative and appropriative strategies, has meant that investigations of modernist primitivism are built on a series of false premises. Because exhibitions like the 1984 show at the Museum of Modern Art (MOMA), *'Primitivism' in 20th Century Art*, continue to uphold the values of modernism they are unable to examine critically and to dismantle the terms of modernist discourse.

It is precisely this narrow misrepresentation of European modernism that I wish to address. A new interpretation of primitivism must take account of the complex melting-pot of attitudes, the forward- *and* backward-looking tendencies implicit in early twentieth-century art. For this reason I have chosen to discuss a group of works by the German expressionist Emil Nolde, his so-called 'ethnographic' still lifes, which are difficult to integrate into a mainstream view of modernist aesthetics. Many of the issues central to a critical understanding of 'the myth of primitivism' lie embedded in these problematic works.

The course of political and cultural history in Germany has highlighted and exaggerated radical polarizations of conser-

vative and modernist forces. The Nazi persecution of modern artists and the notorious Degenerate Art exhibition in 1937 drove a divisive wedge between conservative aesthetics and the revolutionary trajectory of modernist innovation. In the 1937 exhibition, expressionist art was derisively compared to 'negro art' and accused of cultural Bolshevism, thus defining in negative terms the radical associations of its primitivism. In the light of these events, Emil Nolde, looked at fairly and squarely, presents difficulties. Featured prominently among the 'degenerate' artists and suffering from the removal of over 300 of his works from German museums, Nolde nevertheless joined the National-sozialist Party in 1933/4 and continued to seek the support of the party leadership after 1941, when he was forbidden to paint and forced into internal exile. Rightly, Nolde recognized a similarity between his own ideas concerning the rebirth of German culture and their translation into fascist rhetoric. Confusing ideals and political reality he failed – tragically – to see the difference between his own romantic motivations and those of the Nazis.[3] Originally, as I plan to demonstrate, his ambitions for a renewal of German art involved both conservative and critical, progressive strategies.

From the left rather than the right there emerged in the 1930s recognition of some of the internal divisions and contradictions of modernism. In the famous 1938 debate about expressionism, centring on articles published by Ernst Bloch and Georg Lukács, in *Das Wort*, the expressionists' primitivism featured prominently.[4] Lukács and Bloch agreed about the political and social responsibility of art making but they parted company in their attitude to how this was best achieved: through realism or through modernism? For Lukács, expressionism was formalist, subjective, solipsistic, and 'cut off from the mainstream of society'.[5] Instead he advocated a realist tradition, capable of penetrating 'the laws governing objective reality . . . to uncover the deeper, hidden, mediated relationships which go to make up society'.[6] Ernst Bloch saw Lukács's reassertion of realism from the standpoint of the Popular Front as dangerously close to the cultural policies of the Nazis, and he accused Lukács of crudely simplifying expressionism by concentrating on the theories of the movement rather than its art. He also questioned the validity of Lukács's concept of 'objective reality', arguing that it was little more than a neo-classical ideal. The fragmentation and subjectivity of expressionism, he insisted, were a truer reflection of the contemporary world.

While Bloch saw expressionist modernism as an oppositional force, Lukács insisted that, because of the romantic individualism of the expressionist world-view, the artists unwittingly colluded in the 'ideological decay of the Imperialist

bourgeoisie',[7] and failed to effect anything more than a 'pseudo-critical, misleading abstract mythicizing form of Imperialist pseudo-opposition'.[8] Symptomatic of this for Lukács was their use of the art of non-European cultures. Bloch claimed that the expressionists' interest in tribal and folk art showed that they wanted to create an art of and for the people. For him, the primitivizing revival of folk art also involved a critique of capitalist society. Lukács considered that Bloch's comments confused all the issues: 'Popular art', he wrote, 'does not imply an ideologically indiscriminate "arty" appreciation of primitive products by connoisseurs. . . . For if it did, any swank who collects stained glass or Negro sculpture, and snob who celebrates insanity as the emancipation of mankind from the fetters of the mechanistic mind, could claim to be a champion of popular art.'[9] For Lukács, authors like Thomas Mann created true popular art, 'for all their remoteness from an artiness which artificially collects and aestheticizes about the primitive, the tone and content of their writings grow out of the life and history of the people'. Bloch, he claimed, saw cultural heritage simply as 'a heap of lifeless objects in which one can rummage around at will, picking out whatever one happens to need at the moment. It is something to be taken apart and stuck together again in accordance with the exigencies of the moment.'[10]

In this exchange, Bloch and Lukács formulated a central question which must be posed in a critical examination of modernist primitivism. Could the inspiration the expressionists drew from non-European and folk art be used as a disruptive strategy to challenge the norms and values of European culture? Or was it, as Lukács suggests, merely an appropriative device, reaffirming precisely those values they set out to undermine? The exact terms of the expressionist debate were rooted in the circumstances and preoccupations of the 1930s, but the dichotomy between realism and modernism that Lukács and Bloch proposed also engaged with the ongoing problems provoked by the rupture in western traditions of representation that have been recognized as the prerequisite for western artists' responses to 'primitive' art at the beginning of the modern period; namely, the challenge to post-Renaissance techniques of illusionism.[11]

To pursue these issues I have chosen to discuss a group of works that represents the transition from realism to modernism in visual terms. Emil Nolde's 'ethnographic' still lifes, based on drawings of objects in the Berlin ethnographic museum, do just this, and relate, moreover, to both sides of the argument. They are modernist and primitivist, redeploying fragments of non-European cultures in formally experimental and subjectively arranged compositions, but they are also copies of objects and

refer in this sense to a realist aesthetic. This results in a series of powerfully contradictory paintings which have proved elusive because they occupy a space where alternative modes of representation cross: realism and modernism on the one hand and, because they are primitivizing *copies* of tribal artefacts, western and non-western traditions of representation too. In the context of Nolde's own oeuvre, as we shall see, the still lifes occupy a crucial position, mediating between those aspects of his work which engaged directly with modern life subjects, and his religious paintings which propose spiritual counter-images to the fractures and fragmentations of modern urban change.

In the era of German expressionism, the decisive split between realist and avant-garde factions did not involve a united rejection of academic traditions, but rather a series of battles fought within the modernist camp itself. Since 1898 the Berlin Secession, under the leadership of Max Liebermann, was committed to providing an exhibiting forum for modern foreign art and to the development of a non-literary *plein air* naturalism within Germany. Although the Secession encouraged a break with provincial academic values, in 1910 the jury baulked at the entries of the younger expressionist generation and rejected them *en masse*, including Emil Nolde's *Pentecost* (1909) (Figure 5.1). By December Max Liebermann, who strongly objected to *Pentecost*, and Emil Nolde emerged as the main protagonists of the dispute when Nolde sent an open letter to *Kunst und Künstler* criticizing the leadership and values of the Secession.[12] In the ensuing scandal Nolde, who had been elected as a Secession member in 1908, was expelled from the group.

The basis of their argument seems to have been a clash between the internationalist and realist position represented by Liebermann and the literary and spiritual values embedded in Nolde's religious works. Since the 1890s Nolde had engaged with various aspects of nineteenth-century tradition, which he aimed to combine in a new and radical synthesis in his 1909 religious paintings. The theme of figures seated around a table had appeared in his work before: in his Böcklinesque *Mountain Giants* (1895), for example, and again in his 1902 composition *Fishermen*, which took as its model Wilhelm Leibl's peasant paintings.[13] In the early years of the century both Böcklin and Leibl were cited by writers subscribing to conservative *volkish* ideology as models for a revival of a national *Germanic* art, to encourage *Volk* solidarity, and to bypass the internationalist trends fostered by the Secession.[14] Nolde's *Pentecost* combines the visionary, imaginative aspects he drew from Böcklin with references to regional peasant painting; the apostles were described by Gustav Hartlaub in 1919 as retaining the features of north German fisherman.[15]

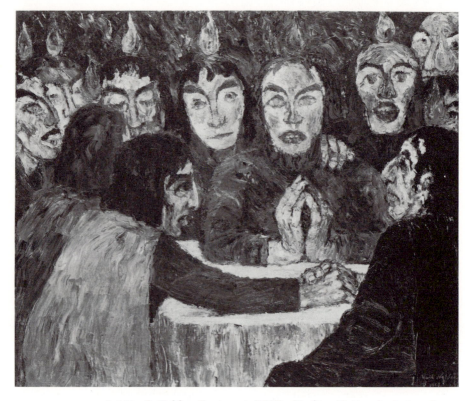

5.1 Emil Nolde, *Pentecost* (1909) (Berlin, Nationalgalerie: photo-
graph Jörg Anders).

In the second volume of his autobiography, *Jahre der
Kämpfe*, published in 1934, Nolde articulated his objections to
the Secession in terms of what he judged to be its dependence on
French models and its commercialism; to this he opposed his
own non-materialistic, spiritual, and 'inner' Germanic art.[16]
Although this can be interpreted as a later attempt on Nolde's
part to foster an image of 'Germanic' respectability in the Nazi
years, the incidents in 1910 suggest a complex shift within the
modernist camp. Recent scholarship has pointed out that
Nolde's Germanic idealist position was close to the terms of con-
servative discourse,[17] although Nolde's work was as unpopular
among the traditionalists as it was in the Secession. In 1911, Carl
Vinnen's *Protest Deutscher Künstler*, which attacked the pur-
chase of French paintings by German museums from the stand-
point of nationalist conservatism, also condemned the new
directions in expressionist art.[18] In a sense, the new 'avant-garde
art' from 1910 fell between the stools of conservative and

modernist values, relating to aspects of both but identifying fully with neither. And the aspect of their art which distinguished them from both factions was primarily their primitivism. The mask-like faces and raw painterly handling of Nolde's *Pfingsten* were equally unacceptable to both groups. In May 1910 Max Pechstein's poster for the first exhibition of the avant-garde Secession depicted a primitivist nude brandishing a bow and arrow, symbolic of the expressionists' new intents and purposes.

The fractures within the German art world during this period and the terms of the debates relate to the rapid circumstances of industrialization in Germany which intensified and exaggerated more general western dilemmas and contradictions involved in modernization.[19] The so-called 'Arnold Böcklin affair' in 1905 demonstrates most clearly the playing-out of these issues in the field of artistic concerns. In that year Julius Meier-Graefe, one of the main supporters of French painting in Germany, published a book called *Der Fall Böcklin* that attacked the literary style and theatricality of the Swiss painter, who achieved enormous popularity in Germany during the 1890s. This attack was countered by Henry Thode, who upheld Böcklin and the Böcklinesque painter Hans Thoma as Germanic spiritual leaders who would free the German people from artificiality and materialism, returning them to 'a mystic and medieval oneness with heaven, earth, clouds and sea'.[20] What is interesting for our purposes is that despite their disagreement both Meier-Graefe and Thode based their arguments on an attack on modern materialism. While Thode saw in Böcklin an alternative to the materialistic values of the times, Meier-Graefe claimed that it was precisely the bad taste and 'lack of culture' in modern times that produced enthusiasm for an artist like Böcklin.

Before 1914, the link between traditionalists and modernists, between right and left, was their common recognition of the fragmentation and materialism of the modern world, and in both camps attempts were made to formulate counter-images to this fragmentation. In Thode's eyes this took the form of a spiritual Germanic unity, while for Meier-Graefe, from the time of his involvement with *Pan* and *Dekorative Kunst* in the 1890s, it was the postulated reintegration of art and society through the agency of the decorative arts. In the introduction to his *Modern Art* (1904), Meier-Graefe discusses the conditions of alienation governing both the production and consumption of art in the modern world: the artist no longer knows for whom he is producing, and art has been reduced to a commodity, an investment value in the hands of the modern collector. Meier-Graefe sought a solution to this state of affairs, not in a rejection of modern historical reality but rather in a combination of

artistic and utilitarian values, by putting art at the service of industry. In the early years of the century a similar position was adopted by Karl Ernst Osthaus, director of the Folkwang Museum in Hagen, who collected expressionist art after 1906, and encouraged expressionist participation in the Gilde Westdeutscher Bund für Angewändte Kunst, founded in 1910, to promote avant-garde activity in the decorative arts and to foster contacts with big business and design firms in the West German Rhineland. Through such activities a reform of industrial processes through craft was envisaged, rather than any radical rethinking of the social bases of production; bourgeois commercialism was to be replaced by *Volk* industrialism.

In essence, these ideas relate to the claims made for art production by Georg Simmel in his *Philosophie des Geldes* (1900), where he suggests that art was the one area where the fragmentation and alienation involved in the production of objects under capitalist conditions of divided labour could be avoided. He writes:

> This autonomy of the work of art signifies that it expresses a subjective, spiritual unity. The work of art requires only one single person, but it requires him totally, right down to his innermost core. . . . Conversely, where the division of labour prevails, the achievement becomes incommensurable with the performer, the person can no longer find himself expressed in his work; its form becomes dissimilar to the subjective mind and appears only as a wholly specialized part of our being that is indifferent to the total unity of man. . . . The subjective aura of the product also disappears in relation to the consumer because the commodity is now produced independently of him.[21]

The search for authenticity, felt to be lacking in the art and life-style of their own times, guided the expressionists to the art of non-European peoples. In 1906, when Nolde joined briefly the artistic circles gathered around the Folkwang Museum, he would have seen displayed in the Jugendstil interior Osthaus's collection of modern European art alongside non-European art and artefacts.[22] Since the opening of the museum in 1902, the display of non-European art, consisting mainly of oriental and Indian examples before 1912, was presented to guide modern art and design with examples of 'unalienated' artefacts. Osthaus's commitment to Jugendstil involved a belief in reform and rebirth; and non-European cultures seemed to offer a model for a more 'whole' and integrated relationship between art and society. Such idealistic representations of non-European societies had provided Europeans since the eighteenth century with a counter-image to the fractures and transforma-

tions under way in the modern world, avoiding all discussion about the realities of historical change wrought by colonial exploitation. As far as Nolde was concerned, the aesthetic display of non-European art in the Folkwang Museum provided a welcome alternative to the 'scientific' criteria of the ethnographic museums, and this context for his early encounter with non-European art guided the forms of his later interest.[23]

Although Nolde was aware of non-European art by the early years of the century, it was not until 1911, following the Secession row, that he began to use tribal artefacts as a visual model. To some extent this was a sign of solidarity with the expressionist Secession, which asserted its identity through the use of primitivist references. As we have already observed, the splitting-off of the old and new Secessions constituted a crisis within German modernism that we find reflected in the thematic alternatives in Nolde's paintings of the period. In 1910 and 1911, Nolde continued to work on his religious works, beginning in the summer of 1911 a series of paintings which he assembled into the nine-part polyptych *The Life of Christ* early in 1912. These were the continuation of the spiritual, inner direction in Nolde's work, and, coinciding in terms of subject if not style with aspects of conservative, *volkish* ideology, they can be seen as his antidote to the fragmentations of modernity.[24] Nolde shared with the conservative wing in the debates around national identity and modernity, a deep-seated mistrust of change in the countryside: he fought against the introduction of customs-houses, pumping stations, and dykes into the North Schleswig countryside, where he was born in 1867 and spent the summer months of his working year. But his attitudes to the city did not fall into the classic conservative mould, and he approached Berlin with mixed feelings of fascination and distrust.[25] Since 1902, Nolde had spent the winter months in Berlin, which provided important opportunities to learn about the international modern movement and to make known his own art.

Concurrent to his religious paintings, Nolde began a second group of works. During the thick of the Secession row, as if to reassert his commitment to modernity, Nolde began a sustained series addressing the kaleidoscope of city life. In his drawings, graphics, and then paintings, we find scenes drawn from the cabaret, cafés, and theatre, favoured by other New Secession artists, and unique to this phase of Nolde's oeuvre. Nolde depicts the artifice of city life as a spectacle in which the characters assume fantastic costumes and often become interchangeable with the actors he sketched at the local cabarets or in Max Reinhardt's Kammerspiele and Deutsches Theater. In 1911 he painted similar subjects, using bright, 'artificial', fluorescent

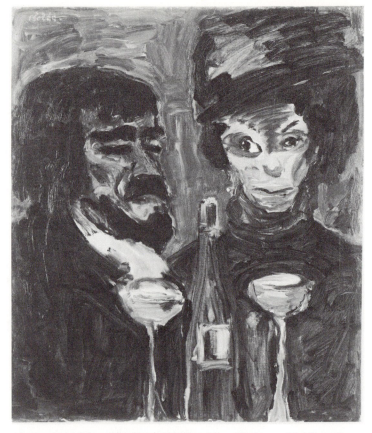

5.2 Emil Nolde, *Slovenes* (1911), 80 × 69.5 cm (Nolde-Stiftung
Seebüll: photograph Ralph Kleinhempel).

colours which recur in his 'ethnographic' still lifes. *Slovenes*
(1911) (Figure 5.2) shows an East European couple whose faces
have assumed mask-like expressions, adding to the theatrical
effects of the city. The subject-matter of these works – but
once again not the style – engages directly with modernist
precedents; *Slovenes* is an updated version of an impressionist
subject, treated by local Berlin Secessionists like Leo von König,
whose *Café* was shown in the controversial 1910 exhibition.
Thus, within Nolde's oeuvre, in 1910 and 1911, there emerged
a rift between modernity and tradition symptomatic of the
current situation in German modernism. With his 'ethno-
graphic' still lifes, it seems that Nolde tried to resolve this inter-
nal division in his work by producing a series of paintings which,
I shall argue, straddle the terms of the debate about modernity
and its idealistic counter-images, and embody in visual form
some of the contradictions at the heart of primitivism.

In 1911, Nolde left Berlin and made a journey to Belgium and Holland. In the Palace Stoclet in Brussels he encountered a second collection of non-European art in the context of a Jugendstil environment. An early work in the still life series, *Mask Still Life I*, does not depict any specific ethnographic items; rather it refers to another important encounter on Nolde's Belgium trip, James Ensor. The bright colours and grotesque expression clearly show Ensor's influence, although Nolde had begun to depict mask-like faces in a Jugendstil caricature tradition as early as the 1890s. In his controversial *Pentecost* (1909), he conveyed the religious ecstasy of the apostles by transforming their faces into illuminated masks. The important development in *Mask Still Life I* is a difference in the use of masks: they are no longer faces, as in Nolde's earlier work and in Ensor – who used masks to reveal the grotesque reality of human behaviour behind the façade of polite society. In *Mask Still Life I* the masks are objects, hung against a painterly blue background; but they are objects paradoxically animated by human emotions – laughing, exclaiming, pensive. As such they occupy a peculiar middle ground between objective reality and subjective emotion. They are like relics of a theatrical event still imbued with the stylized emotions of performance; and it is worth remembering Nolde's current visits to Reinhardt's productions as well as the spirit of Dithyrambus which animates paintings like *Dance Around the Golden Calf* (1910), and *Candle Dancers* (1912).

Returning to Berlin in the autumn of 1911, Nolde began to visit the Ethnographical Museum (see frontispiece) – like Ernst Ludwig Kirchner and Franz Marc that year. As an apprentice wood-carver in Heinrich Sauermann's studio in Flensburg, Nolde had begun to sketch after local decorative arts and he continued this practice in the Berlin Decorative Arts Museum in 1889. According to standards of historicist taste and executive skills, Nolde had copied decorative styles – in carvings, candlesticks, inkwells, ivories, vases – to improve his drawing technique and to expand his visual vocabulary.[26] Possibly feelings of insecurity, following the Secession row, prompted Nolde to resume his early practice of sketching in museum collections; although his choice of 'primitive' artefacts testifies to a translation of his old historicist mode into new avant-garde terms. His 'quotations' of non-European styles refer back to the magpie attitudes implicit in eclectic historicist methods; but at the same time he attacks the values of historicism by positing a new, original, and 'ahistorical' (as he saw it) alternative to the continuities of European tradition.

The Berlin Ethnographical Museum drawings, grouped as loose sheets in a portfolio in the Nolde estate according to sub-

jects, can be chronologically ordered according to size, style, and relationships with dated paintings, allowing us to chart Nolde's changing and developing attitudes during the period of his museum visits.[27] In accordance with such a chronology, the earliest drawings in 1911 are a large group of simple outline sketches in pencil after decorative and utilitarian objects from Mexico and Peru, such as pots and jewellery. During the winter, Nolde began to use coloured crayons and to sketch figurative pieces, like the Yoruba statuette shown in Figure 5.3. He then combined these different types of drawings and objects in the painted still lifes. Only one statement in the autobiography refers directly to the sketches, and this suggests that Nolde intended to use some of them to illustrate a book he was planning to write in 1912 on *The Artistic Expression of Primitive Peoples*.[28] Nolde describes his drawings as providing 'a deeper penetration into the essential than mechanical reproductions and illustrations could give, although my drawings were quite spare'.[29] The distinction he makes is between the superficiality of resemblance in the mechanized reproductive techniques of the industrial age and the authenticity of the hand-made sketch. His 1912 notes make clear that he saw the native artefacts too as *alternative* to modern modes of production. He speculates:

> Our age has seen to it that a design on paper has to precede every clay pot, ornament, useful object or piece of clothing. The products of primitive peoples are created with actual material in their hands, between their fingers. Their motivation is their pleasure and love of creating. The primal vitality, the intensive, often grotesque expression of energy and life in its most elemental form – that, perhaps, is what makes these native works so enjoyable.[30]

Nolde understood native art to result from an organic, unmediated relationship between producer and product, capable of expressing subjective emotions in objective form. It is this aspect he first attempts to visualize in the *Mask Still Lifes* which occupy that peculiar middle ground between objective and subjective reality. The language of Nolde's interpretation is very much his own, but his view of tribal art comes close to Simmel's description of art objects *per se* in the *Philosophie des Geldes*. As we have seen, Simmel understood the work of art as a 'subjective, spiritual unity', capable of expressing the artist's emotions in a way no longer possible under the fragmented and alienating conditions of divided labour. Conceived in the spirit of Ensor, the *Mask Still Lifes* lack his pointed social satire, but they nevertheless address the alienating and reified conditions of modern society more obliquely, by positing a romantic alternative interpretation of tribal art.

5.3 Emil Nolde, *Yoruba Wood Carving* (drawing in pencil and crayon) (1911–12), 27.8 × 12.4 cm (Nolde-Stiftung Seebull).

Nolde's critique of the materialistic values of his times also led him to attack the scientific evolutionary approach to tribal art that ignores its aesthetic potential. While 'Coptic, Early Christian, Greek terracottas and vases, Persian and Islamic art', he complains, have been admitted to the canons of high art, 'Chinese and Japanese art are still classified under ethnography and primitive art is ignored altogether'.[31] In fact, the crowded conditions in the Berlin Ethnographical Museum did, by default, encourage discussion about the reclassification of non-European art according to aesthetic rather than scientific criteria. The urgent necessity to rehouse at least part of the collection led to the decision in 1911, warmly supported by Arnold Bode, Director General of Museums in Berlin, to separate off the Asian '*Kulturvölker*' from the tribal artefacts and to organize the former according to aesthetic and qualitative rather than scientific and quantitative criteria. Nolde's remarks in 1912 relate, therefore, to more general debates about the fate of non-European art in the city collections.[32]

In contrast, the Folkwang Museum, as already mentioned, provided Nolde with one positive model for an aesthetic display of tribal artefacts. In a pre-1914 manuscript, Osthaus had written:

> We had already foreseen that the display of ancient decorative arts should provide an example for contemporary art. Consequently, it is not so much the rareness or scientific value of the objects that is emphasized, but rather their aesthetic worth. According to this principle the art of all periods and all parts of the world are displayed.[33]

One very important point emerges from this statement. It is certainly true that intrinsic issues at stake in European art and aesthetics prompted the initial response to tribal artefacts, but the ahistorical and formalist biases – which Lukács later described as the two main hallmarks of modernism[34] – were in part a *result* of the kinds of juxtaposition between tribal and modern art that characterized Osthaus's Folkwang Museum, and the illustrations in the 1912 *Blaue Reiter Almanach*. As Carl Einstein was to point out in his *Negerplastik* (1915), the ethnographic objects, prised out of their historical and social contexts and set adrift as objects, were empty vessels in Europe into which meanings could be read.[35] The search for an alternative to the evolutionary and scientific biases of nineteenth-century positivism resulted in a reading of the objects in ahistorical and formalist terms, which then became available to reinforce and justify the nascent ideologies of modernist criticism. In this sense the notions of primitivism and modernism at the beginning of the modern period stand in symbiotic rather than causal relation to each other.

The shift from a scientific and evolutionary appraisal of tribal objects to an aesthetic and ahistorical appreciation can be illustrated by the ways Nolde went about collecting material for the still lifes and planning the compositions. At the beginning, the drawings of American jewellery and pottery show groups of objects from single display cases, reflecting quite directly the organization of the museum collection, where geographical and other categorical divisions had been established at an early date. A small drawing of eight heads, used for *Mask Still Life II* (Figure 5.4) and *Mask Still Life IV* are of this type; the heads are depicted in two rows on a single sheet and are all from the American collection. The identifiable heads are a Mexican Teotihuacán death mask 19 cm (7.4 in.) high (far left), and a tiny Aztec ornament, *c*. 3 cm (1.1 in.) high (centre head, top), which have been reduced to the same scale in the drawing.[36]

Nolde, it seems, was not so much interested in an accurate record of the objects as in the facial expressions he found in

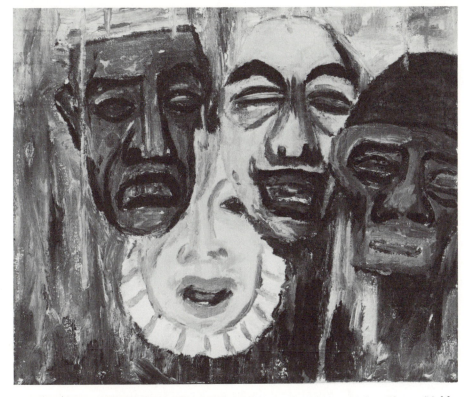

5.4 Emil Nolde, *Mask Still Life II* (1911), 65.5 × 78 cm (Nolde-Stiftung Seebull).

different types of American heads. In *Mask Still Life II*, he proceeded to hang the heads as large-scale masks with grotesque physiognomies in an Ensoresque style. In *Mask Still Life IV* the bottom two masks are abstracted from *Mask Still Life II*, but he referred back to the drawing of the Aztec ornament for the top left mask. In this pair of paintings the heads are gradually abstracted from their original context and status as ethnographic specimens and exploited for their formal and expressive qualities. Moreover, the practice of repetition and variation of a single theme in the *Mask Still Lifes* sets up a mode of self-reference and internal coherence within Nolde's own aesthetic construct that counteracts his 'realist' dependence on material objects – despite their persistent reference to a specific exterior reality. In the winter of 1911–12 Nolde began to orchestrate this practice of internal self-reference in pairs or groups of still life paintings according to musical principles, in the most general sense of the word, such as repetition, variation, and inversion.

Exotic Figures 1 and *Exotic Figures 2*, for example, are inverted versions of each other in that the first shows two Hopi dolls and one 'cat', and the second, one Hopi doll and two stylized feline creatures. The drawings for these paintings no longer depict groups of objects, but rather single figures on separate sheets of paper from different geographical locations in the museum. In this way Nolde began to extract objects from the museum displays and to juxtapose them in new expressive constellations.

Sometimes he went a stage further, drawing only a figurative fragment from his ethnographic source. Thus, the male figure for *Man, Woman, and Cat* (1912) (Figure 5.5) is taken from a Cameroon throne and the 'cat' from the top panel of a carved Nigerian door. It is this method of double decontextualization that results in the proto-surrealist effect of *dépaysement* in the still lifes of this type. Nolde stages the ethnographic fragments into increasingly theatrical encounters lifted out of time and place. Moreover, the subject-matter of *Man, Woman, and Cat* and its variant pair *Man, Woman, and Fish* (1912), sets up an opposition of 'types' rather than specific or particular characters. Like the protagonists in Kokoschka's contemporary expressionist drama – *Murder, The Hope of Women* (1909) – these have mythic implications. In Nolde's still lifes the 'mythic' opposition of 'man' and 'woman' is mediated by animals with sexual connotations like the cat and the fish.

To what extent do the modernist principles we see operating in Nolde's still lifes affect a critique of the evolutionary categorization of tribal artefacts? One marked feature of his sketches in coloured crayon and pencil, is the distinct childlike quality, quite different from Nolde's reductive but sophisticated drawings of other subjects at this date. In *Jahre der Kämpfe* Nolde praised children's drawings for their freshness and spontaneity, and he chose this style, presumably, to match his sense of the tribal objects themselves as authentic and unalienated objects.[37] His own childhood drawings were preserved lovingly, although they reveal laborious attempts to copy as accurately as possible illustrations from school textbooks and objects, according to the values of nineteenth-century drawing instruction.[38] Ironically, these drawings are far closer to the inherited traditions of copying and the repetition of received norms that characterize the production of tribal art than his later notions of spontaneity and intuitive creation, with which he credited child, folk, and native art.

The association between tribal art and child art in a positive, creative light rather than in derisive evolutionary terms was also made in ethnographic literature by this date; for example, Koch-Grünberg's *Anfänge der Kunst im Urwald* (1907). But

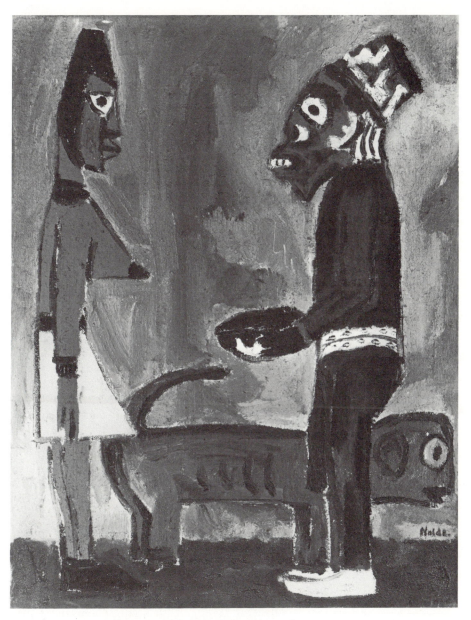

5.5 Emil Nolde, *Man, Woman, and Cat* (1912), 67 × 53 cm (Nolde-Stiftung Seebull: photograph Gerd Remner).

such notions of the 'primitive' still relied on underlying evolu-
tionary criteria which located tribal societies on a simple,
unsophisticated level. Dissatisfaction with modern civilization
at the beginning of the century involved an inversion rather than
a radical rethinking of such criteria, and did little to dispel
fundamental prejudices about non-European peoples which
justified the power structures of colonial rule. Nolde's still life,
Exotic Figures and Monkeys (1912), which depicts Negro figures
in stages of 'regression', becoming increasingly similar to a
monkey perched on a pole, shows the extent to which conven-
tional evolutionary values still operate in these paintings –
although this is probably intended as a positive celebration of
'animal' vitality.

But in another 1912 still life, *The Missionary* (Figure 5.6),
Nolde does criticize the imposition of western values on to native
peoples. Here we find a grotesquely masked man of God – in
true Ensoresque fashion – diverting a native woman from her
own religious practices, symbolized by the African mask
hanging on the wall behind. This predicts Nolde's reactions
during his South Seas journey in 1913, when he joined a medical
demographic expedition sent to investigate native conditions in
German New Guinea. In letters home he complained bitterly
about colonial exploitation of tribal societies, and as early as
1907 he had voted for the Social Democrats in the Reichstag
elections, who fought unsuccessfully to halt the course of
German colonialism.[39] In the third volume of his autobio-
graphy, *Welt und Heimat*, written during the years of Nazi rule,
Nolde wrote:

> Colonization is a brutal matter. If a history of colonialism
> could be written from the point of view of the natives we
> white Europeans would crawl off to hide. . . . Perhaps it is
> possible to comfort ourselves with ideas about the survival of
> the fittest as it exists in the animal and vegetable worlds as a
> natural law. If it is possible to draw comfort from such a law
> to justify the actions of Europeans here. . . . One thing is for
> sure. White men are the enemies of coloured native peoples.[40]

But these enlightened criticisms of colonialism are mixed in
Nolde's writings with statements affirming his nationalist
affiliations and belief in racial purity. Nolde's claims that tribal
societies should be left in their 'original' state (*Urzustand*) refer
back to the conservative aspects of his thinking, set against the
dialectics of historical change. From the European standpoint,
tribal society could be idealized as a 'natural' counter-image to
the modern industrial world; but the impact of colonial rule, as
Nolde experienced it, could make these very same societies
appear as a grotesque caricature of western modernization.

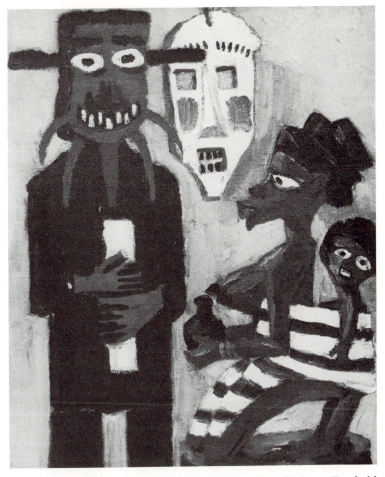

5.6 Emil Nolde, *The Missionary* (1912), 79 × 65.5 cm (Berthold Glauerdt, Solingen-Oligs).

This complex network of critical *and* conservative strategies recurs when we locate Nolde's primitivist mode in relation to his own European cultural context. As Bloch claimed in 1938, expressionist primitivism like Nolde's in the 'ethnographic' still lifes was *intended* as a critical strategy, aimed against the materialistic values of society, and the norms of European pictorial tradition; in the *Blaue Reiter Almanach* artistic realism was seen as a visual expression of the superficial values of the times. But, in Nolde's case, the still life paintings are problematic because they relate *both* to those modernist aspects of his work which engage with urban subjects, *and* to the 'spiritual' counter-images to the modern world he presented in his religious paintings.

In several ways, the 'ethnographic' still lifes relate to the modern Berlin scenes. The confrontations between 'man' and 'woman', most clearly expressed in the 1912 still lifes, pick up on the male/female oppositions in the Berlin café scenes like *Slovenes*, where bottles and glasses occupy the same position as the ethnographic animals. Also, there is a similar play between artifice and nature, which revolves around the spectacle of city life in the Berlin scenes, and the rhetoric of gesture and costume. In the still lifes, as discussed above, it has to do with a crossing of the boundaries between the animate and inanimate, to produce representations of 'living' objects. Most important, the theatrical effects which Nolde explored in his sketches of Max Reinhardt's productions recur in the still life series, and undermine in a powerful way the narrative continuity and coherence of the scenes he depicts. In the 1912 still lifes *Figure and Roosters* and *Figure and Bird*, the extremity and exaggeration of gesture and expression go beyond all narrative determinations and become a sort of autonomous rhetoric of gesture for its own sake. This is partly because the original significance of pose and gesture in the tribal pieces was lost when they were cut adrift from their own historical contexts; so that, from the western artist's point of view, they could now appear redolent with unspecific but powerfully expressive significance.

It is this aspect of the still lifes which links them in a fundamental way to Nolde's contemporary religious paintings. Of course, there are more obvious similarities; the non-European figures are themselves objects with religious significance, which Nolde translates into his notion of expressive authenticity. The influence of Grünewald in his religious polyptych *The Life of Christ* relates to Nolde's inclusion of pre-Renaissance German styles in his pantheon of the 'primitive'. In his 1912 notes *On the Artistic Expression of Primitive Peoples*, he writes:

> We cannot stand Raphael and we are indifferent to the statues of the so-called Greek Golden Age . . . worldly-wise artists, driven by their age, created art for popes and palaces. We love and respect those modest people who worked in their shops, who lives are completely unknown to us, whose names are unrecorded but who made the simple and grand sculptures of the cathedrals of Naumburg, Magdeburg and Bamberg.[41]

But it was Nolde's reapplication of theatrical effects and an exaggerated gestural code, which he worked out in the still lifes, to the narrative sequence of his nine-part polyptych *The Life of Christ* that had the most far-reaching effects. The repetition and variation of gesture which plays across the entire surface of the paintings introduces an element of synchronicity

and simultaneity – rather of atemporality – which works against the diachronic unfolding of the story. It is precisely this self-referential code of gestures and forms that separates Nolde's paintings from the nineteenth-century precedents he admired, like Arnold Böcklin. Like Nolde, Böcklin retained in his work a precarious balance between painterly realism and symbolic intent. His tendency, however, to cast his subjects in conventional literary moulds separates his work fundamentally from the modernist disassociation at work in Nolde's 1912 paintings.

The question of the fate of narrative became central in the 1930s debate about expressionism between Lukács and Bloch. For Lukács, the modernists' attack on narrative sequence, like the plundering of non-European art, was an attack on objective reality in favour of an inturned, subjective vision. Most important, it was an attack on history itself; the 'dynamic and developmental' sequence of narrative realism was challenged by the 'static and sensational' emphasis of modernist fiction, whereby man stands isolated and ahistorically confined within the limits of his own experience.[42]

Whether or not one accepts the value judgements surfacing in Lukács's analysis, his notion of the attack on history is crucial to our understanding of the expressionists' primitivism. The formulation of a timeless, ahistorical counter-image to the onslaught of historical change is an aspect that ties together Nolde's 'ethnographic' still lifes and his religious paintings, and, as I have suggested, this is written into their frozen theatrical effects. But the ahistoricism of the expressionists' primitivism was also necessary for their engagement with modernity. As Paul de Man points out:

> In order to renew one's experience of the present it is necessary to sever it from the past and to view the world with the freshness of perception that results from a slate wiped clear, from the absence of a past that has not yet come to tarnish the immediacy of perception.[43]

Hence the relationship, on the other hand, of the 'ethnographic' still lifes to Nolde's modern urban subjects. And this engagement with the present via the expressionists' primitivism could be pushed to extremes unimaginable in first-generation Secession modernism, which continued to foster the standards and values of European taste. Primitivism could be used, in a Nietzschean sense, as a revolutionary tool to sweep away the cobwebs of the past. In 1912, Franz Marc's report of the revelation he had experienced in the Berlin Ethnographical Museum makes clear the revolutionary potential of the expressionists' primitivism as a challenge to artistic tradition. Echoing Nietzsche's attack on

historicism in *On the Uses and Disadvantages of History for Life* (1874). Marc writes:

> I find it natural that we should look for the rebirth of our artistic consciousness in this dawn of artistic intelligence rather than in cultures with thousands of years of history like the Japanese or the Italian Renaissance . . . our ideas and ideals must be clad in hairshirts . . . they must be fed on locusts and wild honey, not on *history* [emphasis added], if we are ever to escape the exhaustion of our European bad taste.[44]

The division in Nolde's oeuvre between paintings affirming modernity and those proposing timeless anti-modern alternatives to the ruptures of historical change, illustrates the complex and contradictory ingredients of expressionism in Germany after 1910. Primitivism, because it involved, on the one hand, a search for an authentic, holistic area of cultural experience beyond the contradictions of historical change, and, on the other, a Nietzschean engagement with the potential of present rather than past time, bridged the gap between the conservative and revolutionary aspects of the movement. It allowed the expressionists to distinguish themselves from both conservative and modernist factions, and yet to engage with the struggles and debates between these two forces. Both sides of the equation must be taken into account in a critical study of primitivism. In a sense, Bloch and Lukács were both right, in that they recognized the alternative critical and conservative modes within expressionism. They were wrong in seeing these as mutually exclusive aspects.

In the particular case of the 'ethnographic' still lifes, it is possible that on an unconscious level Nolde tried to resolve the crisis between modernity and tradition which had split the German art world in 1910 and had driven a rift too within his own oeuvre. In practice, the paintings reveal rather than resolve and conceal the contradictory ingredients of his position. Their alternative modes of western and non-western representation, the combination of realist and modernist aesthetics, and their Janus-faced relation to his modern life paintings on the one hand and religious works on the other, makes them operate in a space which, as Bloch later claimed, shows up 'the real fissures in surface inter-relations',[45] rather than providing a false and conciliatory resolution of irreconcilable forces.

NOTES

1 William Rubin (1984) 'Modernist primitivism: an introduction', in *Primitivism in 20th Century Art*, exhibition catalogue, New York: Museum of Modern Art, p. 6.
2 For example, the debates attacking the MOMA primitivism show,

This chapter is a revised version of an article originally published (Spring 1985) in RES 9: 36–52, entitled 'Emil Nolde's still lifes 1911–1912, modernism, myth, and gesture'. All translations from the German are by the author unless otherwise stated.

mainly Thomas McEvilley's series of exchanges with the exhibition organizers in *Art Forum*, Autumn 1984–Spring 1985.

3 See William Bradley (1981) *The Art of Emil Nolde in the Context of North German Painting and Volkish Ideology*, Evanston, Ill.: Northwestern University.

4 Ernst Bloch, 'Diskussion über Expressionismus, Das Wort' (Moscow 1938) reprinted in (1962) *Erbschaft dieser Zeit*, Frankfurt: pp. 264–75. Georg Lukács, 'Es geht um den Realismus, Das Wort' (1938) reprinted in (1971) *Essays über Realismus*, Neuwied: pp. 313–43. Both essays are translated by Ronald Taylor in (1977) *Aesthetics and Politics*, London: New Left Books, pp. 16–59.

5 ibid., p. 49.

6 ibid., p. 38.

7 ibid., p. 18.

8 ibid., p. 19.

9 ibid., p. 53.

10 ibid., p. 54.

11 See R. Guidieri and F. Pellizzi (Spring 1981) Editorial, *Res* 1: 5.

12 The second volume of Nolde's autobiography, *Jahre der Kämpfe, 1902–1914*, was written in 1933–4; Nolde's account of the incident is on p. 145 in the second, extended edition (1958), Flensburg; hereafter abbreviated as *JDK*.

13 The composition is based apparently on Wilhelm Leibl's *Village Politicians* (1876–7).

14 See Julius Langbehn (1925 [originally published 1890]) *Rembrandt als Erzieher*, Leipzig: Deutsche Kunst, ch. 1.

15 Gustav Hartlaub (1919) *Kunst und Religion*, Leipzig: p. 86.

16 *JDK* p. 143.

17 Peter Paret (1980) *The Berlin Secession*, New York/London: p. 210f.

18 C. Vinnen (1911) *Protest Deutscher Künstler*, Jena.

19 Georg Mosse, in (1966) *The Crisis of German Ideology*, London, and Fritz Stern, in (1961) *The Politics of Cultural Despair*, Berkeley/Los Angeles, Calif., discuss the ramifications of this historical process in cultural life.

20 Paret, op. cit., p. 174.

21 Georg Simmel (1978) *The Philosophy of Money*, trans. Tom Bottomore and David Frisby, London: pp. 455–7. First published as (1900) *Philosophie des Geldes*, Leipzig.

22 Paul Vogt (1965) *Das Museum Folkwang in Hagen 1902–1927*, Cologne: pp. 10–11. Osthaus began his collection of eastern art in 1898, and by 1902 African objects were being acquired (pp. 12–14). The museum guide for 1912 describes the mixed display of European and non-European art as an attack on 'klassizistisch-europäischer Vorurteile' and as an affirmation of the aesthetic worth of tribal art (pp. 183–93).

23 Emil Nolde (1965) *Welt und Heimat*, Cologne: p. 39. A letter to Gustav Schiefler, dated 14 April 1914, from Rabaul, New Guinea, reiterates Nolde's praise for Osthaus's display of non-European art (Max Sauerlandt (ed.) (1927) *Emil Nolde Briefe 1894–1926*, Berlin: p. 101).

24 See Bradley, op. cit., ch. 3.

25 Emil Nolde (1974) *Das Eigene Leben, 1876–1902*, 4th edn, Cologne: p. 197.

26 Manfred Reuther (1985) *Das Frühwerk Emil Noldes*, Cologne: p. 124f.
27 All the drawings on 30 x 18.5 cm (11.8 × 7.2 in.) paper relate to paintings dated 1911. Out of twenty-nine animal drawings only two are on 30 × 18.5 cm (11.8 × 7.2 in.) paper, and these are the only two relating to 1911 paintings – *Exotic Figures 1* and *2*. Thirty drawings come into this category, and eight drawings that are stylistically similar but executed on half-size paper measuring 15 × 18.5 cm (5.9 × 7.2 in.).
28 Nolde completed only notes for this book, published in *JDK*, p. 176f.
29 ibid., pp. 222–3.
30 ibid., p. 177. Translation from Victor Miesel (ed.) (1977) *Voices of German Expressionism*, New Jersey: p. 34.
31 *JDK*, p. 177.
32 Nolde was unenthusiastic about Bode's plans, presumably because his scheme to separate off *only* the Asiatic collections for an aesthetic display highlighted by way of contrast the status of tribal artefacts as scientific curiosities. See *Das Eigene Leben*, p. 265 and *Emil Nolde Briefe*, p. 103.
33 Vogt, op. cit. pp. 33–4.
34 In G. Lukács (1963) 'The ideology of modernism' (1955), in *The Meaning of Contemporary Realism*, London: p. 17.
35 Carl Einstein, 'Negerplastik', in (1980) *Werke, Bd. 1*, ed. R.P. Baache, Berlin: p. 245 (originally published in Leipzig, 1915).
36 Respectively, Berlin Museum für Völkerkunde Kat Nr CA 3017 and Kat Nr 1V CA 977.
37 See *JDK*, p. 221. Nolde's enthusiasm for child art was shared by the artists of *Der Blaue Reiter*. See, for example (1967) *Der Blaue Reiter Almanach*, Cologne: p. 168, originally published 1912. In 1908 Nolde had acquired some examples of 'outsider art' by Ernst Josephson from his family in Sweden (*JDK*, p. 99), which he also saw as 'spontaneous' and expressive.
38 Reuther, op. cit., p. 52f.
39 See Robert Pois (1982) *Emil Nolde*, Washington DC: pp. 185–6.
40 *Welt und Heimat*, pp. 57–8.
41 *JDK*, p. 177. Translation from Miesel, op. cit., p. 34. The interest in pre-Renaissance 'Gothic' styles was again shared by the Blaue Reiter group. The 'Gothic' revival in expressionist art was inspired by Wilhelm Worringer's (1911) *Formprobleme der Gothik*, Munich.
42 Lukács, op. cit., pp. 17–25.
43 Paul de Man (1971) *Blindness and Insight: Essays in the Rhetoric of Contemporary Criticism*, New York: p. 157. Man is discussing Baudelaire's *Le Peintre de la Vie Moderne, 1863*, which is one of the first instances where the concepts of modernity and primitivism cross.
44 (1964) *Briefwechsel August Macke Franz Marc 1910–1914*, Cologne: pp. 39–40.
45 *Aesthetics and Politics* p. 22.

6 Unofficial versions

GUY BRETT

Pier Paolo Pasolini once wrote: 'Feelings cannot change: they are historical. It is what one feels that is true (in spite of all the insincerities we may have within us).'[1]

His words seem to have a twofold meaning: both of listening to one's 'inner self', and of declaring where one is, one's position (as a product of the historical process) in relation to those of others. Such an idea is particularly helpful in writing about 'primitivism'. In spite of my desire for objectivity, I feel sure that what I write will inevitably be a personal analysis of where I stand in relation to a very large and complex cultural phenomenon which we are all somehow caught up in. For primitivism, to adapt a phrase of the art historian Max Dvorak, combines 'problems peculiar to art' with 'momentous questions which confront every thinking person'.

Having identified so strongly with the formation of modern art in this century, and the ongoing explorations of the avant-garde, I have also identified with the 'myth of primitivism': the two are clearly connected at so many points. I mean this identification not only in terms of my continuing fascination with all those forms which were once considered outside the canons of art, or beneath notice, and which have influenced many twentieth-century artists: the masks, carvings, and other artefacts of 'tribal' societies, prehistoric cave painting, archaic art, popular, folk and peasant art, the paintings of children, psychotics, naive art, toys, graffiti, and so on. As Robert Goldwater points out in his book *Primitivism in Modern Art*, the contact with 'ethnographic arts' (and by implication also with the other arts above) is only one occasion for the expression of a 'primitivist impulse' in modern art which is deep and widespread.[2]

What, then, is this impulse? I saw it as a great and productive paradox: of looking 'back' in order to go forward, of an idea of the original, the primary, the ancestral perhaps (though none of these words is quite right), as a springboard for the modern and the radical. There were many ideological strands and deeply attractive ideas caught up in this, among them the desire to escape the restrictions of one's inherited and localized worldview, of ethnocentrism; to challenge official academic culture

and bourgeois values; to look critically at spiritual needs in a corporate, technological civilization; to seek a kind of psychological renewal in the primary energies of materials, colours, forms, and so on.

It was in the late 1960s and early 1970s, with my growing awareness of the rise of liberation movements in the Third World and the black movement in the west, and the way they affected artists whose work I knew and admired, that I began to realize that the 'myth of primitivism' in modern art is connected with the whole issue of imperialism. It is part of a Europe-centred ideology which looks out over the world and sees, not other autonomous peoples, but societies occupying levels in a hierarchy with Europe at the top; a schema confirmed by the economic, military, and political power of the west, maintained directly at the expense, and by the deprivation, of most of the world's people. When we thought we were looking at other cultures we were really looking at the west's version of them, not the self-representation of those peoples themselves. In the field of culture, it was exactly the rise of this self-representation in the context of the liberation movements which administered the shock: the inhumanity, low intelligence, and self-deception of ideas completely taken for granted in the west were grotesquely revealed.

It became clear too that these assumptions operated internally as well as externally. Western culture seems to have attained its *official* identity not only by defining itself against its own version of other peoples, but also by suppressing certain cultural strata at home (popular culture and history, for example), and by continually concealing the way its acknowledged great artists broke with official canons of their time.

One starting-point at least for this investigation from-the-inside would be to look critically at the typical institution which, for the visual arts, propagates the official version, by mediating in a particular way between art, 'life', and the public – the museum. Architecturally, museums may wear a neo-classical or a postmodern mask, but their internal structure is always the same. They construct their official version by selection (by displaying some objects and consigning others to the basement or storeroom); by classification (the choice of what is said on the labels); and by their very nature of being 'removed from life'. It is always these three aspects which are challenged in times of cultural upheaval or revolution. It has often been pointed out that the first appearance of museums was more or less simultaneous with the rise of the bourgeoisie, European expansion, and the beginnings of colonialism. The museum represents the victory of one version of culture over all others. Though made up of fragments, though having to cope with

changing time, the museum is the epitome of all that is completed. Everything merely ages, nothing can be renewed.

> In the service of those two abstractions called Art and Science, everything that is living fermentation [is] systematically excluded. (Michel Leiris on the Musée de l'Homme)[3]

The attitude of artists within western societies towards museums has always been ambivalent. They use them, they are inspired by them, but they also mock them. One could even say that a part of the inspiration a great artist takes from an object in a museum is the energy to break the museum framework, to make the object contemporary, a part of contemporary struggles, as the particular artist interprets those struggles.

Contemporary western 'Museums of Modern Art' impose a homogeneity on what has actually happened in twentieth-century art in order to consolidate the power of the centre. They gloss over, for example, the struggle between countryside and metropolis in the work of many early modern artists, a conflict which can be seen as a particular instance of the historical crisis of industrialization. Western museums are virtually silent about indigenist modernist movements (for example, that of Mexican revolutionary art) which have challenged European primacy with versions of their own history. And they ignore (if they cannot succeed in seducing) artists of Third World origin today, innovators, whose work is subversive not only to the global powers but also to their own native establishments, in the way in which it rejects the museum/market axis and proposes new art practices in a new relationship with life. These are all themes I want to return to later.

As far as the treatment of once-subject peoples in ethnographic museums is concerned, this function of 'representing' culture while detaching it from any connection with living behaviour has clearly been essential. Living behaviour could only be an expression of resistance. The characteristic attitude of Europe (though not necessarily of all imperialisms) towards the description and representation of other cultures has been one of removal or detachment: Edward Said in his book *Orientalism* has succinctly described it as 'the transformation of the human into the specimen'.[4] This attitude could well be taken as near the focal point of oppression, and of resistance. A key factor, for example, behind the rapid growth of the indigenist Hau-hau movement in New Zealand, which led to the Maori wars of the 1860s, was 'the consent given by the authorities to the mutilation of a great Maori chief's corpse so that a British doctor could preserve a piece of his tattooed skin'.[5] A requirement of western science was, 'from the other point of view', a violation of life and its wholeness (this was only one factor, however; the main

motivation for the Hau-hau movement was to resist the white appropriation of Maori land).

Even the selection from among the 'ethnographic objects' which museums do possess, tends to inflate the self-image of the global powers. Their very beauty harmonizes in a lament for 'disappearing peoples', who are seen as possessors of a homogenous and timeless 'tribal' culture which has been destroyed either directly in wars and conquest, or indirectly by the 'march of progress'. Another outcome of the resurgence of the Third World has been to reveal unmistakably that peoples responded to colonialism not as passive victims but as active subjects, making their own representation of the experience from their point of view, as part of a survival struggle.

'ALL THE EUROPEANS WERE KNOWN . . .'

As might be expected, the artistic response of indigenous peoples to colonialism is not nearly as well documented as Picasso's response to African masks. The few scattered references, not limited to one part of the world, convince one that there must be much more which is hidden. In Peru and Mexico after the Spanish conquest, and in parts of Africa even into the twentieth century, artisans would sometimes subvert the Christian themes they were obliged to carry out by priests and missionaries, or use them as a vehicle for their real feelings:

> When a [Makonde] sculptor departs from the stereotype . . . this is nearly always because an element of doubt or defiance has been worked into it: a madonna is given a demon to hold instead of the Christ Child; a priest is represented with the feet of a wild animal, a pieta becomes a study not of sorrow but of revenge, with the mother raising a spear over the body of her dead son. (Eduardo Mondlane [founder of FRELIMO] in The Struggle for Mozambique)[6]

I had the remarkable experience in Mexico of being given a 'resistance' interpretation of the fantastic popular-baroque decoration (carried out by Indian artisans soon after the Spanish conquest) in the church of Tonantzintla, Puebla, by the young Indian guide who took care of the building. For him, the presence of Indian gods and symbols among the Christian ones, the figure of a Spaniard moulded upside down, Indian faces given to the angels (though not the saints!), the precise illustration of local fruits and flowers – all these were signs of defiance. Needless to say, this version does not appear in the official art historical monographs of this famous building. Our guide had heard it from an old villager who had called him to his house one

6.1 Nineteenth-century African carving of an Englishman (from Julius E. Lips (1940) *The Savage Hits Back*, London: p. 104).

day and told him: 'I want you to know how things are in the world.' This was 400 years after the conquest!

On the other hand, the highly respected Mexican museum curator with whom we visited the building commented: 'Well, that is the local version. . . .' For him the church was essentially a syncretic wonder, an extraordinary episode in the history of styles. Only much later did I realize that my own amazement at the existence of the 'local version' was due to my ignorance of the sheer number and extent of resistance movements (uprisings, revolts, wars, religious and messianic cults) of the indigenous peoples against colonial conquest, not only in the Americas but all over the world.

As if by the same dialectic of concealment, many carvings and other representations of Europeans by indigenous artists in formerly colonized parts of the world have been stored unseen for years in the basements of western museums: only intermittently and recently have some of them come to light. Although they may have been made for tourists, or in earlier days for colonial officials, they can also be read in an oppositional sense. In a curious way they both accentuate and eliminate the distance between colony and metropolis. They deflate the romantic myths of colonialism for home consumption. They reveal it as a mundane operation of bourgeois humanity, with its motley cast of characters: the solemn teacher, the pompous official, the bawling officer and submissive soldier, the drunken sailor, the sedentary merchant with his pipe and dog. The acute observation and psychological insight of these carvings dispel the myth that Africans, for example, were uncomprehending victims of

6.2 Carved drum in the form of a liquor-swigging European sailor, west coast of Africa, nineteenth century.

colonialism, or that the forms of 'tribal' art are produced by a kind of irrational, instinctual, 'low' mentality. As the Ivory Coast writer Bernard Dadié wrote in his novel *Climbié*:

> All the Europeans were known . . . their customs and char-
> acters were known, as well as the amount of education each
> one had. The entire *curriculum vitae* of each white man was
> known by every negro in the city.[7]

The naturalism of these carvings is therefore of considerable significance. From the European point of view, the 'tribal' artist's ability to change styles does not fit with the image of the primitive being constructed in ethnographic museums (which must be one of the reasons they are not displayed). From the point of view of their makers, naturalism may have been the most suitable artistic language in which to convey messages to Europeans. Perhaps it was also used to depict what may have seemed the folly and inadequacy of westerners: their atomized individuality. In one depiction – on a bamboo pole made in New Caledonia – one precisely individualized Euro-pean is surrounded by 'we', the people, stylized as if to empha-size communal solidarity.

Quite strikingly, the vast majority of these images are concerned with power relations. Sometimes they are represen-tations of white power, sometimes of its negation (as in the famous 'Tippoo's Tiger' in the Victoria and Albert Museum, an eighteenth-century automaton made for the sultan of Mysore, in which a wooden tiger sinks his teeth into a prone British trader to the accompaniment of groans). But most often, and pri-marily, they 'question the assumptions of power on which white administration and political authority is based'.[8] This is the dominant theme of Julia Blackburn's anthology *The White Men*, which collects verbal and visual accounts of indigenous peoples' first encounters with Europeans.[9]

> I have asked the Great White Chiefs where they get their
> authority to say to the Indian that he will stay in one place,
> while he sees white men going where they please. They
> cannot tell me.[10]

Chief Joseph's indignation, in the 1880s, is expressed in many variations. Colonial power did not seem to be vested in the personal qualities of individuals, or even ultimately in weapons. It was distant and abstract, a matter of written instructions, contracts, and orders from thousands of miles away, and yet its effects were immediate and devastating:

> As to their victory over us, they were not victorious by armies,
> they were victorious by sitting still.[11]

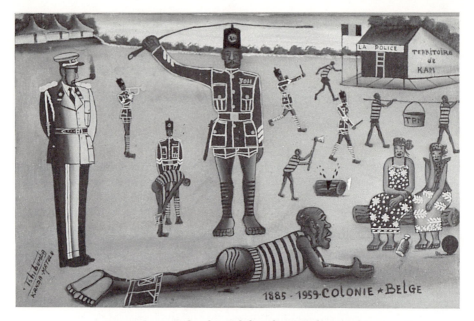

6.3 *Colonie Belge* by Tshibumba Kanda-Matulu, a contemporary
popular painter of Shaba Province, Zaire (photograph Etienne Bol).

Nothing could illustrate more clearly this widespread and
ongoing interrogation of western power than the popular
paintings being produced today in Shaba province, Zaire. These
are African paintings for an African public, part of the urban
popular culture which has grown up in the copper-producing
centres since Zaire's independence from Belgium in 1960. One
genre of Shaba painting, the *Colonie Belge*, always portrays the
same scene in which a prisoner is being flogged by an African
policeman, while a white administrator in neatly pressed uni-
form looks on, *but does not act*. His authority is unmistakable
but is remote, abstract.[12]

For a long time the debt of modern art to so-called primitive
art was not officially acknowledged. Robert Goldwater's 1938
book *Primitivism in Modern Art* was a pioneer in making this
visible. Earlier on, the influence of African or Oceanic art was
usually constrasted with the Graeco-Roman and Renaissance
tradition; it was considered something alien, inhuman, and
spelt the end of classical humanism. This view was expressed as
late as 1969 by Kenneth Clark in his book *Civilization*, when he
said:

> To the Negro imagination [the spiritual] is a world of fear and
> darkness, ready to inflict horrible punishment for the smallest
> infringement of a taboo. To the Hellenistic imagination it is a

world of light and confidence, in which the gods are like ourselves, only more beautiful.[13]

This effusion is most absurd in imputing dark to one culture and light to another, when they are dialectically related in all cultures. And his supposed tribute to the Greeks is actually an insult to their intelligence!

The numbing of part of the mind, a brutalization of the pysche: if this now seems so clear in the ideas of a scholar like Clark, it is because of the 'decolonization of the mind' undertaken by the former subject peoples themselves. Power therefore, as time goes by, needs to find more subtle forms in which to perpetuate itself. Traditional art forms of extra-European peoples are now genuinely loved and venerated by many in the west. But as several critics have pointed out, a subtle Eurocentrism has shaped the prestigious exhibitions which have recently brought together in the west some of the finest examples of non-European art (such as *Sacred Circles* and the *Festival of India*, both in London, *Treasures of Ancient Nigeria*, a travelling show, and *'Primitivism' in 20th Century Art* at the Museum of Modern Art (MOMA) in New York). The MOMA exhibition was subtitled *The Affinity of the Tribal and the Modern*, a revealing choice of words. The 'tribal' is a category easy to remove from history, from questions of nationhood and political representation; in terms of the contemporary world it implies shadowy peoples who do not exist, who do not have a voice. At the same time it imputes to them a free-floating genius, imagination, sensibility, as *artists*. To talk of an 'affinity' between the tribal land the modern is also in a sense to remove 'western' artists from a life context.

The museum, in other words, continues to evolve its containing and controlling role. Its strategies cover a wide range and will probably increasingly approach the borderline with 'life'. This has already happened in at least one bizarre case. In Hawaii there exists a Polynesian Cultural Centre, actually an artificial Polynesian village peopled by a staff of 800 paid employees. The centre 'selectively . . . emphasizes the best of those tangible, believable aspects of Polynesian culture with which the tourist can identify'[14] – in other words *actually creating a community of people to fit our own fantasized representation of it*.

> There is simply not enough time in a one-day visit to discuss the nature of the Polynesian extended family (ramage) with its complex variations in political, economic and kinship elements; or to explain the economic aspects of conscription of manual labour as a form of capital; or to explore many of the other deeper, more complex aspects of Polynesian culture.

Nor does the centre see its mission as a forum for address-
ing the long-standing social and economic injustices found
throughout the Pacific.[15]

The static image of 'primitive cultures' produced in ethno-
graphic museums has also been projected outwards to condition
the actual, artistic production of contemporary peoples (often
with the best liberal intentions!). When, for example, the Inuit
(Eskimo) craft-producing co-operatives began to be set up in
northern Canada after the Second World War to aid the ailing
Inuit economy (first through the mediation of the artist James
Houston and later through the Canadian government), every-
thing produced had to meet a definite requirement which was
somehow neither traditional nor modern, but 'primitive'. A
government-employed art-and-crafts specialist edited out any
unsuitable carvings.

Among these once was a soapstone sculpture of Elvis Presley.
'It was rescued from the sledge-hammer by a public servant who
felt the piece reflected the reality of the Sugluk settlement with
which he was familiar.'[16]

At the same time, in Canada, 'life' has put its pressure directly
on the museum sanctum. Margaret Holm has related how, at
the Expo 67 in Montreal, the Canadian government decided it
could not allow the Native Indians themselves to control a space
in the projected 'Indians of Canada' pavilion because they
would use it to draw attention to their present-day struggles,
especially land struggles.[17] In 1988 another prestigious interna-

6.4 Inuit soapstone
sculpture of Elvis
Presley, c. 1963.

tional event in Canada – the Winter Olympics – was marked by another exhibition of North American Indian art, a $2.6 million display at the Glenbow Museum, Calgary: *The Spirit Sings*. The Lubicon Cree Indians living in northern Alberta, involved in a bitter 49-year land claim dispute with the federal and provincial government, boycotted it. The show was partly sponsored by oil companies operating in their area.

The following exchange was published as part of an interview in an Alberta magazine:

> *Q*: You don't feel that the viewer will get an insight into con-
> temporary Indian culture through the historical artefacts?
> *Bernard Ominayak, chief of the Lubicon Cree*: No. There's a
> great difference between the past and the present. What's
> happening now is that our people are slowly being killed. I
> think a lot of times our people would be far better off if
> someone came up to them and got rid of them instantly.
> Anything so that we wouldn't be dying a slow death.

A problem with the meaning and use of the word 'culture' opens up on a world scale:

> *Q*: But as it stands now, it's really just a show for white
> people in the city?
> *Bernard Ominayak*: That's right. And again it's glorified by
> the same people who are doing the damage to the Native
> people, in our area.[18]

MOBILITY

The struggle for land rights is pitched at the fundamental, the original level of colonial appropriation. In fact a good many of the 'indigenous visual forms' of colonized peoples – which may look perhaps decorative or anecdotal to westerners – are actually *land claims* (Mexican codices and some Australian Aboriginal paintings are examples). The Shaba popular paintings already imply a movement from the countryside to the new urban centres: this is reflected in some images which conjure up an ancestral village past. When we come to the work of 'professional' or 'specialist' artists who are part of the intel-ligentsia, whether in the west or in the 'Third World', it seems even more true that their work implies some kind of journey, or series of journeys, back and forth between 'periphery' and 'centre'. It is hard to speak of any such outstanding artist in the twentieth century up to now whose work has not been mediated in some way or other by the great metropolitan centres, *neces-sarily*, as the painter Malevich pointed out when he wrote of his youth in the Russian hinterland: 'Nature was all around me, but

the means of representing it were in Moscow where famous artists lived'.

The mobility of the artist (which is multivalent: cultural, social, stylistic, as well as geographical) itself dramatizes the extraordinarily uneven development of the world in the twentieth century. The itineraries of individual artists take on different meanings, and to follow them from their place of origin is to some extent to open up, to challenge, the homogeneity imposed on the actual development of modern art by established power. For these displacements enable us to see every artist's work not in terms of object but of process, not as completion but as creative tension. I would like speculatively to consider some of these tensions in the work of artists both of 'western' and of 'Third World' origin, both of early modernism and of today.

PRIMITIVISMS AND FUTURISMS

In some of those expressions of early twentieth-century art in which the primitive and the modern are most closely entwined one feels the sharpest sense of the internal contradictions of western society. Primitivism was linked in paradoxical ways with questioning the assumptions of capitalist and industrial society: questioning the ideology of progress while at the same time ardently wishing for a new world and the sweeping away of old privileges and prejudices. But for this to become clear one has to recall the period before 'modernism' became part of official culture and power, an instrument of state policy – when it stood against the consensus. And also, we need to investigate a notion of the primitivist impulse broader than that suggested by the current fixation on Picasso's discovery of African masks.

Implicit in both Brancusi's and Malevich's work, for example, is a journey from the countryside to the metropolis. (It is remarkable, incidentally, how many of the early twentieth-century European avant-garde artists come from rural, conservative, even feudal surroundings. Moholy-Nagy and Luis Buñuel are two further examples, very different from one another. Brancusi is famous for having walked all the way to Paris from rural Romania.) Vladimir Tatlin spent several of his teenage years as a sailor. After visiting Picasso in his Paris studio in 1913, Tatlin returned to Russia, bringing with him the inspiration of Picasso's cubist reliefs.

Brancusi worked with a large canon of forms which could be described perhaps as 'polycultural', in an atmosphere of primordial constructive effort, of the beginning of the world. Sculptures referring to technological rationality were produced by methods far removed from machine production. Age-old popular symbols – the crowing cock, for example – were stream-

lined to express modern but timeless aspirations for flight, even for outer space. Brancusi's world of forms, as extended, for example, into the environment with his park at Turgu-Jiu, aspired to a kind of anonymity, a collective ethos, though it was of course produced by the highly individualist artist of modern capitalist society, one who was even famous for a fierce kind of independence. A number of contradictions are challengingly revealed, or beautifully resolved, in the actual visible and tactile conglomerates of his sculptures: a tension between traditional craft and modern industry; a tension between the instrumentality and rationality of technology, and its possibilities for play and fantasy; a tension between sculpture as a detached object and as a kind of modification of the environment itself; and a tension between the normative constructs of western official aesthetics and all that lies outside and beyond it. (The creative tensions in Brancusi's work are hard to exhaust. One can also see another, pertinent to his 'journey', between the ephemeral glamour and 'buzz' of big-city fashion, in sculptures like his *Mlle Pogany* series, and supposedly durable and rock-like 'peasant' values.)

In his autobiography Kasimir Malevich has given a fascinating account of growing up in rural Russia (1880s), precisely between the old world and the new. He roamed in the huge fields of a sugar-beet plantation while his father worked in the noisy and smelly plant which processed the beet. His friends were the children of both peasants and workers. In pointing out how much he preferred the peasant children, Malevich makes two revealing statements:

> I didn't like the factory children, their clothes or their way of life. They always wore shoes and socks in which they couldn't climb trees or jump in the river after frogs. The country children always wore simple, canvas clothing which was comfortable for doing anything. I also liked peasant clothes because they were colourful and had designs, and because everyone sewed his own clothes however he wanted. One wove them, embroidered and dyed them oneself.[19]

However idealized, Malevich's memory of peasant life connects, revealingly, a number of things: sensuality, art, practicality, and non-specialization. Later, with his suprematism, Malevich contributed to the great modernist vision of the Russian futurists, constructivists, and other groups, which owed so much of its electrifying energy to the fact that it *was* born in a still largely rural society. However, very often a vein of 'primitivism' emerged among these artists as a critique of the actual development of life under industrialism, and the way it seemed to conflict with the aims of socialism. Tatlin's career is a good

example. Having produced his famous Tower monument in praise of the Communist International (an uncompromisingly modern and technologically daring project), Tatlin concerned himself with the invention of an 'air bicycle', or glider, the *Letatlin*. It was intended to be based on bird flight. It was ridiculed as primitive by some of the technicist Soviet critics of the time. Tatlin replied, in terms similar to those of Malevich's memoirs:

> I want to give back to people the feeling of flight. This we have been robbed of by the mechanical flight of the aeroplane. . . . We can no longer feel the movement of our body in the air.[20]

As he grew older and more isolated, Tatlin was referred to by some in vaguely pitying terms as a clown, or Big Fool. In fact his life exemplified the real dilemmas of a struggle with the dichotomy between art and technology. If in his Tower he used his revolutionary outlook and artistic imagination and daring to reveal the possibilities of technological innovation, which would otherwise be assimilated to archaic, traditional patterns of thinking and daily life, with his glider he seemed to resist the inevitable drift and rationale of mechanical, industrial culture. He insisted that he conceived the glider as an artist, that it should be aesthetically perfect. Against the 'iron laws of technology' it was considered a failure. Yet although his proposal was taken for what it partly was – a critique of social life and values – in some ways Tatlin was still bound by technological priorities. He still felt, like Leonardo before him, that the 'feeling of flight', which is really a psychological desire and dream of freedom, could be satisfied by a machine. The drama of his whole position was to be caught between the real and the imaginary, between art as a representation of life, and life itself.

MEXICANIDAD

Quite different issues are raised by the itineraries of the Mexican painter Diego Rivera. He made the aspiring artist's journey from periphery to centre: he travelled to Italy, and to Paris where he painted as one of the cubists. He also absorbed at first hand the energy of the two emergent global powers, the USA and the USSR, and he joined those other Mexican intellectuals whom the revolutionary upheaval of 1910–20 spurred to travel widely over their own country for the first time. But the key move of Rivera's was from the metropolitan art centres back to his own country at a time when Mexico was reasserting itself against the effects of centuries of invasion and brutalization by outsiders. He radically changed his style and began to produce the monu-

mental, didactic murals in which he set out to reinvent the history of Mexico (and its modern development) in visual images for a still-overwhelmingly non-literate population.

In Paris Rivera may well have absorbed the avant-garde discovery of 'primitive' and non-European art: some of the evocations of Mexico in his early murals appear to owe something to the paradisal tropics of Gauguin and Rousseau. But in Mexico such 'primitivism' became absorbed in the powerful and complex movement of indigenism or nativism which was a driving force of the revolution in the area of culture and which spread across all disciplines (art, architecture, archaeology, folklore, music, poetry, education, literature, medicine, and so on). Anthropologists define nativism as an organized and conscious effort on the part of members of a society to revive parts of its own culture – in Mexico this implied not only national resurgence but also the rediscovery of indigenous cultural values despised by most of the ruling class within Mexico itself.

Characteristically, Rivera's style evolved from primitivist projections to an extraordinary effort of factual research into ancient and folkloric Mexico, which he converted into painted images. In a late mural like the one in the Hospital de la Raza in Mexico City, Rivera gave a vast and detailed portrayal of Aztec medical practices equal space with a portrayal of modern medicine. This in itself was a bold assertion, but when one looks longer at the layout of this painting one sees complex tensions of fact, fantasy, and desire. The Aztec scenes are painful but open and communal; the modern ones painless but torn by class strife and segmented into alienating boxes. The very colour and conviviality of the Aztec scenes show the way in which Rivera has marshalled and constructed an ancient world to point beyond the present to a Utopian communist future.

Rivera's gargantuan project and his position in twentieth-century art raise many questions. Interestingly, some of the contradictions of his art become clearest in the comparison between his own painting and that of his wife Frida Kahlo, certainly his equal as an artist. In keeping with his socio-political role as educator and illustrator, his relationship to the masses always seems to be one of depicting and organizing *from the outside*. He stylized both ancient and modern Mexicans as a people, as a historical force. Rivera's contemporary, the Peruvian critic José Carlos Mariátegui, had said that the 'idealization and stylization of the Indian' was an inevitable feature of 'indigenist' literature in Latin America. An 'indigenous' literature would appear only 'when the Indians themselves are able to produce it'.[21]

It is revealing too that women could enter Rivera's murals only allegorically. Even though very often they were his friends

or lovers, in the mural they took on a generalized, abstracted persona, an actor either in historical events or in the world of concepts: 'fertility', 'America', 'agitation', etc. Frida Kahlo's method – although she lived with Rivera for so many years and was as militantly communist as he – was almost opposite. She had no links with the tradition of 'high art' and architecture. She was self-taught and because of ill-health was almost forced to work on a domestic scale, and even from her bed. Where Rivera generalized, Kahlo particularized, thinking on the level of the individual and lived experience. When Kahlo came to represent the Indian, it was the Indian in herself. *My Nurse and I* (1937) conveys the idea of being nurtured by the indigenous culture of Mexico in as intimately close, as physical, a metaphor as one can imagine (Kahlo herself was of mixed ancestry: German on her father's side, Spanish and Indian on her mother's). By showing herself as an adult she implies the continuation of this nourishment throughout her life. She suggests the 'continuity of consciousness', claimed by revolutionary archaeologists between the ancient and contemporary Indians of Mexico, by giving her nurse an archaic mask; this in turn modifies a comforting image into one of power.

While Kahlo and Rivera shared the same enthusiasm for Mexican popular culture, Kahlo's relationship to these sources was less schematic, more organic than Rivera's. Her own work was strongly influenced by the style of popular *retablo*, or *ex-voto* paintings, where the traumas of individual lives are rendered with cruel and often bloody directness. In one sense these vernacular images represent the breaking-out of a suppressed voice; the same can be said of Kahlo's work as a woman artist. Through the individual she arrived at the general, the collective.[22]

Nativism seems to have been an extremely complex phenomenon in Mexico. A more subtle analysis would have to take account of class (in the dichotomy between Rivera's 'personality' portraits of the rich and famous and his 'humble' portraits of the poor, it is hard not to see a form of primitivism which has been avidly consumed as such by Mexico's upper classes). And this is further complicated by the tendency of Europeans to see Mexican nativism in primitivist terms. In fact there is a sense in which the Indian in Mexico became part of Europe's argument with itself. The elements in Mexican culture formerly thought inferior to European elements were made visible and celebrated in *Mexicanidad*, and gradually became fashionable, rather in the way Africanity did in Paris in the 1920s. Rivera and the other artists had done much to define this Mexicanity. And although, unlike Africanity, Mexicanity was constructed 'at home', it could be said to have created an imaginary Mexico

6.5 Hélio Oiticica, *Cape 6* and *Bólide 5* ('Homage to Mondrian'), both 1965. Mosquito of Mangueira is seen dancing with the Cape, which reads: 'I am the Mascot of Parangolé/Mosquito of Samba'. Projeto HO, Rio de Janeiro.

which would later have to be 'deconstructed' in the name of the real.

ANOTHER AVANT-GARDE

There is a significant sequel to this story of the Mexican experience: its almost complete suppression in European and North American histories of twentieth-century art soon after the Second World War. In his *Concise History of Modern Painting*, which has become a standard textbook since its publication in 1959, Herbert Read actually declared that he was deliberately leaving out the Mexican artists. He left out much else besides, in fact the whole relationship of art to social change. But this was not unusual. With the growth of the art market, the philosophy of the Cold War, the aggressive exportation of western culture and life-style to the rest of the world, especially by the USA (an exportation, overwhelmingly, of *objects*), modern art was constructed almost as a western capitalist monopoly enterprise. This has made the cultural expression of the power relations more complex. We see, for example, the projecting on an international scale (with the help of the art market, of corporate self-interest, of museums and publicity), as in some way universally 'modern', of art which actually embodies local or national myths ('Pop Art is American ethnic art' – Rasheed Araeen).[23] Many major 'Third World' cities today (Rio de Janeiro, Caracas, Buenos Aires, Manila, Delhi, etc.) are as instantly well informed of developments in Paris or New York as those cities themselves, sometimes more so. But the traffic is always in one direction, confirming their satellitization in the world of multinational capitals. Their reception, their critical transformation of new ideas, let alone their own discoveries, remain unknown and forcibly localized. New dialectics between local and global, between art centres and the rest, are coming into existence. On the one hand, artists of Third World origin find themselves marginalized within western capitals or separately categorized according to an exclusive mainstream. On the other, there are numbers of artists (film-makers, theatre groups, etc.) working 'locally' in the Third World but with modern techniques and world connections.

Any attempt to describe the relations of these artists to the dominant centres of power in the post-war world would produce the most complex map: of emigrations, of returns, of exile, of staying home. Such conditions are not generally known, let alone the significance of an individual's movement and practice between different social spaces and cultural contexts. But a particular perspective is shared by all those who take the question radically 'from the other side'. Their consciousness of the

6.6 Lygia Clark, *Antropofagia* ('Cannibalism') (1973). An event in Lygia Clark's series 'Collective Body'. A group of people, blindfolded and communicating only by touch, eat the fruit lying 'in' the 'stomach' of one of them (photograph Hubert Josse).

daily socio-economic realities of 'underdevelopment' – of which a colonized culture is part – becomes inseparable from their critique of art, of its commercialization and neutralization in western cultural institutions. This perspective is expressed too, I believe, in radically different meanings and uses of 'primitivism'.

Consider, for example, the work of two outstanding Brazilian artists, Lygia Clark (1920–88) and Helio Oiticica (1937–80), of which the 'international museum circuit' remains ignorant. In the 1950s a 'universal' modernist movement was tested out in Brazil: constructivism. It flourished as part of the post-war

economic and construction boom, answering the desire of dynamic sections of the Brazilian society to create an 'absolutely modern' environment. Both Lygia Clark's and Helio Oiticica's early work was done in the constructivist vein (and has always since retained some traces of its geometric ordering). But almost at once they began to question its application as a ready-made model to Brazilian conditions, and to explode the limitations of its rationale.

According to a technicist notion of constructivism, Lygia Clark's and Helio Oiticica's work apparently 'went back' to 'primitive' materials, to the body, to 'primordial' sensations, relationships. In fact its radicalism was of another kind. An acute sensitivity to traditions and tensions in their own environment is combined with a searching questioning of the artist's production in a corporate, consumer society.

By the early 1960s, Lygia Clark had broken with the traditional idea of sculpture as a detached object, in which the body's energy and the artist's expressive power are somehow captured, frozen. She had begun to work directly with her own body and those of others. Her 'sculptures' had become simple, flexible, somewhat organic devices made of rubber bands, polythene, air, stones, and so on, which were to be handled, worn, or passed from one person to another. If earlier art had aimed to produce a compressed sign of vitality 'out there', Lygia Clark's signs were inner, representing people's complex sensations of identity, of the individual and collective body, 'to themselves'. One of her works which plays most strikingly and subversively on 'primitivistic' images is *Cannibalism* (1973). This event involved one person lying down, and the others, all blindfolded and communicating only by touch, eating the fruit lying 'in' the person's 'stomach'. As Lygia described it:

> This goes beyond a purely muscular or motor linking between body and body. It is something more interior like entering each other's bodies. There is no spectator here. It is a monstrous idea turned into an intimate joy.[24]

Helio Oiticica added new inventions to the concepts of modern art, among them the *Bolide*, the *Penetrable*, and the *Parangolé*. *Bolide* (energy-centre, nucleus, fireball) is a device for ordering the chaos of reality but different from those of recent modernism such as minimalism, conceptual art, land art, concrete poetry, although it touched these concepts at certain points. *Bolides* are a kind of generic class of containers: boxes, bags, bottles, basins, cans, sacks, nests, beds – full of a substance or waiting to be entered by the spectator, a way of focusing perceptions and desires across a whole range of phenomena, natural and cultural, communal and personal.

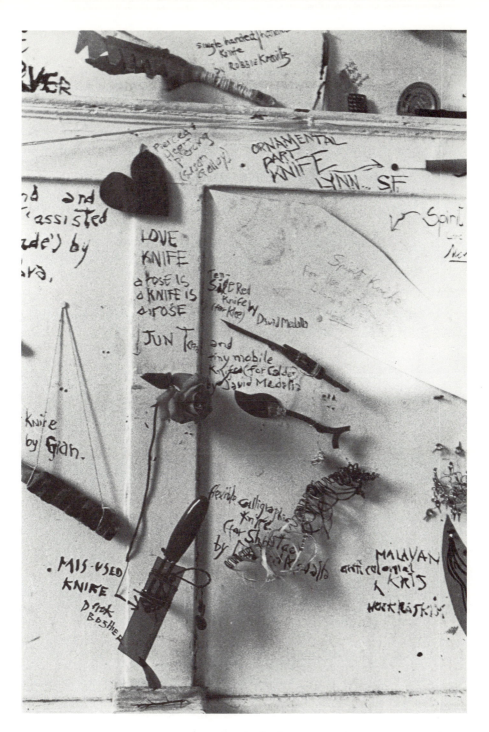

6.7 David Medalla, details of *Eskimo Carver* (1977). Knives made and titled by visitors (Artists for Democracy, London).

Discreet objects which exist for the purpose of making links, of proposing environmental and social wholes, Oiticica's works, like Lygia Clark's, counteract the obsessive way in which the finite object has become the be-all and end-all of aesthetic concepts in so much recent western art.

Oiticica's *Parangolés*, or capes, are a brilliant extension of the *Bolide* idea to encompass the energy of a very kinaesthetic people. Elements of painting, sculpture, and poetry are united with gesture and body movements in a kind of clothing-utterance, an externalization of the wearer's inner feelings of love or revolt. It is revealing that both Lygia Clark's and Helio Oiticica's moves abroad (Clark lived in Paris in the late 1960s and early 1970s, Oiticica in London and New York at roughly the same period), coincided with the world-wide emergence of concerns similar to theirs, in the 'international youth revolt' of that time.

A great many of these themes and preoccupations were brought together with typical grace and wit by the London-based Filipino artist David Medalla in his 1977 event *Eskimo Carver*. The pertinence of this work has become clearer and clearer as time has gone by. It consisted of a display of the artist's drawings and transcriptions of Eskimo poetry, a performance, *Alaska Pipeline*, which was about the superpower incursion into the Arctic as mediated by English tabloid newspapers, and a 'participation-production' piece. Using as a model the traditional Eskimo practice of making poems – which is democratic and participatory; everyone composes poems or songs but it is nevertheless considered very hard to produce a good new one – David Medalla invited people to make knives and drums from a pile of waste and scrap collected in the neighbourhood.

The knives were titled and placed on the walls in a playful parody of ethnographic museums. Everyone, including the artist, was astonished by the variety of people's contributions. Not only did these often seem to have more vitality than assemblages sold for huge sums in West End galleries, but the proposition was potentially infinite. There was no end to people coming in and making knives, promising the *inundation* of any museum hosting this work of art. In fact the metaphor of creativity proposed in this piece challenged our museum culture in two of its guises simultaneously: showing up on the one hand the bourgeois notion of the isolated genius and the sanctification of art objects in 'museums of modern art', and on the other the 'objective representation' of other cultures made in ethnographic museums! One of the ironies of ethnographic museums is that they usually display the materials and ceremonies of communal and participatory cultures which we consume privately, almost as voyeurs. Medalla's work, by its particular use of parti-

cipation, both pointed up and temporally overcame this schizophrenia.

In what context does one place these recent works, which contain a built-in criticism of the 'myth of primitivism'? Can they in turn be appropriated to reorient *western* modernism and revitalize its institutions, as has clearly happened with artists' innovations in the past? This is a very hard question. Logically, the answer must be 'yes', if there is no change in the relations of power. Artists give signs. Art has been described as a 'locus where futures not otherwise possible can begin to shape themselves'.[25] Clearly the social nature of this 'locus' is dependent on factors beyond the control of artists. My intention has been to challenge Eurocentrism in the myth of primitivism but not to condemn the process of 'looking back' or of cultural borrowing. As we saw in relation to examples like the Inuit carvings (p. 122), to deny the appropriation by indigenous peoples of forms from the west has itself been an integral part of the western projection of primitivism. Appropriation, in relation to the evolution of art forms, is surely a universal process, a dialectic of encounters too numerous and complex to describe. It is almost by its very nature unofficial and impure, open to chance encounters and creative misunderstandings – a paradigm of vitality! Appropriation becomes a political and ethical issue because of its connections with the concrete, contemporary realities of power.

I wanted to challenge some of the invisibilities and silences imposed by this pattern of power – by showing images by former subject peoples as a form of resistance to colonialism, neo-colonialism, and the western projection of primitivism; and by showing work by twentieth-century artists which is both cognizant of the socio-political reality of 'underdevelopment' and a contribution to world culture. The fusion in these artists' work between modernity and certain indigenous forms or experiences keys in precisely with a very widespread discontent with the norms and values of the dominant culture. Their experimental forms show, in a great variety, artists' practice as a form of cultural activism: this surely needs to become a genuinely international movement since the dominant culture itself is increasingly expressed in a world-wide division of labour controlled by the global powers.

NOTES

1 Pier Paolo Pasolini (1983) *Lutheran Letters*, trans. Stuart Hood, Manchester: Carcanet New Press, p. 11.
2 Robert Goldwater (1967[1938]) *Primitivism in Modern Art*, revised edn, New York: Random House, Vintage Books.

3 Quoted by James Clifford in (1981) 'On ethnographic surrealism', *Comparative Studies in Society and History* 23, 4:561.

4 Edward W. Said (1978) *Orientalism*, London: Routledge & Kegan Paul, p. 142.

5 Julia Blackburn (1979) *The White Men*, London: Orbis, p. 143.

6 Eduardo Mondlane (1969) *The Struggle for Mozambique*, Harmondsworth: Penguin, p. 104.

7 Bernard Dadié (1971) *Climbié*, trans. Karen C. Chapman, London: Heinemann, p. 24.

8 Blackburn, op. cit., p. 24.

9 See reference 5.

10 Quoted in T. C. McLuhan (ed.) (1973) *Touch the Earth*, London: Abacus, p. 124.

11 From a statement by the Amazulu, South Africa, quoted in Blackburn, op. cit., p. 109.

12 For a fuller discussion of Shaba painting see my book (1986) *Through Our Own Eyes: Popular Art and Modern History*, London/Philadelphia, Pa: GMP/Heretic/New Society Publishers. I drew on the pioneering study by Ilona Szombati-Fabian and Johannes Fabian (1976) 'Art, history and society: popular painting in Shaba, Zaire', *Studies in the Anthropology of Visual Communication* 3, 1:11.

13 Kenneth Clark (1982 [1969]) *Civilization, A Personal View*, Harmondsworth: Pelican, p. 18.

14 Max E. Stanton, 'The Polynesian cultural centre; a multi-ethnic model of seven Pacific cultures', in Valene L. Smith (ed.) (1978) *Hosts and Guests: The Anthropology of Tourism*, Oxford: Basil Blackwell, p. 196.

15 ibid.

16 Tom Hill, 'Indian art in Canada: an historical perspective', in Elizabeth McLuhan and Tom Hill (1984) *Norval Morrisseau and the Emergence of the Image Makers*, Toronto: Methuen, p. 19.

17 Margaret Holm, in discussion of her paper 'Moulding the image of the American Indian: a history of ethnology exhibits at world fairs', given at the symposium 'Limits of Objectivity in the Representation of Other Cultures', British Museum, February 1986. Quoted with the author's kind permission.

18 *Last Issue*, Alberta, Autumn 1987.

19 Kasimir Malevich (Fall 1985) 'Autobiography', *October* 34:24, 25.

20 Quoted in (1968) *Vladimir Tatlin*, Stockholm: Moderna Museet, p. 78.

21 José Carlos Mariátegui (1928) *Seven Essays Interpreting Peruvian Reality*, Lima: Amauta, p. 274.

22 As regards her 'journeys', Kahlo was already a mature artist when she travelled to Paris and the USA. Her letters reveal a remarkable lack of awe towards the great art centres and their avant-garde stars (or 'big *cacas*' as she called them).

23 See Rasheed Araeen (1984) *Making Myself Visible*, London: Kala Press.

24 Letter to the author, 1974.

25 By Susan Hiller. Interview in (November/December 1981) *Fuse*, Toronto.

The resurgence of the night-mind: primitivist revivals in recent art

LYNNE COOKE

In these days it is important for an artist to grasp that the logical exploratory voyage of reason is the finest process of the mind. Every other activity is a form of regression . . . thus the much vaunted 'night-mind'; the subconscious world of myth and nostalgia, the child, imagination and instinctual drives, though richer, stronger and more powerful than the world of reason . . . nevertheless owes its strength to our falling back on all that is primitive and infantile; it is an act of cowardice to the God in Man. (Cyril Connolly, **The Unquiet Grave**, 1944)

As Dore Ashton has argued, European fascination with tribal cultures is generally agreed to date from Montaigne who 'softened the ground' for thinkers in the later eighteenth century through his essay on cannibalism, written some two hundred years earlier. Twentieth-century manifestations are therefore but the most recent chapter in a continuous history, not a unique event. At the same time, by quoting the French philosopher's assertion that 'each man calls barbarism whatever is not his own practice; for indeed, it seems that we have no other test of truth and reason than the example and pattern of the opinions and customs of the country we live in', she acknowledges that difference is inherent in this concept: irrespective of whether it is viewed positively or negatively the primitive is always a manifestation of the 'other'.[1] The study of 'primitivism' in post-war art has shifted ground from the course it took in previous eras: discussions of indebtedness, expressed as morphological similarities, together with questions of formal inventiveness and expressiveness, have given way to a study of its intellectual basis, for, recently, artists have increasingly come to interest themselves in the belief systems of non-western and prehistoric societies as much as in the material artefacts produced by those cultures. At

the same time anthropological theory has increasingly informed their approach to such objects and ideas. Other factors, too, have also contributed to this changing dynamic. The surrealists were not only the first group of western artists to integrate their knowledge of ethnographical material with their response to tribal artefacts, but in their choice of material objects from the Pacific and the Americas they drew on sources which had not previously been appropriated by cubist or German expressionist artists. Conversely, instead of unearthing even more remote or arcane examples as a stimulus, several contemporary artists have reversed the process, identifying the barbaric in certain debased local modes and finding great sophistication in tribal objects and concepts.

The tendency prevalent in the immediate post-war years was to synthesize responses to tribal and ancient western artefacts on the grounds that they were similar manifestations by mankind when in a state of extreme unfettered emotional *Angst*. Although fallacious, these beliefs gained widespread currency. The abstract expressionist position in the mid-1940s is epitomized in the following statements by Adolph Gottlieb: 'While modern art got its first impetus through discovering the forms of primitive art, we feel that its true significance lies not merely in formal arrangement, but in the spiritual meaning underlying all ,archaic works.'[2] 'If we profess kinship to the art of primitive man, it is because the feelings that they expressed have a particular pertinence today. In times of violence, personal predilections for niceties of colour and form seem irrelevant. All primitive expression reveals the constant awareness of powerful forces, the immediate presence of terror and fear, a recognition of the terror of the animal world as well as the eternal insecurities of life. That these feelings are being experienced by many people throughout the world today is an unfortunate fact and to us an art that glosses over or evades these feelings is superficial and meaningless.'[3] For many of the Cobra artists in Europe who melded the ancient, the folkloric, and the childlike in a parallel 'primitivism', man was once again considered to be at the mercy of the irrational, and a prey to anxiety and to primal fears.

By contrast, during the 1960s the preoccupation with the primitive as the seat of the 'night-mind' gave way to a reverse interpretation, one which celebrated the cohesion and unity felt to be endemic to such societies. At the same time the focus shifted from the primitive interpreted in terms of the recent past to the distant past. In an essay written in the 1950s André Breton, a former enthusiast for non-western artefacts, argued that the unbridgeable gulf separating modern from primitive man had finally resulted in a loss of interest in and engagement with tribal artefacts. In their places autochthonous prehistoric

western cultures might fulfil modern man's need to counter his
rootlessness:

> The modern spirit [made] . . . a complete break with the past
> and was inevitably followed by a prolonged spiritual drift in
> search of new home ports. As we know, the reaction against
> Greek aesthetics and Mediterranean modes of thought led
> this spirit of enquiry very far indeed, in particular in its
> search for – and discovery of – support and lasting resources
> in the so-called primitive arts (of Black Africa and the South
> Seas) and in those of the Pre-Columbian civilizations. Unfor-
> tunately, ethnography was not able to take sufficiently great
> strides to reduce, despite our impatience, the distance which
> separates us from ancient Maya or contemporary Aboriginal
> culture of Australia, because we remain largely ignorant of
> their aspirations and have only a very partial knowledge of
> their customs. The inspiration we were able to draw from
> their art remained ultimately ineffective because of a lack of
> basic organic contact, leaving an impression of rootlessness.[4]

This statement was written at a moment when Breton was
enthusiastically studying Gallic coins, a field he had formerly
neglected: 'they suddenly light up', he noted, 'divulge the heart
of their enigma and simultaneously put us in possession of the
telluric key which we had lacked. What makes it such a
marvellous key is, first, that it deciphers an ancestral message
the meaning of which had hitherto eluded us.'[5] The vital terms
here are 'telluric' and 'ancestral', for it was in this spirit of a
return to shared ancestral roots, to a cohesive totality and to a
more organic contact with nature that the next generation
elaborated its attitude to primitivism.[6] Where Breton posited an
unbridgeable gulf to prehistoric man, most artists in the 1960s
experienced a feeling of unity and affinity. Crucial to the chang-
ing climate were certain factors, amongst the most important of
which were new discoveries and interpretations concerning neo-
lithic cultures, and the impact of the writings and theories of
Claude Lévi-Strauss. The post-war years have witnessed a great
expansion in our knowledge of prehistoric eras, both through
fresh discoveries and the subsequent publication of much
palaeolithic painting, and through novel interpretations of
neolithic monuments.

Whether directly or indirectly, the theories of Wilhelm
Worringer, as set forth in his book *Abstraction and Empathy*,
first published in 1908, underlay the responses of both abstract
expressionist and Cobra artists to the primitive. At the mercy of
irrational fears and anxiety, primitive man, according to the
German writer, created an art that in its abstraction reflected
this psychological state, whereas Renaissance man, confident of

his central place in the world and his control over nature, expressed himself in mimetic styles. Such ideas were not only discredited but virtually reversed during the 1960s as Lévi-Strauss's theories gained widespread currency. His insistence on the logical structure of primitive thought, different from yet not inferior to western rationality and science, his refusal to see western civilization as privileged and unique, his preference for societies in which 'there was a certain balance between man and nature, the diverse and multiple forms of life', together with his apparent rejection of history and humanism contributed significantly to the changing climate of ideas.[7]

The sophistication that Lévi-Strauss emphasized in these non-logical systems of thought was, obliquely, bolstered by the new interpretations advanced to explain such neolithic sites and monuments as Stonehenge.[8] In particular, the theories which Alexander Thom published in 1967 discerned in these sites evidence of astronomical calculations and functions which revealed a degree of understanding and accuracy in prehistoric man's charting of the cosmos hitherto unrecognized. Such theories contributed considerably to the growing view of prehistoric societies as marked by a cohesive totality in beliefs, devoid of competing cosmologies, alienation, and fragmentation.

The fascination with archaic and prehistoric societies in the 1960s stemmed, as formerly, from a disaffection with modern urban society. As Lucy Lippard has argued: 'The simplest explanation for contemporary artists' current attraction to ancient images, artefacts and sites is nostalgia – not only for those periods we now imagine offer a social life simpler and more meaningful than our own, but also for any time when what people made (art) had a secure place in their daily lives.'[9] This idealizing of societies (often more fictional than actual) in which communal values united the inhabitants, in which there was no body/mind split, and in which a harmonious organic oneness with the natural world pertained, resulted in work that often was nostalgic, escapist, and Utopian. In the search to reappropriate such values for their own work artists placed great store on elementary sign languages and archetypal imagery, such as concentric circles, spirals, meanders, zig-zag and labyrinthine patterns which, it was claimed, are still meaningful today even if their sources and symbolic content cannot be actually elucidated. Lippard typifies this position when she asserts: 'Certain images, rooted then uprooted, can still carry seeds of meaning as effectively as the most detailed realism, even in our individualistic society, estranged as it is from nature.'[10]

Many of the works produced under the impact of such ideas shunned the conventional genres of painting and sculpture in favour of new modes which were felt to be both more immediate

and direct, and therefore closer to their prototypes, and to lie outside the constraints of the gallery system with its commodification of the art-product.[11] Yet these ineffable archetypes, whose communicability is so vague and so diffusely open-ended, too often proved merely the occasion for romantic nostalgia, a longing for a past that was mythic only in the sense of being legendary, rather than actual. Nostalgia and sentimentalism of this kind vitiated much of the primitivizing land- and site-based art of the later 1960s and 1970s. A notable exception was Robert Smithson who, unlike many 'earth-artists', eschewed escapism in lost eras by forging a syncretic, contradictory, and shifting vision that has as its central tenet Nabokov's observation (which Smithson quoted approvingly), 'The future is but the past in reverse.' In his attempt to fuse science fiction with prehistory, geology and crystallography with topology and ecology, and nature with technology, the artificiality of the containing myths was openly espoused.[12] His irreverent, quizzical yet deeply serious theories were intended to be as comprehensive and gargantuan as Borges's and, commensurately, they were expressed in an elliptical fabulist mode:

> The deeper an artist sinks into the time stream the more it becomes oblivion; because of this he must remain close to the temporal surfaces. Many would like to forget time altogether, because it conceals the 'death principle'. . . . Floating in this temporal river are the remnants of art history, yet the 'present' cannot support the cultures of Europe, or even the archaic or primitive civilizations; it must instead explore the pre- and post-historic mind; it must go into places where remote futures meet remote pasts.[13]

This desire to fuse pre-and post-historic minds echoes the kind of conjunctions between magic and mathematics, astronomy and cosmology that astroarchaeology was exploring in the late 1960s. In different ways these conjunctions also fed the growing interest in a type of performance art which explored the darker side of primitivism: what Thomas McEvilley, who has surveyed this terrain impressively, calls the primitive with primitivism.[14] In this, the 'hard' version of primitivism, the social practices rather than the material artefacts of tribal and prehistoric societies – rite, ritual, and shamanic ceremony – became preeminent. Albeit for reasons that had little to do with a desire for novelty, the forms and modes of primitivism burgeoning in these two decades were distinct from, and drew on, sources that had largely remained untapped by earlier manifestations of primitivizing art this century.

None the less, by the beginning of the 1970s, repetition, sentimentality, and slackness had overtaken much of the art that

drew on these sources. Just as a kind of exhaustion was becoming apparent, it was also increasingly evident that the media and communication explosion had so absorbed and made familiar the material cultures of all eras and places that the possibility of any position 'outside' western culture had become completely eroded: what had taken its place was 'a plurality of cultures', as Paul Ricoeur has argued:

> When we discover that there are several cultures instead of just one and consequently at the time when we acknowledge the end of a sort of cultural monopoly, be it illusory or real, we are threatened with the destruction of our own discovery. Suddenly it becomes possible that there are just others, that we ourselves are an 'other' among others. All meaning and every goal having disappeared, it becomes possible to wander through civilisations as if through vestiges and ruins. The whole of mankind becomes an imaginary museum.[15]

The result is that these numerous and diverse cultures become, effectively, part of our daily visual fodder. Direct contact with tribal objects has not only been mediated and conditioned by Sunday supplements, television documentaries and advertising, it has been almost superseded by such intermediaries. Such images consequently have become as much a part of our culture's visual lexicon as virtually any other type of mass media imagery. That they fully belong to its sprawling image bank is vividly demonstrated in David Salle's *Goodbye D*, with its overlay of disconnected unrelated motifs gleaned from various visual vocabularies, both high art and kitsch. With the possibilities for fresh contact rendered remote by this barrier of second-hand mediation, and with the growing interest in anthropology, ethnology, and archaeology, the opportunities for a deconstructed or critically engaged primitivism have significantly increased.

In the 1980s primitivism in the visual arts seems to have maintained those two basic types, established earlier in the century, though the terms in which they are realized have been substantially transformed. On the one hand, the 'soft' variant has continued to focus on the *visual appearance* of non-western artefacts, at its best acknowledging the way that such imagery, in being incorporated into contemporary society, has thereby become hackneyed and banal. This exploration has generally been carried out within the conventional genres of painting and sculpture, their very conventionality at times playing an important part.[16] On the other hand, the 'hard' version of primitivism has adopted a very different guise in order to render the transgressive and the primordial, rather than their simulacra. As Robert Goldwater argued in 1965 in a new preface to his

pioneering study of the subject, *Primitivism in Modern Art*:

> The primitivist impulse in modern art is deep and wide-
> spread, and contact with the 'ethnological arts' only furnishes
> one of the occasions for its expression.[17]

Its domain has currently become the vernacular rather than the
exotic, the 'civilized' not the barbaric, and the indigenous not
the foreign.

Both the resurgence of interest in painting as such and the
concurrent tendency to ransack the art of the past to enrich or
revitalize its visual vocabulary have fostered the early 1980s rash
of primitivist works, a rash which reached epidemic level as a
result of the recent fashion for expressionism as a style and an
aesthetic. But recourse to primitivist imagery can no longer be
an innocent act, its character as a social construct, as a mani-
festation of the 'other' must be taken into account, and the
ramifications of the appropriation of such imagery – its conse-
quent ubiquity and even banality – examined, or at least
acknowledged.

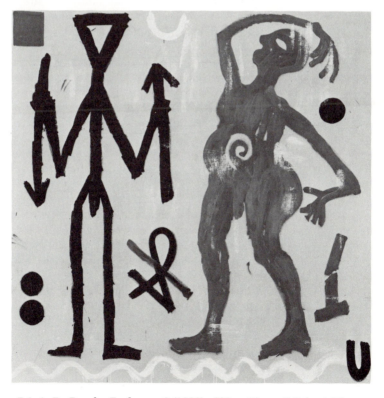

7.1 A. R. Penck, *Exchange I* (1982), 280 × 28 cm (Michael Werner
Gallery, Cologne).

In ignoring or denying such transformations in the character and tenor of primitivism, A.R. Penck produces work which is faux-naif in expression and specious in content. Hieroglyphs, signs, and ideographs are spread evenly across the surface of paintings like *East* and *West* in a cursive, seemingly spontaneous manner that betrays a nostalgia for the innocence of an expressionist gesture. Empty ciphers in themselves, these motifs fail to cohere in a manner that would communicate above the most basic level, in the way that traffic and airport signs do, for example. Contrary to Penck's aims, neither the antiquity nor the ubiquity of images like those culled from cave paintings in themselves guarantee anything beyond a recognition of their original sources. Sentimentalism and pattern-making, albeit shrouded in an atmosphere of worthy ideals of a quasi-political tenor, as with his untitled painting devoted to the theme of the British miners' strike, do not produce palimpsests which invite decoding. Neither grappling with the complexities and specifics arising from the incorporation of such imagery into our visual vocabulary, nor addressing the socio-political theme in terms appropriate to it, they unfortunately trivialize both subject and style by leaving them at the level of vapid platitudes.

Rather than exploring those conditions which reduce this material to the level of cliché, too many painters merely exploit the styles and imagery conventionally associated with primitivist expression in an uncritical or cynical fashion. The abrasiveness and estrangement that Rainer Fetting, for example, appears to seek by means of such paroditic paraphrases of German expressionist and primivitist painting as found in *Die Häscher* ('The Harriers') (1982: collection of the artist) are no longer viable tactics against conventional thought and values as they were for artists like Kirchner; they are conventional thought itself. The promiscuous yet calculated debauchery of styles and subjects which permeates Fetting's art never rises above a regressive self-indulgence, a chic collusion with those very forces and values he seemingly mocks.

By contrast it is only by openly acknowledging the banality of such imagery and modes of expression that Baselitz has been able to incorporate them into his art in such a way that his assertion that the subjects of his paintings and sculptures are merely motifs by means of which he engages more firmly with issues of art-making becomes at least plausible if not fully satisfying. From the moment in 1968 when he first inverted the motifs in his paintings, Baselitz has been engaged with questions relating to genre, to categories and conventions inherent in various types or classes of subject-matter.[18] The traditional genres – still life, landscape, portrait, the figure, etc. – have largely broken down in the twentieth century and in their place certain other classes

of subject have evolved, including the primitivist image, the art-historical quote, the mass-media emblem, and so forth. From a utilization of the former, Baselitz has turned recently to the latter for subjects. Yet by inverting the image he lifts it from the realm of the particular to the generic: its position within a class or category, not its individuality, thereby becomes the focus of attention. It reverts from subject to motif. By the same token, he reduces the referentiality of the motif and so renders associations irrelevant. The business of responding to the pictorial issues can proceed unhampered, or almost. For referentiality is never completely expunged: the procedure is not self-enclosed. The recognition that the image as sign lacks a referent, or that the sign has no inherent relationship with the signified, does not eliminate the question of referentiality *per se*. It only leaves it in a fractured or suspended state. Baselitz not only questions the capacity of the image to signify but simultaneously disrupts its expressive function. The emotions that should normally attend it become diffuse or otiose: once more the only recourse is to pictorial concerns. By means of both the overt artifice and the disjuncture between image and process which lie at the heart of his painting, Baselitz is able to acknowledge the conventions that subtend picture-making whilst avoiding being constrained by an art that is reductivist and analytical in character. If the recognition that the romantic underpinnings of expressionist strategies are now defunct owes much to the endeavours of Gerhard Richter, it is Baselitz who has been seminal in decoding certain of the conventions which pertain to the image as subject.

In his sculpture his assertion that the souvenirs and trophies of other cultures function only as art, that they discard their former roles when displayed in a western art or anthropological museum, is central to his approach. The religious, magical, and totemic function of idols, gods, and other sacred beings is rendered null and void, he maintains, irrespective of whether they are the products of our forefathers in classical antiquity or of our relatives in other societies.[19] For Baselitz, the elongated form and roughly hewn surfaces of his sculptures betray their origin in single tree-trunks, which he has rapidly hacked with saws and adzes, leaving the traces of the tools apparent on the surface. To Baselitz, this crude handling, resulting in only a rudimentary indication of facial features which he sometimes further elaborates in paint, represents a spontaneous raw mode of working far removed from that of the tribal craftsman whom he regards as a highly gifted and sophisticated artist.

What is primitivist in his sculptures stems from a method of approach which is in fact more akin to a rough whittling in a vernacular idiom than to the skills employed on tribal artefacts: any affinities that occur on a formal level with non-western

carvings are no closer nor more meaningful than the parallels that might be drawn with Romanesque jamb figures. In either case it derives from the nature of the given material; any additional connection is specious. Baselitz thus construes primitivism in terms of the techniques displayed in three-dimensional image-making. It is to him an inherently sculptural question, not one relating to subject or extra-aesthetic function.

If Fetting's savages or Hödicke's *Goddess Kali* reveal no more than jejune fantasizing by the artist, Malcolm Morley locates these figures in the realm in which they now have most resonance: the nursery. Whether inspired by the droll if kitsch splendour of those souvenirs which provide the prototypes for his gaudy inhabitants of the rococo desert of *Arizonac*, or by the opulent charm of the frontier spirit which is transformed into *Christmas Tree – The Lonely Ranger Lost in the Jungle of Erotic Desires*, he elicits a sense of delight that is rooted in the childish, not the childlike. Where once the savage and the child were linked on account of their purported innocence and simplicity, neither can be so conceived now. Child psychology has made the childish far more pertinent and significant than the

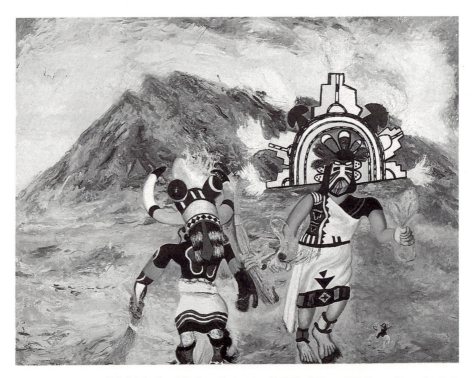

7.2 Malcolm Morley, *Arizonac* (1981), 203 × 266.5 cm (Saatchi Collection, London).

childlike, which was once the recipient of so much sophisticated acclaim and connoisseurship. If the childish has its ludicrous as well as its charming facets, so too do adult fantasies. *Cradle of Civilisation with American Woman* superimposes a Trojan horse and a fractured archaic household god on to the kind of idyllic beach scene that bedecks travel brochures and posters. Suspended on the picture surface, wrenched out of the space in which the remainder of the world resides, these images become no more than figments of the imagination, the exotic spice that adds 'culture' to what might otherwise be for the holiday-maker a purely hedonistic experience. The deliberative nature of Morley's technique, its detachment, and the constant disruption of the seamlessness of his visions by a humour that ranges from the wry to the caustic and the whimsical invest his version of primitivism with great richness. He exposes the trite, sham, and casual ethos of much of this vogue by embracing and utilizing it in precisely those terms, as souvenirs or frivolous playthings.

Kirk Varnedoe has made the suggestion that the present counterpart of the early twentieth-century avatars of primitivism is the graffiti artist.[20] If graffiti ever played a disruptive anarchic role within the fine arts it was in the work of Dubuffet in the 1940s. By contrast, Haring's decorative doodles, to which that writer appears to be alluding, are the antics of a fully socialized artist, one who moves comfortably from the surfaces of his canvases to those of the gallery walls to those of imitation Greek urns and T-shirts. There is nothing abrasive, disquieting, or transgressive in these squiggles spewing forth over every available surface. Ironically, it is Jean-Michel Basquiat, no longer a graffiti artist in the terms in which this label is normally employed, who is perhaps the real heir to Dubuffet's sophisticated assimilations. Basquiat's paintings frequently contain primitivist imagery in addition to signs, words, numbers, and other marks which may or may not be coded messages. This is a knowing subtle art, one that owes much in its use of materials, its calligraphy, and its composing, to artists like Rauchenberg and Twombly. There is nothing naive in this juxtaposition of images garnered from Christian icons, Old Master sketchbooks, anatomical studies, ethnographic museums, and the artist's imagination. Yet through the introduction of certain phrases, diagrams, or emblems, which become cryptic messages, Basquiat makes evident the muteness of his more familiar imagery. Just as his access to part of his own heritage has been filtered through his socialization in this culture (of Puerto Rican descent, he was born and raised in Brooklyn, NY), to the point where it may be available to him only in these terms, so in turn our language is rendered strange, inaccessible, and impenetrable when employed in code. The

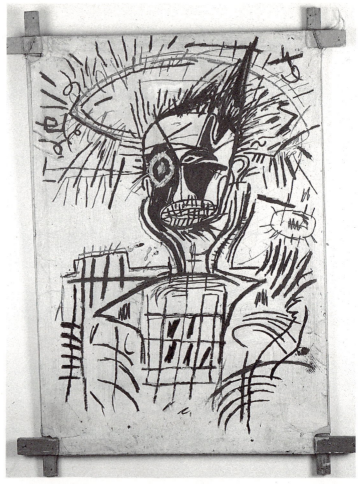

7.3 Jean-Michel Basquiat, Untitled (1982), 48 × 36 in (Vrej Baghoo-
mian, Inc., New York: photograph Mark Sink).

debate as to whose meaning defines the content of the painting,
that is, who constructs and controls its meaning, dissolves into a
set of endlessly ramifying eddies, made more complicated by the
spirit of capriciousness or even facetiousness that permeates
Basquiat's work, and that provokes the suspicion that no cogent
meaning may have been intended by the artist. This may be a
deliberate conundrum. Instead of attempting to revitalize and
reappropriate these images which belonged initially to his
ancestors, and so reclaim them, Basquiat may be making empty
doodles. This tantalizing uncertainty is further heightened by
the fact that the whole panoply of imagery exists within the
framework of conventional or at least very acceptable modes of

picture-making. The impeccable lineage, the elegant handling, the decorous composing together effectively aestheticize his visual vocabulary and so render any earnest or straightforward approach to the question of his subject-matter misplaced and perhaps even spurious.

Albeit in very different ways, the works of these artists are part of that legacy of 'soft' primitivism, as Krauss defined it. For they all respond to the material artefacts of tribal cultures, whether directly or not. But where once this 'soft' version implied a concern with formal experimentation, with subverting normative modes of picture-making, now the images are openly quoted, and at best as in Baselitz, Basquiat, and Morley, in ways that acknowledge their fictive character as constructions of otherness, and their present place within (mass) western culture. In this they distinguish themselves from those more debased forms of 'soft' primitivism which merely exploit populist imagery uncritically and superficially. Tamed and toothless, that results in a codified, unregenerative, and conformist art, the very antithesis of most former constructions. However, for artists who wish to draw on those aspects of the disruptive and transgressive that formerly adhered to or could be construed by means of the primitive, a different approach is required, one that is commensurate with shifting social mores and values. An exemplary and pioneering figure in this redefinition – or, better, reformulation – of the primitive within primitivism is Lucas Samaras, who has been aptly dubbed 'a barbarian Byzantine.'[21] Samaras sites the primitive within a pre-eminently psychological rather than geographical locus, one which pinpoints the shifting space occupied by our notion of the primitive, on the one hand by acknowledging that it is a cultural construct, whose outward appearance changes in accordance with the fluctuating needs of different socio-historical moments, and, on the other hand, by identifying the very real psychological and social needs that it meets. The key to his position, which is realized in a plethora of modes from overtly narcissistic pastels, photographs, and paintings to icons, reliquaries, and other fetishistic objects, lies in the fact that Samaras accords them all fictional, never mythic, status.

As Frank Kermode has argued, if myths are redemptive and consolidating, fictions may be transgressive and disruptive:

> Fictions can denegerate into myths whenever they are not consciously held to be fictive. . . . Myth operates within the diagrams of ritual, which presupposes total and adequate explanations of things as they are and were; it is a sequence of radically unchangeable gestures. Fictions are for finding things out, and they change as the needs of sense-making

change. Myths are the agents of stability, fictions the agents
of change. Myths call for absolute, fictions for conditional
assent. Myths make sense in terms of a lost order of time, *illus
tempus* as Eliade calls it; fictions, if successful, make sense of
the here and now, *hoc tempus*.[22]

Unlike Beuys, for whom the role of the shaman conferred a
mythic stature, for Samaras it is a form of artifice, a means of
decentring, or dissolving the self. He does not attempt to devise a
redemptive art as did Beuys, but an aberrant, transgressive,
excessive one. Various devices for undermining the self, from
mirroring (multiplying the self to infinity) to mimicry, repeti-
tion and duplication, to transvestitism and X-rays are employed
in an effort to transform the individual into the type, or to dis-
solve identity – and thus uniqueness – into a multiple persona,
a genus, skeleton, effigy, or icon. Samaras's photographs, for
example, are not a consistent affirmation of the self but a means
to subverting and disrupting identity, their bravado, opulence
and narcissism notwithstanding. Similarly, his boxes (reliq-
uaries), chairs (thrones), and other transformed implements use
the forms, appearance, and rituals associated with fetishes and
other sacred, votive, and cult objects, together with the taboos,
eroticism, violence and ecstatic or exorcistic moods that accom-
pany them in a novel synthesis of the tribal, Byzantine, kitsch,
and folkloric: it is at once preposterous, disturbing, and highly
effective. Bizarre mockeries of their authentic prototypes,
blasphemous, irreverent, scatological, grotesque, frivolous, or
frightening, they transcend any neat aesthetic boundaries. In
the same way that superstitions and irrational, unfounded fears
are often impervious to rational explication, so these objects by
overtly acknowledging their fictional, artificial character go
beyond it, and thereby regain something of the aura that once
attended the originals, an aura which has been dissipated or
divorced by contemporary western culture. Samaras employs
his chameleon-like multiple persona with disarming sophistry as
a tool to act out and appease those fears, impulses, and psycho-
logical needs that primitivism, along with science fiction and the
childlike, were constructed to give expression to, and to contain.
In his wish to create 'an art that would be of wonder and horror',
that violates as it fascinates, Samaras sports with the received
notion of primitivism. His disguises, feints, and fetishes form
part of a strategy aimed at revitalizing the underlying ideas,
without, however, attempting to integrate them into any
expanded rational or coherent overview.

 If primitivism lies at the core of Samaras's art, it is but one
strand in the more catholic vision of several other artists, notably
Susan Hiller, Nancy Spero, and Lee Jaffe, each of whom

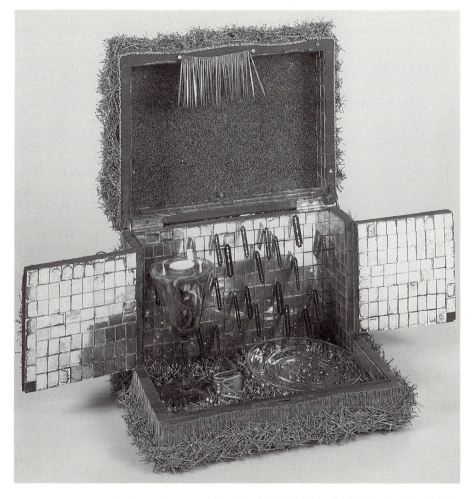

7.4 Lucas Samaras, *Box No. 4* (1963) (Saatchi Collection, London).

employs it to very different ends. In Hiller's case it takes on a
new guise in works like *Midnight, Baker Street*, a triptych of
colour photographs in which the artist is seen full face, in
profile, and in three-quarter view. These three positions do not,
however, render up the sitter, as do Van Dyck's similar trio of
images of Cardinal Richelieu, which were intended to provide
Bernini with all the visual information necessary to sculpt a
bust. The surface of Hiller's photograph is coated with a dense,
illegible calligraphy. Perhaps merely graffiti, perhaps a secret
script, it at once defaces the image and embroiders it – like tat-
tooing. It seems to allude to the manner in which verbal dis-
course structures all experience, and in particular to the manner

in which like a veil it intervenes to condition perception, but equally it seems to be a mode of self-mutilation, evoking a kind of sympathetic magic, whereby damage to the surrogate for the individual brings harm to that person. It raises the question of the degree to which an extreme rewriting is necessary for the female, and the female artist especially, in order to wrest herself from fixed and conditioned modes of definition. Hiller has commented about this work:

> it is an attempt to show the inside on the outside. . . . My adoption of 'primitivist' devices is a deliberate one, with reference to the (female) self as cultural site of mystery, otherness, etc. As an artist I flow between this constructed self and an interior/anterior self. Any artist of female gender in our society who seeks 'authenticity' or even 'significance' as an artist must deal with this – representation is *not* value-free.[23]

This unpacking of the positive and negative associations that cohere around the notion of primitivism is also found in the work of Nancy Spero. Spero manipulates this concept in diverse ways, prising apart its contradictions in a series of strategies devised to re-present and rewrite the cultural archetype of woman into its antithesis. The generic female is evoked in her works through a heterogeneous array of sources, ranging from prehistoric to contemporary signs and ciphers. In certain works these visual images are interlaced with accounts of the political torture to which women have been subjected in recent times, torture which often incorporates sexual sadism. Present-day barbarity jars with the euphoric images of unfettered freedom in the primitivizing signs which flow freely across the unbounded undefined space of strips of fragile paper glued together to form scrolls. Libidinous spontaneity, implying both an unrestrained sexual expression and uninhibited brutality and aggression, is central to current colloquial, unanalysed notions of primitivism. Despite the popularizing of recent anthropological theories, and of the work of Lévi-Strauss especially, such notions have still not lost their hold on popular opinion: Spero seeks to expose these stereotypes for they are the most constraining. Physical abandonment is the hallmark of Spero's epigones of unlicensed passion which assume a collective wholeness on account of the multiplicity and heterogeneity of female hieroglyphs, as well as the techniques of layering and overlapping that she employs. As an ensemble they comprise a vision which is the antithesis of the sparagmos rituals intrinsic not only to Dionysiac myths but to many beliefs which posit a destructive component as a necessary element in full sexual expression. Spero thus counters Bataille's belief:

we cannot reduce sexual desire to that (which) is agreeable and beneficient. There is in it an element of disorder and excess which goes as far as to endanger the life of whoever indulges in it. . . .

Sexual disorder discomposes the coherent forms which establish us, for ourselves and for others, as defined beings – it moves them into an infinity which is death.

In attempting to reconstitute notions of sexuality and gender, Spero inevitably takes on the acculturated notion of primitivism.

A black humour informs Lee Jaffe's malefic primitivism. In *Silver Skins*, for example, a number of pelts have been decoratively arranged across a surface coated in silver leaf. The initial impression of a kind of natural history display is vitiated by the

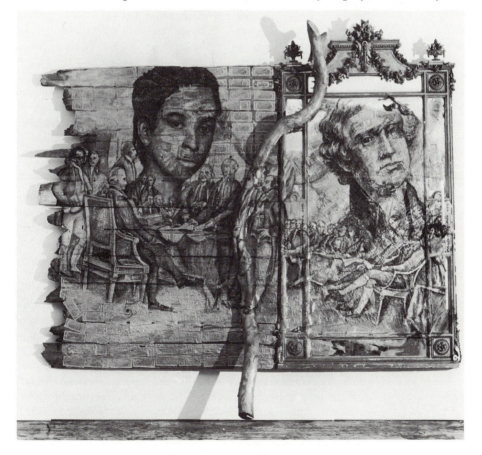

7.5 Lee Jaffe, *The Life and Times of Sally Hemmings, Part II*, 9'3" × 10' (Metropolitan Museum: photograph Jan Abbott).

realization that these specimens lack skeletons and innards. Their role is purely aesthetic, and what this in fact entails rapidly becomes disturbingly clear. Subjugated, in that it provides luxury fashion goods, the feral has here been further debased to become the stuff of functionless luxury. If, in other words, that gesture which transforms raw material into art is one involving gratuitous wastage, how often will the results rise above an unabashed vulgarity and ostentation? If *Silver Skins* alludes with corrosive irony to the normative function assigned to contemporary art, *Venus Flytrap* pursues further certain of the unpalatable contradictions inherent in this art. Four stoles, three mink and a muskrat, have been stacked to form a bizarre emblem. Each is surrounded by a halo made from fly-paper on which hundreds of these insects have immolated themselves: yet more are embedded beneath the gold leaf which elegantly coats the remaining surface. The dichotomy between the extravagantly lavish items, with their sensual seductive textures, and the repellent and foul, gives the work an extraordinary tension. The appalling yet irresistible fascination it engenders recalls not only its namesake, but the hypnotic power of the transgressive, even the sacrilegious, for these stoles may be the modern counterpart to the copes and mantles, the sacred robes of priests and shamans of other ages and societies.

Jaffe's work pivots on the theme of gratuitous excess, an excess which renders the destructive and savage inseparable from the desired and valued/valuable. His method often involves a brutal juxtaposition or stark montaging of the crude and the refined, the uncultivated and the so-called civilized, nature and culture. Rather than attempting to meld these antimonies into an encompassing unity he leaves open and insistent the fissures and dislocations. In *The Life and Times of Sally Hemmings, Part II* a monochromatic image of Jefferson's black mistress is superimposed on to a ground made of two-dollar bills pasted on to a rough wooden raft. The other half of the work contains an ornate gilded mirror, whose surface is dominated by the presidential head. Sections from Trumbell's painting of the signing of the Declaration of Independence, reproduced on the banknote, have been copied beneath both portraits and the whole suffused with gold leaf, including a sinewy branch which bisects the two parts. Made from the raw material that comprises both the raft and the fake gold of the mirror frame, it sets the tone of incongruous intrusion and unwelcome likeness that links the various components.

Both Hemmings and Jefferson are, in one sense, spectres. But there are crucial differences. She is an errant ghost, not only because her image unlike the others does not appear on the currency, but in contrast with her lover, Jefferson's face, placed

on a reflective surface to the side of which a lighted candle burns, shines wanly through the tarnished glass: not a ghost but an icon. The falsely gilded, the blemished reflections, and the hollow illusions together create a compelling metaphor for the savagery and hypocrisy that normally attend extremes of wealth and power: the phoney splendour of these revered historical events and idealized figures, whose role it has become to embroider and refine the naked power of money, is exposed by means of a method that amounts almost to an act of blasphemous defilement. The contending forces are rendered naked and blatant. Jaffe's works not only belong to that kind of modern art which Bataille so esteemed but are amongst its most compelling contemporary manifestations.

As these heterogeneous examples make evident, primitivism, however manifest in European and American art of the 1980s, can no longer be treated as a simple unproblematic concept, whether construed in psychological terms of otherness or as the material expression of alternative social possibilities. Although purporting to concretize notions of difference, otherness, and

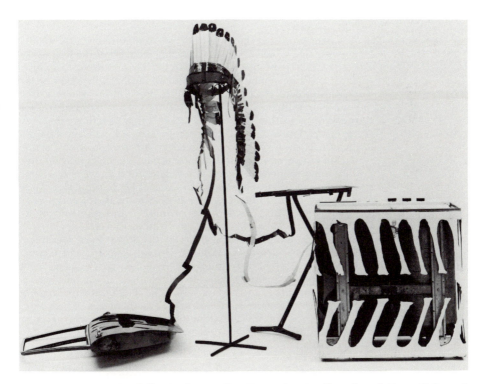

7.6 Bill Woodrow, *Car Door, Ironing-Board and Twin-Tub with North American Head-dress* (1981) (3355, Tate Gallery, London).

alternatives, primitivism is more aptly seen as a case of enantio-
sis. In Bill Woodrow's sculpture *Car Door, Ironing-Board and
Twin-Tub with North American Indian Head-dress* (1981)
(Figure 7.6) the two are connected by an unsevered umbilical
cord, for he juxtaposes the rejects of western consumerism with a
facsimile of a feather head-dress cut from their metal casings. If
the umbilical cord serves metaphorically to intimate that primi-
tivism has always been the offspring of western culture, the
technique, which is akin to making cut-out toys from cereal
packets, indicates that the containing concept has always been a
fabrication, a construct. It is the achievement of the 1980s that
the critical mythification of primitivism is at last being explored
in contemporary art.

NOTES

*This chapter is a
version of an arti-
cle first written in
December 1984
and published as
'Neo-primitivism'
in (March–April
1985) Artscribe 51:
16–24. It includes
material from my
seminar in the
'Primitivism' series
at the Slade School
of Art (University
of London), 1986.*

1 Quoted in Dore Ashton (November 1984) 'On an epoch of paradox:
 "primitivism" at the Museum of Modern Art', *Arts*: 77.
2 Quoted in Kirk Varnedoe (1984) 'Abstract Expressionism' in *'Primi-
 tivism' in 20th Century Art: Affinity of the Tribal and the Modern*,
 Museum of Modern Art, New York: p. 616.
3 Quoted in ibid., p. 619.
4 André Breton (1972) 'The presence of the Gauls' (1955), reprinted
 in *Surrealism and Painting*, New York: Icon edn, p. 333.
5 ibid., p. 334.
6 It is significant that the roots of Beuys's sculpture lie in the 1950s.
 Beuys sought a redemptive art, one that would heal the wounds in
 post-war German society by a revitalization of ancient Germanic
 and pan-European myths wedded to an idealizing Utopian socio-
 political vision. His primitivizing thus drew on prehistoric Euro-
 pean sources, though in his actions from the 1960s onwards, as a
 shaman, he synthesized a more catholic range of influences.
7 In *Tristes Tropiques* (1955), arguably Claude Lévi-Strauss's most
 popular book, he describes the modern American metropolis as a
 kind of jungle, reversing the familiar urban–wilderness dichotomy.
 Two other influential books, *The Savage Mind* and *The Raw and
 the Cooked*, were published in 1962 and 1964 respectively. For a
 discussion of his influence, refer to E. Nelson Hayes and Tanya
 Hayes (eds) (1970) *Claude Lévi-Strauss, The Anthropologist as
 Hero*, Boston, Mass.: Massachusetts Institute of Technology.
8 Among the most influential texts of the 1960s were Alexander
 Thom's (1967) *Megalithic Sites in Britain*, Oxford, and Gerald
 Hawkins's and John B. White's (1965) *Stonehenge Decoded*, New
 York. For a general discussion of changes in archaeological
 thought, refer to Lucy Lippard (1983) *Overlay: Contemporary Art
 and the Art of Prehistory*, New York. For a discussion of the conti-
 nuing yet shifting interpretation of such prehistoric sites refer to
 John Mitchell (1982) *Megalithomania*, Ithaca, NY.
9 Lippard, op. cit., p. 4.
10 ibid., p. 11.
11 The impact of prehistoric sites was not restricted to younger artists
 or to those working in new idioms. Henry Moore, for example,
 published a suite of lithographs in 1974 based on Stonehenge, whilst

Barbara Hepworth's later work, especially *The Family of Man* (1972), makes overt allusions to such precedents.

12 For an excellent discussion of these relationships, refer to Elizabeth C. Childs (October 1981) 'Robert Smithson and film: the spiral jetty reconsidered', *Arts*: 68–81.

13 Quoted in Lippard, op. cit., p. 77.

14 Refer to Thomas McEvilley (Summer 1983) 'Art in the dark', *Artforum*, and (November 1984) 'Doctor, lawyer, Indian chief: "primitivism" in the twentieth century art at the Museum of Modern Art in 1984', *Artforum*, and subsequent correspondence in *Artforum*.

15 'Universal civilisation and national cultures', in (1965) *History and Truth*, trans. Chas. A. Kelbley, Evanston, Ill.: Northwestern University Press, p. 278.

16 Rosalind Krauss distinguishes between 'soft' and 'hard' versions of primitivism, arguing that whereas the former is 'a primitivism gone formal and therefore gutless' (at its worst exemplified by a type of Africanizing stylization), the 'hard' variant employs ethnographic data to transgress the neat boundaries of the art world with its categories based on form: 'it uses the "primitive" in an expanded sense (although with close attention to ethnographical detail) to embed art in a network that, in its philosophical dimension, is violently anti-idealist and anti-humanist.' Central to this strand of the primitivist is the regressive, the atavistic and primeval, as exemplified in the writings of Georges Bataille: refer to 'Giacometti', in *'Primitivism' in 20th Century Art*, op. cit.

17 Robert Goldwater (1967 [1938]) *Primitivism in Modern Art*, revised edition, New York: Random House, Vintage Books, p. xvii.

18 Two statements by Baselitz spell out this position: 'Until 1968, I did all I felt I could do in traditional painting. But since I do not believe in traditional painting, cannot believe in traditional painting also on account of my training, I started in 1969 to use normal, standard motifs and paint them upside down' (Henry Geldzahler (April 1983) 'Georg Baselitz', *Interview*: 83). 'There are two types of painting: the first is concerned with the painting process only, and the second with content, making a statement of meaning. I decided for the first type, concerning painting alone. Since I want to retain the object, or rather, since I didn't want to abandon the objective approach, I had to turn it upside down' (quoted by Amine Haase in (1981) *Gespräche mit Künstlern*, Cologne: pp. 17–18).

19 Refer to 'Four walls and top lighting' (1966), reprinted in (1983) *Georg Baselitz: Paintings 1960–83*, Whitechapel Art Gallery, London: pp. 66–7.

20 Varnedoe, 'Contemporary explorations', in *'Primitivism' in 20th Century Art*, op. cit., p. 682.

21 Peter Schjeldahl's phrase in (1984) 'Lucas Samaras', *Art of Our Time, The Saatchi Collection*, Vol. 11, London: p. 19, echoes Samaras's oft-repeated request, 'Call me the last Byzantine.'

22 Frank Kermode (1970 [1966]) *The Sense of an Ending*, Oxford: Oxford University Press, p. 39.

23 Letter to the author, 19 June 1986.

8 From primitivism to ethnic arts

RASHEED ARAEEN

The subject of my talk is somehow unusual and it is also unusual for an institution like the Slade to open its doors to it and ask someone like me to come here and speak. It is unusual because the issue here is something which has always been considered outside the ethics or limits of art and art education by the bourgeois/liberal establishment. Only a few years ago I was invited here to do a series of art performances. But, when the nature of my work became known to the higher authorities, no other than those who teach humanities here, no other than those who talk about universal human values and are never tired of talking about the freedom of expression we have in this country, the invitation was shelved and it was shelved quietly and without an explanation, as if nothing had happened. After being fed up waiting for months, when I approached the individual who had invited me in the first place (and I believe he was serious in his invitation), I did not even receive an apology. I was not naive enough to be surprised by the action of the authorities, but one expects some kind of courtesy in such matters, particularly from those who claim to have a monopoly on civilized values.

I am therefore very pleased that I have been invited[1] to speak to you; not only to speak to you but to explore the question of racism that underlies primitivism and how this question is relevant to how we perceive the artistic function of non-European peoples and their cultures in our contemporary society today. I also hope that this invitation is not a freak incident but signifies a change taking place inside the art institutions to represent the aspirations of this society, which is no longer an exclusively white society as it was before the Second World War.

The above incident is not an isolated incident. It is the kind of thing that one faces all the time if one is not prepared to conform to the institutional constraints. The ideas of total freedom and freedom for every individual, irrespective of colour, creed, or race, in the western societies is the kind of myth that begins to explode when one enters into the domain of ideology that under-

pins the institutions of these societies. Without necessarily going into an elaborate argument it can be said that the ideas and values that support these institutions are of a hierarchical nature, and this hierarchy is maintained through patriarchy as well as through a world-view that developed during the west's imperial domination of the world over the last few centuries. This domination continues today in the form which is described as neo-colonialism. What is not often recognized is the fact that neo-colonialism now exists within western metropolises with large populations of non-European peoples from the ex-colonies of Asia, Africa, and the Caribbean, the purpose of which is to perpetuate their status of subservience to the dominant white society. The incoming African/Asian cultures have provided an opportunity for the development of a new primitivism that goes under the official title of Ethnic Arts.[2]

I'm not suggesting here that institutions like the Slade are directly responsible for the development of this new situation. On the contrary, these institutions are unaware of what has been happening outside their doors. In fact they often shut their doors on the assumption that what is happening outside has little to do with them. The intellectual complacency and smugness of these institutions have played a large part in not confronting this situation. It is time that they should wake up and face up to the reality of this society if they have any humanistic or educational function to perform.

The Slade is indeed a liberal institution, and I use the word 'liberal' in its generic and positive sense. It is governed and run by a set of rules, not always visible, and a general intellectual ethos which together emphasize its humanistic function and which thus exclude any activity that would cast a shadow on its presumed objectives. I am not being sarcastic now. I am only pointing out the functional boundaries of art and art-educational institutions, which may be questionable in the light of the new reality of this society today, but which nevertheless claim to have a deep concern for the promotion of knowledge, human achievements, enlightenment and welfare, irrespective of colour, creed, or race. Such aims and objectives are indeed laudable and I will not cast a shadow of doubt on their sincerity, neither would I think of suggesting any other function for these institutions.

However, it is also important that we do take note of the fact that the ethics which govern these institutions, and indeed their educational function, were formulated at a time in the nineteenth century when England was at the height of its colonial power, ruling and educating a large proportion of the world as its subject people. Liberal scholarship has thus been part of colonial discourse and even today this remains fundamental to

these institutions, not only in Britain but in the whole western world, as well as in that part of the post-colonial world which is still under western influence or domination. And it seems that we really cannot deal with this subject outside this context.

These institutions in fact embody and represent specific ideas and values, a philosophy that is specific to the (western) dominant culture, as a result of which there exists a view which separates western people from the peoples of the rest of the world. This separation is rationalized by accentuating cultural differences between the west and others by the development of a philosophical discourse that gives western man a historically advanced position, a position that justifies his messianic ambitions in the world. Equipped with the ideas of progress and World-Spirit (Hegel), he performs the task of providing both material and intellectual leadership to the world in its advance towards perfection and ultimate salvation. In his missionary vision to transform the world into his own image, the world becomes other than himself: a pagan or primitive entity that has been trapped in the irrationality of its past history, in its primeval or pre-rational existence. In fact this entity does not even possess consciousness of itself, its own past, present, and future. It is the victim of its own timelessness, a static condition characterized and contained by ethnic, tribal, communal, irrational, unconscious, traditional . . . modes of existence. The victim must therefore be rescued, not necessarily for its own sake, but for the sake of the advancement of humanity.

The 'primitive' can now be put on a pedestal of history (modernism) and *admired* for what is missing in western culture, as long as the 'primitive' does not attempt to become an active subject to define or change the course of (modern) history.

What I am trying to establish here is that primitivism has little to do with the actual conditions of the peoples or cultures it refers to, but it is an idea in western culture by which others are defined in various periods of its recent history. As a projection and representation of non-European peoples and their cultures in western philosophy or discourse, it in turn justifies western colonial expansion and domination. In other words, primitivism is a function of colonial discourse, and it is therefore imperative that we try to look at the nature and complexity of this discourse.

The imperative becomes clear when we realize that the task here is really to explore the relationship between primitivism, racism, and the idea of so-called 'Ethnic Arts' that has been recently introduced in Britain; and it seems to me that the question of racism is central here. This is an extremely difficult task, not because it has not been undertaken before in this context but the attractiveness of being drawn into the rhetoric of anti-racist slogans and denunciation is enormous, given the blessing it is

receiving from some quarters that claim to be radical. The radicalism of these institutions of the left is as questionable as those institutions which appear to keep a distance from politics in this respect.

To deal with the history of the idea of primitivism in western culture, as a function of colonial discourse which goes beyond the point in history when the 'artefacts' of African/Oceanic cultures were appropriated by modernism, would require volumes of books in order to do justice to its enormity and complexity. And yet I find it necessary at least to cast a glance at this history. The attempt to sift through only the relevant material in order to pick those components which are essential to our issue is in itself an enormous task, and it would be foolish on my part to think of doing all this, not only that we are restricted by the format of this presentation, but the expertise required for this purpose is not altogether at my disposal.

I must also take note of the fact that I am on difficult ground here. I am entering into the domain of others, the domain of the specialists: art historians, art critics, anthropologists, psychologists, etc. Not that the specialist knowledge worries me much (it can be useful as well as intimidating), but the reason why specialist knowledge builds barriers around itself to protect its so-called autonomy, is in fact to protect itself from an ideological scrutiny – thus keeping so-called political questions out of this domain; and I find this highly questionable. As Edward Said in his remarkable book *Orientalism* says: 'These are common ways by which contemporary scholarship keeps itself pure' so much so that 'philosophers will conduct their discussion of Locke, Hume, and empiricism without ever taking into account that there is an explicit connection in these classic writers between their "philosophical" doctrines and racial theory, justification of slavery, or arguments for colonial exploitation.'[3]

I have really a task ahead of me for which I am perhaps not well equipped, but that should not prevent me from putting forward my own understanding of the matter. These notes are in fact rough and rudimentary, but they are meant only to draw question marks around some ideas in western culture which are related to our subject and also draw attention to the fact that we cannot continue to ignore these ideas while discussing contemporary reality no matter how unpleasant they might be. It is in fact my aim to establish somehow that these ideas are very much part of the contemporary reality, as it is represented by contemporary liberal institutions or/and scholarship and also as it exists on a more general level of 'collective consciousness' of this society today.

But before we go further I shall declare my own position, both

my shortcomings and self-interest, from the outset. I am a practising artist within the context of modernism, and I shall speak to you *as an artist*. I have chosen verbal language to express myself, not because I enjoy writing or speaking (I would rather spend this time to make a work of art) but because the issue here is related to my own position, and if I do not deal with this issue nobody else will. We do not have any professional writer on art who fully recognizes this issue or understands the complexity of its influences on contemporary consciousness or perception.

I also believe that an artist is not a dumb maker of art objects. S/he has a rational mind, like anybody else, and there is no reason why this mind should not also be put to use in the verbal articulation of ideas.

Having said this, let me tell you briefly why I am here in this country. Not that I am particularly interested in telling you my life story, but the point I am making is relevant in relation to what we are considering. About thirty years ago in Karachi I was introduced to modern art, through the information we used to get in the magazines and books imported from the west, as well as through the activities of contemporary Pakistani artists. I became so fascinated by the 'progressive' aspect of modernism that I decided to devote my life to its pursuit. I decided to abandon the professional career of an engineer and came here to establish myself as an artist. Soon after my arrival I became active in the post-Caro period, and what I did then was the result of and belongs to that historical period. But by the early '70s I began to realize that whatever I did, my status as an artist was not determined by what I did or produced. Somehow I began to feel that the context or history of modernism was not available to me, as I was often reminded by other people of the relationship of my work to my own Islamic tradition. . . . Now I am being told, both by the right and the left, that I belong to the 'Ethnic Minority' community and that my artistic responsibility lies within this categorization. It is my intention to show you later that this categorization is the function of a new primitivism in Britain. In other words, the issue is directly related to my position as an artist in this society. My position is therefore *within* the text, and if this text has any significance it is due to this position.

Trying to deal with the question of primitivism and racism, in its full complexity and objectivity, is therefore for me to be able to jump successfully over all the pitfalls of personal frustrations and anger of the last twenty or so years, and also not to be bogged down by what some of my white friends call my fantasy of seeing racists and imperialists everywhere. I do not wish to deny my paranoia, but I can assure you with all my rational

abilities that I do not see racists and imperialists everywhere. If I did, the prospects for me would be too gruesome. As for the paranoia (or whatever) of my friends or others I cannot do much about it except humbly to advise them that they should at least try to see things beyond my supposed chip on the shoulder. On my part I shall try to be as objective as possible, given the circumstances, and my main attempt here would be to find a common ground for a dialogue, in order to understand the meaning of all this within the context of the contemporary world we *all* share and live in today.

Primitivism in western art did not start with Gauguin, as the Museum of Modern Art (MOMA), New York, would have us believe. What about Delacroix? What about orientalist paintings in nineteenth-century Europe? What about the images of Africans particularly in the work of Hogarth?[4] It is true that with Gauguin there started a historically different relationship between western art and other cultures, a historical watershed that changed the direction of western art away from its ethnocentric Graeco-Roman tradition of classicism since the Renaissance. It is not the purpose of this paper to go into the nature of this specific relationship, in the sense of finding out who did what and why. I am more interested in the status of the cultures called 'primitive' within this relationship, and in turn the status of the peoples implicated in this relationship. Did the admiration and fascination of the modern artist for these cultures, which could be from any part of the non-European world, help improve the status of these cultures in western consciousness? The answer appears to be No, as the MOMA exhibition[5] of 1984–5 showed. This can be explained by reference to the reality of non-European people who live in western metropolises and whose status in society is characterized by both the bigotry of the extreme right and fascination of the white liberal/left with the exotic.

Before we go further, I would like to describe to you my visit to MOMA in New York in 1984, when the famous exhibition *'Primitivism' in 20th Century Art* was on. To tell you the truth I was overwhelmed by what I saw, not only by some extremely beautiful and powerful works of African sculpture that I had not seen before, and perhaps will not see again, but also by the works of some European artists. Picasso's *Les Demoiselles d'Avignon* had a magical presence and it was difficult not to feel that. The texts displayed around were sometimes interesting and informative but at other times also disturbing in the way they mediated between the work of the modern artist and the so-called 'primitive' art. I came out of the museum with a mixed feeling of exhilaration (just seeing all those works together) and

also with some anger. I talked to some people about this later, including some black artists, and the general feeling was lack of interest and cynicism. Some shrugged their shoulders, saying what else would one expect from MOMA, and others denounced the whole thing as another imperialist enterprise, with which I somehow agreed.

Back in London, and going through the texts in the massive glossy catalogue of about 700 pages, the denunciation of the exhibition as an imperialist enterprise (it could not be anything else) became more clear. It is not that there were no informative or interesting texts, but it seems that the purpose underlying all this scholarship was to perpetuate further the idea of primitivism, to remind the so-called 'primitives' how the west admires (and protects and gives values to) their cultures and at the same time tell the modern artist, who could only be the western artist, the importance of this in his[6] continuing historical role as an advancing force.

It is not my aim here to denounce this exhibition as merely an imperialist enterprise or turn my back on it in favour of more contingent social and political issues in the Third World. We have a responsibility to look at such cultural manifestations critically, more importantly, with a perspective which is not Eurocentric, and at the same time it should be done within the framework of contemporary practices: art, art criticism, and art historical scholarship. The point is that those who have been seen as 'primitives' are in fact part of today's society, and to ignore their actual position in this respect is to indulge again in imperialist fantasies. I take issue here with those Marxists who say that the Museum of Modern Art in New York is a temple of imperialism, and the only way we can deal with it critically is within and in relation to its function in advance capitalism. Any attack on this temple must be launched from a position of class struggle. It is not that I disagree with this view, but this view often ignores the issue of racism underlying contemporary cultural imperialism, both world-wide and within western societies. It seems therefore that we cannot continue sweeping the issue of racism under the carpet of Marxism, and we really need to look specifically into all those ideas in western culture to see how these ideas have underpinned a world-view of which racism is an important part. We ought to pay more attention to the emerging Third World scholarship[7] in which it is reiterated that classical Marxism *alone* is inadequate in the understanding of the relationship between racism and imperialism both in its historical and contemporary sense.

However, I would now like to draw your attention to some of the beautiful African sculptures[8] I saw in the MOMA exhibition. I have chosen these works for their extraordinary formal

qualities. I am aware that I might be accused of reducing these works to only aesthetic qualities and perhaps seeing them with the eyes of a western observer. The reason for this limited treatment, is only to prove a point which is very relevant in our context.

I am aware that I am being very selective about these works, and I am also presenting these works out of their social contexts and without much historical information. By whom and for whom are these works produced and under what socio-economic conditions? I do believe that we cannot understand the full significance of art works without taking into account the socio-economic and political conditions under which they are produced. The difficulty here is that we do not have this information. (And even if we did have this information, it would not have been possible for me to go into a full analysis within the scope of this chapter.)

What I therefore propose, contingently, is that we should look at these works as we would do in the case of any other work in an exhibition or museum, and try to respond to them – ignoring their anthropological interpretations. The intricate and complex formal and spatial qualities of these works tell us that these works are the products of highly sophisticated and intellectually engaged minds. At this point, I have deliberately not concerned myself with their sensuous qualities in order to avoid the pitfalls of that discourse which attributes sensuousness to irrationality. However, these works debunk the western myth about them, of being produced by an unconscious and irrational mind. They might have been produced for some ritual purposes. But so are many works in western culture which are made for religious purposes. Do we reduce the works of western culture only to religious meanings when we look at them or analyse them? Why do we have a different attitude towards the works of non-European cultures? Why do we not accept that African artists were able to transcend the imposed specific function (whatever that may be) of their roles as artists and were able to produce works which were multilayered in terms of concerns, functions, and meanings resulting from their own individual creative imaginations?

It is commonly believed that African peoples themselves were not aware of the aesthetic qualities of what they were producing and that it was the west which 'discovered' these qualities and gave the African 'objects' the status of art. It is true that Africans did not write books on aesthetics, plasticity, or formalism (or whatever relates to art), but to deduce from this that African artists were not aware of what they were doing is to indulge in the kind of stupidity which can only result from a mental blockage or an intellectual dishonesty. Even a cursory study of

various world cultures shows us that ritual itself does not demand the kind of formal complexity and perfection we find in many African works. Let us here take the example of a Mumuye sculpture from Nigeria, illustrated on page 43 of MOMA's catalogue: the way the human body is transformed into small geometrical spaces, and then interrelated to form a whole does not display either an expressionistic *Angst* or a ritual concern. It is more likely to be the result of a fascination and highly concentrated engagement with *space*, to create a *sculptural* space which is formally independent of naturalistic human form and yet at the same time represents the human body. I have yet to come across such a spatial complexity in a figurative sculpture in the west, even in the twentieth century.

My above comments do not deny other aspects of African sculpture, which may be religious, ritualistic, ceremonial, or whatever. The point is that we cannot reduce it to one particular aspect and certainly not to those aspects which are attributed to primitivism. African sculpture is profoundly complex, which is the result of rational minds, and not to recognize its complexity would be not to understand its true achievement.

What I am trying to say here is not altogether new. Modern anthropology tells us that what we used to think of as simple phenomena or structures of so-called 'primitive' societies are in fact highly complex projections of rational minds in no way less developed than the contemporary/modern mind. However, the ideas of modern anthropology have made no impact on art historical scholarship, on art criticism, or on western consciousness in general about the people who have been explicitly primitivized in the past. The ideas of nineteenth-century Europe are still with us today and they are being used to *define* and *fix* the positions of non-European peoples in such a way that they are deprived of their active and critical functions in contemporary cultural practices. This is particularly true in relation to the development of modern art in the twentieth century. If African/Asian cultures have not produced (or are not known to have produced) great artists in this century it is not because Afro/Asian peoples lack mental or intellectual ability or/and modern consciousness. The reasons are different and they are to do with the colonial primitivization of the non-European world, and this primitivization continues today in the form of ethnicization of non-European cultures globally as well as within western societies.

Edward Said describes orientalism 'as a system of knowledge about the Orient, an accepted grid for filtering through the Orient into Western consciousness . . . the idea of European identity as a superior one in comparison with all non-European peoples and cultures'.[9]

We can easily replace the word 'orientalism' with 'primitivism', particularly when we know that the word 'primitive' was in fact used frequently for *all* non-European cultures up to the end of the nineteenth century, notwithstanding that orientalism does have its own specific boundary in the same way as primitivism now exclusively refers to African/Oceanic cultures. William Rubin of MOMA refers to it as modern primitivism. Mr Rubin is perhaps right in also saying that 'Primitivism is . . . an aspect of history of modern art', but then to imply that this does not mean to reflect upon the status of the cultures and peoples primitivism refers to is to add insult to injury. However, I shall leave this matter here as my real intention is to go beyond the context of the twentieth century and show that primitivism as an idea or perception was already there as part of western consciousness before it entered into its modernist phase. I am therefore using the term 'primitivism' in a much broader and more general sense to reflect upon Europe's attitude towards all non-European cultures as part of the development of its art historical scholarship or discourse since the mid-nineteenth century.

However, I find it necessary again to reiterate that this paper does not concern itself much with the catalytic role African/Oceanic 'artefacts' played early this century in the development of modern art (cubism) or the role they have been playing since, as objects for appropriation by the western artist. My main concern is with the question of the *status* and *representation* of non-European cultures in western scholarship and popular knowledge since the eighteenth century, and, more importantly the implication today of this history *vis-à-vis* the *status* of non-European peoples in the modern world. The idea of the colonial Other as a group of racial stereotypes, with their equivalent cultural stereotypes, has played an important part in the development of primitivism in colonial discourse. And it seems that these stereotypes are still with us today and provide a source (though often unconsciously) for racist ideas both in popular consciousness, institutions, and scholarship.

What is interesting and central to western scholarship since the Renaissance is the idea of progress, which in the eighteenth century began to be rationalized for universal enlightenment and advancement. The methodology used for this purpose was to do comparative studies and analyses of world cultures and to establish their interrelationships and their relative positions in the preconceived universal hierarchy. The adaptation of the Graeco-Roman tradition in post-Renaissance Europe is understandable, but the consequences of placing Greek art at the top of the hierarchy can only be grasped in relation to the function of colonial discourse. The concept of a universal history of art

was developed in the eighteenth century, as part of colonial discourse, and since has been continually developing as a function of the idea of progress, constantly evaluating and appropriating world cultures within its own terms of reference.

The history of universal art was conceived as the history of human progress towards some kind of perfection, and modern art is seen to be the latest phase in its linear continuity. The concern for human progress towards betterment, towards some kind of perfection and salvation, is not a western invention. But the theory of linear progress and freedom, based on an ideological framework in which all the different cultures and races of people are chained together in a hierarchical order, is specifically western, based on the idea of progress in western philosophy.

In general, we can say that some kind of idea of progress must exist in all peoples and in all cultures throughout history, even when the nature and manifestation of it might vary from people to people. If the human species has evolved from its primeval origin through a process of reflection and rationalization, then this process must belong to all peoples and cultures even if it does not give rise to ideas about linear progression. That there existed and exist complex social organizations in all cultures is not disputed. All cultures produce ideas, beliefs, values, and some kind of cultural artefacts – temporary or permanent – in their attempt at survival, subsistence, and improvement. The ability to move beyond one's own territory and relate to other people and establish a sophisticated system of interrelationships that goes beyond one's mere need or concern for subsistence, must also belong to all human beings irrespective of racial or ethnic differences. There is no scientific evidence to prove the contrary. Many civilizations[10] and cultures throughout history had in themselves the idea of progress.

But the idea of progress under consideration here is different and is specific. It is specific only to western civilization, particularly since the Renaissance. What is singular about western civilization[11] is its grotesque ambition to supersede every other culture or civilization in its schizophrenic desire to expand, dominate, control, and rule everything on earth. It is perhaps a paradox of history, given all the material and cultural resources at its disposal, that the west had to rationalize its idea of progress through constructing a philosophy of racial superiority. It can be argued that once the Augustinian idea of all human races originating from one source began to be questioned after the Reformation, giving rise to a conflict between monogenetic and polygenetic theories, this inevitably led to pseudo-secular liberal scholarship and to human classification based on the knowledge available then. What is important here is to recognize that this

had no empirical basis. The hierarchical classification was constructed as a conceptual framework of an *a priori* idea of universal progress 'under the tutelage of the west', a phrase used by Edward Gibbon to stress the west's responsibility to educate and civilize 'savage nations' in order to safeguard western civilization from its likely downfall.

In the following pages I shall discuss some of those ideas, which are applicable to the development of the discipline of art history in the west, which today is the main discipline that determines the nature and evaluation of contemporary art practices, and their place in the history of art. The general ideas related to the notion of progress are in fact an integral part of the development of the concept of art history; the concept of a universal art history being synonymous with the notion of universal progress – of course, determined and realized by the west. What is interesting is that within this concept of history there are peoples who are considered to be incapable of any *modern* progress by themselves, and this incapability is often attributed to racial differences.

Winckelmann is considered to be the first writer to write a universal history of art, published in 1764, in which he employed the prevailing doctrine in order to establish a hierarchical structure for world cultures. Winckelmann's formulation, which established the supremacy of Greek art over the arts of all other cultures only by using the argument of climatic determination that attributes backwardness to hot climate, was important for later historians, particularly Creuser and Hegel. Once the supremacy of Greek art was established, this 'led to the seizing upon the shapes of Greek and Roman bodies', as pointed out by Robert Nisbet in his book *History of the Ideas of Progress*,

> as criteria for the biological best in the modern world; biological and also mental and cultural best! The fusion of the two Enlightenment obsessions – science and belief in Greco-Roman superiority – helped popularise the use of 'scientific' measurements and other tests for the determination of who among modern peoples were closest to the Greeks and Romans, and also who were farthest and therefore the most primitive and backward.[12]

Hegel is an extremely important figure in European thought, and his influence has been universal as one of the major philosophers of the idea of progress. What concerns me – and I am mainly paraphrasing Partha Mitter's ideas from his book *Much Maligned Monsters*[13] – is the way Hegel uses India as a model of a 'primitive' culture and then builds up the whole evolutionary continuum in which the west takes up the most advanced position. The result of this, by implication, is not only that non-

European peoples are seen as belonging to the past, but that they also become fixed entities with historically exhausted physical and mental abilities.

One is amazed by the extent of the fascination with and admiration of the west for other cultures, and the amount of effort it puts into documenting, studying, contextualizing, and philosophizing world cultures, with an ambivalence that has been its constant hallmark. It first builds up a complex ideological framework to look at others and their cultures, and, by fixing them in past historical periods, rationalizes its own position as the final link in the chain of human evolution. Hegel's ideas provide an extremely important framework in this respect, especially those relating to the development of art history. I quote Partha Mitter here.

> For Hegel, every nation had a preordained place in his 'ladder' of historical progress and reflected a unique 'national spirit'. Hegel also argued that each particular facet of nation or culture was interlinked with the rest, for the national 'spirit' permeated all spheres of life. The conclusion was that if we were to judge a particular type or tradition of art we must first of all see what particular national spirit it represented and to what particular point in history that nation in turn belonged. . . . Paradoxically, his dynamic principle of history, the dialectics of change, only helped to establish a fundamentally static image of Indian art, its immemorial immutability, its unchanging irrationality, and its poetic fantasy, all predetermined by the peculiar Indian national spirit. It needs to be repeated here that Hegel's characterisation of the Indian 'spirit' was not based on empirical evidence but determined essentially by India's temporal position in Hegelian metaphysics. . . . It was thus condemned to remain always outside history, static, immobile, and fixed for all eternity.[14]

While earlier philosophers of the idea of progress thought in terms of cultures and civilization arranged in linear order, rather than in terms of races, in the nineteenth century racist hypotheses – partly derived from Darwin's theory of evolution – became increasingly common as explanations of the vivid differences of cultures on earth. Gobineau's *Essay on the Inequality of Human Races* (1853–55) 'is the source of racist conceptions of human progress which, during the late nineteenth century, spread throughout Western civilisation',[15] but the idea of 'fixity' of certain peoples or races with their specific cultural achievements fixed in the past, is evident in most western scholarship, such as in Hegel's *Philosophy of History* and *History of Art*, which have been highly influential in the

development of modern art historical scholarship. It is, in fact, my contention that there is no essential or basic difference between liberal scholarship, such as represented by Hegel, and explicitly racialist theories. From Winckelmann to Creuser to Hegel to Ruskin to Fergusson, and in our present day Lord Clark and Professor Gombrich . . . it is the same story. It is the same grand narrative, in which the detail and emphasis change from time to time but every chapter ends on the same note: the west's inherent superiority over all other peoples and cultures.

The ideas of 'racial romantics', such as Gustave Le Bon, for whom a style of art was determined from the start by the unique spirit of a race, and whose special talents could not be imitated by people belonging to a different race without exposing themselves to grave dangers, may not be very helpful in understanding institutional racism in western societies today, because these institutions have now become highly sophisticated and bureaucratized and they do not express their attitudes openly and explicitly. The institutions are nevertheless heirs to the ideas of western scholarship. Notwithstanding the fact that institutional policies often present a misunderstanding of these ideas, they are never explicitly rejected; instead there is often a 'silence', but when sometimes things do come out they echo the same ideas of nineteenth-century primitivism.

However, it is not necessary for these ideas to exist openly in their extreme forms, particularly when there is no essential or basic difference between the liberal and extreme positions: the former providing the latter with a respectable shield or mask to protect it from a radical attack. The most extreme ideas can either lie dormant under the carpet of liberalism (just ignore them!) or they will seep through and appear on its multi-coloured surface, as has happened recently in Britain, in the form of a benevolent multiculturalism with all its fascination with and admiration for exotic cultures. What is not fully realized, by either white or black[16] people, is that the ideas which are essential to the kind of multiculturalism which is being promoted in Britain today, come from the racial theories of art discussed earlier.

Many of the ideas of the 'racial romantic' thinkers, such as Le Bon and Chamberlain, were in fact recognized as extreme by some of their contemporaries and by later historians. Yet they did re-emerge in Nazi Germany, which only shows that ideas do not die or disappear from institutions or common consciousness just because we can ignore their importance in normal circumstances.

It could be argued, though, that I am unnecessarily indulging in ideas which should be forgotten or considered 'archaic' since we are no longer living in the nineteenth century. Marxism,

moreover, rejects the metaphysics of Hegelian dialectics, and on this basis we should safely ignore all those racially based ideas in western discourse or philosophy. This argument betrays the complacency of those who have been impotent or reluctant to do anything about it in practice. The ideas of racial or ethnic determinism as part of 'Ethnic Arts' have now been with us officially for almost ten years, and what did the 'left' do about them? Nothing. It preferred to sit on the fence or/and give out its usual sermons; and in other cases actively supported what I call new primitivism. However, it needs to be recognized that Marxist scholarship is marginal to dominant bourgeois culture and, within it, cannot really change the basis of contemporary art practice, or make a direct intervention in institutional structures where the ideas of racial cultural stereotypes still prevail.

I would like to start this section by mentioning the name of John Ruskin, who is quite a darling of the British art establishment. He believed that there was 'no art in the whole of Africa, Asia or America', and he expressed such an attitude towards other cultures often, openly, and viciously. I cannot attribute such a viciousness to his likely spiritual protégé, Peter Fuller,[17] who believes that good painting or sculpture is not possible without good drawing. I am not disputing here the importance of basic drawing in art practice – although it is not always necessary, the emphasis somehow expresses the kind of attitude that went into teaching the 'primitives' in the colonies, how to draw, and how to draw from the plaster casts of classical sculptures.

The 'primitive' has now indeed learned how to draw, how to paint, and how to sculpt; also how to read and how to write and how to think consciously and rationally, and has in fact read all those magical texts that gave the white man the power to rule the world. The 'primitive' today has modern ambitions and enters into the Museum of Modern Art, with all the intellectual power of a modern genius, and tells William Rubin to fuck off with his primitivism: you can no longer define, sir, classify or categorize me. I'm no longer your bloody objects in the British Museum. I'm here right in front of you, in the flesh and blood of a modern artist. If you want to talk about me, let us talk. BUT NO MORE OF YOUR PRIMITIVIST RUBBISH.

I did promise you that I would not go into an angry rhetoric, and it is unfair also to pick on an individual, particularly William Rubin whom I have never met. He probably is a very nice guy; and I should perhaps apologize to him for my rudeness if I ever meet him. However, the institutional authority that he represents exists throughout the western world, and I do not see why the *anger* of the 'primitive' against this authority has no legitimacy given the dialectics of what this

authority has perpetuated all over the world.

The anger is not an inability to communicate on 'civilized' terms or within an intellectual framework of modern cultural practices. On the contrary, it is the inability of the institutions to recognize and respond to the modern aspirations of all peoples irrespective of race, colour, or creed that has created a confrontational situation. This may not be a very happy situation, but that is what is happening in our contemporary world. I do not want to take you around the world. This would complicate the matter. However, I will draw your attention to what is happening in Britain (in Bristol, Liverpool, Birmingham, Southall, Brixton, etc.)[18] which, in my view, is the failure of this society to come to terms with the aspirations and demands for equality for all people in this society. This failure is also noticeable in liberal scholarship and art institutions, not that similar consequences of street riots are being foreseen here. There is a general lack of will to face up to the reality of post-war Britain. There is a lack of will to listen to those who had no voice during the colonial era but who are now part of a 'free' and modern society and want to speak and establish a meaningful dialogue across racial and cultural boundaries. If you had read my correspondence in my book *Making Myself Visible*,[19] or/and elsewhere, you would know what I mean by all this. What one often faces is the brick wall of silence, arrogance, and self-righteousness.

I am not suggesting here that there has been no awareness of the problem, or that nothing whatsoever has changed. But what is being done generally and officially is highly objectionable. Right from the very day African/Asian peoples set their feet on this soil (my concern here is only with the post-war period), the whole official machinery was set in motion to deal with them. Since then special research units have been set up under various organizations for the sole purpose of studying their *traditional* customs, beliefs, behaviour, values, and what not, and also what are called ethnic cultural artefacts; all lumped together and labelled ethnographical material. I am not an anthropologist or a sociologist, but it is not difficult to see what this game is all about.

The establishment, if not this society in general, is surprised and amazed that these people, who have been given the *privilege* of coming to this country, should now demand more. The 'primitive' demanding equality and self-representation within a modern society is unthinkable. There must be something wrong with them. They don't know what they want. *We* know what they want.

The problem is that these people are uprooted – say the experts of the race relations industry – from their own cultures, from their own traditions, and as a result they are feeling

alienated and frustrated in this highly complex technological society. We shall therefore provide them with all the facilities to bring here and practise their own traditional cultures; and let them enjoy themselves. After all they are no longer our colonial subjects.

The need for various peoples to have their own cultures, particularly when they find themselves in an alien and hostile environment, is not something we should dispute. But the way this is being approached and manipulated has taken us away from the basic question of equality for all peoples within a modern society. It would be foolish not to recognize the differences between European and non-European cultures, but it has been the function of modernism since early in this century to 'eliminate' the importance of these differences in its march towards an equal global society. Why are these differences so important now? Instead of seeing the presence of various cultures within our modern society as our common asset, why are they being used to fulfil the specific needs of specific people? Does this not somehow echo the philosophy of apartheid?

The answers to these questions are not easy, particularly when the 'difference' is now being internalized by many people in the black community, and is seen as essential to their cultural survival. My attempt, in the following pages, is to deal with some aspects of what is a difficult and complex situation.

The history of primitivism is full of humbug. Lies, distortions, ignorance, confusions, etc., are *rationalized* into 'truths' that give the system credibility and power. The discontent and resistance of the underprivileged are turned into issues of culture, a shift that is manageable within the prevailing ideology. And thus a new conceptual and administrative framework is set up to deal with the demands of what the establishment calls ethnic minorities. This seems to have all the hallmarks of neo-colonialism, with specific features specific to metropolitan conditions, rationalized by a body of scholarly work done under the race relations and ethnic studies within some British universities and polytechnics;[20] and it does not seem unreasonable to call this scholarship neo-colonial discourse.

Homi Bhabha, who has recently made an important contribution towards understanding the complexity and ambivalence of the colonial stereotype, has suggested that we should treat colonial discourse – i.e. liberal scholarship – as part of colonial power:

> It is an apparatus that turns on the recognition and disavowal of racial/cultural/historical differences. Its predominant strategic function is the creation of space for a 'subject people' through the production of knowledge in terms of which sur-

veillance is exercised and a complex form of pleasure/
unpleasure is incited. It seeks authorisation for its strategies
by the production of knowledge of coloniser and colonised
which are stereotypical but antithetically evaluated. The
objective of colonial discourse is to construe the colonised as a
population of degenerate type on the basis of racial origin, in
order to justify conquest and to establish systems of adminis-
tration and instruction.[21]

The 'degenerate' is no longer easily recognizable as it has
become a cultural stereotype that attracts the tremendous
admiration and fascination of the white society. The cultural
traditions that colonialism once wanted to supress and destroy
are allowed to 're-emerge' for 'the creation of space' that is
essential for the surveillance of neo-colonial relations. The idea
of 'Ethnic Arts' is central to this development.

But, first, let us go back to colonial times. The idea of progress
and freedom was also proclaimed in the colonies. In fact
colonialism was often justified on the basis that it brought
progress to the colonized people, and would ultimately also
provide a framework for the freedom of all humankind. This
was particularly incorporated in the colonial education system,
the purpose of which was, of course, to create a westernized elite
for colonial administration.

One of the consequences of this education was that the
educated elite in the colonies became uprooted from its own
cultural traditions, and this was particularly the case *vis-à-vis*
the visual arts. Even when the traditions were not forgotten or
ignored altogether, they became marginal or were exoticized
internally in relation to the production of contemporary art in
the capital cities.

My account and analysis here are generalized and oversimpli-
fied. There were, of course, exceptions to the rule: there were
constant oppositions to the colonial type of education. However,
the influence of colonial education remained predominant.
And, paradoxically, this education provided the leadership for
anti-colonial struggles.

The models which were the basis of art education in the
colonies were often outmoded, conservative, and backward.
When European artists were revolting against and over-
throwing the whole tradition of Graeco-Roman classicism early
this century, as part of their search for new modes of expression
that would represent the spirit of modern times, art students in
the colonies were being taught how to draw faces from the
Graeco-Roman casts imported from Europe. Modern art, there-
fore, also gave a basis to African and Asian artists to oppose the
traditions of conservativism, European as well as indigenous.

This opposition was often also part of the artists' participation in anti-colonial struggles.

As a matter of fact, many artists in the Indian subcontinent, including Sri Lanka, formed groups, often called 'progressive groups', to discuss, practise, and propagate the ideas of modernism; and I believe similar things happened in the rest of the colonies as well. The progressiveness of these groups was manifested in their support for freedom from colonialism, as they realized that without this freedom it would not be possible to fulfil their aspirations for their own modern societies based on science and technology.

Immediately after independence, art became a focus and expression of newly found, modern freedom. There was a frenzy of enthusiasm and search for the latest modes of modernist expressions and styles; but the artists, at the same time, found themselves in a difficult situation. There were no modern institutions to support and recognize them. This created a post-colonial dilemma among many Third World intellectuals, particularly visual artists, whether to stay in their own countries and fight for their place at whatever cost or to leave for the west which offered better prospects. Some did leave, particularly the ambitious ones; and that is how we had the first generation of African/Asian artists in Britain immediately after the war.

It is important to mention that some of these artists, after initial difficulties and frustrations, did eventually receive some support and recognition in Britain. By the end of the 1950s they were well accepted by the establishment, but it so happened that their short-lived recognition and success were partly to do with the fact of their being 'different'. I am not suggesting that there was something wrong with their being different, and in no way am I implying that the support they received was based only on the cultural difference. There was a post-colonial euphoria among the liberal intelligentsia, and it is important to recognize that many British people genuinely looked forward to a new and equal relationship between the different peoples within the spirit of Commonwealth. Why then, did not this euphoria last beyond the early 1960s? This is an important and difficult question, and trying to deal fully with it would drag us into the politics of the post-war transatlantic relationship that developed in the 1960s. However, it seems that American domination of the British art scene, beginning in the 1960s, did play some role in this change.

However, Souza was admired for expressing the anguish of being a Christian from a predominantly Hindu country, that is, India. The funny thing is, that he began to paint such paintings only after he had stayed in Britain for some years. Both Shemza and Avinash who developed their specific styles after living in

Britain for some time, were taken up for the exoticism of their respective cultures, rather than being understood in the context of their problematic relationship with modernism. The success of some black artists in Britain today is also due to the exoticism of their work, which has been legitimized in the context of neo-primitivism within the reactionary 'postmodernism' promoted by corporate interests.

My own work of the 1960s, i.e. minimal sculpture, also attracted some interest but in most cases it was seen as 'Islamic art'. The point is that this thing called 'Islamic art' never entered my head before I heard about it from others in connection with my work. As far as I am concerned, my work was the result of my fascination with and understanding of modernist sculpture in Britain in the early 1960s, particularly of Caro. My attempt was to go further than what my modern precursors were doing, and what I produced is similar to what is today internationally recognized as minimalism.

It is not my purpose to dwell on my own achievement. But what I am saying here clearly illustrates the prevalence of the ideas of primitivism and how they are used to exclude non-European artists from the history of modernism. The suggestion seems to be that I have been carrying my culture all the time in my unconscious, and that it found expression *naturally*. My consciousness of modern history and my intellectual efforts to produce something new within this context appears to have no significance.

I accept that my work has an affinity with Islamic geometric art, which may be the result of the influence of Islamic culture I come from. But the same is true in the case of the English artist Tess Jerry, who accepts the influence of Islamic art on her work, and also in the case of French artist François Morellet, whose work was inspired by his visit to Granada in Spain. We could say the same thing about some American minimalists who had great admiration for what they called 'oriental art'. Barnett Newman and Ad Reinhardt were particularly inspired by what they considered to be the aesthetics of meditation and contemplation as opposed to the expressionism of western art of the time, and both are important figures in the history of minimalism (modernism). If Islamic art has in fact influenced modern art, particularly in recent times, what, then, is at issue here? In order to understand this complex issue, one has to understand the *difference* between the 'Orient' and the 'modern', the former being a category of primitivism which can enter the latter, but only if it is transformed through the consciousness which, according to Hegelian philosophy, is an attribute of European people only.

There is no contradiction here. The consistency of the

western/bourgeois world-view is the consistency of the philosophy of modernism. It appears to me that the terms of reference of modern art as a progressive force unfolding continually on the basis of Hegelian dialectics of *Thesis, Antithesis and Synthesis* is not available to the colonial Other. The *Thesis* represents an Authority, which is the authority of the west over the world; and it seems that this authority can only be challenged at a particular time in bourgeois history within its own terms of reference and through what Hegel calls 'World-Spirit'. It is therefore understandable why the access to modernism is blocked whenever the colonial Other appears in front of it, because the *difference* between the 'primitive' and the 'modern' is fundamental to this western authority. . . .

The idea of this 'difference' is not only the prerogative of academic philosophical discourse, but it is part of the collective consciousness of western societies. I am not suggesting here that this necessarily represents a pejorative attitude of the white society towards non-European people, or that it is exclusively part of it. Often this 'difference' is invoked in a 'positive' manner to appreciate something that is missing from the dehumanizing western culture. It so happens that the ideological implications of this 'difference' are not often or commonly understood.

Before I go further I would like to give you another example of this 'difference' which I encountered personally. In 1980 I was invited by the Ikon Gallery in Birmingham to participate in a group show, and I was *persuaded* by its then director to do a particular work about which I was initially reluctant. But when the other participating artists came to know about my work, they strongly objected to my being in the show. I was eventually asked to withdraw. The interesting thing is the reason they gave for my exclusion: 'the show is to do with sources for work *deep within the imagination* and this source is profoundly *different* from yours – since the ritual is, as it were, a *normal occurrence* albeit in a particular milieu' (emphases added).[22] I wrote back arguing that 'all artistic activity is to do with imagination', and the response was a blunt refusal to enter into any kind of further argument.

The reason why this 'difference' is invoked again and again, and consistently, whenever a person of African/Asian origin appears on the scene, can also be understood in terms of what Martin Barker has argued in his book *The New Racism*, the emergence of a new racism in Britain today which is not based on the idea of white superiority but on the maintenance of a *separate status* for black people based on cultural differences:

It is called up by the stimulus of those who are genetically unrelated, whose cultures reveal their different origins, and

specifically those who display their genetic difference on their skin. Of course, it is not claimed that these outsiders are degenerate, immoral, inferior; they are just different. . . . It is all the more dangerous, if that is conceivable, than older forms, because it can ward off any spectres of Nazism; all the time such writers, politicians and activists will distance themselves from doctrines of superiority/inferiority because racism is not possible or needed in that form any longer. The unit has passed on, and now takes a new form: we have a 'natural' tendency to stay apart from culturally alien things; even if they are not inferior, they are culturally different.[23]

Although the above quote refers to the New Tory philosophy, it should not be, in my view, attributed exclusively to the right. The idea of 'difference' is fundamental to the idea of 'Ethnic Arts' which is being supported by both the right and the left. My argument is not against the presence and recognition of all the different cultures in Britain today. They can and should in fact play an extremely important critical role in the development of this society into an equal multiracial society. But the idea that the creative abilities of black people are 'fixed' or can only be realized, even today, *within* the limits of their own traditional cultures is based on the racist philosophy of 'ethnic determinism' in art developed during the late nineteenth century. What worries me most is the fact that even our socialists[24] do not seem to realize the implication of their support for separate 'Ethnic Arts'. They may be well-meaning in their expedient support for the cultural activities of black people, but that does not mean that we should ignore its harmful consequences.

The issue of multiculturalism is extremely complex, and it is not my purpose here to go into this complexity. However, the question of 'Ethnic Arts' is different and it should not be confused with the need for a multicultural society. The idea of 'Ethnic Arts' has not fallen from the sky, nor was it something that was demanded by black artists or cultural workers themselves. It is part of the emerging neo-colonialism within Britain, and it is sad that 'socialists' are also instrumental in its development.

The policy of 'Ethnic Arts' has been systematically and insidiously introduced into the system, through the cultural management of the desires, aspirations, and demands of black people for equal status in this society. The Establishment had realized from the beginning that these demands would be made, and it also knew that it would be impossible to meet them within the prevailing reality or ideology. It would be in fact detrimental to the political power of both the major parties: Labour and Tory. So, what was to be done? The demands could

not be ignored indefinitely. The idea of a black functionary class, a buffer, is not a new thing in the colonial apparatus. *When chickens come home to roost, you don't let them inside the house.* The creation of black functionaries (well-versed in anti-racist rhetorics, almost ignorant or mediocre in artistic matters, intellectually timid . . .), who would speak on behalf of their respective African, Asian, or Caribbean communities, dealing only with their specific different needs, would do the job. This, in turn, would help disenfranchise black people in terms of their demands for equal power within the dominant culture or main-stream as they would be turned into *minority* cultural entities. And thus emerges a *new* 'primitive' within western metro-polises, no longer a Freudian unconscious, but physically present within the dominant culture as *an exotic*, with all the paraphernalia of grotesque sensuality, vulgar entertain-ments. . . .

A voice: your culture still has spirituality, why bother with our sick and material world?

Another voice: I would have thought that you would have preferred to be outside the history (of art).

The pyramid of western civilization, built on top of all the cultures of the world, is thus yet again saved from the onslaught of the 'primitive' outsider. For centuries western civilization not only occupied the summit, but also formed its own crust all around this pyramid; the rationality of the Enlightenment turn-ing the whole thing into a white monolith. But as this rationality began to falter by the end of the nineteenth century and there appeared cracks on the surface of the monolith, it seems that other cultures poured out of its repressed interior, its uncon-scious. This indeed fascinated the western artist, the avant-garde of the world, who is always present on such historic occasions. What poured out of the cracks, with all the exotic forms and colours, was something that had been deliberately kept hidden away from him all those years. Overwhelmed by his new 'discovery', he cursed all those who put him into the chains of rationality, deprived him of the sensuous pleasures of the unconscious, and thus prevented him from becoming a free and complete *man*. Dazzled as he was with his new insight into humanity, he began to play with his newly discovered material. His new-found creativity turned the material into patchwork that covered the whole pyramid. The history of these patch-works is the history of twentieth-century modern art with all its radicalism and internationalism. But under these patchworks, we see the same order, same hierarchy, same Eurocentric ideas, values, and attitudes. It is no wonder that the History of Modern

Art remains an exclusive territory of the west, accessible only to the children of the Enlightenment. The Other remains perpetually outside history.

The great monolith is now covered with patchworks of every conceivable form and colour, shape and material, high technology intermingling with the material from so-called 'primitive' cultures, forming a great spectacle which is as fascinating to watch as *The Triumph of the West*.[25] Even before the final episode of this BBC film, its narrator has already said that we in the west have perhaps failed in the ideas of the Enlightenment and the real triumph will perhaps be in the east.[26] What he is suggesting is to me another slippery slope. The idea of building wedges into the cracks looks more interesting.

NOTES

This chapter was a paper delivered as part of the 'Primitivism' series of seminars organized by Susan Hiller at the Slade School of Art (University of London) in winter 1985–6, and was published initially in Third Text, no. 1, autumn 1987.

1 I am indeed grateful to Susan Hiller for this invitation.
2 The idea of 'Ethnic Arts' was first suggested by Naseem Khan in her book (1976) *The Art Britain Ignores*, London: jointly sponsored by the Commission for Community Relations, the Gulbenkian Foundation, and the Arts Council of Great Britain.
3 Edward W. Said (1978) *Orientalism*, London: Routledge & Kegan Paul. Said here refers to the work of Harry Bracken (Winter 1973) 'Essence, accident and race', *Hermathena* 116.
4 David Dabydeen has pointed to the ambivalence of black images in Hogarth's work in his book (1985) *Hogarth's Blacks: Images of Blacks in Eighteenth-Century English Art*, Denmark/England: Dangaroo Press.
5 *'Primitivism' in 20th Century Art*, New York, Museum of Modern Art. A massive catalogue (two volumes) under the same title was published to accompany the exhibition (1984).
6 Masculine gender here is deliberately used to emphasize the (white) male domination of modernist discourse.
7 I have particularly in mind Frantz Fanon, Edward Said, Gayatri C. Spivak, and Homi Bhabha.
8 The sculptures are *Mumuye* from Nigeria, *Dogan* from Mali, *Boyo* from Zaire, *Luba* from Zaire, reproduced in the MOMA catalogue (n. 5) on pp. 43, 50, 56, and 161 respectively.
9 Said, op. cit.
10 I am thinking particularly of the achievements of Egyptian, Chinese, Indian, and Islamic civilizations.
11 I am not proposing an essentialist view. My remarks should be read in the context of modern capitalism.
12 Robert Nisbet (1980) *History of the Ideas of Progress*, London: Heinemann. Nisbet here refers to the work of George L. Mosse, *Towards the Final Solution: A History of European Racism*.
13 Partha Mitter (1977) *Much Maligned Monsters*, Oxford: Clarendon Press.
14 ibid.
15 Nisbet, op. cit.
16 The word 'black' is used throughout this chapter for people of both African and Asian origins, who live in the west and whose status is often determined by white racism.

17 Drawing as basic to good painting or sculpture is not Fuller's own original idea. It is an accepted fact in western art; and an emphasis on *freehand* drawing can also be found in the early writing of John Berger. However, what Peter Fuller is now proposing is for the development of nationalist British art which is grounded in the experience of English pastoral traditions and which is free from foreign influences, in total disregard of the reality of a multi-cultural British society. Fuller, in fact, represents a pathetic aspect of a common English phenomenon which begins its intellectual life with extreme left and ends with extreme right.

18 Some of the towns and cities where open confrontation between the police and black communities took place in recent years, resulting in street riots.

19 Rasheed Araeen (1984) *Making Myself Visible*, London: Kala Press.

20 See Jenny Bourne's essay (1984) 'Cheerleaders and ombudsman: the sociology of race relations in Britain', *Race & Class* XXI, 4.

21 Homi Bhabha (November/December 1983) 'The other question – the stereotype and colonial discourse', *Screen* 24.

22 Araeen, op. cit.

23 Martin Barker (1981) *The New Racism: Conservatives and the Ideology of the Tribe*, London: Junction Books.

24 Most art institutions and funding bodies now recognize and support the category of 'Ethnic Arts', but the GLC's initiative and support in this respect is worth special attention. A large amount of public money was dispensed by merely employing a staff of black functionaries (under the policy of positive discrimination) who had nothing to do with the arts; in fact, the money was wasted through gross ignorance, inefficiency, and nepotism, and in many cases preference was given in support of community projects which were meant to enhance the Labour Party's electoral position in the black community.

25 *The Triumph of the West*, a BBC film series written and narrated by the historian J. M. Roberts, which traced the history of western civilization going back to the Greeks.

26 His reference here is to Japan's post-war economic success.

PART III

Editor's introduction

Although objects from Oceania, Africa, and the Americas have been collected by Europeans since the sixteenth century, the great museums of ethnography which classified some of them[1] as 'cultural artefacts' worthy of scientific study were not founded until the third quarter of the nineteenth century; even later (about 1912), some ethnographic objects began to be appreciated and exhibited as art for aesthetic contemplation. In ethnographic museums, a wooden carving will be displayed alongside other objects from the same location; the names of individual makers are not noted, indeed, usually were not 'acquired' with the objects. In art museums, works are often identified as the creation of a known individual, and are displayed as though their place within a specific set of cultural connections is irrelevant.

During the early years of this century, many artists began to express admiration for the 'barbarous curios' found in ethnographic collections, which led to the modernist reassessment of the aesthetic value of tribal materials and produced a class of objects labelled 'primitive art', which overlaps the classifications within which such objects are placed by social scientists. But, as Robert Redfield said pointedly rather a long time ago, formalized displays of ethnographic materials are always either 'temptations to mistaken speculations about "primitive" peoples', or 'invitations to forget, for the time, those people and look at the thing as art'.[2] In either case, the objects are assigned value within a system of meaning foreign to them; the function that 'we' assign the objects is to generate a fictional (because one-sided) discourse in which meanings can be produced and exchanged among 'us' alone.

Annie Coombes's chapter focuses on the ways that ethnographic museum collections have been used as vehicles to produce and maintain a cohesive cultural self-identity for the west, integrally connected to its historic drive for imperialist domination. The transformation of colonial souvenirs and curios into objects of scientific interest was achieved in England in the early twentieth century by the introduction of appropriate formal systems of classification, based on evolutionary assumptions emphasizing a close relationship between 'race' and 'culture'.

Scholarly displays demonstrated to the public at large that 'the colonies' were inhabited by peoples in a state of development 'corresponding more or less closely to the prehistoric races'. The production of this picture of the colonized peoples presented itself as 'objective' representation.

Despite more recent efforts to eliminate the derogatory evolutionary bias from scientific displays, the stereotypes remain in place. Perhaps they persist because physically removing objects from their cultural settings to locate them within a museum is such an extreme form of appropriation it will always override any 'information' appended by means of captions discussing factors exterior to an object but nevertheless determining it, such as how it was made or what use it had. This kind of explanation does not assist the viewer's comprehension of the object 'itself' or the cultural context from which it has been excised, because the meaning produced by its present ownership, display, and classification is much more significant, permitting a return to what is known and familiar in the fixed stereotypes of myth.

Increasingly, ethnographic items are being moved out of anthropological, 'scientific' contexts into art or 'aesthetic' contexts. The global ambitions of a society apparently committed to universalizing its own world-view can be recognized in statements valorizing this taxonomic shift: 'Thus the artistic creations of the primitive cultures have entered freely into the world history of art to be, like those of any other cultures, understood and appreciated on their own merits.'[3] But the decontextualization that occurs when tribal objects enter 'art' means it is precisely *not* on their *own* terms that they achieve this universal significance, but only when they are assimilated completely to a western world-view which is imagined to be universal. Display in an art museum is the final stage in a series of powerful, institutionalized strategies of appropriation, a mythologized denial that there is any specific meaning in the collecting, possessing, and displaying of ethnographic objects by the west.

As Signe Howell indicates in her chapter, it is impossible to isolate aesthetic response from cultural context; aesthetic response is a social fact, socially learned and transmitted. While not denying the possibility of a 'profound emotional or intellectual response by members of different cultures' to an exotic object, this response 'must be interpreted in the light of the cultural values of the spectator'. Since an understanding of art from one society by people who live in another is inevitably based on assumptions built into the cultural categories of the interpreters, the refusal to attend to the actual cultures where ethnographic art is made, or to the particular relationship of

power and meaning expressed in 'our' possession and display of certain exotic artefacts, creates a space for the return of fantasies which are as primitivist and racist as those that formed the basis of early scientific exhibits of tribal objects.

All classes of meaningful objects, including those defined as great art or scientific evidence, function as part of symbolic systems; western displays of ethnographic items as 'art' evoke a circular response in which our culturally and historically formed interpretations are projected on to the objects and their makers. The act of 'transcending' cultural differences requires that *difference* be defined in the fixed categories of myth rather than in the particularities of history and culture.

> Few are the visitors to a 'tribal arts' gallery that displays objects largely without ethnographic context, who do not in some way compensate for the absence of interpretation by calling on western 'common sense' misunderstandings about the life of 'primitives' – including images of cannibalism, superstition, and rituals performed by flickering torchlight.[4]

Western 'civilization' objectifies and absorbs the worlds at what it perceives to be – and defines as – its 'margins'. The classification, interpretation, and consumption of ethnographic objects need to be understood as the visible, public face of the process of constructing the exotic 'other' as object in western art and anthropology. To destabilize this construction requires negotiating a position from which the 'other' can speak (and speak 'objectively', through and by means of objects presented as evidence) while simultaneously 'shifting the parameters of a discourse demanding such positioning'. In Desa Philippi and Anna Howells's chapter, the authors' readings of certain contemporary European and American art works, point to convergences between the production of external 'others' and the process of internal 'primitivization' of women in western society. Art history's 'fantasy of cultural coherence' creates its own 'others', unconscious and irrational; ' "the native" and "woman" . . . as a "represented" ' are both 'paradoxically invested with the "essence" of difference'. The authors' interest is in excavating instances 'where, however momentarily, a crisis is induced in accepted patterns of differentiation and identification'.

In Christina Toren's discussion of the appropriation, reclassification, and display of an image from the European tradition, Leonardo da Vinci's *The Last Supper*, the 'original' remains in Italy while numerous reproductions of it circulate within a specifically Fijian discourse. In the conservative *and* innovative implications of Fijian uses of *The Last Supper*, 'Fijians are at once transforming their culture and affirming its dynamic

integrity'. Optimistically, Toren concludes that in the struggle over meaning and 'for domination of the terms given by particular forms of colonization . . . the "cultural other" has to reconstitute its images of "cultural self" . . . but – however apparently successful – the colonizing power cannot finally "win" this struggle for consciousness'.

NOTES

1 Over the years, ethnographic collections have been edited to exclude items shocking to contemporary sensibilities, such as the 'scalps, fingers, and men's, women's and children's privates' collected along with shields, blankets, beadwork, and clothing by the US Cavalry after the Sand Creek massacre. (See J. D. Forbes (ed.) (1965) *The Indian in America's Past*, New York: Prentice-Hall, pp. 35–40, and Susan Hiller (December 1978) 'Sacred circles: 2000 years of North American art', *Studio International*, London, reprinted (1979) in *Art & Society History Workshop Papers*, London.) The more aesthetically acceptable items are considered worthy of display, but what becomes of the others? At what point do they disappear from history? And what are the implications of this drastic pruning of the content of ethnographic collections?

2 Robert Redfield, 'Art and icon', in Charlotte Otten (ed.) (1971) *Anthropology and Art: Readings in Cross-Cultural Aesthetics*, New York: p. 54.

3 Robert Goldwater (1967) *Primitivism in Modern Art*, revised edn, New York: p. 13.

4 Sally Price (January 1986) 'Primitive art in civilized places', *Art in America*: 13.

9 Ethnography and the formation of national and cultural identities

ANNIE E. COOMBES

And so it is interesting to remember that when Mahatma Gandhi . . . came to England and was asked what he thought of English civilization, he replied, 'I think it would be a good idea.'[1]

Multiculturalism has become, albeit belatedly in England, one of the buzzwords of the educational establishment. Some years on from the Swann Committee Report of 1985, optimistically entitled *Education for All*, and in the wake of the ensuing debates on the relative merits of an initiative that may be 'multicultural' but is not necessarily always actively 'anti-racist', the controversy continues.[2] By April 1986 multiculturalism was also on the agenda of the museum ethnographic establishment, at the annual conference of the Museum Ethnographers Group (M.E.G.). In addition, specific proposals were advanced that a policy decision be made by the group, concerning dealings with the apartheid regime in South Africa.[3]

This chapter was written, then, in the context of what might be interpreted as the moment of a more self-consciously political conception of the roles available to museums in general. It also comes at a moment of renewed interest in the ethnographic collection as a possible site for academic anthropology's engagement with the multicultural initiative inspired by documents like the Swann Report. Moreover, such an involvement has the potential, acknowledged by both the anthropological establishment and its critics, of redeeming the discipline's tarnished reputation as a product and perpetrator of the colonial process.[4]

In order to understand some of the difficulties and contradictions arising from implementing a multicultural initiative in the display of material culture already designated 'ethnographic', I want to elaborate a case study situated at a comparable historical conjuncture in 1902, when the Education Act of that year announced the same objective of 'Education for All'.

More specifically, the 1902 Act also made provision for school children, accompanied by their teachers, to count visits to museums as an integral part of their curriculum; an early indication of government recognition of the educational potential of such institutions.[5] Another effect of this Act was to generate a series of debates within a professional body which is still the official organ of the museums establishment today – the Museums Association.[6] The focus of these discussions was threefold: concern with the problem of attracting a larger and more diverse public; proving the museums' capacity as a serious educational resource; and, in the case of the ethnographic collections, proving their capacity as a serious 'scientific' resource. While the existence of such debates cannot be taken as a measure of the efficacy of any resultant policies, it does give a clear sense of the self-appointed role of museums within the state's educational programme at this moment.

The year 1902 was significant in other respects also, since it marked the renewal of concerted strategies by both contending parliamentary parties to promote the concept of a homogeneous national identity and unity within Britain. Imperialism was one of the dominant ideologies mobilized to this end. The empire was to provide the panacea for all ills, the answer to unemployment with better living conditions for the working classes and an expanded overseas market for surplus goods. Through the policy of what was euphemistically referred to as 'social imperialism', all classes could be comfortably incorporated into a programme of expansionist economic policy in the colonies coupled with the promise of social reforms at home. It was in this context that museums, and in particular the ethnographic sections, attempted to negotiate a position of relative autonomy, guided by a code of professional and supposedly disinterested ethics, while at the same time proposing themselves as useful tools in the service of the colonial administration.

The degree to which the museum as a site of the production of scientific knowledge and as the custodian of cultural property can claim a position of relative autonomy from the vagaries of party politics and state intervention, is an issue central to an understanding of the ethnographic collection's actual and possible role today.

I

The specific roles assigned to ethnographic collections in the discourses on museums and education produced from within the more catholic membership of the Museums Association needs to be seen in relation to another site producing knowledge of the colonial subject. Between 1900 and 1910 Britain hosted a

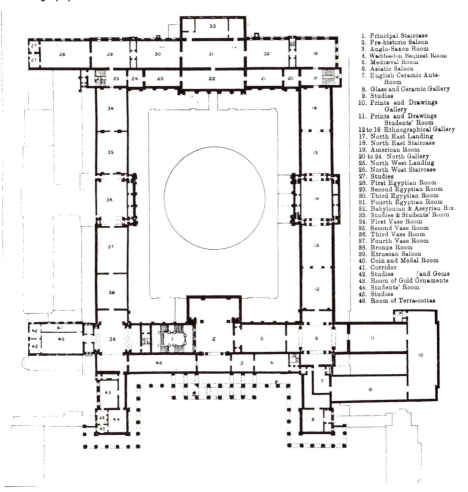

1. Principal Staircase
2. Pre-historic Saloon
3. Anglo-Saxon Room
4. Waddesdon Bequest Room
5. Mediæval Room
6. Asiatic Saloon
7. English Ceramic Ante-
 Room
8. Glass and Ceramic Gallery
9. Studies
10. Prints and Drawings
 Gallery
11. Prints and Drawings
 Students' Room
12 to 16 Ethnographical Gallery
17. North East Landing
18. North East Staircase
19. American Room
20 to 24. North Gallery
25. North West Landing
26. North West Staircase
27. Studies
28. First Egyptian Room
29. Second Egyptian Room
30. Third Egyptian Room
31. Fourth Egyptian Room
32. Babylonian & Assyrian Rm.
33. Studies & Students' Room
34. First Vase Room
35. Second Vase Room
36. Third Vase Room
37. Fourth Vase Room
38. Bronze Room
39. Etruscan Saloon
40. Coin and Medal Room
41. Corridor
42. Studies [and Gems
43. Room of Gold Ornaments
44. Students' Room
45. Studies
46. Room of Terra-cottas

9.1 Plan of the upper floor of the British Museum, London, 1899.

number of National and International, Trade and Colonial exhibitions. Designated as both 'scientific demonstration' and 'popular entertainment', these 'spectacles' were the physical embodiment of different and sometimes conflicting imperial ideologies.[7]

Particularly relevant here is the fact that these extremely popular and well-attended events, held on massive purpose-built exhibition sites nation-wide, often mobilized the same heady rhetoric of education and national coherence which was to become the hallmark of the museum's appeal to the public at this time. While it is beyond the scope of this article to deal in detail with these events, they are an important element in gauging and comprehending the terms on which the

ethnographic curators sought to define their domain and to establish their distinctive contribution to the national education programme after the 1902 initiative. In the face of the much greater popularity of the International and Colonial exhibitions, such a differentiation was only expedient.[8]

The obstacles that faced museum ethnographic curators in their efforts to acquire the same mass audience as the exhibitions without relinquishing any academic credibility, are exemplified through contemporary debates concerning the problems posed by the museum building. Through the internal organization and classification in conjunction with the inevitable restrictions imposed by the architecture itself, the museum guided its public through its collections in a specific though not always linear narrative, encouraging implicit if not explicit associations (Figure 9.1). In view of ethnographic curators' claims to the popular (albeit 'scientific') accessibility of the presentation inside the building, it is significant that the external 'shell', in the case of the larger municipal and national collections, was the 'temple' type. The imposing and distancing connotations of this type of public building were fully appreciated by many contemporary curators and resulted in a series of novel architectural schemes which were designed to overcome this obstacle.[9]

The Colonial exhibitions, on the other hand, were notable for precisely the absence of such a monolithic structure and an *apparent* lack of rigorously imposed control over the viewing space (Figure 9.2). This semblance of endless choice and unrestricted freedom was an important factor in the effectiveness of these exhibitions in obtaining a broad basis of consent for the imperial project. Through the rhetoric of 'learning through pleasure', the exhibitions achieved the sort of popular appeal that the museums dreamed of. Far more successfully than the museum whose exhibits could only signify the colonized subject, the exhibitions literally captured these potentially dangerous subjects and reproduced them in a 'safe' and contained, and yet accessible and supposedly open, environment.

This usually meant constructing mock 'villages' stocked with items that were purportedly characteristic and representative of a particular culture. Often peopled by troupes of professional performers from different African societies, Ceylon, or other participants from Ireland and Scotland, these 'villages' were always favourites for press attention. Railway and other transport networks within the exhibition grounds had the effect, reinforced by the text in the guidebooks, of allowing the visitor metaphorically to travel from one country to another without ever having to leave the site.[10] Consequently, they cultivated, at one and the same time, both a sense of the availability *and* the containability of those societies represented. The 'villages'

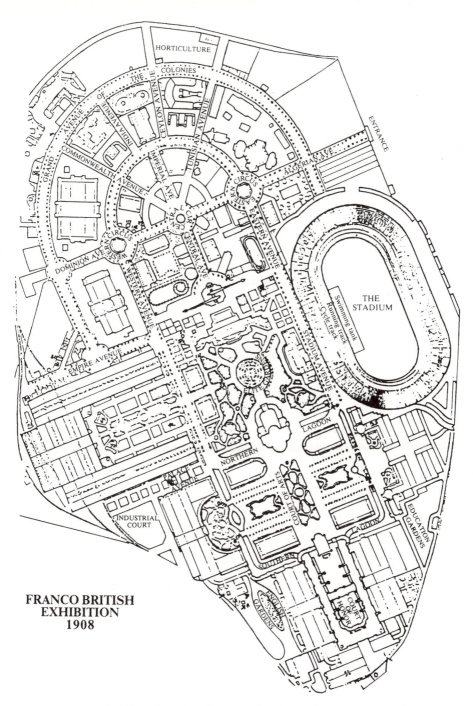

FRANCO BRITISH
EXHIBITION
1908

9.2 Plan showing the extensive site and attractions at the Franco-British Exhibition at the White City, London, 1908 (A. D. Brooks and F. A. Fletcher, *British Exhibitions and their Postcards*, privately printed, 1973, pp. 36, 37).

successfully fostered a feeling of geographical proximity, while the sense of 'spectacle' was calculated to preserve the cultural divide.[11] The possibility of possession as well as a sense of being an active participant at an 'event' rather than simply a passive observer were other aspects of the exhibition that were lacking in the museum experience. The vicarious tourism on offer was available to all who passed the turnstile at the entrance to the exhibition site, providing they had the sixpenny fee that allowed them access to the so-called 'villages'.

The ensuing competition for the same broad public necessitated the implementation of certain policies in order for the ethnographic curators, in their capacity as museum administrators, to distinguish their appeal from that of the exhibition. Such strategies served not only to differentiate the two institutions but, more importantly, to legitimize the museum as the domain of the 'authentic' educational experience in the face of the 1902 initiative.

The debates around the use of 'curio' and 'curiosity' as generic terms for ethnographic material is a case in point. Throughout the first decade of the twentieth century these terms were a bone of contention among museum officials and early acknowledged by them as one of the major hindrances to any effective educational use of ethnographic material. As evidence of the severity of the problem, the journal of the Museums Association published the following comments by an early visitor to the Liverpool County Museum's ethnographic rooms.[12] The visitor contended that one of the main troubles lay in the unfortunate fact that the public 'regard it as a storehouse of curiosities arranged to please and amuse. Certainly there are curiosities in every museum . . . though the fact may be insisted that their original and foremost purpose is to educate.'[13] The solution advised by the influential body of the League of Empire in 1904 was the 'orderly arrangement and the transformation of mere curios into objects of scientific interest by appropriate classification'.[14]

An early guide from the Horniman Museum in London provides a colourful illustration of the eclectic display policy that the association was up against. Prior to the museum's transference into the hands of the London County Council in 1901, descriptions of the Ethnographic Gallery focused on the slave trade or social groups like the Dahomeyans or the Zulu, both of whom were identified in the popular consciousness as aggressive African fighters with a penchant for human sacrifice and gratuitous violence.[15] Prior to entering the 'African and Japanese Room' the visitor would have passed through the Annexe where a collection of 'deities' from China, India, Scandinavia, and Peru were on offer, together with a Buddhist

shrine and 'a Chinese banner fixed on the wall, as also a "skeleton in the cupboard", the bones and ligatures all shown and named; it is labelled: – "the framework on which beauty is founded" '.[16] Glass table cases in one room contained Swiss, African, Eskimaux (sic) Indian, Japanese, and Chinese ivory carvings and a collection of Meerschaum pipes, while on top of such cases, 'are ranged glass Jars, containing Snakes, Lizards, Chameleons and a strange looking spiny lizard from Australia, together with a chicken with four legs and four wings but only one head, hatched at Surrey Mount' (the museum's earlier name).[17] The visit culminated with a walk through the 'Zoological Saloon' and a meeting with the much-publicized Russian bears, Jumbo and Alice, and the Sal monkey, Nellie!

II

The debates in the Museums Association over the classification of ethnographic material were considerably more complex and comprehensive than the resultant displays. The proposals revolved around the choice between a geographical or a typological organization and the relevance of either for different types of anthropological museum. The general consensus delegated the former as the responsibility of the national collections and the latter as that of the local museums. The material at hand was broadly recognized as falling into the two categories of a biological unit and a cultural unit. Ideally, since 'Man's physical evolution and anatomical structure related directly with all his activities', race and culture were assumed to be 'intimately connected'. The objective for the curator was to demonstrate the relationship between the two.[18]

Subdivisions according to tribe and nation, however, provoked discussion that provides us with a particular insight into the function of ethnographic collections in Britain. In this case, colonies as a category acquired the status of a homogeneous 'nation', as part of the British Empire. Evidently, by this definition 'nation' was too large a grouping to be practically implemented in a museum! Nevertheless, the fact that a territorial possession of the British Empire had no recognized status as a nation outside the empire as a whole, had particular ramifications for any colony represented in the displays. Clearly, examples of material culture from these countries functioned primarily as signifiers of British sovereignty.

Above all, in this search for the perfect classification system, there was the certainty that somewhere there existed a 'natural' grouping. Since culture was seen to vary according to geographical and regional factors and since environmental factors created regional affinities within the same groups, the 'natural'

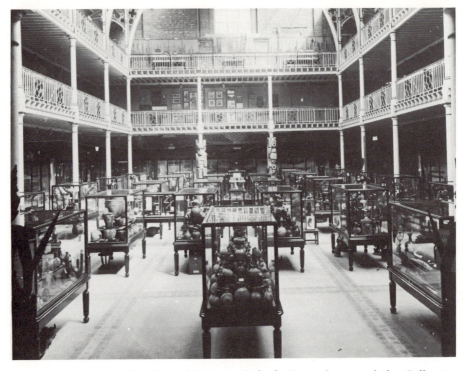

9.3 Pitt Rivers Museum, Oxford: General view of the Collection *c.* 1895.

choice was thought to rest with a geographical classification, which was the arrangement selected by most large British collections.

The other system advocated for smaller local collections was morphological or typological; the most exemplary, then as now, being the Pitt Rivers Museum in Oxford. The theoretical premiss that the past could be found in the present was explicitly laid out here, by inclusion of archaeological exhibits (mainly weapons and implements) from the Stone, Bronze, and Early Iron Ages, alongside typological 'series' of material culture from various colonies. It was this type of organization that was thought to illustrate more specifically the evolutionary nature of man. It concentrated on series of objects from all over the world, grouped according to function and divided into small exhibition groups with the aim of suggesting an evolutionary progression, by placing those forms classified as more 'natural' and organic at the beginning of a series culminating in more 'complex' and specialized forms.

A feature of Pitt Rivers's collection which set it apart from others originally the property of one collector (such as Frederick

J. Horniman), was that it was widely acknowledged as being 'no mere miscellaneous jumble of curiosities, but an orderly illustration of human history; and its contents have not been picked up haphazard from dealers' shops, but carefully selected at first hand with rare industry and judgement'.[19] The classification system employed was the touchstone of the collection, and it was this aspect that recommended it as a model for so many other museums (see Figures 9.3 and 9.4).

This comparative and evolutionary system of classification, which placed the value of anthropology as 'tracing the gradual growth of our complex systems and customs from the primitive ways of our progenitors' through the use of material culture from extant peoples (all of whom were colonized), was the chosen taxonomy throughout this period.[20] Despite academic anthropology's increasing disenchantment with evolutionary theory at this time, it remained the most prevalent means of displaying ethnographic material. Even where this was not necessarily the case in museums, it is clear that this principle had acquired a considerable currency among many members of the museum public. In 1902, for example, the British Museum erected an exhibition in the prehistoric room to demonstrate the use of tools and weapons prior to the use of metals. A review of the exhibition in the *Standard*, drew the readers' attention to the ethnographic galleries, 'Which should be visited, in order to study perishable objects still in use among races in a stage of culture corresponding more or less closely to that of the prehistoric races by whom the objects in this (the prehistoric room) were made'.[21] It is important to recognize that whether or not it was intended by the British Museum, it is symptomatic of the conjuncture that existed in the 'public' consciousness that the reviewer was able to make such a comparison between the two rooms.

III

Moreover, there is also evidence that the evolutionary paradigm served as a direct means of promoting support for that concept of class unity which was so essential to the ideology of social imperialism. Although the primary objective of the Oxford museum was to facilitate academic research, Pitt Rivers was no newcomer to the conception of the museum as an institution with a broad educational role, appealing to a diverse public. Indeed he actually saw himself as one of the main progenitors of this initiative. The early history of the collection included a short sojourn in 1897 at the Bethnal Green Museum in London's East End. It is not insignificant that it was located in an area of social deprivation and class conflict. In line with other similar

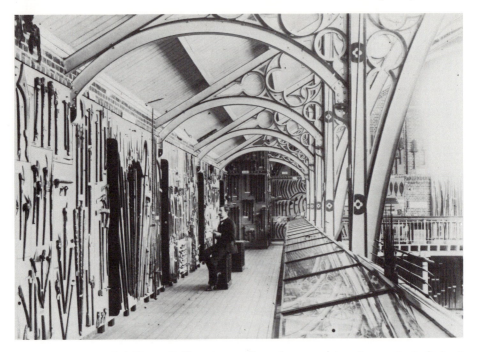

9.4 Henry Balfour in a gallery demonstrating the typological classi-
fication system, Pitt Rivers Museum, Oxford *c.* 1895.

institutions during the 1870s the exhibits were used as an aid in
the task of 'improving the masses'. Pitt Rivers's own intentions
towards the working classes were quite explicitly set out in rela-
tion to the use of his collection. His lecture to the Society of Arts
in 1891 makes it clear that not only was it important that the
schema of the display conform to a 'scientific' classification, but
that it was designed to educate 'the masses' to accept the existing
social order:[22]

> The masses are ignorant . . . the knowledge they lack is the
> knowledge of history. This lays them open to the designs of
> demagogues and agitators, who strive to make them break
> with the past . . . in drastic changes that have not the sanc-
> tion of experience.[23]

In the light of this statement, the persistent preoccupation with
evolutionary theory takes on new and more explicitly political
overtones. Through its tangible exposition in the physical
arrangement of ethnographic collections, it was a paradigm
which emphasized the inevitability and indispensability of the
existing social order and its attendant inequalities, while also

stressing the need for a *slow* move towards technological advancement.[24]

Where Pitt Rivers is explicit in his political affiliations in relation to class interests (while still maintaining that science was essentially 'objective' and non-partisan), later uses of evolutionary theory were less overtly concerned with social control. Nevertheless it was one of the most long-lived paradigms for the organization of displays of material culture from non-western societies and there are certain features of later applications which reproduce the political assumptions of this earlier model.

In both typological and geographical arrangement, for example, cultural elements characterized in the museum's literature as 'the intrusive, generalised elements of civilisation' of the non-European cultures, were deliberately eliminated. The curator was well aware that 'modern civilisation has broken over all natural limits and by means of railroads and ships carries its generalised culture to the ends of the earth'.[25] But the resultant transformation brought about by this contact was not the designated domain of the ethnographic curator.[26] For the material in these displays then, and by implication the cultures they represented, time stood still.

As a means of validating the expansion of ethnographic collections, the rhetoric often employed was one of the necessity of conservation and preservation in the face of the inevitable extinction of the producers of the material culture in their custody.[27] Paradoxically of course, anthropology's desire for government funding in the museum context, as in the academic sphere, necessitated its aiding and abetting this extinction by proposing itself as the active agent of the colonial government. By speeding the inevitability of such destruction, anthropologists encouraged the expansion of the market in ethnographia and boosted the already multiple values assigned to the discipline's objects of study, thus enhancing the status of anthropological 'knowledge', while simultaneously ensuring that those societies who produced such material culture maintained their position at the lower end of the evolutionary scale, since they were destined not to survive.

Since, unlike the International and Colonial Exhibition, the colonized subjects were not available in the 'flesh', their presence had to be signified by some other means. By 1902, the principle that physiognomic characteristics were accurate indicators of intellect and morality (early ingested as a tenet of certain anthropological theses) acquired new potency through its association with the eugenics movement, now marshalled more deliberately to the aid of the state. If evolutionism had ever looked like wavering, it was now here to stay. Consequently, in museum displays of material culture from the colonies, it was

common practice to include photographs, casts of the face or of the figure, or even skeletons and skulls. These were supposed to demonstrate more nearly the relationship between the inherited and cultural features of any race since

> the man himself as he appears in his everyday life, is the best
> illustration of his own place in history, for his physical aspect,
> the expression of his face, the care of his person, his clothes,
> his occupations . . . tell the story with much clearness.[28]

In 1903, the Physical Deterioration Committee had recommended the setting-up of an Imperial Bureau of Anthropology, whose anthropometry section was to be responsible for the collating of data on the physical measurements of those races coming under the jurisdiction of the British Empire.[29] Despite the fact that by 1908 the Royal Anthropological Institute was still fighting for some government support for the scheme, anthropometry had already been put to considerable use by anthropologists working within the British Isles.[30] The Physical Deterioration Committee, under whose aegis anthropometry came into its own in the following years, had originally been set up in response to medical reports on the poor state of health of the working class.[31] While this generated concern about the social circumstances of the mass of the population, the ensuing debate around the issues of deterioration versus degeneration was fuelled by the eugenists, who were still mostly convinced of the biological and inherited, rather than environmental, determinants of such a deterioration. If this complex 'scientific' philosophy had ambiguous implications for the working classes, its implications for colonized peoples are as insidious.[32]

The ethnographic curators' insistence that a person's physiognomy and the expression of the face could designate that person's position in history, takes on particular significance in the context of the preoccupation with and popular visibility of the 'science' of anthropometry. The emphasis on the body as a feature of museum display would have made it difficult to avoid an association with the work of Francis Galton or Karl Pearson, especially at a time of increasing government advocation of eugenics (often in conjunction with 'anthropological' investigations) as a means of strengthening the national stock. Evidently, the Museums Association was fully aware of eugenics policies and the means by which the ideology of selective breeding was implemented as part of a policy of national regeneration. That the 1907 presidential address to the association reads like a eugenics tract, therefore, comes as no surprise. At this meeting a proposal was put forward for an Institute of Museums where once again the emphasis was educational, but where, significantly,

of equal importance would be a regard for heredity teaching, seeing that the teaching of evolution must be based upon it. Here the endeavour would be to instruct the public in the part that inherited traits, character, virtues, vices, capabilities, temper, diseases, play in the destinies of men . . . and to popularise such branches of the subject of heredity as selection, variation and immunity.[33]

The fact that this practice of scrutiny so close to the prevalent eugenist ideology is present to such a degree in the discourse of the Museums Association is another indication of the museums' willingness to participate in the state's concern for national regeneration and points to a further complex of meanings, inscribed in the objects in their collections that was far closer to home.

IV

One means of gauging the potential of the ethnographic collections, both as vehicles for a nationalist ideology *and* as sites for the proliferation of contradictory and therefore productive knowledges concerning the colonial subject, is through an examination of the discourses around education in the literature of the Museums Association for the period 1902–10. It is through these discourses that museums constituted their 'ideal' publics and consequently the 'ideal' function of the collections in their custody.

Much of the discussion was formulated as a result of renewed interest in a concept known as the 'New Museum Idea'. The primary objective of this 'idea' was to 'afford the diffusion of instruction and rational amusement among the mass of the people' and, only secondly, 'to afford the scientific student every possible means of examining and studying the specimens of which the museum consists'.[34] The museum was thus designated as provider of both 'rational amusement' and 'scientific study' for two distinct publics while prioritizing one. What is particularly interesting here is that the 'New Museum Idea' was anything but new by 1902.

From 1902–10, however, the need to attract what was loosely referred to as 'the mass of the people' is revived as one of the central concerns for museum curators. How then was this purportedly liberal extension of the democratic principle of 'education for all' transformed through the institution of the museum, into a discourse inextricably implicated in imperial ideologies?

The notion of an educational practice based on the careful observation and study of museum collections had already been

integral to both the Victoria and Albert Museum and the
National Gallery from their inauguration in the 1850s. And here
also it was designed to attract a certain sector of the working
class. Although this early initiative came primarily from a left
middle-class intelligentsia, demands from within the working
classes for effective educational provision were later met by
workers themselves through the Social Democratic Federation
and other socialist organizations.[35] The fact that 'rational
amusement for the mass of the people' is reintroduced as a
focus of debate within the museums establishment in 1902, by
which time the composition and strength of the working class
had altered considerably, indicates a new function for this
concept.

With the rise of socialism and the subsequent organization of
a large proportion of its numbers, the working class presented
enough of a constituency to be a major target in the electoral
campaigns of both the Liberals and the Conservatives through-
out the period under discussion. If the museums wanted to carve
out a role for themselves compatible with either party's
campaign, it was essential that they were seen to address a broad
public.

By 1902 it is possible to determine more precisely the publics
that were sought by museums in Britain. The Education Act of
that year had made provision for time spent in museums by
children accompanied by their teachers to count as time spent in
school. The *Museums Journal* of the same year expressed the
hope that museums could occupy a territory 'neutral' enough to
provide a common meeting-ground for children from 'different
class backgrounds' in so far as those from private, board, and
voluntary schools were seen to benefit from the Act in this
respect. Furthermore, in conjunction with such adjectives as
'neutral' and 'objective', the museum was proclaimed as

> the most democratic and socialistic possession of the people.
> All have equal access to them, peer and peasant receive the
> same privileges and treatment, each one contributes in direct
> proportion to his means to their maintenance and each has a
> feeling of individual proprietorship.[36]

The notion of the museum as an institution that transcended
class barriers is particularly significant, not only in the light of
the persistent claims for class unity made by organizations
dedicated to juvenile education reform, but also in view of the
constancy with which this rhetoric was applied in organizations
dedicated to the 'ideal' of empire, who also mobilized the
pedagogic apparatus. The Primrose League, for example, was a
society that specialized in popularizing empire through lectures
in rural districts and was founded in 1883 with the aim of

'joining all classes together for political objects . . . to form a new political society which should embrace all classes and all creeds except atheists and enemies of the British Empire'.[37] By 1900 the league claimed to include in its membership 1.5 million workers and agricultural labourers. The special role of the museum for that sector of society described as having no life 'but this life of making money so that they can live', was 'to elevate [them] above their ordinary matter-of-fact lives'.[38]

By 1904 both the Horniman and the Manchester Museum were making claims for the conspicuous presence of both school groups and working-class participation. An exchange in the *Museums Journal* of the same year indicates the degree to which this was now a sensitive issue, in this instance, in the case of ethnographic collections. Free public lectures by A. C. Haddon, the Cambridge anthropologist, now advisory curator of the Horniman, had come in for sharp criticism since 'the time for delivery . . . is 11.30 am which showed that they were not altogether intended for the labouring classes'.[39] The Horniman felt this rebuff keenly enough to respond that despite this unfortunate time schedule 'large parties of workmen from various institutions . . . visited the museum.'[40]

Obviously one should not take the intention as a measure of its effectiveness, but it is important to point out here that the fact that both museums and other public displays of material culture from the colonies felt in some way obligated to define their publics as having a large working-class component, and in terms of an educational priority, is significant in itself, whether or not it was successfully implemented. The emphasis on this priority is more easily understandable in the context of social imperialism, whereby the working classes were wooed by both Liberals and Conservatives on two fronts: imperialism and social reform. As a principle, this policy was designed to unite all classes in the defence of nation and empire by focusing its campaign on convincing the working classes that their interests were best served by the development and expansion of empire.[41] And it is evident as early 1902 that museums' concern with constructing their image as an organ for popular education, was indeed specifically calculated to ensure that they had a recognized part to play in what was acknowledged at the Museums Association annual conference that year as the 'one great national work, the building up of the Empire through the elevation of the communities and the individual'.[42]

In 1903 this declared allegiance was compounded by the formation of the League of Empire, founded with the aim of bringing children from different parts of the empire into contact with one another, and 'getting them acquainted' with parts of it other than those in which they lived, through

correspondence, lectures, and exchanges. The museums played a crucial role in this organization and one which was clearly signalled by the distinguished line-up of museum directors and officials heading a subcommittee entitled 'School Museum Committee'. By 1907 the Museums Association was congratulating itself on the rather ambitious and dubious achievement of 'splendid success in educating and refining the masses of the population'.[43]

Museums' assumed role as specifically 'popular' educators concerned with encouraging working-class participation, received a further fillip of approval through a symposium organized under the aegis of the Empire League Educational Committee. This eight-day conference, held in London in 1907, had a special interest for those involved in museum work. A section was inaugurated specifically to deal with museums and education. Even outside of the parameters of its own professional caucus, the museum was clearly recognized as an important element in furthering the objectives of the empire.

Any interpretation of this educative principle advocated by both leagues, as simply a benevolent paternalism making use of empire as a potential 'living geography lesson', should be dismissed by 1908. By this time it had been transformed into a more specific call for the recognition of the superiority of the European races:

> The process of colonisation and commerce makes it every year increasingly evident that European races and especially those of our own islands, are destined to assume a position in part one of authority in part one of light and leading, in all regions of the world.[44]

Consequently since the British assumed the position of the world's teachers, it was essential that they were themselves well taught.

As late as 1909, the relevance of education, especially through the use of ethnographic collections was as persistent a theme in general museums discourse as it was in the discourse of the professional body of academic anthropology: the Royal Anthropological Institute.

> Heaven-born Cadets are not the only Englishmen who are placed in authority over native races. . . . There are Engine Drivers, Inspectors of Police . . . Civil Engineers of various denominations . . . to mention only a few whose sole opportunity of imbibing scientific knowledge is from the local museum of the town or city in which they have been brought up.[45]

Clearly certain class sectors were seen as an indispensable

means of promoting an image of the museum as the site of consummation of a seamless and unproblematic national unity. Furthermore, the fact that the terms of this address are borrowed, in no small measure, from a 1907 speech by that ardent exponent of social imperialism, the Liberal MP Viscount Haldane, places it firmly within this political discourse.[46]

V

Part and parcel of this ideology of national unity was the constitution of the concept of a National Culture, and here too the ethnographic curator played a particular role. As early as 1904, Henry Balfour, curator of the Pitt Rivers Museum in Oxford and president of the Anthropological Institute, laid plans for what he called a museum of national culture. Balfour went as far as specifying that this museum would denote 'British' in nature rather than possession, which was rather the function of material culture from the colonies as well as that in the larger survey museums. 'We want a National Museum,' he said. 'National in the sense that it deals with the people of the British Isles, their arts, their industries, customs and beliefs, local differences in physical and cultural characteristics, the development of appliances, the survival of primitive forms in certain districts and so forth.'[47] Although this objective was not realized in the museum context until much later, the proposal for a national, or, more accurately, 'folk' museum, is a persistent element in museums' discourse throughout the years 1902–12.[48]

The same rhetoric of extinction and preservation, once applied by academic anthropologists to specifically colonized races, as a means of validating anthropology's expansion, was now systematically applied to certain communities within the British Isles. Furthermore, this conception of a national British culture as a resilient 'folk' culture, surviving in rural communities, was a popular fantasy shared by those at both ends of the political spectrum, and certain members of the middle-class intelligentsia assumed it to be their responsibility to bring it to light in the common cause of national unity.[49] Since 1905 supposed 'folk' culture had already been officially mobilized in the sphere of juvenile education to instil the correct patriotic spirit. By October 1907 Cecil Sharp, that untiring middle-class campaigner for the revival of 'folk song', had published his collection of what he defined as 'authentic' folk music since it was

> not the composition of an individual and as such, limited in outlook and appeal, but a communal and racial product, the expression, in musical idiom, of aims and ideals that are primarily national in character.[50]

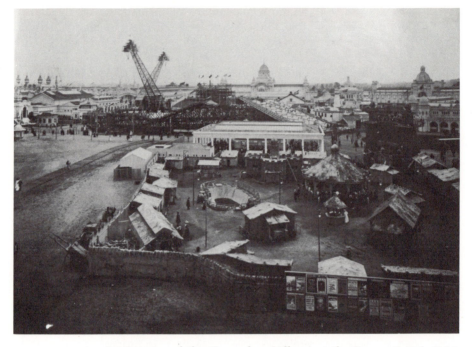

9.5 Interior of the 'Senegalese Village' at the Franco-British Exhibition, London, 1908.

While the effects of this discourse were visible through anthropological practice by those working within the discipline, it was not incorporated into museum practice until much later. Its visibility in the public domain lies rather in the sphere of the 'amusement' section of the International and Colonial Exhibition. Here, Irish and Scottish villages were reconstructed together with Dahomeyan, Somali, and Senegalese villages. Without exception these are all presented through the official guidebooks as quaint 'survivals' in the anthropological sense. But while both European and African villages were produced as 'primitive', it was a 'primitiveness' that had already been clearly qualified in both cases, in terms that would have been familiar to a large proportion of the exhibition public through the discourse on national tradition constructed through the renewed interest in folklore. Consequently the proximity of these 'villages' on site had the inverse effect of accentuating the distance between the European 'primitive' and its colonial counterpart. This was further reinforced by the suggestion in the guidebooks that, even in these supposedly simple European communities, there was evidence of an inherent superiority in relation to the colonized races represented. The predominance

9.6 Entrance to the 'Irish Village', Ballymaclinton, at the Franco-British Exhibition, London, 1908.

of adjectives such as 'healthy', 'beautiful', and 'industrious', together with descriptions of the Irish and Scottish living quarters as 'spacious', compare favourably with the constantly repeated assurances that the Africans are in fact much cleaner than they look.[51] (See Figures 9.5 and 9.6.) Similarly, while the guidebooks are full of references to the ancient traditions of the Irish and the Scots, the Africans are accredited with no such history or tradition (Figure 9.7). [52]

Consequently, what at first appears to constitute an irreconcilable contradiction – the construction of certain 'British' communities as themselves essentially 'primitive' – must be understood as a means by both museums and exhibitions of establishing the notion of an intrinsically national culture through the discourse of origination. In addition, by emphasizing the relative 'difference' of the black colonized subject, both the museum ethnographic collection and those 'villages' in the International and Colonial exhibitions representing these peoples, reinforced the illusion of a homogeneous British culture.

Because the educational policies adopted by the museums over the period 1902–10 could be appropriated by either the

9.7 Interior of the 'Irish Village', Ballymaclinton, at the Franco-British Exhibition, London, 1908.

more conservative ideology of national efficiency or the more liberal ideology of social reform the ethnographic collections were able to negotiate a particular space for themselves. In an educational capacity they operated in the conjuncture between popular and scientific theories of race and culture, and thus acted as an agency for different imperial ideologies. There was, however, an ambivalence underpinning the relationship of the ethnographic curators to the colonial government. By declaring that their aim was to provide 'objective' education on 'neutral' territory those anthropologists working within the museums establishment claimed a degree of independence from specific government policies. The emphasis on the 'scientific' nature of the knowledge produced through the classification and organization of their collections was calculated to reinforce their role as purveyors of 'objective truth'. At the same time, as a deliberate strategy of survival, the new academic discipline of anthropology relied on the argument that anthropological knowledge as produced through museum collections, was an essential training for the colonial servant and an indispensable facilitator in the subjugation of the colonies. Furthermore, the focus on evolutionary paradigms to represent material culture from the

colonies to British publics, reinforced some of the worst aspects of those racial stereotypes disseminated through the more propagandist International and Colonial Exhibitions.

VI

Now, nearly a century later, we find ourselves on the threshold of another educational initiative, equally optimistically referred to as 'Education for All' under the rubric of multiculturalism.[53] It is a moment when debates on the restitution of cultural property take up prime time in the media. It is also a time dominated by the euphemism of 'rationalization' for the arts, humanities, and education and by a government characterized by the outright hostility to ethnic minorities of Margaret Thatcher's infamous aliens speech and by the jingoism of her Falklands victory speech on 2 July 1982:

> We have learned something about ourselves, a lesson which we desperately needed to learn. When we started out, there were the waverers, and the fainthearts. . . . There were those who would not admit it . . . but – in their heart of hearts – they too had their secret fears that it was true: that Britain was no longer the nation that had built an Empire and ruled a quarter of the world. Well, they were wrong.

How does a museum displaying the material culture of other nations negotiate a position of relative autonomy from the rabid xenophobia characterized by Thatcher's speech, while at the same time justifying its expansion and maintenance?

The controversy generated over an exhibition at the Museum of Mankind, *The Hidden Peoples of the Amazon*, is a useful marker of the problems involved in working towards any self-critical representation of other cultures within a museum context. It also demonstrates how difficult it is to escape the legacy left by the historical formation of the institution itself.

On 8 August 1985 the museum was picketed by representatives from Survival International (S.I.) and two Indians representing different Indian rights organizations. The demonstration concerned not so much the absence of any culture contact, assimilation, and adaptation in the display but, rather, the lack of acknowledgement of the dialectical and dynamic relationship of diverse Amerindian populations to such contact – not simply at the level of some sort of hybridization of material culture – but at a much more fundamental social level. It concerned, in fact, the absence of any evidence of the ongoing struggle between the Indians and the Brazilian government or indeed of any resistance by organizations such as themselves, in the display. According to Richard Bourne (chairman of S.I.)

one of the objections against incorporating evidence of such resistance into the exhibition was that it would have disrupted what was an essentially '*objective*' account.[54] It is also true to say that without the goodwill of the Brazilian government it would have been extremely difficult to have carried out the extensive fieldwork necessary for the exhibition.

Evidently today, more than ever, the public ethnographic museum is caught between two stools. On the one hand, the museum still perceives itself as both purveyor of 'objective' scientific knowledge and as a potential resource centre for a broad-based multicultural education. On the other hand, it is clearly hostage to and sometimes beneficiary of, the vagaries of different state policies and political regimes, and aware of the necessity of being seen to perform some vital and visible public function to justify its maintenance, while fighting to preserve a measure of autonomy.

A surprising degree of correspondence evidently still exists between the International and Colonial exhibitions of old and certain contemporary ethnographic display practices. Now that both scientific exegesis and popular entertainment are contained within the same edifice, the invitation to partake of a vicarious tourism is as strong as ever an incentive to visit the museum.

Furthermore, despite any criticism levelled at the museum as an institution *its* authority speaks louder than the voices of those represented within its walls, as this passage from a recent *Arts Review* testifies:

> During a week in or around the Amazon, I found it difficult to escape from the other tourists and enjoy even a semblance of the jungle. . . . This was all white man's territory and for a *truer* description of life with the Hidden Peoples of the Amazon I would recommend both this exhibition and the fascinating book that accompanies it.[55]

NOTES

This chapter is a revised version of a paper delivered as part of the 'Primitivism' series of seminars organized by Susan Hiller at the Slade School of Art in 1986 and at the London Conference of the Association of Art Historians in March 1987. This version is reprinted, with some amendments, from The Oxford

1 Salman Rushdie (1982) 'The new empire within Britain', *New Society* 62, 1047: 417.

2 (March 1985) *Education for All: the Report of the Committee of Inquiry into the Education of Children from Ethnic Minority Groups*, London: HMSO. The committee was initially chaired by Anthony Rampton until 1981 when Lord Swann took over. A. Sivanandan's comments on the distinction between a multiculturalist education initiative and one that is actively anti-racist, are worth citing in full here:

> Now there is nothing wrong with multiracial or multicultural education as such, it is good to learn about other races, about other people's cultures. It may even help to modify individual attitudes, correct personal biases. But that . . . is merely to tinker with educational methods and techniques and leave unaltered the whole racist structure of the educational system.

Art Journal, *1988,*
11, 2. My thanks to
Susan Hiller, Fred
Orton, Michael
Orwicz, and Alex
Potts for their criti-
cal comments on
earlier stages of this
essay.

And education itself comes to be seen as an adjustment process within a racist society and not as a force for changing the values that make that society racist. 'Ethnic minorities' do not suffer 'disabilities' because of 'ethnic differences' . . . but because such differences are given a differential weightage in a racist hierarchy. Our concern . . . was not with multicultural, multi-ethnic education but with anti-racist education. Just to learn about other people's cultures is not to learn about the racism of one's own. (A. Sivanandan (Autumn 1983) 'Challenging racism: strategies for the 80's', *Race and Class* xxv, 2: 5)

For an excellent analysis of the multicultural experiment in one case study, see also Sneja Gunew, 'Australia 1984: a moment in the archaeology of multiculturalism', in F. Barker *et al.*(eds) (1985) *Europe and its Others*, Vol. 1. Chelmsford: University of Essex, pp. 178–93.

3 Agenda of the annual conference of the Museum Ethnographers Group (M.E.G.) (a Subcommittee of the Museums Association), held on 25 April 1986, at the Bristol Museum and Art Gallery. Item 9.2 reports a discussion on the *'new'* (my emphasis) importance of multicultural education and a request from some members that the M.E.G. form a policy regarding dealings with the apartheid regime in South Africa.

4 See, for example, the recent debates in one of the two journals of the Royal Anthropological Institute: Jean La Fontaine (president of the Institute) (1986) 'Countering racial prejudice: a better starting point', *Anthropology Today* 2, 6:2; Mary Searle-Chatterjee (1987) 'The anthropologist exposed: anthropologists in multi-cultural and anti-racist work', *Anthropology Today* 3, 4: 16–18; Stephen Feuchtwang (1987) 'The anti-racist challenge to the U.K.', *Anthropology Today* 3, 5: 7–8; Brian V. Street (1987) 'Anti-racist education and anthropology', *Anthropology Today* 3, 6:13–15.

5 For a detailed analysis of the 1902 Education Act, see G. R. Searle (1971) *The Quest for National Efficiency*, Berkeley and Los Angeles, Calif.: pp. 201–16; E. Halevy (1939) *History of the English People* (Epilogue: 1895–1905, Book 2), Harmondsworth: pp. 14–29; B. Simon (1965) *Education and the Labour Movement 1870–1920*, London: pp. 208–46.

6 The Museums Association was founded in York in 1888 at the initiation of the York Philosophical Society as the professional body of museum curators and administrators. The journal, founded in 1901, was to represent the interests of all types of museums, within Britain mainly, but also in the empire and later the Commonwealth and Dominions. The aim of the monthly publication was inter-communication between the museums in the association.

7 One of the largest purpose-built exhibition sites in England was London's 'White City', built in 1907 by Imre Kiralfy and so called because it covered approximately 140 acres. For more details concerning these exhibitions in Britain see Annie E. Coombes (1985) ' "For God and for England": contributions to an image of Africa in the first decade of the twentieth century', *Art History* 8, 4:453–66, and 'The Franco-British Exhibition: packaging empire in Edwardian England', in J. Beckett and D. Cherry (eds) (1987) *The Edwardian Era*, Oxford: pp. 152–66; Paul Greenhalgh (1985)

'Art, politics and society at the Franco-British Exhibition of 1908', *Art History* 8, 4:434–52; John M. Mackenzie (1984) *Propaganda and Empire*, Manchester: pp. 96–121.

8 The distinction was implicit rather than explicit and is demonstrated through the absence of almost any discussion or mention of exhibitions in the pages of the *Museums Journal* despite the active participation by members of the Museums Association and in particular by anthropologists. Such silence is stranger in view of the fact that many museums including the Horniman, Liverpool County Museum, and the Pitt Rivers Museum acquired ethnographic material from such sources.

9 See, for example, B.I. Gilman (1923) *Museum Ideals of Purpose and Method*, Boston, Mass.: pp. 435–42.

10 See, for example (1909) *The Imperial International Exhibition, Official Guide*, London: p. 43. Describing the 'amusement' entitled the 'Dahomey Village', the writer says, 'Entering the Gateway here, we are at once transported to Western Africa.' The entry for the 'Kalmuck Camp' in the same guide (p. 45) began: 'Entering their camp, we first detect them coming down the distant steep mountains with their camels and horses.'

11 This division was clearly not maintained as rigorously as the authorities would have wished. See Ben Shephard, 'Showbiz imperialism; the case of Peter Lobengula', in John M. MacKenzie (ed.) (1986) *Imperialism and Popular Culture*, Manchester: pp. 94–112. This examines an instance of marriage between an African 'performer' and a white woman and the ensuing *furor* over miscegenation in the press.

12 The *Museums Journal* contained regular comments from visitors to the various collections.

13 (March 1903) *Museums Journal* 2: 269.

14 ibid. (September 1904) 2: 101.

15 n.d. (pre 1901) *First Guide to the Surrey House Museum*: p. 9.

16 ibid.

17 ibid., p. 19.

18 W.H. Holmes (1902) 'Classification and arrangement of the exhibits of an anthropological museum', *'Journal of the Anthropological Institute* xxx111:353–72; Christine Bolt (1971) *Victorian Attitudes to Race*, London: p. 9.

19 (January 1883) *University Gazette*: 4.

20 William H. Flower (September 1889) 'Inaugural address to the British Association for the Advancement of Science', *Nature* 40: 465.

21 (3 March 1902) *The Standard*.

22 Lieutenant-General Pitt Rivers (18 December 1891) 'Typological museums as exemplified by the Pitt Rivers Museum at Oxford, and his provincial museum at Farnham, Dorset', *Journal of the Society of Arts* XL:115–22. This was also the theme of an address to the British Association for the Advancement of Science, at Bath, 1888. For a history of the Pitt Rivers collection up to 1900 see William Ryan Chapman (1981) 'Ethnology in the museum: A.H.L.F. Pitt Rivers (1827–1900) and the institutional foundation of British anthropology', 2 vols (unpublished PhD dissertation, University of Oxford).

23 Pitt Rivers, op. cit., p. 116.

24 See Pitt Rivers, op. cit., p. 119. Evolutionary theory as applied in Pitt Rivers's collection clearly also had implications for the 'new woman'. In this passage Pitt Rivers describes a series of crates shown carried by women from various countries. According to him these were 'collected expressly to show the women of my district how little they resemble the beasts of burden they might have been if they had been bred elsewhere.'

25 Holmes, op. cit., p. 355.

26 ibid.

27 See, for example (1894) *Annual Report of the Committee of the Public Libraries, Museums and Art Galleries of the City of Liverpool*, Liverpool: p. 15; (November 1910) *Museums Journal* 10: 155.

28 Holmes, op. cit., p. 356.

29 See (1911) *Man 11:157; A. Watt Smyth (1904) Physical Deterioration: Its Causes and the Cure*, London: pp. 13–14.

30 (1908) *Journal of the Royal Anthropological Institute* xxxvlll: 489–92; (1909) *Man* 9:128 describes the 'science' as demonstrating 'how measurements of physical and mental characteristics are a reliable test of physical deterioration and progress'.

31 See Watt Smyth, op. cit.

32 G. R. Searle (1976) *Eugenics and Politics in Britain 1900–1914*, Leiden; G. R. Searle, 'Eugenics and class' in Charles Webster (ed.) (1981) *Biology, Medicine and Society 1840–1940*, Cambridge: pp. 217–43; David Green (1984) 'Veins of resemblance: Francis Galton, photography and eugenics', *Oxford Art Journal* 7, 2: 3–16, provides a useful documentation of the interrelation between photographic techniques of recording social 'deviancy' and the classification deployed by some eugenists; Anna Davin (1978) 'Imperialism and motherhood', *History Workshop Journal* 5:9–65, gives an excellent analysis of the contradictory implications of eugenic theory for British women. See also Jeffrey Weeks (1981) *Sex, Politics and Society: the Regulation of Sexuality since 1800*, London; Frank Mort (1987) *Dangerous Sexualities: Medico-Moral Politics in England Since 1830*, London.

33 (December 1907) *Museums Journal* 7: 203.

34 William H. Flower, 'Presidential address to the Museums Association, London, 1893'; reprinted in W. H. Flower (1898) *Essays on Museums and Other Subjects Connected with Natural History*, London: p. 36.

35 For a detailed analysis of educational initiatives from within the working class see Simon, op. cit.

36 (September 1902) *Museums Journal* 2: 75.

37 See J. H. Robb (1942) *The Primrose League, 1883–1906*, London: p. 148.

38 (July 1902) *Museums Journal* 2: 11.

39 ibid. (February 1904) 3: 266.

40 ibid. (January 1905) 4: 235.

41 For a fuller discussion of the policy of social imperialism, see Bernard Semmel (1960) *Imperialism and Social Reform*, London; and Searle (1971) op. cit.

42 (July 1902) *Museums Journal* 2: 13.

43 ibid. (July 1907) 7: 8.

44 ibid. (July 1908) 8: 12.

45 ibid. (November 1909) 9: 202.
46 Viscount Haldane (1912) *Universities and National Life*, London: p. 69 (given as a rectoral address in 1907). See also Viscount Haldane (1902) *Education and Empire*, London; Simon, op. cit., ch. 5, 'Imperialism and attitudes to education'.
47 Henry Balfour (1904) 'Presidential address', *Journal of the Anthropological Institute* xxxlv: 16.
48 See, for example (June 1904) *Museums Journal* 3:403; ibid. (1901–2) 1:173, ibid. (July 1909) 9:5–18.
49 D. Harker (Autumn 1982) 'May Cecil Sharp be praised?', *History Workshop Journal* 14: 54.
50 C. Sharp (1907) *English Folk Song: Some Conclusions*, privately printed: p. x; quoted in Harker, op. cit., p. 55.
51 See, for example (1908) *The Franco-British Exhibition Official Guide to the Senegalese Village*, London: p. 8.
52 See, for example (1908) *The Franco-British Exhibition Official Guide*, London: p. 53. This lists no fewer than five 'realistic reproductions' of 'ancient monuments' included in the 'Irish Village of Ballymaclinton'.
53 See note 2.
54 R. Bourne (29 November 1985) 'Are Amazon Indians museum pieces?', *New Society* (my emphasis).
55 B. Beaumont-Nesbitt (24 May 1985) 'The hidden peoples of the Amazon', *Arts Review*: 253.

10 Art and meaning

SIGNE HOWELL

In Paris during the early decades of the twentieth century when Picasso, Derain, and other artists were visiting Trocadero to look at African sculpture, Durkheim and his associates in the *Année Sociologique* were developing the new discipline of sociology. They suggested we regard human behaviour, ideas, and institutions of all kinds as social facts: political organization is a social fact, death is a social fact, so too are marriage rules, rituals of all kinds, as well as concepts of space, time, and self. My purpose in this chapter is to view art in the same light – and more specificially the 'art' of other cultures.

In support of my argument, I will suggest that indigenous psychological explanations similarly are social facts; indeed I even go as far as to claim that the body and its parts should be, in the present context, so regarded. To a still greater extent, art products of all kinds should be understood as social facts. They are all social facts in so far as they are imbued with social meaning, and *this meaning cannot be divorced from the objects or acts themselves*. According to Durkheim, social facts should all be studied as 'things' whose significance in a particular social setting is constructed by the collective representations of the members of that society. The phenomena are not 'natural' or neutral, they cannot exist outside society. Thus, no social fact can be studied objectively, divorced from its context and contextual meaning.

Meaning is integrally part of epistemology, and anthropologists are becoming increasingly interested in the indigenous epistemologies of other cultures, accepting that questions may be formulated, and answers sought, in ways very different from the procedures developed in a western tradition. This involves attempts to understand the underlying principles guiding practice and a presentation in terms of the indigenous ideology. In summary, knowledge of all kinds is socially constructed.

Having briefly outlined the approach to anthropology which I myself favour, I now turn to the main part of my chapter. It falls into several parts, which may seem unrelated but which I hope to bring together. I shall start by discussing some problems

of cross-cultural interpretation of emotions and gestures, an issue facing anthropologists which is also of relevance to anyone using, or interpreting, 'art' and artefacts from other cultures. It seems to me that there are two possible approaches to such an enterprise. First, one can assume a universality in the experience of being human which means one need not worry about the specificity of cultural context. I will consider whether one *can* assume any universal meanings, and I will highlight some of the methodological problems in trying to establish any such. Alternatively, one can claim that experiences of all kinds, and their expression individually and aesthetically, can only be properly approached from within the context of a specific ideology. Depending on which view one takes, the approach to cross-cultural borrowing of concepts, of cultural artefacts, or of art, and to the validity of such borrowings will vary, and I will end by considering some of the possible ways in which one may borrow from other cultures, giving some examples from very different societies.

INNER STATES AS UNIVERSALS?

With regard to the position that claims universality of experience, I wish to take as my starting-point some comments made by art critic Peter Fuller (1983 and 1985) which bring together, in a single passage, both of the issues which I am discussing here – the appreciation of emotion and the appreciation of art. Fuller is highly critical of much recent Marxism, which, he says, ignores the biological and physical levels of human life and exaggerates the determinative significance of economic and political factors.

Quoting Timpanaro, Fuller suggests that there is an unchangeable human condition that continues regardless of changing historical circumstances. He says, 'Since the beginning of civilization, men and women have lived their lives in bodies which are very much as they are now. Though everything is mediated through historical circumstances, the range of human emotions has not altered much either' (1985: 7). Making a similar point elsewhere, he says 'there are very important elements of human experience that remain relatively constant and are subject to change only through the infinitely slow processes of biological evolutions, not through social, political, or economic developments' (1983: 3). The relative constants of human experience are birth, infancy, sexuality, love, mourning at the loss of others, death, and a sense of smallness given the limitlessness of the cosmos. It is, of course, exactly these sorts of phenomena that I have suggested should be regarded as social facts, not simply biological ones. I return to this below.

Fuller refers to an exchange with a 'prominent post-structuralist art-historian'. At one point, he said to her,

> 'Well, then how do we know that the Laocoon is in pain?'
> [Laocoon was the priest of Apollo who, by breaking his vow
> of celibacy, fathered twin sons and aroused Apollo's anger.
> Apollo arranged for two sea-snakes to strangle them. A Greek
> sculpture depicting this event, from the second century BC,
> and now in the Vatican, has made the Laocoon famous.]
> To which she replied 'We know the Laocoon is in pain
> because we have studied the modes of production prevailing
> in Greece at the time it was made, and the signifying
> practices to which it gave rise.' To which I replied, 'But
> Griselda, he's being strangled by a sea-monster.' 'Yes,' she
> retorted, 'but we have no means of knowing whether or not
> he's enjoying it' . . . 'And she was not joking.' (1983: 3)

Fuller cannot accept such reasoning, because he insists that the quality of human emotional experience is universally identical; the onlooker *does* understand the meaning of the sculpture, being a representation of the human body in suffering. He does not deny the enhancing value of historical or social knowledge in particular cases, but argues that we *need* know nothing of the Greek myth on which the sculpture is based, about the cosmological or religious context in which the myth is set, or the cultural context in which the sculptor made the sculpture. The mere fact that we are all human beings is sufficient to create a deep bond of understanding – a bond which traverses space, time, and cultural contexts.

Is this really so? Can we assume an identity in human levels of experience and conceptualizations of experience? That is, first, do all humans perceive the world in identical ways? And secondly, are the meanings attached to our perceptions also identical? Do we all have the same emotions, do we all react in emotionally similar ways when confronted with a work of art? These sorts of assumptions are at the basis of the belief of many westerners that they do indeed 'understand' tribal art. But, in the words of Sahlins, an anthropologist extremely critical of biological explanations for social phenomena,

> Between the basic drives that may be attributed to human
> nature and the social structures of human culture there enters
> a critical indeterminacy. The same human motives appear in
> different cultural forms, and different motives appear in the
> same forms . . . culture is not ordered by the primitive emo-
> tions of the hypothalmus; it is the emotions which are
> organized by culture. (1977: 11, 13)

I agree with Sahlins that this is indeed so, and that the

anthropologist has little option but to study motives, ideas, emotions, ritual, and 'art' as these are expressed within a particular society, by placing them in an overall context. Do we all then react in emotionally similar ways when confronted with a work of art? Quite apart from the problems which are involved in defining a work of art, I would maintain that the problem of assessing individual reception of 'art' work is even more problematic, especially when we cross cultural boundaries. In view of this, can we agree with Fuller in his statement that a confrontation with a Henry Moore sculpture will always produce in men and women a response – regardless of 'whatever social transformation may or may not take place' because they are 'rooted in the imaginative and affective response to the mother's body' (1985: 7)? This is an assertion with very little empirical basis. Not all cultures perceive the relationship mother/child in the way we do in the west, where that particular relationship has received an enormous amount of cultural elaboration, largely shaped and legitimized by Christian dogma and the idealization of the Madonna/child relationship, finding numerous expressions in the visual arts over many centuries. It may be reasonable, in view of this, to assume some commonality in experience among westerners brought up within Christian ideology and familiar with the traditions of western fine arts. We can assume no such response in members of cultures whose ideologies do not emphasize this particular bond. A response there may be, but very likely it will be of a different kind. So that, when Fuller states that 'aesthetic response has its roots in congenital, instinctive response' (1985: 6) and that research on such 'physiological roots of aesthetics' can teach us why 'we can enjoy . . . medieval madrigals, Japanese kimonos, Islamic architecture, Navojo Indians rugs' (ibid.), I can register only profound doubt. To talk of human congenital and instinctive responses is highly dubious, to state that 'we' enjoy cultural artefacts from other times and places existentially cannot be the case. 'We' are shaped by the aesthetic values of our peers. By all accounts, our great-grandparents did not think much of medieval madrigals, and Japanese Noh theatre bores all but the most intrepid European. The Norwegian folk instrument, the dulcimer, is a string instrument where the pitch of each tone is determined by the position of its frets. In the 1880s, a well-known dulcimer musician was told by an urban musical expert that two of the tones were 'false'. He offered to 'correct' this by moving the relevant frets. The result was a classically tempered scale which was so incompatible with the musician's own conception of music that he gave up the instrument altogether (Sinding-Larsen 1988).

Let me turn briefly to the Chewong, a hunter-gatherer society

in the tropical rain forest of the Malay Peninsula among whom I conducted fieldwork for nearly two years (see Howell 1989). While I do not disregard the likelihood of some kind of a response in a Chewong individual if confronted with a Henry Moore sculpture, I do not think that it would be along the lines suggested by Fuller. The Chewong do not make sculptures in stone – or in any other materials. The only form of visual images they make are highly stylized representations of certain plants and animals in their environment. These are represented on two objects only, the blowpipe and the cane girdle worn by women. The Chewong have no tradition of visually depicting humans or human relationships. Furthermore, while they love their children very much, they do not single out the mother/child bond as stronger or more profound than the father/child one. Nor do they attribute any transcendental quality to either relationship. I would be extremely surprised if a Chewong person told me that s/he was deeply moved by Moore's rendering of mother and child. It is not something that provokes special emotion response.

Another society whose members fail to respond in the expected way to a Henry Moore sculpture, is the Chinese of Hong Kong – if one is to believe a report in the *Sunday Times* (19 January 1986: 7). The largest exhibition of Henry Moore sculptures to be staged anywhere was mounted throughout Hong Kong. ' "What are these strange bodies?" wailed Candy Wong, a secretary. "I am frightened. I do not like these things. Why they have holes where their stomachs should be? Is not possible to tell what they are meant to be doing. Is most confusing. Bad statues. Mr Moore bad man." '

Conversely, let us imagine a society where the production of stone sculptures is common and where sculptures denoting a woman and a child are made. Even here, we could not assume that our western responses to such a sculpture correspond to the intentions of the sculptor, or to the responses of the members of the society where it was made. Our response is legitimate, but it must be regarded as largely shaped by our own ideology, not an expression of a universal, innate one. We must not confuse the issues. For reasons that I will elaborate in this chapter, we cannot assume identity in experience, or in the expression of experience, across cultures. Therefore, I am not in sympathy with Fuller in his argument with the 'post-structuralist'.

To understand social phenomena, we have to abandon a search for causes, and seek instead to explicate ideas and practices in terms of a context of meaning. Thus both the human biology and modes and relations of production are constructed within associated meanings and values which shape their partic- ular form at particular times and places. I am pointing to a

domain of relations in which meaning and values are created and expressed and the total discourse of ideas and practice is formed. Ideas concerning reality cannot, I argue, be treated as something separate from reality. Nor can ideas and practice be seen as two separate domains. Both inform and are informed by each other. I therefore do not say that one is predicated upon the other, but that they are both informed and changed by interaction. Ideas and values are not created individually, but are part of an overall social process. They are not static, but respond to new ideas, phenomena, and outside influences. This last point is particularly important in respect to western attitudes to non-western art and outside influences.

Bearing in mind Fuller's statements, I shall now consider some of the anthropological problems encountered in the study of human meaning-making with particular reference to the human body and its psychological aspects.

Durkheim and his associates, particularly Mauss and Hertz, addressed themselves to a cross-cultural investigation of the Aristotelian categories of the human mind; that is, ideas of space, time, number, class, cause, substance, and self. Their concern was to establish whether these categories were indeed innate, as Aristotle and most subsequent western philosophers had claimed, or whether some at least were social in their origins and formulation. In each case the French theoreticians concluded a social origin of the phenomenon under study, and firmly rejected any innate characteristics of human make-up as an explanatory factor. All formulations of these categories are, they argued, purely, and in all instances, the product of the particular collective representations of the society in which they occur.

Such an extreme position fails to account for the origin of collective representations in the first place and begs as many questions as it answers. As Steven Lukes, one of the foremost commentators on Durkheim, says:

> No account of relations between features of a society and the ideas and beliefs of its members could ever explain the faculty, or ability, of the latter to think spatially and temporally, to classify material objects, and to individuate persons, to think causally, and in general to reason. . . . We cannot postulate a hypothetical situation in which individuals do not think by these means, since this is what thinking is. (1973: 447).

If one agrees with this position, which, it must be emphasized, is not founded in biological determinism, but which nevertheless accepts as a basic premiss some universal, innate, human proclivities or 'human hard wiring', then the anthropologist

can try to ascertain how members of a particular society conceptualize themselves and their environment and the social mechanisms by which the cognitive processes are developed. While from a formal and logical point of view the 'hard wiring' must be assumed identical in all human instances, specificity and degrees of elaboration vary enormously between cultures.

There would appear to be certain cognitive capacities and constraints which can be accepted as universal (the hard wiring) even though what these actually *are* has not been established, nor, perhaps, can ever be (see Needham 1981). I would argue, therefore, that similar capacities and constraints exist at all levels in humans everywhere; that is, one must assume an *a priori* innate intellectual, emotional, and physiological potentiality – but the way these are conceptualized and expressed is constructed by the particular cultural context. A related capacity (and contraint) is the human body. It is identical regardless of culture, it performs the same physiological functions, and operates formally in the same way. (For some anthropological studies of the body see Mauss 1979, Douglas 1973, Needham 1981, Leach 1972, Polhemus 1978, Heelas and Lock 1981, Strathern and Strathern 1971.) But are these functions and operations thought about in the same ways, regardless of cultural context? Can we unequivocally agree with Shylock in his famous and impassioned speech:

> Hath not a Jew eyes? hath not a Jew hands, organs, dimensions, senses, affections, passions? fed with the same food, hurt with the same weapons, subject to the same diseases, healed by the same means, warmed and cooled by the same winter and summer as a Christian is? – if you prick us do we not bleed? if you tickle us do we not laugh? if you poison us do we not die? and if you wrong us shall we not revenge?

At first reading, one's reaction is affirmative, and indeed we assume that Shakespeare intended it to be so. On second thoughts, however, I suggest the issue is not so straightforward and the answer to his questions depends on the level at which one is approaching them. Shylock is, in fact, presenting us with a rag-bag of human attributes. Some of these are clearly universals, others equally clearly are not, and several are debatable. We all have eyes, hands, organs, and dimensions; we all bleed from the same weapons. We all die from poisons – although not necessarily the same ones, since the body can be trained to withstand the effect of many. These are all matters which can be verified. Conversely, to revenge oneself when wronged is not a discernible physiological condition, but a social one; the same applies to the food we eat. But are we all subject to the same diseases? Do we all laugh if tickled? And do

we all have the same senses, affections, and passions – that is, do we experience identical inner states and do we express our inner states in identical ways? Having put the question like this, it is obvious that there are serious problems involved, problems of classification and definition. What do we mean by affections and senses, and how do we measure them, and how do we compare them? It might be relatively easy to obtain data with regard to members of the same culture, but can we legitimately extend our analysis to other cultures? Are we really talking about one discernible phenomenon when we say, for example, that everybody experiences anger? Does a Chewong man mean the same thing – and evoke an identical understanding in his listeners – when he says his liver is *chan* (a word I have translated as 'angry'), as an eighteenth-century aristocratic English woman when she says that she is 'furious'? And can we, with any degree of confidence, claim that not only are those two experiences identical, but that the facial and bodily expressions that go with each statement are also identical? I think we are entering very problematic areas.

A fair amount of attention has been attracted, in recent years, by sociobiology, the branch of sociology or social anthropology that studies human behaviour as one form of animal behaviour from the perspective of evolution by natural selection, and seeks to explain culture in terms of genetic and environmental factors, Robin Fox, one of the better-known anthropologists adhering to this paradigm, has tried to get around the 'problem of culture' by reducing what he sees as the problematic aspect of human behaviour, namely the symbolizing function, to nature. Thus he says 'symbol-making is as much a human attribute as sex and food' and, in my view more interestingly, 'as sex and food can be woven into systems of meanings, so can symbols themselves . . . and the human imaginations can weave symbolic systems out of symbolic systems' (1982: 13). While I question Fox's basic assumptions, I am in agreement with these statements. I would, however, go one step further and replace 'can' with 'are'; i.e. sex and food *are* woven into systems of meaning, that is, these activities can *never* be performed outside of meaning; to eat and to copulate can never be natural acts for human beings. Thus there is an infinite possibility of complexity in the semantic order of societies, and very little, if anything, remains natural.

To say that humans in all societies eat and copulate, and walk and sleep and make grimaces, etc., and that similarities can be observed in the way these actions are performed cross-culturally is true, but it is a trivial truth. But if one accepts that all these acts are not natural acts but are performed within a semantic system by which they are informed, however implicitly, then it becomes much more important to try to establish the meanings

10.1 'Facial expression of fear, which evidence suggests is universal' (Paul Ekman, 'The anthropology of the body', figure 8, in J. Blacking (ed.) (1977) *The Anthropology of the Body*, London: Academic Press).

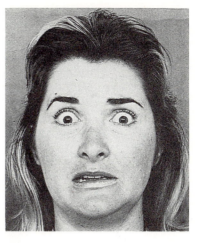

10.2 'A blend of sadness (eyebrows, forehead, and eyes) and happiness (lips)' (Paul Ekman, 'The anthropology of the body', figure 6, in J. Blacking (ed.) (1977) *The Anthropology of the Body*, London: Academic Press).

related to all these acts in a particular social setting, rather than to assume a universal intentionality and perception. Similarly, 'art objects' often display similar features across cultures, but we can no more allow ourselves to think that therefore these have identical meanings, than we can assume identical meaning with regard to behaviour – however 'natural' it may seem.

Fuller rightly points to the fact that humans have the most complex facial musculature of any animals, and that by combining the various movements in a variety of ways, we convey to each other complex moods and mood changes (1983: 18). But whether facial expression was 'the most basic form of communication in our species' (ibid.) is more dubious, as is his reason for stating it: 'being the means to cement the infant–mother social bond'. The last proposition, certainly, could never be empirically tested. What is undeniable, however, is that the face and

body are certainly focused upon deliberately in many cultures to convey meaning. Ekman (e.g. 1977) has collected a great deal of cross-cultural data to support the claim that there appears to be a universal range of facial configurations. But, even if we accept the formal similarities, we cannot, it seems to me, infer a corresponding meaning attributed to each expression. In a study concerning some changing western attitudes regarding human attributes, Skultans (1977) has argued that, in the west, not only has the blush stood for different things at different times, but the frequency of its manifestation is culturally determined. LaBarre, one of the first anthropologists to make a serious study of the cultural basis of emotions and gestures, taking his examples from a wide range of societies, suggests that these can be understood only in their own cultural context. For instance, he suggests that smiling and laughter can be mapped as cultural traits. He says:

> In Africa Gorer noted that laughter used . . . to express surprise, wonder, embarrassment and even discomfiture; it is not necessarily, or even often a sign of amusement . . . [non-Africans] make the mistake of supposing that similar symbols have similar meanings. (Quoted in Eibl-Ebesfeldt 1972: 311)

Similarly, collecting art objects which apparently resemble each other formally from our point of view, while originating in unrelated cultures, can never tell us anything about their content or quality. Any apparent resemblances are chance, or merely trivial.

ART AS TRANSCENDER OF CULTURAL BOUNDARIES

If inner states cannot be taken as trans-cultural, trans-historical categories, where does this leave the artist – or indeed anyone from the west confronting artefacts from other cultures? Must we all become anthropologists if we are to have the right to make use of such artefacts? Or is there *no* legitimate use – display or usage being merely an appropriation by a dominant culture of the products and ideas of a subordinated one?

There seem to me to be three possible ways to react.

1. The formal, aesthetic position which holds that art is art wherever it may be made, provided it displays some assumed universal aesthetic characteristics according to which it may be evaluated and appreciated. Linked to this is an assumed universality of some fundamental human experiences and their expression which enables us to understand at some deep, intuitive level. A good example can be found in Henry Moore's statement: 'All that is really needed is a response to the carving themselves, which have a constant life of their own, independent of

whenever and however they came to be made and as full of
sculptural meaning today to those open and sensitive to perceive
it as on the day they were finished' (1941, quoted in Hiller 1986).

2. A functional approach whereby a particular object may be
approached in terms of its function in the society where it was
made. This may be done in two ways: (i) where the function is
relatively unambiguous, e.g. a cooking pot, a spear; (ii) where
the function is far from clear, but the outsider, whether justi-
fiably or not, thinks that it is. This second category is by far the
most common. Often the outsider wishes to 'exoticize' the object
and imagines some mystical, ritualistic purpose which may have
nothing to do with its original creation and usage (see Price 1986
for examples of this).

3. A third alternative is to regard the artefact as a found
object to be used in a process of *bricolage*. As such it need be
treated no differently from any other found object. The fact that
it is shaped by human hand need not be allowed to interfere any
more than if it were a stone interestingly shaped by the sea.
Anything may qualify, a thrown-away coca-cola can from our
own culture, a gnarled branch, a picture postcard depicting
'rough sea', an amulet from an African society, a necklace from
Afghanistan, a potsherd from the Etruscans, a picture of the
Laocoon. This may avoid the possible objections to the two
former positions; the objects are denuded of any universal
human or other-cultural significance, but openly treated as
'natural objects' as far as the artist is concerned. Natural, that is,
in so far as any subsequent significance is made possible by the
artist, when it becomes a product of his or her own culture.
As such there are no pretensions to pan-cultural signifi-
cance – unless the artist specifically wishes to raise the problems
involved in such an enterprise. At this point the object becomes a
social fact and can be interpreted in the context of the culture of
the western art discourse. The artist may wish to make a critical
point concerning western appropriation of 'primitive' art, but
such a statement is itself bound up in western ideology.

Let me return to Peter Fuller and his claims for trans-cultural,
trans-historical understanding of 'art'. Certainly, the modern
Englishman may gain something from looking at a sculpture
made 2,000 years ago by an individual in Greece, but that expe-
rience may or may not have anything to do with the intentions of
the artist, or with the way his contemporaries appreciated his
work. It can be only at the most trivial level that we appreciate a
work of art from another time or another culture; trivial, that is,
in respect to the cultural domain in which it was created. I am
not denying the possibility of a profound emotional or intel-
lectual response by members of different cultures, but that
response must be interpreted in the light of the cultural values of

the spectator. To go further and claim empathy with the culture
of origin is presumptuous.

As many critics have pointed out, the interest in so-called
'primitive art' in the twentieth century by many artists,
collectors, curators, and the public was rooted in a romanticiza-
tion of the 'primitive' – not a new phenomenon in the west, but
a particularly potent one in this century, possibly reflecting a
reaction against a perceived dehumanization in modern life,
and a longing for a purer, less decadent culture. Such longings
are of course not founded in any real understanding of
'primitive' cultures, but are the product of a particular tradition
in western thought – one that elevates certain characteristics of
human potential at the expense of others. These reactions were
linked to an evolutionary paradigm, whereby it was thought
that societies went through certain stages to arrive at the con-
temporary western one. This theory, which owes much to
Darwin, was also adopted by Durkheim, but he was prepared to
study alien social formations in their own terms. It is a pity that
artists in Paris did not extend their interest in the primitive and
the exotic far enough to include reading the works of these socio-
logists who were, after all, their exact contemporaries. Interest-
ingly, two decades later, with the surrealist movement, there
was a meeting of interests between artists, ethnographers, and
anthropological theoreticians. In Paris in a single year, 1925, we
find a veritable explosion of attention given to 'the exotic'. The
successful season of the *Revue nègre* with Josephine Baker
virtually naked abandoning herself to the hot rhythms of jazz,
delighted the bourgeoisie, exemplifying the exotic other *par
excellence*. In the same year, Paul Rivet (founder of the Musée
de l'Homme), Lucien Lévy-Bruhl (philosopher who for the first
time investigated alternative epistemologies), and Marcel Mauss
(student of Durkheim and professor of social anthropology at
Ecole Practique) established the Paris Institut d'Ethnologie.
And, also in the same year, following the recent publication of
the *First Surrealist Manifesto*, André Breton, Michel Leiris and
others made themselves notorious for their behaviour, and for
their open support of the North African anti-colonialist rebels.
Many of the surrealists went to Mauss's lectures and visited
Musée de l'Homme regularly. Mauss, Lévy-Bruhl, and Rivet
and their more traditional students – including Alfred Metraux,
a life-long friend and collaborator of Bataille, and Marcel
Griaule – went to the surrealist gatherings and events (Clifford
1981). Leiris subsequently became an ethnographer, participat-
ing in France's first major fieldwork expedition to Africa in
1931. Clifford suggests that, unlike the nineteenth century's
search for a temporary *frisson*, 'circumscribed experience of the
bizarre, modern surrealism and ethnography began with a

reality deeply in question. Others appeared now as serious human alternatives, modern cultural relativism became possible.' And 'For every local custom or truth [including our own] there was always an exotic alternative, a possible juxtaposition or incongruity. Below (psychologically) and beyond (geographically) any ordinary reality there existed another reality. Surrealism shared this ironic situation with relativist ethnography' (ibid, p. 542). In other words, the exotic can be found in your own backyard; it is not *where* you look, but *how*; a notion many contemporary anthropologists would support. Art and Culture lose their capital letters, they cease to be special categories and became a necessary part of what human social life means. So, for this brief period in European history we can discern a unity in philosophy and approach between artists and ethnographers, a unity which, sadly, did not last long. The bounded categories re-emerged and continue to exist today.

Let us return to the example of the Henry Moore mother figure which we are all supposed to react to similarly as a result of our experiences of our mother's body. That this sort of reaction is provoked in the western mind is probably correct, but whether we react in this way because of our physical contact experienced as babies or because of the values surrounding the mother–child relationship in the west is not so clear. The Chewong and Hong Kong examples referred to above raise possible objections to the universalistic claim.

Because some object designated by outsiders as an 'art object' resembles an object from elsewhere, it is tempting to leap to the conclusion that both are communicating the same message. A commonly found sculpture in Lega society in West Africa is that of a woman with a distended belly, which has been described by many art critics and museum curators as proof of a 'fertility cult'. However, anthropological investigation of Lega society has shown that its significance to the Lega lies in its being a warning against committing adultery while pregnant – an act held by them to result in serious effects on mother and foetus. This example highlights the prevaience of unfounded assumptions of universality in meaning made by many people in the west (Layton 1981).

A related point can be made by examining western art historians' ceaseless attempts at deciphering the Mona Lisa smile. Leonardo told us nothing about her. We do not know whether the painting was drawn from life or from the imagination. If the former, is the smile accurately reproduced? Did he know what the model was thinking about at the time? Did he misunderstand the meaning of the smile? If Leonardo drew from the imagination what were his intentions in portraying her the way he did? Did he wish to illustrate the 'eternal feminine' as

10.3 Mona Lisa in Nepal (photographed by the author).

some critics will have us believe? Is it a particular kind of smile
which was embedded in the ideology of the time but whose
meaning we are no longer party to? Did he have no particular
profound intention at all? Or did the model wish to hide her bad
teeth? The answer is that we have absolutely no way of saying.
We are entering the realm of pure speculation and one guess is as
good as another. What can one make of the fact that I found a
large reproduction of the *Mona Lisa* hung on a wall in a lodge in
the mountains of Nepal? Does this prove that 'great art' trans-
cends cultural boundaries? Since the adjacent pictures port-
rayed Abba, Michael Jackson, and the reigning monarch of
Nepal, I think this would be difficult to argue.

JAH HUT WOOD CARVINGS

While humans everywhere appear to be interested in the ideas
and cultural products of other cultures, this does not necessarily
lead to an adoption of such ideas and practices. However, there
clearly are instances of inter-cultural influences of varying
degree of profundity. What we must beware of is equating the
adoption of the sign (the object, the word) from one culture into
another with an adoption of the signified (the idea, the con-
cept). There is a tendency for us to be horrified or depressed at

the apparent dominance of western culture. Thus, the presence of cheap T-shirts, cotton dresses, and sun-glasses in New Guinea villages is regarded as proof that the 'traditional' culture has been encompassed and transformed by the supposedly much more powerful one of the west. The people in question are no longer 'pure', no longer worthy subjects of expensive glossy books; they do not satisfy the requirements of the primitive, the traditional, the ultimate 'other'. In my view, there are several serious flaws in such thinking. First, it reconfirms the exotic other, expressing the desire to preserve other cultures unchanged and unchanging, like beautiful butterflies pinned to the board. While relentlessly pursuing change and 'betterment' (however defined, often an adoption of supposedly lost primitive practices like 'natural childbirth', a misnomer if ever there was one) for ourselves, we deplore it elsewhere. Second, the notion that the adoption of western clothing and consumer goods is sufficient to destroy a culture is arrogant in the extreme. 'Traditional' cultures (except in those instances of genuine destruction of both infra- and super-structure, or genocide) are much more resilient than we like to flatter ourselves. Third, it is perfectly possible for members of other cultures to adopt a western practice or product and to transform it beyond recognition. One well-known example is the Trobriand version of cricket – unrecognizable to the British or Australians, but adapted to suit their own traditions of feasts, exchange, and hospitality. Cricket may have suffered in the process, but not Trobriand society.

Let me give one small example that I observed at a distance. The Jah Hut are a group of aboriginal people who live in the rain forest of the Malay Peninsula and are close neighbours of the Chewong. The Chewong and the Jah Hut share many cosmological and social ideas, and similarities in practice can be found at all levels. There are also many differences. For instance, while they both conceptualize most illness as being caused by various types of non-human beings who inhabit the forest, generically known as *bes* (*bas* by the Chewong) and who are confronted in trance seances in both societies, the Jah Hut make small wooden effigies of the disease-causing beings as part of the healing ritual, whereas the Chewong do not.

The wooden representations of the various *bes* are small (about 4 inches or 10 cm high) and very crude; sticklike, with only a few stylized features of the particular species of *bes* indicated. No elaboration in design or form is thought necessary; no aesthetic evaluations are made. For purposes of the healing seance, the effigies are required to trap the 'soul' of the *bes*, after which it is destroyed. Anyone who knows the characteristics of the beings can make *bes*; the presiding 'shaman' manipulates them.

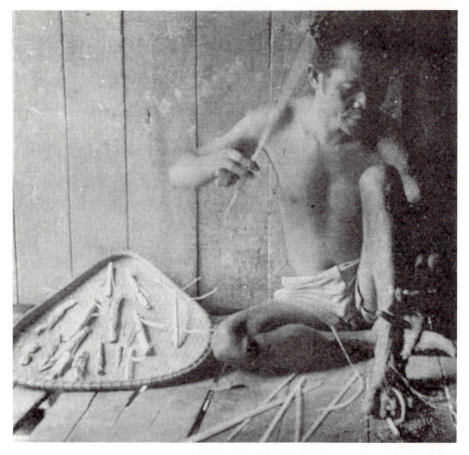

10.4 Jah Hut shaman with small stick-like figure (from Marie-Andrée Couillard (1980) *Traditions in Tension: Carving in a Jah Hut Community*, Penang: Penerbit Universiti Sains Malaysia).

Then, about twenty years ago, large (1 to 2 feet, or 30 to 60 cm, in height), elaborate and naturalistic wooden sculptures made by Jah Hut appeared in the international primitive/ethnic art market. They were described as the indigenous representations of illness-causing beings as used in ceremonies. A German art historian/critic became interested and went to the Jah Hut to write a book about them. This he did. A large book with numerous photographs and detailed descriptions of the various *bes* was published. Each *bes*, it appeared, was uniquely different from every other, with bodily features elaborately represented in the sculptures. The Jah Hut were presented as a culture in which these sculptures had a traditional and integral part (Werner 1975).

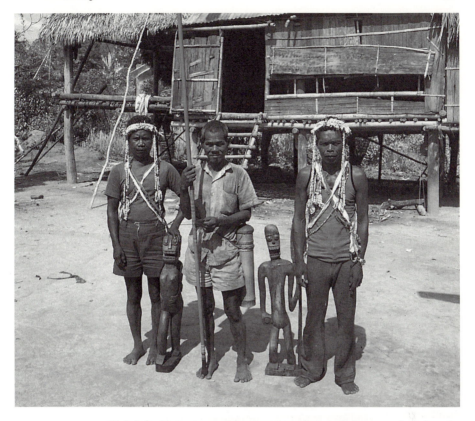

10.5 Jah Hut men with recent sculpture (photographed by the author).

When a Canadian anthropologist, Marie-Andrée Couillard, went out to study these Jah Hut carvings, she was amazed to discover that their production was a very recent phenomenon. Apparently, an Englishman who worked for the Department of Aboriginal Affairs, had known that the Jah Hut made wooden effigies as part of their healing ceremonies. He was concerned that the Jah Hut should be able to make some money as they become more and more exposed to the outside world. Armed with a motley collection of photographs of wooden sculptures from New Guinea, Oceania, and various parts of Africa, he suggested that the Jah Hut set up business, carving wooden sculptures specifically to sell. Several individuals agreed, and the Englishman arranged for an exhibition at the National Museum in Kuala Lumpur, from where it was but a short step to the international circuit. A new 'primitive culture' had been discovered whose wooden sculptures amazed and delighted all (Couillard 1980 and personal comunication). Meanwhile, back

in Jah Hut land, more and more individuals, men and women, took up this profitable and, to many, enjoyable work. They showed a keen interest in similar work done elsewhere and were not reluctant to borrow ideas. They began to take a pride in their own carvings and some individuals emerged who were generally acknowledged as better carvers than others. The iconography became increasingly elaborate, the distinguishing features of the various *bes* ever more pronounced, and the buyers increased. However, the healing ceremonies continued as before. The wooden effigies were made in the same way, their efficacy could not be questioned. Apparently, there was no suggestion that the new elaborations would improve the healing ceremonies in any way. The large, elaborate sculptures are never used in ritual, they are made solely for sale. It is still too early to draw any firm conclusions from the Jah Hut example, but some tentative suggestions may be made with regard to the production of 'art', and the borrowings of art practices and art objects from cultures different from one's own.

In the example of the Jah Hut, it is members of the 'primitive' culture who appropriate the art styles of other cultures. Perhaps surprisingly, I wish to suggest that the introduction of pictures of sculptures from other cultures to the Jah Hut is similar to the exhibitions of African sculpture in Paris during the first decade of the twentieth century. Both were momentous events. In Paris, the exhibits were influential with the cubists and the German expressionists, among others. Among the Jah Hut the pictures inspired a new discourse and practice. Each instance demonstrates how members of one culture react to, and treat, the art of another. There is, I think, a tendency to assume that it is only westerners who appropriate art from elsewhere. Who then is to say that in the case of cubism and expressionism the influence was beneficial while in the case of the Jah Hut it was destructive? Indeed, Couillard argues that the Jah Hut wood-carving is 'not just a new way of earning a living . . . but is an extension of the traditional ideological framework' (1980: 14).

With regard to the possible ways members of one culture might react when confronted with 'art' from another, it is inter-esting to consider the differences between the two examples. The European artists may be interpreted as reacting in conformity with a need for the primitive other – attributing mystical ritualistic purposes to the objects, while paradoxically also proclaiming some universal unity. The following quote from Gottlieb exemplifies a typical attitude:

> Modern art got its first impetus through discovering the forms of primitive art, we feel that its true significance lies not merely in formal arrangements, but in the spiritual meaning

underlying all archaic works. . . . If we profess kinship to the
art of primitive man, it is because [*we* think] the feelings [*we*
suppose] they expressed have a particular pertinence
today. . . . All primitive expression reveals the constant
awareness of powerful forces, the immediate presence of
terror and fear, a recognition of the terror of the animal
world. (In Cooke 1985: 19; my parentheses)

Picasso expressed similar sentiments describing his first
encounter with African sculpture:

They [the tribal artists] were against everything – against
unknown threatening spirits. . . . I too, am against every-
thing. I too believe that everything is unknown, that every-
thing is an enemy. . . . I understood what the Negroes used
their sculptures for . . . all were weapons . . . I understood
why I was a painter. All alone in that aweful museum with
the masks, the dusty mannikins. *Les Demoiselles d'Avignon*
must have been born that day, but not at all because of the
forms, because it was my first exorcism – yes absolutely!
(Quoted in Foster 1985: 45)

These quotes reflect a long-standing western attitude to
primitive peoples, exemplified also in the statements made by
Fuller to which I have already referred. Such beliefs grant no
status to cultural context. Ideas concerning the primitive are
products of the western mind, satisfying particular needs in
western ideology from the eighteenth century onwards. They
tell us much more about ourselves than about the primitive
people they are supposed to explain.

Recent critiques of western colonialism have pointed out a
fundamental western ambivalence with regard to the colonized
unknown other: admiration of attributed purity and innocence
coupled with fear of some primitive, uncontrolled forces – 'that
"otherness" which is at once an object of desire and derision, and
articulation of difference contained within the fantasy of origin
and identity' (Bhabha 1984: 20). Edward Said has argued that
the category 'the oriental', with the subsequent discipline of
'orientalism', not only disregarded the vast number of different
cultures thus designated 'oriental', but also emphasized contra-
dictory attributes depending on circumstances. Homi Bhabha
has extended these ideas, suggesting that the stereotype of the
other is 'a form of knowledge and identification that vacillates
between what is always "in place", already known, and some-
thing that must be anxiously repeated' (1985: 18). While largely
agreeing with their arguments, I think it pertinent to comment
that while their analyses do contribute to an understanding
of western colonialism, it is a mistake to assume that the

construction of the category of 'the other' is solely a western phenomenon. All known societies have similar categories concerning their neighbours. Few ideologies grant 'humanness' to members of other societies. Indeed, it has been suggested that the idea of cannibalism – as the ultimate characteristic of people who are not attributed full humanity – is nothing but a manifestation of the attribution of otherness to neighbours, enemies, or allies (Arens 1979). A possible twist can be found in modern western ideology where the construction of otherness was coupled with an assertion of a 'psychic unity of mankind', giving rise to a profound internal contradiction.

While many western artists, curators, and collectors have been eager to embrace an assumed purer, more fundamental approach to art, sentimentalizing the alien and insisting upon some profound identity of existential experience, claiming an affinity between their own art and 'primitive art', the Jah Hut reaction to a confrontation with alien sculptures is very different. They made no assertions concerning any assumed meaning of the sculptures pictured, but used them as sources for ideas to be explored in connection with existing ideological constructs. While the new practice of carving wooden sculpture has not been incorporated into existing concepts of illness and healing, it nevertheless is informed by these concepts and contributes to their elaboration and development. As such, the practice can be interpreted as an observed instance of change in religious ideas – not a rupture.

It may be appropriate to call the incorporation of art objects or styles from non-western cultures a neo-primitivism in art, but if western artists persist in developing it, they must do so fully conscious of the fact that what they are doing has nothing to do with art as produced in so-called 'primitive societies', but everything to do with western traditions. To claim affinity with imagined artists elsewhere and in different historical periods shows a high degree of sociocentrism. Indeed it is as unacceptable as to create the 'other'. It is, I would argue, not a mistake made by the Jah Hut.

CONCLUDING REMARKS

Much has been written on the ideological soundness (or otherwise) of the major exhibition *'Primitivism' in 20th Century Art* held at the Museum of Modern Art in New York in 1984–5, in which famous modern paintings were juxtaposed with 'primitive art' objects which in one way or another inspired and/or influenced the western artist. This chapter can be regarded as another contribution to the issues raised by the exhibition. What is emerging is that the issues are extremely

complicated: there are no easy answers. If one asserts that the exhibiting of cultural artefacts from other cultures – and more importantly culturally, economically, or politically subjugated ones – constitutes either a simplistic claim for 'affinity' and universalism, or a piecemeal appropriation of ideas and objects, then the logical conclusion would be to stop *all* exhibitions. Is this really what we want? Can we not show people in one society how people elsewhere live, what they think and believe? This would have to apply not just to western museums, but to any exhibition of non-indigenous art and artefact anywhere. I am not convinced that to bring in the artist/craftsperson as well, to allow him/her to make a work on the premises of the exhibition hall – as Clifford (1985: 176) suggests in his example of the Indian totem-pole being built outside the IBM Gallery in New York – actually solves the problems. Are we not just replacing one kind of dominance with another? In my view, such debates are extremely important, even though I do not believe that any solution will ever be found. Just to raise the issues, to highlight the significance of a cultural practice which, in the west, includes the ambivalence of a conquering people in their attitudes to the conquered, is of utmost importance. Neutrality in this domain is no longer acceptable.

There is something special in this western ambivalence. Non-western cultures are classified as less evolved than western civilization, people and their fashioned objects as more like children and their objects than like the adult westerner and the adult art of the west, while at the same time claims are made for some form of universal affinity – a psychic unity of humanity. More recently, their artefacts have undergone a classificatory metamorphosis. Clifford has pointed to a 'taxonomic shift' (1985) whereby what was previously classified as 'ritual object' or 'cultural artefact' is suddenly reclassified and elevated as 'art'. This he regards as 'a more disquieting quality of modernism: its taste for appropriating or redeeming otherness, for constituting non-Western arts in its own image, for discovering universal, ahistorical "human" capacities' (ibid: 166). This chapter is an attempt to provide a critique of the various possible positions open to one, while at the same time claiming that although the study of other cultures *is* of importance to all of us, an awareness of the complexities of such an enterprise is of equal importance.

Since I argue that the constitution, consequences, and significance of any human phenomenon depend upon socially constructed beliefs and categorizations, I cannot endorse theories that ignore this and attempt to locate social and cultural research in human biology or psychology. What the anthropologist can do in the study of inner states and their expression is to treat these as social facts, and attempt to build up the meanings

of indigenous concepts that are translated as 'angry', 'jealous', 'happy', 'sad', 'surprised', 'depressed', etc. We should be extremely wary of accepting direct equivalences in this realm. It is possible that equivalences do exist, but how can we ascertain them? There are similar proclivities, but different meanings. While all ideologies contain ideas concerning human nature, these ideas may vary widely; but without models of human nature, the individual would not be able to act consistently and meaningfully. Ideas concerning inner states, their development, handling, and expression, are part of any discourse about human nature.

This argument can, I think, be extended to include symbolic artefacts made by members of any society. These are only explicable within the cultural context in which they are produced. In my view, it is not acceptable to make encompassing generalizations concerning the meanings of any of these elaborations, any more than it is to do so about intentions and experiences of members of other cultures. Each must be understood in terms of the overall cultural context in which they are elaborated. As such, they can all be studied as social facts.

BIBLIO-
GRAPHY

An earlier version of this chapter originated as a paper in the 'Primitivism' series at the Slade School of Art (University of London), 1985.

Arens, W. (1979) *The Man-Eating Myth: Anthropology and Anthropophagy*, Oxford: Oxford University Press.

Bhabha, Homi K. (November/December 1984) 'The Other question . . .', *Screen*, 24, 6: 18–36.

Clifford, James (October 1981) 'On ethnographic surrealism', *Comparative Studies in History*, 23, 4: 536–64.

Clifford, James (April 1985) 'History of the tribal and the modern', *Art in America*: 164–77, 215.

Couillard, Marie-Andrée (1980) *Tradition in Tension: carving in a Jah Hut community*, Penang: Penerbit Universiti Sains Malaysia.

Douglas, Mary (1973) *Natural Symbols*, New York: Vintage Books.

Durkheim, Emile and Marcel Mauss (1963) *Primitive Classification*, London: Routledge & Kegan Paul.

Eibl-Ebesfeldt, I. 'Similarities and differences between cultures in expressive movements', in R.A. Hinde (ed.) (1972) *Non-Verbal Communication*, Cambridge: Cambridge University Press.

Ekman, Paul, 'Biological and cultural contributions to body and facial movements', in J. Blacking (ed.) (1977) *The Anthropology of the Body*, London: Academic Press.

Foster, Hal (Fall 1985) 'The "primitive" unconscious of modern art', *October* 34: 45–70.

Fox, Robin 'The violent imagination', in Peter Marsh and Anne Campbell (eds) (1982) *Aggression and Violence*, Oxford: Blackwell.

Fuller, Peter 'Art and biology', in Peter Falch (1983) *The Naked Artist*, Writers' & Readers' Publishing Co., pp. 1–19.

Fuller, Peter (September 1985) 'Art and politics: Colin Symes interrogates Peter Fuller', *Art Monthly*: 3–9.

Heelas, Paul and Andrew Lock (eds) (1981) *Indigenous Psychologies*, London: Academic Press.

Hiller, Susan (1986) 'An artist looks at ethnographic exhibitions' (unpublished paper).

Howell, Signe (1989 [1984]) *Society and Cosmos; Chewong of Peninsula Malaysia*, Singapore/Oxford: Oxford University Press.

Layton, Robert (1981) *The Anthropology of Art*, London: Granada.

Leach, Edmund 'The influence of the cultural; context on non-verbal communication in man', in R.A. Hinde (1972) *Non-Verbal Communication*, Cambridge: Cambridge University Press.

Lévi-Strauss, Claude (1969) *The Elementary Structures of Kinship*, Boston, Mass.: Beacon Press.

Lukes, Steven (1973) *Emile Durkheim: his life and work: a historical and critical study*, Harmondsworth: Penguin.

Mauss, Marcel (1979) *Sociology and Psychology*, London: Routledge & Kegan Paul.

Needham, Rodney (1972) *Belief, Language, and Experience*, Oxford: Blackwell.

Needham, Rodney (1981) 'Inner states as universals: sceptical reflections on human nature', in P. Heelas and A. Lock (eds) *Indigenous Psychologies*, London: Academic Press.

Polhemus, Ted (1978) *Social Aspects of the Human Body*, Harmondsworth: Penguin.

Price, Sally (January 1986) 'Primitive art in civilized places', *Art in America*: 9–13.

Sahlins, Marshall (1976) *The Use and Abuse of Biology; an anthropological critique of sociobiology*, London: Tavistock.

Sinding-Larsen, Henrik (Winter 1988) 'Notation and music: the history of a tool of description and its domain to be described', *Cybernetics*.

Skultans, Vida (1977) 'Bodily madness and the spread of the blush', in John Blacking (ed.) *The Anthropology of the Body*, London: Academic Press.

Strathern, A and Strathern, M. (1971) *Self Decoration in Mount Hagen*, London: Duckworth.

Werner, R. (1975) *Jah Hut of Malaysia: Art and Culture*, Kuala Lumpur: Penerbit Universiti Sains Malaysia.

11 Dark continents explored by women

DESA PHILIPPI AND ANNA HOWELLS

Squatting, crawling on her knees, Miriam Cahn covers large sheets of tracing paper with hauntingly stylized female apparitions. Wide-eyed faces, drawn in charcoal, are staring out of the picture, empty gazes directed at nothing and nobody in particular, directed perhaps at that absence which circumscribes woman's imaging. The figures are mouthless and thus condemned to silence, immobile with arms and legs frequently missing, while breasts and genitalia are emphasized, turning them into sexualized ghosts. The images bear the marks of their maker: foot and handprints as traces of physical effort and signs pointing to the occupation of a space both physical and pictorial. Held at the precarious moment of their emergence, fantasies of woman by a woman become external to herself – her as self – questioning her origin by being there, on the paper, in the world. The paradox in her assertion in/as (self)mutilation and effacement, draws us, the spectator, the voyeur, the passer-by, into the contradictions which construct and smoothly envelop the space of our imagin(in)g.

In 1983, Mona Hartoum's performance *The Negotiating Table* involved her lying on a conference table, her body bandaged, blood-stained, and wrapped in a body bag. Anonymous, 'denuded of status, property, rank or role,'[1] the victim's body as material obstacle as well as direct result of 'negotiation' was displayed with the utmost theatricality: the spot-lit, isolated, centred image. The spectacle of the enacted dead body splits. The physical object specific, yet general(ized), is disposable, already disposed of, while the image only begins to disturb and to unfold in its ambivalence. Curious we move near, look, touch and, embarrassed by our shamelessness, draw back, retreat. The image mocks us, the body is warm and breathing. We feel cheated. The 'victim' has 'victimized' us by turning our voyeuristic pleasure into a source of discomfort and self-consciousness. *We* cannot deal with bodies.

What, you may ask, does this have to do with primitivism? Our concern in this chapter is with primitivism as an ideological construct which effectively marginalizes and excludes art pro-

duced both by women and black artists. The argument is
focused on what we see as the conjuncture of race and gender in
the discourses of artistic primitivism. Work on this question over
some time has revealed its enormous complexity, which can only
be alluded to in this context. In rewriting this piece for the
present collection, a change occurred also in the writing itself, a
slippage from the comfortable certainty of 'analytical explana-
tion' which now uneasily coexists with a more descriptive and
perhaps more open-ended enquiry.

The academic orthodoxies of art history and anthropology
have significantly contributed to the production of primitivism
as a discriminatory discourse which posits an 'other' as both the
exotic object for the artist's gaze and an object for analytic
scrutiny. Instituted in a culture which is patriarchal and racist,
certain convergences can be mapped between the constitution of
a colonial or racial 'other' and the production of a subject
woman. And while the particular kinds of oppression which
emerge from this construction differ and cannot be collapsed
into a general category of victimization, it is also evident that
the processes of identification and stereotyping in both cases
share particular patterns and characteristics.

If 'unconscious' and 'irrational' are the main attributes of
primitivism, these very attributes are fundamental in the
construction of woman as 'other'. In the context of art these
classifications operate in two ways in that they constitute parti-
cular objects to be represented, 'the native' and 'woman', which
as a 'represented' are paradoxically invested with the 'essence' of
difference. These categories are also effective in relation to how
art produced by non-western and/or women artists is inter-
preted and (de)valued. The reader will be familiar with the
numerous examples of discrimination which need not be
repeated here, but it is important to emphasize that the way in
which marginalization and exclusion are rationalized hinges on
particular sets of contradictions. 'Intuitive' and 'unreflective'
when applied to work by women and/or non-western artists
disqualifies it from 'serious' consideration, while, simul-
taneously, artistic merit is defined in precisely those terms of
'spontaneity', 'expression', and 'artistic intuition'. Within the
more analytical and historicizing artistic idioms, another
pattern clearly emerges, both in the discussions of feminist art in
the 1970s and, more recently, in relation to art produced by
black/non-western artists. In both cases sustained attempts were
made to move this work outside the boundaries of art altogether
by labelling it propaganda, sociology, documentary, etc., while
at the same time refining those tokenist gestures which would
allow the 'ethnic' and 'feminine' to flourish on the peripheries of
the liberal establishment.

It seems to us that in order to consider primitivism today a broad frame of reference is needed which can broach multiple and diverse areas of enquiry. How a non-western 'other' and a 'primitivized' notion of 'woman' come to figure in the patri-archal culture(s) of the west is a question which involves the very foundations of what it means to be 'western'. These foundations, however, remain out of reach, centred and locked, as they are, into the imaginary as the primal scene of cultural identity. Inscribed on to the surface of images and inscribed again into discourses bound by an obsession to explain, the processes of 'othering' produce their own spectacles. Turning to art history, a predictable pattern presents itself: the fantasy of cultural coherence. It is not surprising to find that analytical discussions of primitivism centre around issues of difference as 'otherness'. The underlying assumption is that the construction of otherness, whether desirable or not, is unavoidable and functionally imperative to define one's own culture.

In *Primitivism in Modern Art* Robert Goldwater considers primitive art as a catalyst which 'helped the [modern] artists to formulate their own aims because they could attribute to it the qualities they themselves sought to attain'.[2] Nothing much seems to have changed since 1938. Interpreting paintings by Gauguin, Picasso, or Kirchner, art historians generally agree that their primitivism has to be understood in terms of stylistic innovation and self-conscious avant-gardism on the part of the artists. Considering more recent art, such as that presented in the 'Contemporary Exploration' section of the *Primitivism* show at the Museum of Modern Art, New York, we are confronted with the same inverted social Darwinism summarized by Goldwater as

> the assumption that the further one goes back – historically, psychologically or aesthetically – the simpler things become; and that because they are simpler they are more profound, more important and more valuable.[3]

Almost fifty years later Kirk Varnedoe wrote:

> this new work aspired to overcome a perceived alienation between modern art and society at large. . . . The new artists and their supporters spoke of future art becoming, as Primitive art had been, more integrally engaged with broader systems of nature, magic, ritual and social organisation.[4]

Typically socio-political issues and their relation to represen-tation do not form part of art historical accounts. When they do, as in *Art in America*[5] and *October*,[6] it is readily assumed that the 'naming' of imperialism and its cultural manifestations will

somehow reinscribe the disavowed 'other' in the map of western knowledge. What these arguments do not consider is the different epistemological status, or rather 'the absence of a text that can "answer one back" after the planned epistemological violence of the imperialist project'.[7] Frantz Fanon too points out the fallacy underlying the attempted incorporation of the colonial subject as a speaking subject into an economy of western dialectics.[8] Its positioning as 'antithetical' proposed by Sartre and others presupposes a consciousness of self which remains denied and prohibited in the dominant (Hegelian) tradition of western thought.

Here again we move on slippery terrain. To take Spivak literally would mean to concede that the colonized subject can meet the 'epistemological violence' with nothing but silence.[9] Obviously this would only be the case if one assumed that the episteme stayed in place untroubled (which neither Spivak nor Fanon do). If deconstruction concerns itself with the 'troubling', the displacement and undercutting of an imaginary stability of relation – between subjects and between subject and object – it has to consider the fixity set out in the discourses of primitivism. And what makes any straightforward notion of critique so difficult in this respect is the necessity for a double inscription of both a position of authority from which the utterance is made (to affirm a position from which the 'other' can speak) while attempting to shift the parameters of a discourse demanding such positioning. From colonial discourse analysis to feminist writing, to critical art practices, strategies oscillating between essentialism(s) and different kinds of deconstructive work testify to the complexity of these issues. In the present context our interest lies with instances where, however momentarily, a crisis is induced in accepted patterns of differentiation and identification.

The work of Astrid Klein[10] presents a particular enquiry into the possibilities and limitations of articulating such a gap, a moment of splitting and uncertainty between what is 'seen' and how it is (comes to be) 'known'. The installation *Endzeitgefühle* ('Apocalyptic Feelings') confronts the spectator with a huge photograph (390 × 550cm) which by its mere size would seem to impose a powerful message. However, any attempt to establish the stable equivalence of a sign is immediately frustrated. Black silhouettes of dogs bound across the scene, but it is not known where they come from nor where they are going to. Their movement is arrested for a moment but we can neither piece together a narrative nor place the image as the scene of an unfolding story. The entrance to the picture is walled up and the look is effectively stopped by literally closing off the background. The combination of perspectival photograph and stencilled shapes

11.1 Astrid Klein, *Endzeitgefühle* ('Apocalyptic Feelings') (1982), 390 × 550 cm. Installation, Halle 6, Hamburg.

produces a conceptual disjuncture which is difficult to bridge. The stencils invade and dematerialize the space of certainty. Klein's work, unlike the surrealist endeavour of a poetics of the unexpected, does not transpose the subject on to a comfortable plane from which the unfamiliar can be viewed against the backdrop of empirical certainty. In *Endzeitgefühle* it is the empirical fact (the recognizable wall) itself which blocks the way to recognition. The look is cut off at the point where it could reconstitute subjective identity through symbolic sublimation.

Other pieces such as *Nature Mort* and *Unerbitterliche Einfalt* ('Inexorable Ignorance') push an illusory materiality to a point where it is corroded by the futile attempt to extract meaning. Cryptic images hover in an ambivalent figure/ground relation alluding to another order, removed in time and space, from the conceptual grid of equivalence and exchange. Toril Moi, following Luce Irigaray, argues that 'thinking depends for its effects on its specularity (its self-reflexivity); that which exceeds this reflective circularity is that which is unthinkable'.[11] For the phallocentric gaze there is nothing to be seen. We are left with the uncanny effect which 'is often and easily produced when the distinction between imagination and reality is effaced, as when

something we have hitherto regarded as imaginary appears before us in reality, or when a symbol takes over the full function of the thing it symbolizes'.[12] What distinguishes these pieces from conventional apocalyptic images is their refusal to name horror and thereby to transform anxiety into fear, into a subject/object relation which might be terrifying but would none the less operate within a familiar frame of reference.

More recently Klein has made pieces in which the image is constituted by little dots like those in newspaper or television pictures but the process seems to have been stopped half-way before the marks could cohere and produce a fixed vision. It is the moment when conceptualization has to stop and thought is suspended between imaginary hallucination and the symbolic. Both alleys are blocked, as there is no imaginary plenitude to be recovered, while any definitive reading is equally refused. Latent meanings surface with shapes and forms in the photographs, but, like dream images, they remain condensed and displaced in the absence of additional information. In Gerd Kimmele's words, it is 'the excess of what can be made over what can be imagined or conceptualised'.[13] The titles are functional in enhancing the expectation of recognition. *Oriental Legends* (1986), for instance, most readily suggests a story which is then refused. There seems to be no alternative and no identity, only a play of signifiers with hazy referents and unstable signifieds. The images are mechanically produced through negative montage, double exposure, photograms, and corrosion.

But is not this refusal to name also the picture's unhappiness? Is there not a trap in this corrosion of the visual sign into an imaginary wasteland in which signification has given way to its (apparently) unpredictable consequences? And does not this radical negation run the risk of reinstituting the image in its most authoritarian dimensions as pure spectacle? Elsewhere[14] it has been argued that this need not be the case. In fact, the problemization of the image in its capacity to represent may be taken as a point of departure to speculate (and the term speculate is used advisedly because there is nothing to 'prove') on the inflexibility with which 'reflection' is posed at the root of representation's *raison d'être* within the classical tradition of European philosophy. Its trajectory can be traced to the social sciences, where it continues to (re)constitute the founding moment of anthropological as well as art historical investigations. Thus, our turning to anthropology in search of writing which might open up the discussion on primitivism, quickly (and perhaps too quickly) revealed itself as idealistic if not naive.

Anthropology presented itself to our discriminate gaze in curiously similar terms to those used by Blanchot to describe the circularity of the relation between subject and image.

The image speaks to us, and it seems to speak intimately to us about ourselves. But intimately is to say too little; intimately then designates that level where the intimacy of the person breaks off, and in that motion points to the menacing near-ness of a vague and empty outside that is the sordid back-ground against which the image continues to affirm things in their disappearance.[15]

To consider primitivism then in terms of anthropology has proved a difficult task; it is as though 'we are afraid to conceive of the *Other* in the time of our own thought'.[16] It is easier to discuss primitivism in relation to the history of the discipline, but acknowledged or denied anthropology is still constrained by the sovereignty of its subject, 'the Primitive', and the use of categories pertaining to cultural totalities. Amidst the collapse of any dominant paradigm, anthropology has been increasingly concerned with 'reflexivity', a shift from its preoccupations as an 'innocent discipline' to an analysis of anthropology as a mode of study. Taking into account the conditions under which ethno-graphic material is constructed, anthropology has assumed the position of a critical science. Despite this self-conscious act, the question 'What are we to do with "the Primitive"?' remains unanswered. This seems to indicate the limits of deconstruction, especially with regard to the questions under consideration here. As long as the aporia between the object 'the Primitive' and its academic explanations is maintained, critical analysis does little else but add to existing concepts and categories; it cannot displace them.

If this closure in the quest for meaning and identity is parti-cularly characteristic of discourses with a stake in truth, discourses whose legitimation relies on a claim for scientificity (however problematic this turns out to be), these restrictions do not seem to apply to art in quite the same way. What we may call 'truth telling in art' (a term borrowed from Susan Hiller), distinguishes itself from other narratives of truth on the grounds that it acknowledges subjectivity as the arena of truth and knowledge. Not a retreat into romantic notions of individuality, the subjective, if understood as complexly constituted both socially and psychologically, may open up a space where cultural analysis could take into account the ambivalent, exces-sive, or otherwise 'troubling' areas of knowledge and experi-ence. These are at issue in *Elan* or *Alphabets* which address the question of woman's relationship to language. Indeci-pherable scripts appear as 'negative' white marks, as does the central empty space in the installation. The marks refer to language in that they too are ordered and presented as a system while their difference cannot be incorporated as they remain

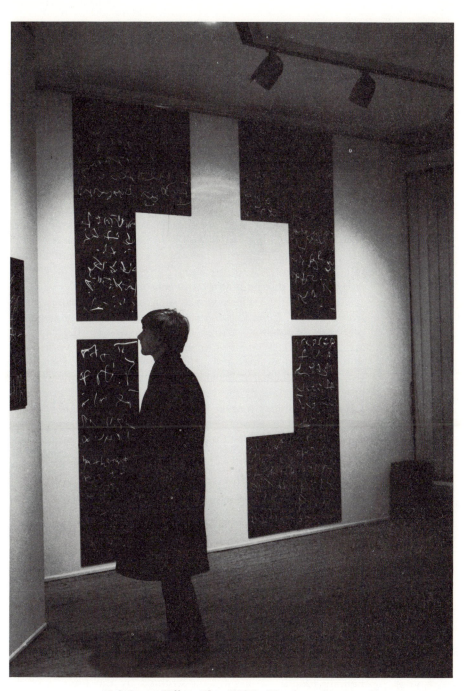

11.2 Susan Hiller, *Elan* (1982), 13 colour photographs with coloured inks, each 76.2 × 50.8 cm (overall 304.8 × 233.68 cm), Installation, Gimpel Fils Gallery.

relational to rather than produced in language. *Elan* also includes a sound-tape on which extracts from tapes of Raudive's experiments in recording the silence which yields voices of the dead, alternate with Hiller's own voice, singing in an unintelligible language. Like the written marks, these chanted utterances are rhythmical, formalized, and distant. They sound distinctly non-European in contrast to the 'voices of the dead' which not surprisingly are exclusively European, in languages known to the scientists. Juxtaposed with her marks and utterances derived through experiments with automatism, the Raudivian voices highlight a desperate, but also quite hilarious, obsession with establishing and maintaining identity beyond death. Placed in the disjuncture between lived reality which includes registers of multiple and heterogeneous meaning, and patriarchal discourse resting on the repression of these registers, *Elan* reveals the fallacy of the subject as always already constituted in language, while taking into account the power of language as a discriminatory and censoring process.

More recently Hiller's works such as the wallpaper series *Home Truths: Love, Death and Language* address the complex processes of identity. Ideology in progress in the cultural artefacts 'surfaces' even in uncoded language. The work maps the relationships between the ciphers, our inability to read them and the ideological constructions of gender. This interdeterminancy emphasizes the problematic position of the female subject as primary marker of meaning. The wallpaper, originally destined to decorate children's rooms, visually sets out the parameter within which the speaking subject moves;.aggressiveness, action, and heroism for the boys, day-dreaming and romantic love for the girls. But ideology is also acted upon. The black paint challenges its coherence but it is telling that precisely where the marks appear as 'other' (in the negative), ideology seeps through.

Hiller's recent photomat portraits, such as *Midnight Paddington* and *Midnight Boca Raton*, unravel the mechanism by which woman becomes the silent and natural bearer of meaning within the nature/culture dichotomy. Both the portraits and the floral designs are mechanically produced and already complexly coded before they are combined in these works. It is no coincidence that approximately 80 per cent of all wallpaper designs incorporate flowers, trees, and exotic plants, thus marking domestic interiors as naturally private, in contrast to public spaces where such decoration is notably absent. Female identity is always constrained by the premiss of its culturally constructed naturalness, even if the representation takes the form of a computer image, with all its connotations of scientificity and objectivity. There is no essential femininity to

be recovered beyond the cultural. Coloured feathers stuck on to the photograph emphasize the image as artifice, alluding to the decoration and masquerade at play in the defining of 'woman'; perhaps this is also the point at which existing definitions can be challenged, identity manipulated, and a different 'I' inscribed. *Midnight Paddington* seems to suggest this possibility. Midnight the collusion of yesterday and today looks both backwards and forwards, in considering the traditions and conventions by which the subject 'understands' its position within culture in the light of a future not entirely predictable and not (yet) in place.

Note the difference in this conception of the relation between time, historical memory, and the subject from that set out in the social sciences. Here in order to guarantee the object (the primitive, the 'other') it has to be moved outside historical time altogether. This happens in the projection of the object as irrational, dangerous, threatening, repressed – the unconscious *tout court* – which is seen as either oppositional or complementary, or both, to the western rational self. As Jürgen Habermas observed, this process relies on a mythologizing of history to the extent that 'historical memory is replaced by the heroic affinity of the present with the extremes of history – a sense of time wherein decadence immediately recognizes itself as the barbaric, the wild and the primitive'.[17] For Habermas this signals a longing for a stable present and the same desire, it seems to us (unconsciously), motivates much academic enquiry. It surfaces in the reluctance to cross disciplinary boundaries and institutional segmentation.[18] The pursuit of knowledges to which differing degrees of 'objectivity' and 'authenticity' are granted derives its legitimation through and in specialized institutional practices. Rather than being defined by their specific objects of investigation, these discourses produce and position their objects, 'for the objects of any rational investigation have no prior existence but are thought into being'.[19] Taking into account this particular relationship between the represented (object of investigation) on the one hand, and the system which represents it on the other, Michel Foucault located a shift in what he called the transition from the classical to the modern episteme in western thought. While 'in the classical age languages had a grammar because they had the power to represent, now they have the power to represent because they have a grammar'.[20] In dealing with primitivism it is this grammar which demands our attention.

The (re)production of sexual difference by means of stereotypical representation (the feminine stereotype)[21] is comparable to racial (racist) stereotyping in so far as in both cases specific meanings are constituted within interdependent but distinct economies of power and pleasure. Discrimination,

marginalization, and exclusion from public language are deter-
mined, not only by hierarchical social relations in terms of
gender, race, and class, but also by their internalization in the
psychic formation. Its particular symbolic forms effectively put
into place and maintain subject positions in terms of racial and
sexual difference.

The interdependence of a regime of power and domination
and orders of identification through the projection of fantasy is
systematically explored with reference to a psychoanalytic
framework in Homi Bhabha's formulation of the concept of
ambivalence.[22] The notion of the colonial stereotype as suture[23]
recognizes the ambivalence of authority that relies at once on
the continual fixing of the stereotype and, equally, on a process
of splitting in order to guarantee its representational function.

Analyses of colonial discourse indicate the fundamental lack
of stability in the relation between colonized and colonizer, in
fact, this relationship emerges over and over again its full
fetishistic character whereby the recognition of difference is
profoundly repressed in order to be reinvented in terms of fixed
hierarchical and essentially separate categories. And staying
with psychoanalysis a little longer we can draw a connection
between historical processes of subjugation and the construction
of particular 'others' in relation to (western) identity. If we
argue that, differently from the Cartesian ego or the Kantian
transcendental I/eye, identity is always already a relation (pace
Hegel), Freudian and particularly Lacanian psychoanalysis
insists that the identification of the I, the self, is also an identi-
fication of the Other. Thus, when I speak I do not hear myself
talking (consider the great discomfort many people feel when
listening to their own voice on tape) but recognition and identity
occur in terms of response solicited by the address; in the
response my address solicits, I become the Other. If for a
moment we agree with Lacan that 'the unconscious is the dis-
course of the other',[24] the negotiation of differences on the level
of the psychic formation can be read as a doubling and splitting
which involves two simultaneous movements. On the one hand,
the disavowal of difference allows for an identity predicated on
narcissistic identification, while on the other, the intrusion of
the non-identical, heterogeneous and contradictory can only be
checked by repeating the disavowal which always also includes
an appropriation and moulding of a notion of self with and
against what remains intrinsic to it while being censored.

This little psychoanalytic detour which lays no claim to be an
inclusive explanation may none the less help us to consider
primitivism as it poses itself in contemporary art and criticism.

The history of primitivism as part of modernist discourse need
not be recapitulated here. It seems important to stress, however,

that since the mid-1970s art practices in the west which appro-
priate other cultures have proliferated on an unprecedented
scale and questions around strategies of appropriation and
meanings thus produced now occupy a central position in
critical and non-critical writings alike. Celebrations of post-
modernism, transavantgardism, new subjectivity and the like
tend uncritically to embrace an age of 'cultural nomadism' and
'stylistic eclecticism'. Eclecticism here appears to be the magic
tool that allows the contemporary artist, described by Achille
Bonito Oliva as occupying a 'nomadic position', unproblemati-
cally to traverse the cultural arena. Hunting and gathering from
different traditions, western and non-western, become the very
preoccupation of the artist-nomad moving across the debris
of modernism, at a time when, in Bonito Oliva's words again,
'the decline of ideology, the loss of a general theoretical posi-
tion pushes man into drifting'.[25] Of course this is not as new
and different as some would have us believe. The end of ideo-
logy was already proclaimed in 1960 by the neo-conservative
political scientist Daniel Bell.[26] As far as the nomadic artist
goes, does he not curiously resemble his nineteenth-century
predecessor, the heroic bohemian outsider? First of all he is a
man, no doubt about it, and he has to be for quite specific
reasons. The artist quotes and in quoting he names, he is the 'I'
that speaks. In western society this almost by definition makes
the artist white, male, and middle-class, but one could argue
that this need not necessarily be so and exceptions could be cited.

Quoting, appropriating, and borrowing, whether formal (the
brushstroke, the material, etc.) or the iconic (the mask, African
carving, sand-painting, etc.), have to be distinguished from
other modes of enunciation because the image refers to, or com-
ments on, something that always already exists in a different
context. Typically in primitivism the previous meaning and
context are denied and the reference is thereby reduced to a
signifier of purely western concerns.

As we have tried to argue, this is not surprising and could
hardly be otherwise as historically the process of primitivism is
premised on and reiterates the closure of (western) identity.
Projection, displacement, and condensation are at work both on
the level of production and reception of those images which owe
their existence to the continuous staging of the scenarios which
globalize and maintain the 'western voice'. The various forms of
'cross-cultural' references, of which artistic primitivism is only
one, occupy a highly ambivalent place in their implicit or
explicit reiteration of western identity as the homogeneous and
universal authority against which the 'other' is developed.
Definitions of sexual difference intersect at this point with
constructions of 'primitive others'. Fantasies of a unified subject

can only be set out and maintained in a system of difference in the absence of an object, where words and images stand in for and re-invent the object. This distance (lack) accounts for the possibility of constituting female or male and black or white as mutually exclusive and absolute categories. These categories, however, have to be constantly re-established as they are potentially threatened by the repression on which they rest and the heterogeneous social arena on to which they impose their order. The resulting scenes of conflict indicate that the identity and unity asserted in the text or image have to remain on the level of fantasy.

From a psychoanalytic point of view, primitivism sets out identities in a continuous process of sublimation which submits to paternal metaphor, the law of the (white) father. This *mise-en-scène* is endlessly repeated, one object is substituted for another in the scenarios which precariously hold the identification, never stable and always threatened at the point of emergence.[27]

In his analysis of language in the modern age, Foucault, following Nietzsche and Heidegger, arrived at a similar observation when he wrote that

> The analytic of finitude has exactly the inverse role: in showing that man is determined, it is concerned with showing that the foundation of those determinations is man's very being in its radical limitations; it must also show that the contents of experience are already their own conditions, that thought, from the very beginning haunts the unthought that eludes them, and that it is always striving to recover; it shows how that origin of which man is never the contemporary is at the same time withdrawn and given in an immanence: in short, it is always concerned with showing that the Other, the Distant, is also the Near and the Same.[28]

Colonial discourse provides many examples of the struggle to produce and maintain identity in the face of threatening social and cultural heterogeneity. Here we will take up an example of colonial conflict in order to map the convergence of colonial representation and its anthropological analysis. This will allow us to clarify the strategies of primitivism in art in so far as its (unacknowledged) aim and function rest on analogous presuppositions – the particular production and positioning of the non-western 'other'. To explicate the double bind of race and gender and its crucial place in primitivism, we chose an example in which the subject is both non-western and female.

At the end of 1929 there was widespread rioting and rebellion in the Igbo and Ibibo regions of eastern Nigeria. The colonial authorities were particularly perturbed not simply because this

was the sole insurrection in the region, but because it was led by women; women whose behaviour was described by male witnesses as 'shocking', 'obscene', and 'disrespectful'.

> Many women were dressed in sackcloth and wore nkpatat (green creeper) in their hair, carried sticks and appeared to have been seized by some evil spirit. (Report of the Commission of Inquiry appointed to inquire into the disturbances in the Calabar and Owerri Provinces, December 1929)

> The women were led by an old and nude woman of great bulk. They acted in a strange manner, some lying on the ground and kicking their legs in the air, and others making obscene gestures.(Report 91)

> Some were nearly naked wearing only wreaths of grass around their heads, waists and knees, and some were wearing tails made of grass. The District Officer then began to talk to the crowd, only a few could hear him owing to the noise the others were making. During all this time reinforcements of women were continuing to arrive both by river and land. Some of these were carrying machetes. . . . During this time when I was not standing with the District Officer, I moved up and down the fence (which marked off the administration offices) telling the women not to make a noise. They took no notice of me and told me I was the son of a pig and not a man. . . . The court clerk and the policeman were interpreting for me and told me the women, speaking their native language, were calling the soldiers pigs and telling the soldiers that they wouldn't fire but they didn't care whether the soldiers cut their throats. (Statement from an English Lieutenant of the Hansa Guards, Minutes of evidence by the Commission of Inquiry appointed to inquire into certain instances at Opobo, Abak and Utu-Etim-Ekpo in December 1929)

Anthropological reflections on this text are limited to interpretations operating within the pre-established parameters of the discipline. This is also evident in the writing of the feminist anthropologist Caroline Ifeka-Moller. On the one hand in her analysis she attempts to 'make visible' the particular struggle of female colonial subjects and paradoxically on the other she closes down the space in which this subject articulates. This results from disregarding the hesitations, silences, and 'hysterical' noises running through the colonial reports, where the ruptures of the text themselves throw into question the 'objectivity' of the account it proclaims.

In her article 'Female militancy and colonial revolt'[29] Ifeka-Moller concentrates on a historical reconstruction of

socio-economic events leading up to the 'women's war'. From the 1880s the Igbo women's economic power had steadily increased through their role as petty commodity producers within the developing world market system. Predictably this was not matched by access to the male political sphere of power, prestige, and authority. The women's protest was directed against the colonial authorities as the agency responsible both for their immediate economic exploitation and for actively supporting existing indigenous patriarchal structures.

Certain questions are raised by Ifeka-Moller about the way the Igbo women chose to represent themselves in this context and what this might tell us about the way they saw themselves as women and as women in relation to men, but in her analysis sexual difference is understood in terms of pre-given male and female entities which potentially complete and satisfy each other, typified by men as producers and women as reproducers. For this author, the Igbo women experienced the challenge which ultimately eroded the female power of fertility. Based on a fixed concept of 'indigenous' female belief, Ifeka-Moller suggests that 'hidden from sight behind the genitalia is the womb . . . the operator of female reproduction . . . the source of the Igbo woman's pride in herself as a woman'. The closure of this argument rests with the embracing of sexual difference as an irreducible biological category. Consequently nothing can be said which does not automatically fall back on to this essentialism.

From the colonial reports cited above and the epithets used to describe the women's action, what seems to be at stake, however, is also a symbolic struggle invoked by the ambivalent structuring of male and female positions. Therefore it could be more productively argued that gender operates as a system of signs, the sign woman is only meaningful within the system of signification in which it is produced. It is this system that puts into place sexual relations. Baudrillard[30] maintains that the sign is discriminant, and structures itself through exclusion; that is, the rationality of the sign (for Baudrillard 'logic of equivalence') excludes the ambivalent, the superfluous and the non-classified. Since its meaning is arbitrarily fixed, gender/sexual difference occupies an intrinsically unstable position.

The colonial reports constitute a representation of sexual and racial imperialism in which the colonial mentality sees the 'native' as needing control, focused on the Igbo women as exemplifying the stereotype of the black sexualized female. As an icon of deviant sexuality, atavistic and lascivious, the stereotype of the black female is reproduced across a wide range of discourses.[31] Within the texts cited above, the articulation of this

image is characteristically defined and positioned with reference to its polar opposite, the European male.

Naked, wearing only wreaths of grass, seized by some evil spirit, making noise and obscene gestures, the women are identified with an experience beyond the boundaries of civilization, the domain of the rational white male. Considering the context and function of the colonial report, we could argue that by choosing to act in the way described, the Igbo women were parodying an imposed stereotype in order to assert a position for themselves as subjects. Asserting difference, the body, that threatening otherness, their use of bodily symbolism and genital display mocks and dislocates the colonial representations of them. For a short moment positionality is shifted from the silent bearer of colonial meaning to powerful self-representation. By radically adopting their position of exteriority, the Igbo women forced the symbolic order to teeter on the edge of the social void which it itself created. Gestures and articulations of the women spill over to create that excess of signification which can no longer be bracketed and disavowed by the stereotype. The coherence of colonial discourse gives way; its object becoming, however momentarily, the subject of its own utterance. The breakdown is complete, the District Officer shouts to be heard but the 'voice of reason' is drowned and order is established only by killing a large number of women.

What can be said in the face of violence? Can violence be spoken at all without being reiterated and re-enacted as the trauma of the victim who, remaining the victim, forever refers back to his/her objectification and death? Nancy Spero is an artist who since the 1960s has been concerned with the discourse of the victim which she attempts to develop, in her own words, 'from the repressed victimised states to buoyant, self-confident stances'. Here, discussion will be limited to two aspects of her work: the concern for a 'language' beyond the confines of patriarchal discourse and the positing of a universal subject woman, as the speaking subject of this language.[32] Long scrolls, the longest 64 metres (210 feet), occupy the gallery walls with collaged and handprinted images of women running, jumping, crawling, dancing, escaping. The images are taken from such disparate sources as newspaper photographs of Vietnam victims, Egyptian tomb-paintings, representations of athletes and the Celtic fertility goddess Sheela Na-Gig. On the scrolls these figures are arranged in patterns, rhythms, and repetitions, they are overlaid, assembled into groups or separated to create their own continuations and disruptions in an ideal space of non-temporality and without boundaries. While fragments of text were incorporated into the earlier work, since the early '80s the

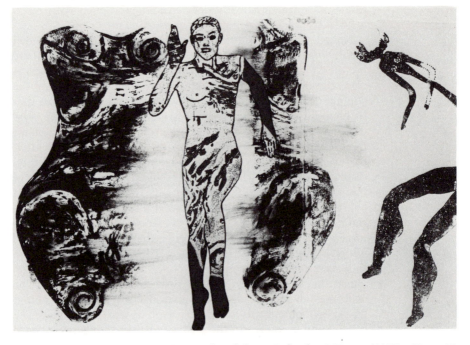

11.3 Nancy Spero, detail from *Rebirth of Venus* (1982), 30′ × 63′ (photograph David Reynolds).

question of a *peinture féminine* is posed exclusively in terms of the female body. This body is ecstatic, is irradiated and reappears, but in its movement across the scrolls it loses all specificity in its celebration of the feminine. It no longer seems to matter that these representations of women were originally made by men, that they had particular meanings in their respective cultures, and that they carried their own stories of resistance, defeat, and survival. Re-presenting these images, Spero makes them her own and they come to suggest women as generic origin, the speakers and protagonists of feminine discourse. But however much the arrangement of the figures violates accepted notions of narrativity and provokes a kind of looking which, instead of freezing the image, scans and multiplies it and however much the spectator is invited to search, piece together and again to lose the threads of this feminine fiction, its 'narrative' is assembled from iconic images of the female body which produce this fiction as an essentially female one, irrespective of women's specific and different experiences, knowledges, and histories.

The question of the body as a point of resistance and/or celebration, also posed in Miriam Cahn's work, is of central impor-

tance here because it marks the very site of 'othering'. Its absenting and spec(tac)ular reinvention contributes to the formulation of the very premises of the western masculine cogito. Critiques of phallologocentrism have therefore closely been associated with attempts to 'rethink' the body.[33] In the tradition of French feminist theory which informs Nancy Spero's work, the question of the female body in general and the maternal body in particular, has consistently been posed in relation to the possibility of a feminine language. Kristeva's theory of the maternal body and Cixous' notion of writing the body privilege the pre-symbolic or imaginary stage, before sexual and subsequently other differences are established in relation to an external authority (the law of the father). The imaginary forms the basis, then, of the *écriture féminine* and renders the female body at once specific, as marking the point of irreducible plurality, and general, in that it exists independently of differences of race, class, and culture. Similarly the effects it produces in language are not discussed as mediated by these differences. Emphasis is placed on syntax, repetition, silence, wordplay, paradoxes, etc., as either a kind of substratum to rational discourses (comparable to the slip of the tongue or pen) or as a more or less direct expression of the female body. Spero's *peinture féminine* also produces a feminine body which is both specific and general. It is specific in its insistence on the female body as a place of origin and general in posing this origin as transhistorical and universal. The simultaneity of archaic and contemporary, western and non-western, historical and mythological representations of women are represented in terms of ritual, dance, and carnival. Urged by their asserted subjecthood, these female bodies are propelled across history, from rape and murder to *jouissance*.

Differently from the work of Susan Hiller or Astrid Klein and many others come to mind (for instance, the recent photographic work of Zarina Bhimji), in Spero's work and especially in the more recent pieces, the body emerges as an unproblematic category, biological in the last instance, and because of that one could argue, immanently representable. If, as Spero's work seems to suggest, the inscription of the 'other' necessitates a different 'grammar', this 'grammar' must effect the vocabulary beyond an inversion of the dominant terms of reference (woman as active, moving, energetic as opposed to passive and submissive).

Miriam Cahn too poses the female body as a point of resistance, but in her work this body is mediated in a way very different from Spero's practice. Cahn explores the terrain of a 'language' which emphasizes the body's physicality in the process of image-making. Most of her large drawings since 1982

are executed with a particular kind of chalk which demands pressure and physical weight for application. Here the process of drawing involves the whole body in contrast to earlier installations such as *Morgen Grauen* ('Dawn'; 'Despair of the Morning')(1980), in which the paper was first hung up then subsequently drawn on, producing faint and fugitive signs. A sound-tape with siren sound forms part of this installation. The sounds were produced by the artist 'lying on (her) back with a tape recorder on (her) breast, blowing the siren pipe until everything inside (her) contracted'.

In the late '70s and early '80s her work included 'male' and 'female' symbols, the former including warships, skyscrapers, computer terminals, and television sets, while the latter incorporate houses, beds, tables, and female heads and torsos. The themes of her installations evolved consistently around women's alienation, which is directly linked to the dynamics of western culture in *Amerika mal so mal so, Westliche Fragen, Inside Passage* ('America Like This Like That, Western Questions, Inside Passage'). Western culture is divided into 'classical' loving, the reality of patriarchy, and 'Wild' loving, also the title of her installation at the 1984 Venice Biennale. In 1983 the male symbols were abandoned and the work focused on stylized female figures as metaphors for a cultural situation in which woman is frequently reduced to a silent cipher so that her equally constructed 'wild' sexuality may be controlled. This is taken up in the work and consciously exploited by personalizing a cultural stereotype. Where Spero's work attempts to universalize a subject woman, Cahn's images try to address the position of women artists under specific conditions which restrict the vocabulary available to represent or articulate the body. In her work it can appear only sexualized and devoid of any individuality and specific physiognomy. Common ground exists in the recognition of the lack of an artistic tradition in which women artists can place their work and consequently the question of a feminine language which can communicate beyond speechlessness assumes central importance for both artists. The consequences drawn in the work differ in so far as Nancy Spero poses the female body in a multiple completeness, while Miriam Cahn's figures remain partial and fragmentary.

Proceeding from an analysis of the constraints and social conditions which marginalize and silence whole areas of experience, Cahn insists that these areas are none the less productive of knowledges which can be represented. This view partly corresponds to the premiss of the dominant/muted model developed by Edwin and Shirley Ardener, in which they propose that different knowledges are produced by different groups in a society on a deep level, while the articulation of these ideas is

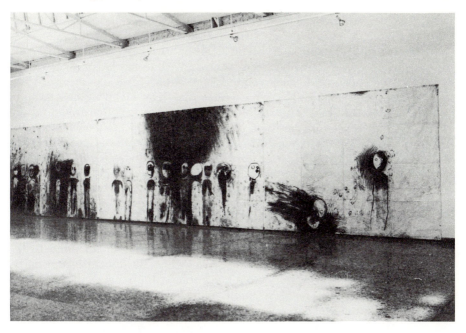

11.4 Miriam Cahn *frauen, frauentraüme, état de guerre* (1984), Venice Biennale.

controlled by the dominant social group. Consequently, any message has to be coded in the dominant linguistic structure.

> This dominant model may impede the free expression of alternative models of the world which subordinate groups may possess, and perhaps may inhibit the very generation of such models. Groups dominated in this sense find it necessary to structure their world through the model (or models) of the group, transforming their own models as best they can in terms of perceived ones.[34]

In different contexts both the Ardeners and Luce Irigaray argue that women have to mimic patriarchal discourse in order to be heard. Cahn's work seems to be doing this in reference to dominant notions of expression but at the same time a big question mark is drawn over concepts of authenticity and expressiveness. It is no longer only the gesture, the drawn mark which communicates, but the ambivalent play of presence and absence. Pictorially this ambivalence is produced in the contrast between different shades of grey, and the black and white areas in the drawing which refuse an ambiguous reading as positive or negative shapes. Instead they continually offset the balance one might wish to establish, by defining and ordering the space in which they exist. This strategy is in marked contrast to earlier

attempts of problematizing the figure/ground relationship in, for instance, American abstract expressionist painting.

The work of Franz Kline in the early '50s produced an equilibrium between black and white marks, or sometimes a newspaper background which allows for a double reading of either the black or the white as 'positive'. Cahn's images prohibit an either/or understanding which relies on definite pictorial and conceptual positions in order for one to be privileged at any one moment. Deliberate allusions to conventional notions of the 'authentic' and the 'expressive' are simultaneously rendered as it becomes impossible to establish to what exactly these concepts could refer in her work. The uneasy relationship between Cahn's installations and existing aesthetic categories spells out the necessity for a different approach, a different way of looking.

As long as discussions of primitivism remain blind to the scenarios of cultural identity of which the discourse of primitivism in art history is but one instance, the debate will continue to produce more research, more 'evidence' and more archival material without ever shifting the parameters within which this material is considered.

The *'Primitivism' in the 20th Century* exhibition at the Museum of Modern Art in New York was the most spectacular manifestation of this status quo. Primitivism, as we have argued, is part of a larger cultural and political dynamic which relies on generating particular knowledges in order to institute and to maintain existing social and cultural hierarchies. We have tried to suggest ways in which it may be possible to approach these issues by considering, on a structural level, the convergences between the production of external 'others' and the processes of internal 'primitivization' as they affect women in western culture. Some readers might object to the 'reading together' of academic discourses and artistic practices, arguing that these present different domains which have to be considered separately and that we conflate issues which have nothing to do with each other. The research and work done on representation and identity both under the umbrellas of colonial discourse analysis and feminist theory suggest otherwise. The connections and the relations sketched in this chapter are in no way taken to be conclusive but are seen rather, as a starting-point for further enquiry.

NOTES

1 Mona Hartoum (Autumn 1987) *Third Text* 1: 26–33.
2 Robert Goldwater (1967 [1938]) *Primivitism in Modern Art*, New York: Random House.
3 ibid.

4 Kirk Varnedoe (1984) *'Primitivism' in Twentieth Century Art: Contemporary Explorations*, New York: Museum of Modern Art.

5 James Clifford (April 1985) 'Histories of the tribal and the modern', *Art in America*: 170.

6 Hal Foster (Fall 1985) 'The "primitive" unconscious of modern art, or white skin, black masks', *October* 34.

7 Gayatri Chakravorty Spivak (1985) 'The Rani of Sirmur: an essay in reading the archives', *History and Theory* 24/3: 251.

8 Frantz Fanon (1986 [1952]) *Black Skin, White Masks*, trans. Charles Lam Markmann, London/Sydney: Pluto Press, p. 133.

9 Benita Parry criticizes Spivak on the grounds that her theory of imperialism's epistemic violence posits the colonized as a historically muted subject. Benita Parry (1987) 'Problems in current theories of colonial discourse', *Oxford Literary Review* 9,1–2: 27–58.

10 Astrid Klein is a German artist working in Cologne. In the 1980s her work has focused on an examination of photographic images beyond their conventional limits as coded messages.

11 Toril Moi (1985) *Sexual Textual Politics*, London: Methuen, p. 132.

12 Sigmund Freud (1955) *Standard Edition XVII*, trans. James Strachey, London: Hogarth Press, p. 244.

13 Gerd Kimmele (1978) 'Spiegelschrifft im Auderssein, Schrecken', *Konkursbuch* 9: 82.

14 Desa Philippi (September/October 1987) 'Cerebral somersaults: Astrid Klein', *Artscribe International*: 79.

15 Maurice Blanchot (1981) *The Gaze of Orpheus*, Barrytown, New York: Station Hill Press.

16 Michel Foucault (1972 [1969]) *The Archaeology of Knowledge*, trans. A. M. Sheridan-Smith, London: Tavistock, p. 12.

17 Jürgen Habermas (1983) 'Modernity – the incomplete project' in *The Anti-Aesthetic*, ed. Hal Foster, Port Townsend, WA: Bay Press, p. 5.

18 The particular implications of the humanist constructions of 'autonomous' spheres of knowledge, *vis-à-vis* women's oppression, are analysed by Christine Delphy, (1984 [1970]) *Close to Home*, trans. and ed. Diana Leonard, London: Hutchinson.

19 Pierre Machery (1978 [1966]) *A Theory of Literary Production*, trans. Geoffrey Wall, London/Henley/Boston, Mass.: Routledge & Kegan Paul, p. 5.

20 Michel Foucault (1970 [1966]) *The Order of Things*, trans. from the French, London: Tavistock, p. 237.

21 Parker and Pollock identify the feminine stereotype as a functionally imperative historical corollary of the modernist notion of the artist as male creative genius. Roszika Parker and Griselda Pollock (1981) *Old Mistresses, Women, Art and Ideology*, London/Henley: Routledge & Kegan Paul.

22 The notion of ambivalence is developed from Frantz Fanon's writings, especially *Black Skin, White Masks*, op. cit.

23 Homi Bhabha (November/December 1984) 'The Other question . . .', *Screen* 24, 6.

24 Jacques Lacan (1982 [1967]) *Ecrits, a Selection*, London: Tavistock, p. 172.

25 Achille Bonito Oliva (1982) *In Labyrinth der Kunst*, Berlin: Merve Verlag.

26 Daniel Bell (1960) *The End of Ideology; On the Exhaustion of Political Ideas in the 1950s*, Free Press of Glencoe.
27 Elizabeth Cowie establishes a direct relationship between original fantasies (of subjective origination) and fantasy in film in which the unconscious obsession with primal fantasies manifests itself in 'the enormous repetition of cinema: the same stories replayed before the cameras, always the same but differently, which has been the key to cinema's success as a mass form of entertainment'. Elizabeth Cowie (1984) 'Fantasia', *M/F* 9: 83.
28 Foucault, *The Order of Things*, op. cit., p. 339.
29 Caroline Ifeka-Moller (1975) 'Female militancy and colonial revolt', in S. Ardener (ed.) *Perceiving Women*, London: Malabay Press.
30 Jean Baudrillard (1972) *For a Political Economy of the Sign*, trans. Charles Levin, St Louis, MO: Telos Press.
31 Sander Gilman examines the conventions of human diversity captured in the iconography of the nineteenth century, focusing on the linkage of two female images – the icon of the Hottentot female and the icon of the prostitute – as epitomizing the representation of the sexualized female. Sander Gilman (Autumn 1985) 'Black bodies, white bodies: toward an iconography of female sexuality in late nineteenth-century art, medicine and literature', *Critical Inquiry*: 12: 204–39.
32 For a more detailed discussion of Nancy Spero's work see exhibition catalogue (1987) Institute of Contemporary Art, London.
33 In the context of Spero's work, Antonin Artaud's notion of the body is considered as a complex metaphor for both the artist's outsiderism as a woman artist, negatively situated in relation to language, and the possibility for a 'feminine' expression in *Codex Artaud*.
34 Shirley Ardener, op. cit.

12 Leonardo's 'Last Supper' in Fiji

CHRISTINA TOREN

THE ETHNOCENTRIC ANTHROPOLOGIST

On Gau, the island in central Fiji where I did fieldwork, there are sixteen villages, each of which has a Wesleyan church.[1] I attended services in nine of these villages and in every church there hung a reproduction in tapestry of Leonardo's *The Last Supper*. Some were large – about 160 cm by 80 cm (64 inches by 32 inches); those that hung in many villagers' houses were perhaps half that size. These tapestries had each been brought home from Lebanon by villagers who served as members of the Fijian Army force in Unifil (United Nations Interim Forces in Lebanon) from 1978 onwards. Clearly they were considered to be a most suitable and valuable gift by a returning soldier to the church congregation (i.e. to his kin at large) in the village of his birth, or to his parents or other close kin. However, I have to confess that during my eighteen months in Gau I did not ask my hosts why they valued these tapestries or why they were apparently the first choice of gift on the part of a returning soldier.

Obviously I have to convict myself here of the ethnocentric assumption that underlay my failure to make any enquiry: I thought I knew the significance of *The Last Supper* for committed Christians. So while the number of reproductions in churches and homes was perhaps rather unusual in terms of sheer quantity, their presence there could be attributed simply to the fact of Fijian Christianity. Only after I returned from Fiji did the significance of *The Last Supper* for Fijians become problematic to me.

This instance of my own insensitivity raises the issue that underlies what is to follow. Whenever we assimilate new information we do so in terms of what is already known to us. In respect of cognition, this is perhaps so obvious that it does not require re-statement. But its implications tend to get lost when we look at forms of appropriation across cultures. In such cases, the process of appropriation contains a paradoxical reconciliation of radical change with a rooted conservatism.

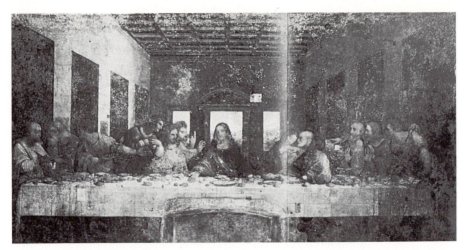

12.1 Leonardo da Vinci, *The Last Supper*, refectory, S. Maria della Grazie, Milan.

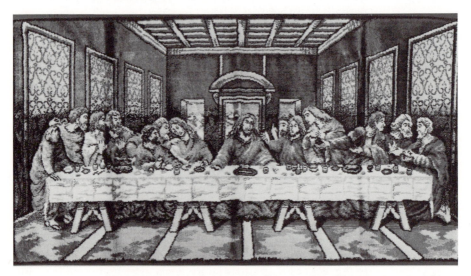

12.2 Machine-made tapestry of Leonardo's *The Last Supper* (photograph, collection of the author).

Primitivism in modern art provides a clear example: it was revolutionary in that it demanded a radical re-vision of western aesthetics, conservative in that it achieved this goal only by virtue of an appeal to a prevailing definition of certain non-western peoples as simple, 'natural', childlike, as peoples without history. So, in their celebration of a 'primitive aesthetic', artists willy-nilly lent their aid to the continuing construction of

European culture as dominant, colonizing, vital, and intellectually and aesthetically 'superior'.

Anthropological analysis too is a process of appropriation; moreover its nature implicates the anthropologist as 'colonizer'. At the same time, anthropological studies offer the potential for a radical reappraisal of western social and cultural institutions: the study of another society forces the questioning of one's own. But anthropology has been historically founded upon a taken-for-granted distinction between 'them' and 'us'. This premiss allied the anthropologist with the colonial administrator; 'the primitive' became the irrational 'other' against which westerners constructed an image of themselves as rational and 'civilizing'.

Anthropologists no longer make this distinction in its crude form; nevertheless the problem is still with us. It is inherent in the nature of anthropological analysis which transforms any given anthropologist's experience of her own and others' daily lives into objectifying scholarly discourse. Many would argue that this makes the discipline itself indefensible, or that its studies should be confined solely to one's own society. My own view is that study of ourselves, our society, and our institutions has become possible only via our study of others and theirs, and that this will continue to be the case; the possibility of each kind of analysis is inevitably predicated upon the other. Given that this is so, we have to recognize the paradox of appropriation: that in any form it *always* conserves even while it signals potential radical change.

Fijian appropriation of Leonardo's *The Last Supper* provides an instructive example. As we shall see, it calls into question the notion of 'culture loss' and forces us to recognize the highly ambiguous nature of the supposed cultural domination of the west.

In this respect my initial response to *The Last Supper* in Fiji is interesting; it is one that is symptomatic of western attitudes in general to the appropriation and transformation of aspects of our own culture by other peoples – and especially by those cultural groups whose recent history has been marked by European colonization and/or by insertion into a world-wide capitalist economy. The extreme and indeed popular view, as represented by television documentaries and apparently well-meaning articles in the Sunday supplements, is that any appropriation of western culture by non-western peoples represents a 'loss' or a degeneration of the indigenous culture. The implicit assumption of western superiority is one that often escapes us – we see our own culture as 'enriched' by borrowings from others while the latter are inevitably 'undermined'. It is no doubt apparent to the reader that this is a patronizing view, that

it denies to others the freedom to borrow and transform that we allow to ourselves – a freedom we represent as an essential part of the vitality of western cultures. Even more important is that this denial is itself implicated in the constitution of western culture as dominant and dominating, is symptomatic of a desire to keep other peoples in their place; that is, the place that we decide should be theirs.

I would argue that the notion of 'culture loss' is itself an artefact of the history of colonialism and western political domination. Fijian appropriation of *The Last Supper* is historically based in the fact of Christian Europe's cultural imperialism and British colonization; this is not denied. But it is arrogant to suppose this to be a complete explanation, to suppose that appropriation of our own artefacts is 'obviously' determined by western political and economic power. This is to constitute that political and economic power as an absolute force against which no culture can retain its integrity.

Cultural change can never be fully explained in terms of force, whatever the prevailing power relations. Even where subject peoples are killed in large numbers, dispossessed of their lands, forced into reservations or 'settlements', and coerced into becoming wage labourers and consumers of western goods, the colonizing power cannot control the transformative nature of the process by which their 'acceptance' occurs. The conservative aspects of cognition feed into the construction and transformation of a subject culture in ways that a colonizing power cannot predict.

The irony here lies in our failure to recognize that, just as we constitute ourselves as autonomous cultural beings in our appropriation and transformation of *their* culture, so other peoples are engaged in precisely the same cultural project in their appropriation of aspects of *our* culture. The inevitability of this process is manifest in the conservative side of the paradox of appropriation. It occurs even where appropriation has been, at base, imposed by colonization rather than chosen. So, in their appropriation and transformation of aspects of European culture, Fijians continue to assert the integrity of their own culture and of the social organization in which this culture is constructed over time. I shall illustrate this process here via an analysis of how images in *The Last Supper* resonate in Fijian culture.

The Last Supper may be understood to have a special symbolic significance for Fijians; but this is not to say that Fijians would give, or even be likely to give, the same gloss on Leonardo's painting as the one that I shall propose. Rather I want to suggest that a series of very powerful connections can be made between the 'Last Supper' considered as a ritual meal and

ritualized aspects of Fijian meals, between Christ's ritual dispensation of the bread and wine and a Fijian chief's ritual dispensation of kava (*yaqona*, i.e. a drink made from the ground root of the plant *Piper methysticum*). In particular there is an analogy to be drawn between the relationship between God and Christ as his son, 'the word made flesh', and the relationship between a properly installed paramount chief and the ancestor gods (*kalou vu*) of his 'country' (*vanua*). I shall argue that the process by which Fijian hierarchy is ratified by a divine and transcendent power underlies the appropriation of Leonardo's *Last Supper* as an ideal image of the chiefs who are the guardians of Fijian 'tradition'.

Connections of this kind may, or may not, have been consciously made by the young soldiers who brought back to Fiji from Lebanon so many tapestries of *The Last Supper*. Indeed, it seems probable to me, for reasons to which I shall return later, that Fijians would be as likely to deny these connections as blasphemous, as to accept them as having informed their choice of religious representation.

My analysis can make sense only if the reader has some knowledge of social relations in Fiji, and so I begin by giving a brief outline of those features that are most salient here – that is, those concerned with Fijian hierarchy and its manifestation in the everyday activities of the meal at home and the communal drinking of kava. There follows a discussion of *The Last Supper* which shows how its imagery and the disposition in space of the figures represented are peculiarly evocative in the Fijian context.

KINSHIP AND HIERARCHY

The 'country' of Sawaieke is a small chiefdom made up of eight of the sixteen villages on the island of Gau. Sawaieke is its chiefly village and it was there that I lived during my fieldwork. The chiefs of the other seven villages owe formal allegiance to the chiefs in Sawaieke village. In 1981–3 the 'country' had a population of some 1,400 people and the villagers of Sawaieke numbered 260. Fijian villagers on the smaller islands, including Gau, have a mixed economy based on subsistence gardening, the keeping of a small number of livestock and the occasional production of cash crops and of copra. My data refer primarily to the 'country' of Sawaieke. However, while specific details will vary somewhat from place to place, much of what follows is in general applicable to the islands of central and eastern Fiji.[2]

For the purposes of my argument the reader is asked to remember the following points: that in Fiji the term for 'kin' (*weka*) not only takes in one's known kin by blood and marriage

but may be extended to include all Fijians; that all the inhabitants of a village, or a 'country', refer to and address one another in kinship terms; and that with only one exception, *all* relations between kin are hierarchical and give authority to the older party.

The single exception, where relations are entirely equal, is for kin who are permitted marriage partners or possible siblings-in-law; the partners to any such relationship call each other 'cross-cousin'.[3] Any pair of cross-cousins are equals *outside* marriage. Across sex, the fact of marriage transforms this equal relationship into a hierarchical one, it being axiomatic that any man has authority over his wife. This relation of authority is the pivot on which turn hierarchical relations within and, by extension across, households.

The household is those people who routinely eat meals together; it often includes kin beyond 'the nuclear family'. Within the household, relative status is given by an interaction between seniority and gender.[4] So a girl's authority as 'the eldest' is limited by the fact that she will one day marry 'out' (i.e. go to live with her husband's family) and the relative seniority of girls within a set of siblings is often ignored. Even so, a woman who is the eldest is bound to be respected by her younger brothers, over whom she has formal authority. An unmarried woman is subject to her father and elder brothers; on marriage she accepts the authority of her husband and parents-in-law. But a woman's relation with her male cross-cousins *outside* marriage is by definition a relation between equals.

Equality is evident in a young woman's behaviour with her cross-cousin; she can make demands on him, tease him, defy him, and so on.[5] *All* other relations are hierarchical and require varying degrees of avoidance and respect, most saliently for those who call each other brother and sister (this being the focal relationship for the incest taboo) and for those who call each other parent-in-law or child-in-law across sex. These relations of respect ultimately turn on the hierarchical relation between husband and wife; thus the equal relationship between cross-cousins across sex *has* to change on marriage. This change is ritually expressed in the betrothal and marriage ceremonies where the woman becomes an object of exchange.[6]

A woman has influence with her husband, she is not 'powerless'. However, her acceptance of her husband's formal authority within the household is crucial for his authority among other men. It is among married men as 'leaders' of households that status *across* households is reckoned. The hierarchical relation that places a man quite plainly 'above' his wife is inscribed in the symbolic space of the house.

All horizontal spaces inside buildings and in certain contexts

out of doors can be mapped on to a symbolic spatial axis whose poles are given by the terms 'above' (*i cake*) and 'below' (*i ra*). When people gather together inside a building, those of high social status 'sit above', those of lower social status 'below'. However, this distinction refers to a single plane and so no one is seated literally above anyone else. Hierarchy in day-to-day village life finds its clearest physical manifestation in people's relation to one another on this symbolic spatial axis and is especially evident in the context of meals, kava-drinking, and worship.[7]

MANIFESTING HIERARCHY

Meals in a Fijian household are always ritualized. The cloth is laid on the floor to conform with the above/below axis of the house space, and members of the household take their places in terms of their relative status: the senior man occupies the pole 'above', others are ranged 'below' him, males in general being 'above' females. The wife of the senior man sits at the pole 'below', nearest the common entrance, with either her eldest son's wife, or her eldest daughter (if her sons are unmarried) opposite her. Every meal is preceded by prayer, the cloth is laid just so and seating arrangements are as described. The best and largest portions of food are placed on the cloth 'above', so that one not only sits, but eats, according to one's status. Women and older girls delay their meal to wait upon the males of the family. The seating arrangements and the conduct of the meal are a material manifestation of hierarchical relations within the household, whose membership is constituted in the act of eating together.

In the wider community, beyond the household, hierarchical relations between people considered as individuals are given by the interaction of three highly salient moral notions: those of rank (i.e. as a member by birth in the chiefly clan or one of the commoner clans), of seniority (i.e. relative age), and of gender. At the level of the group, in the 'ideal' model of Fijian social organization, the chiefs of ranked clans hold sway over their own clan and to a certain extent over those of lesser rank. Every child born to a married couple belongs to the father's clan.[8]

The top-ranking clan provides the paramount chief of Sawaieke 'country'; all its members are 'chiefly'. The four other clans are ranked in terms of their traditional ritual obligations to the chiefs.[9] This ranking is constituted by the interaction of two symbolic oppositions. The first of these places chiefs *above* commoners; the second *aligns* the chiefly clan with other clans who are 'people of the sea' in opposition to those who are 'people of the land'. The latter denotes balanced reciprocity in exchange

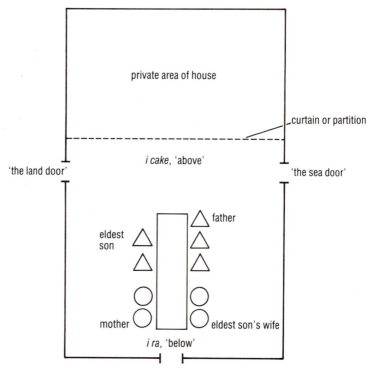

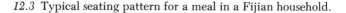

12.3 Typical seating pattern for a meal in a Fijian household.

relations rather than hierarchy: so 'landspeople' do not eat pig, shrimp, and other 'land' foods when they eat in the company of 'seapeople', who do not eat fish. In other words, when eating together, each group symbolically makes available to the other the products of its labour.

Balanced reciprocity is also given by the term *veigaravi* which means, literally, 'facing each other'; this refers to reciprocal obligations between clans to exchange goods and perform traditional services (e.g. burial rites). However, the term *veigaravi* is also used to denote attendance on others in a ceremonial sense. Here it connotes hierarchy in that it may refer to the worship of God and to attendance on a chief, especially that given by the drinking of kava, a mildly intoxicating but non-alcoholic drink made by infusing the ground root of the kava plant in water.

The kava ceremony and the *sevusevu*, or ritual presentation of the plant, are the central rituals of Fijian social life. They are performed on *all* occasions: for the most minor get-together, for rituals attendant upon birth, marriage, circumcision, and

death, and for the grand and lengthy ceremonial mounted to install a chief, or to welcome a high chief.

The ritual significance of kava is as follows. First, drinking a bowl of kava in the proper ritual context installs a chief in his office; for a paramount chief this kava is served under the aegis of the chief of the 'chief-making' clan. It is in the drinking that a chief's *mana* ('power', literally 'effectiveness') is conferred upon him. After he has drunk the kava of installation, a paramount chief of Sawaieke has 'at his back all the ancestor gods of Gau'. Second, it is as tribute to chiefs that a bundle of kava roots is offered in the *sevusevu*. This ceremony requests permission to join a kava-drinking group, to claim the hospitality of one's kin in another village, etc., but whatever the ostensible reason for the presentation of kava it is always, ideally, an offering to chiefs. Third, one must not prepare and drink kava alone; this is an idiom for witchcraft. It implies the pouring of libations to the ancestor gods to gain their aid in some evil deed. By contrast, kava may be drunk publicly in a special ritual to cure witch-craft-induced illnesses. Fourth, kava-drinking is hedged about by prohibitions and ceremony, even at its most informal. There are proper modes of deportment to be observed in the prepara-tion, serving, acceptance, and drinking of a bowl; once one has joined a kava group one should not leave it until the large central bowl is 'dry'. Kava is the drink of chiefs; the root is presented to them as tribute and they redistribute it as drink that must be accepted; this is ritually acknowledged irrespective of whether any actual chief is present. As the quintessential social act, kava-drinking is considered virtually obligatory; a refusal to drink effectively constitutes a denial of society and a rejection of the status quo.

It is important to realize that kava-drinking is always in some way *mana*, that is to say, 'effective' in a transcendent sense (the term is sometimes glossed as 'spiritual power'). In the nineteenth century, *mana* was understood to be derived solely from the ancestor gods. In kava-drinking, the 'top' central position of the high chief exemplifies the pole that is 'above' on the symbolic spatial axis and, on the scale of human effectiveness, a properly installed paramount chief is thought to be the most *mana*. In this sense he is closest to the ancestors – his *mana* being almost akin to theirs. Historically, it was probably this *mana* that allowed him to become the focus of what is 'above'; the ancestors were 'above' the high chief but it was he who was the channel for the *mana* that they dispensed 'downwards' from ancestor to chief to commoner.

The symbolic constitution of the status of chiefs is crucial in the contemporary political context. A chief no longer has powers of life and death over his people; nor can he easily exploit their

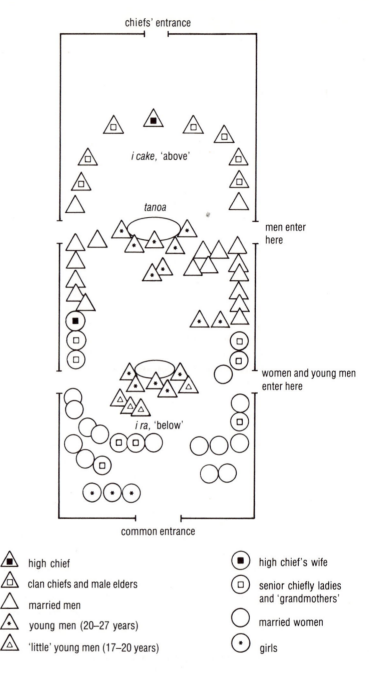

chiefs' entrance

i cake, 'above'

tanoa

men enter
here

women and young men
enter here

i ra, 'below'

common entrance

▲ (■)	high chief	⬤ (■)	high chief's wife
▲ (□)	clan chiefs and male elders	⬤ (□)	senior chiefly ladies and 'grandmothers'
▲	married men	◯	married women
▲ (*)	young men (20–27 years)	⬤ (*)	girls
▲ (△)	'little' young men (17–20 years)		

tanoa – the bowl in which kava is prepared and from which it is served

Note: the young men below the tanoa are 'attending on the kava'

12.4 Typical seating pattern inside village hall when people are gathered to drink kava.

labour or extract from them goods or services they are unwilling to give. Each village is run by an elected council on formally democratic lines and so a chief's political influence depends on whether he has been properly installed (for his *mana* can then exact automatic retribution for any disobedience) and on the respect in which he is seen to be held by the community at large.

In this context of a marked diminution in the actual politico-economic power of chiefs, kava-drinking is of central importance. The current mode of drinking is said to be traditional (*vakavanua*) and eminently Fijian, even though people are aware that in the past women and young men were not permitted to drink kava at all. Women were excluded from kava-drinking groups, while young men (i.e. unmarried men) were allowed only to prepare and serve the drink to their elders. There is also said to have been a great increase in frequency of drinking over the past sixty years or so. Today kava-drinking is the prime ritual manifestation of the 'traditional' order and one in which chiefs are seen to occupy a pre-eminent position 'above' others who are seated in their due order 'below' them. Its imagery stresses a hierarchy that is dependent on political, economic, and spiritual factors that differ in kind from those that obtained in the recent historical past and at the same time effectively denies that irreversible changes have occurred.

So, today, chiefly status and prerogatives are understood to be ultimately given by the power of the Christian god; the salience of 'ancestral power' has been reduced in the face of Christianity which was firmly established in the central and eastern half of Fiji by the late 1850s. Today virtually all Fijians are practising Christians, with Wesleyans (Methodists) predominating, a minority of Roman Catholics, and many other sects also in evidence. The authority of a high chief is still dependent on *mana*, but it is also derived from 'the strength of Jehovah, the high God' and is ratified by association with his divine nature.

Given the association of kava-drinking with the *mana* of the ancestors and of chiefs and by extension with the power of God, it is understandable that it is always hedged about by ceremony. Kava is prepared and drunk under the auspices of 'the chiefs': however informal the occasion, the highest-status persons present must sit 'above' the central serving bowl (*tanoa*) so that it may be seen to 'face the chiefs'. Those who sit 'above' the *tanoa* are of higher status than those who sit 'below' it; within this gross division, one is always 'above' or 'below' other people present, according to one's position relative to the top, central position. If only men are drinking then it is young men who are seated 'below', while if both sexes are included it is women who take this place.[10] Thus relative status across households finds expression on the spatial axis of 'above'/'below'; this is confirmed

by the order in which the drink is served to all participants – the highest-ranking person present drinks first with others following in their due order. The image of ordered and stratified social relations exemplified in people's positions relative to one another around the kava bowl is one encountered virtually every day in the village of Sawaieke.

The young men who look after the kava are said to be *qaravi yaqona*, literally 'facing kava', or *qaravi turaga*, literally 'facing the chiefs', and indeed, all those 'below' the central kava bowl literally do 'face the chiefs'. Here the notional equality of 'facing each other', which describes traditional obligations across clan and lineage, is transformed into a hierarchical construct whereby the chiefs of the various clans, and especially the paramount chief, are seen to be in positions of authority.

This transformation is mediated by the structural position of cross-cousins who are equal partners to a relationship that typically obtains *across* households; by contrast, relations *inside* the household are always hierarchical. The relation between (male) cross-cousins as equals underlies the notional equality of 'facing each other'. Across sex, the fact of marriage transforms the equality of a given man and woman as cross-cousins into the hierarchy of husband and wife. Through marriage, the relation between men as equals and as affines (brothers-in-law) is at once contained by hierarchy and subordinated to it in principle. This occurs because a man is axiomatically 'above' his wife.

In any space where kava is drunk this means that 'wives' – for by definition all adult women are married – are clearly 'below' married men with young men occupying an ambiguous position which is either 'above' or on a level with women. Thus, whatever the case for young men, women are always at the pole 'below'. This is because the highest-status woman present takes up this position with respect to her own husband, just as she does for meals at home. Even if she be the wife of the paramount chief she must, when he is present, be seen to be unambiguously 'below'. By virtue of having excluded their wives from the reckoning, married men take their places in terms of their own status *vis-à-vis* one another – their relative status being given by an interaction between rank and the relative seniority given by age and kinship relation.

In kava-drinking balanced exchange across groups is transformed into tribute to chiefs. Because kava is drunk under the auspices of chiefs, they symbolically provide it via its redistribution as drink. At meals the balanced exchange of labour between a husband and wife is similarly transformed into a hierarchical exchange in which a wife is symbolically rendered subordinate. By analogy, the imagery of kava-drinking ultimately evokes the notion of one vast household where the high chief is 'provider'

and 'father of his people' and hierarchical ranking can be taken
for granted.

'THE LAST SUPPER' AS AN OBJECTIFICATION OF AUTHORITY

And what of *The Last Supper*? Its representation of ceremonial
eating and drinking seems likely to be highly relevant to Fijians,
especially when considered in the light of the figures represented
and their orientation. In Sawaieke, eating together in part con-
stitutes the household, while drinking together constitutes the
'universe' of kin, i.e. the community at large; in other words
eating and drinking together in part constitute the actual nature
of hierarchical relations between kin.

Da Vinci's fresco shows only men, with Christ in the centre.
This is crucial because, as I have shown, women in Fiji have to
be largely excluded from the reckoning if a man is to be accorded
his proper status among men. Christ is a manifestation of God
on earth, the disciples are his chosen executives. Their disposi-
tion around the table evokes that of men 'above' the *tanoa* when
kava is served. It is also analogous to the seating positions of clan
chiefs in church: they are seated 'above' and face 'down' the
church towards the congregation which is seated 'below'. So the
chiefs are seen to be chiefs in the eyes of both minister and
congregation; their position is ratified by association with the
divine. In kava-drinking the status of chiefs (and especially of
the high chief) is similarly ratified by association with the *mana*
of the ancestors *and* with the power of God.

Women are excluded from positions 'above' the *tanoa* in kava-
drinking, and from the area 'above' in the space of the church;
this symbolic assertion of their ritual insignificance is mirrored
in their exclusion from *The Last Supper*. However, the seating
position of women 'below' in the body of the church shows that,
here at least, they are the equals of their husbands. In the body
of the church, wives and husbands are seated on the same level,
the sexes being segregated with women occupying one side of the
church and men the other. This is highly significant for the
status of women both historically and in the contemporary
context.

In pre-Christian Fiji, women were barred from the temples of
the gods, from the consumption of human sacrifices, and from
kava-drinking; so they had access to the *mana* of the ancestors
only through their menfolk (father, brother, or husband).
However, during the past century, with the conversion of all
Fijians to Christianity, women have been admitted to signi-
ficant positions in the hierarchy of at least some Christian sects.

And all women, including the young and unmarried, are now able to drink kava.

Women's current inclusion in kava-drinking would seem to be connected with their inclusion in Christian rituals on the same general basis as men. Since the Christian God has displaced the ancestors as the ultimate source of transcendent power and women have direct access to that power through prayer and observance of Christian beliefs, they can no longer be properly excluded from rituals that ultimately connect with lesser powers. The same reasoning takes in too the inclusion of young, unmarried men and women. But given that in Christian ideology a child's duty is to his or her parents and a woman's to her husband – precepts that are constantly reiterated in sermons and informal religious talks – and that it is women as in-marrying wives who are most salient to adult men, it is hardly surprising that when women entered into kava-drinking they took up a place 'below' the young men who in former times would have only prepared but not drunk the kava, but whose position 'below' the *tanoa* was a marker of the most junior of male statuses. That women may still be rightfully excluded from any claim to full equality is symbolically confirmed by their exclusion from *The Last Supper*.[11]

The orientation of the disciples in *The Last Supper* is that of *veiqaravi*, 'facing each other'. The disciples are at once facing Christ in that their heads are turned towards him and facing the viewer in that they do not present their backs to us. The small group to the far left of Christ, though not actually facing towards him, show by their attitudes that it is he with whom they are concerned. In general the composition is such that the figures irresistibly evoke the image of a group of clan chiefs with the paramount chief at their centre. Moreover, for a Fijian viewer, his or her own orientation in looking at *The Last Supper* is that of 'facing the chiefs' – the same position he or she adopts when drinking kava or when seated in the body of the church and facing 'up' towards those who are 'above'. To worship God is to face God, just as to attend upon a chief is to face the chief, or to look after the kava is, literally, to face kava. So the orientation of the figures in *The Last Supper*, and the orientation of the viewer, confirm the transformation of the balanced reciprocity of 'facing each other' into the unambiguous hierarchy of 'attendance on chiefs' that is manifest on the above/below axis of 'above' and 'below'. The clan chiefs themselves, like the disciples, may be considered as relative equals in their closeness to the divine, but 'the people' are unambiguously inferior to them.

Other important connections have to do with *The Last Supper* as a ceremonial meal where food and drink are transformed by the power that Christ the Son has from God the

Father. The disciples, under orders from Christ, provide the Passover meal; in ritually re-presenting it to them in a form that cannot be further transformed but only ingested, Christ confirms his own authority and their discipleship. Christ's ritual transformation of the bread and wine into his *own* body and blood is made possible by his power as the Son of God and in making his disciples eat of the bread and drink of the wine he symbolically confers upon them some of his own power – a pre-figuring of that time when, having been raised from the dead, he will appear again to the disciples and breathe upon them so that they receive the Holy Spirit into themselves. A recent analysis of Fijian cannibalism in myth and historical practice has shown both that the mythical origin of cannibalism is also the origin of culture and that, as the provider of the cannibal feast, the Fijian chief was at once the feeder of the people, and their food; the link with Christian ritual is also noted (Sahlins 1983).

The historical fact of cannibalism is still highly salient to Fijians even while it is rejected by them as a practice associated with 'devil worship' – that is to say, attendance upon the ancestors in their most fearful and least respectable guise – and is understood as connected with the dangerous powers of great chiefs in earlier times. However, the parallel drawn here is likely to be rejected by Fijians as both invalid and blasphemous.

Less controversially, Christ's presentation of the wine and bread to his disciples evokes the drinking of kava which is presided over by the chiefs and symbolically dispensed by their favour. The hierarchical relations exemplified in those of chief and commoner are manifest in *sevusevu*, where kava is given 'raw' as tribute to be disposed of by a chief who redistributes it as drink that must be accepted. In other words, the root of the kava plant is transformed into drink under the auspices of chiefs and this drink is one that allows access to the power of the ancestor gods. Historically it was in human sacrifice and kava-drinking that men attended on the gods, and in the ceremonial ingestion of this sacred food and drink the *mana* a chief had from the gods was dispensed 'downwards' to other male adults (i.e. married men).

In a more fugitive sense the story of the Last Supper also evokes the ritual installation of a chief in his office: that moment when, in the proper ritual context, the potential paramount is served kava under the aegis of the chief of the 'chief-making' clan who thus confers upon him the *mana* or mystical effective-ness of the ancestors of all the people of a 'country'. However, given that Christ installs himself (for he is at once man and god), his ritual dispensation of the bread and wine, in terms of my analogy, combines the powers of the installing chief *and*

the man he makes paramount. This is fitting in that the chief who installs another man as paramount, willy-nilly constitutes his own ritual inferiority. By contrast Christ remains 'above' his apostles even while he confers some of his authority upon them.

I noted above that these associations may be rejected by Fijians; however, they are certainly compelling. Fijian knowledge of the Bible and Christian lore is extensive and highly detailed; most adults are likely to know that the symbol of Christ is a fish, and that Peter, the chief of the apostles, is 'the rock' – a symbolic opposition that evokes the relation between the chiefly clan (associated with sea) and their commoner 'executives' (associated with land). In Fijian myth, the founding ancestor of the chiefly clan is always a 'foreigner', one who came over the sea; he is 'different in kind' from those whose ruler he eventually becomes. Christ too was different in kind, the Son of God, and his disciples were 'mere commoners' (*tamata ga*, literally 'just people') as are those members of the 'chief-making' clan who nevertheless have from God the power (*mana*) to install a chief, just as Christ's disciples had the power from the Holy Spirit to establish his church.

Moreover, Christ contains all oppositions within himself and in this his authority is constituted, as is also the case for a paramount chief who is properly installed in his office. In drinking the kava of installation, he dies as man to be reborn as a god. A chief is associated with the *mana* of the sea, his emblems are the whale's tooth, the turtle, and the chiefly fish, *saqa*, but in his installation a paramount chief gains access to the *mana* of the gods of the land. In Fijian terms, Christ is also at one with both sea and land; his emblem is the fish, he can calm the ocean waves and its waters are a path on which he walks; at the same time he is a carpenter, i.e. in traditional Fiji, one of the 'landspeople' and thus one who, as Fijians say, should 'be a little afraid of the sea'. Finally, a chief is benign provider, 'the father of our land' (*tama i noda vanua*) and disinterested vehicle of divine justice in that he does not will punishment, but his *mana* causes illness to those who disobey him; so Christ is the mild father of his flock, 'the good shepherd', but in his divine manifestation brings punishment on those who wilfully abjure him.

The copies of *The Last Supper* that are so popular in Fiji are reproduced in cloth. I did see some prints of *The Last Supper* in Fijian houses and churches, but tapestries were far more numerous. This is significant because indigenous decorations for both house and church often consist of pieces of barkcloth, beautifully printed with geometric designs in earth pigments. Morever, traditional chiefs are often referred to as *ko ira na malo*, literally 'the cloths' – a reference to their traditional obligation to provide for their people. The existence of chiefs is

still understood to be essential for the general well-being of the people and the land, and 'a good chief' is still one who brings prosperity to his people. The 'cloths' that represent *The Last Supper* are thus a material manifestation of the ideal chiefs, not only in the images that are represented *on* them, but in their very nature as cloth.

CONCLUSION

I hope I have demonstrated above how images derived from Leonardo's *Last Supper* may be especially resonant in the context of Fijian culture. In their display of reproductions of *The Last Supper*, Fijians are at once transforming their culture and affirming its dynamic integrity. I suggested in the introduction that a fugitive conservatism is inherent in any type of cultural appropriation, if only because the nature of cognition is such that new information is inevitably at least partially assimilated to what is already known. This process is at once exaggerated and obscured by the kind of material objectification that we find in art. The immediacy of the image is such that it apparently identifies itself, and thus requires no careful enquiry either into its sources or into the cultural context of its appropriation. At the same time, the image is being 'fixed' in that new context, so that willy-nilly it evokes an increasing number of associations with long-established ideas and ritual imagery that are apparently very different.

I would like to conclude by reiterating some remarks made in the introduction respecting western attitudes to the appropriation of certain aspects of western culture by other cultural groups. The general view is that such appropriation is a sign of culture loss and thus, implicitly, a sign of western domination. The pious bemoan this supposed loss of culture, and in so doing refuse to recognize that the integrity of a culture is not given by stasis.

People constitute their notions of 'self' and 'other' in a system of reciprocity: our image of the 'other' is formed over and against our image of 'self' and vice versa. The nature of prevailing power relations is a crucial factor in this process. When we consider this as a cultural process that is taking place in history at the level of the group, it becomes clear that the process of domination, that is colonization begins by apparently silencing the 'cultural other' who is made to acquiesce to the forms imposed. However, this acquiescence inevitably involves a struggle over meaning, a struggle for domination of the terms given by particular forms of colonization. In this struggle, the 'cultural other' has to constitute its images of 'cultural self' in a system of reciprocity where the constituent images and terms

are apparently those initially provided by the colonizer. But – however apparently successful – the colonizing power cannot finally 'win' this struggle for consciousness.

So the history of Fijian colonization is also the history of the continuing constitution of a specifically Fijian cultural practice. Fijian villagers in the area where I worked view their cultural practice as being *vakavanua*, 'traditional' or 'in the manner of the land', and their Christianity is understood to be as much a part of their own way of life as those practices which an outsider could recognize without difficulty as 'Fijian'. Contemporary independent Fiji is in an entirely new phase of its history and, in the course of its transformation, historically recent cultural forms are being reworked in terms of 'the old ways' to forge a new culture which can only be called Fijian. Fijian Christianity is perhaps the prime example of this conjunction.

What may be most instructive here is that in their whole-hearted embrace of the Christian faith, exemplified in this chapter by their appropriation of Leonardo's *Last Supper* as a cultural artefact of crucial importance, Fijians force us to recognize the mythic quality of our own iconography. However, the particular resonance of this iconography is as likely to be denied by ourselves as it is by Fijians, for in the west as in Fiji the central iconography of Christianity ultimately recalls an earlier history in acts of human sacrifice and ritual cannibalism.

NOTES

I wish to thank my colleagues Alfred Gell, Peter Gow, Andrew Jones, and Maria Phylactou for constructive criticism on an earlier draft of this paper, and to thank Susan Hiller for inviting me to participate in the 'Primitivism' series at the Slade School of Art.

For reasons of space I have referred in the text to only two published sources; however, the reader should know that there is an extensive bibliography on Fiji, to which I have made implicit reference.

1 Fieldwork from June 1981 to March 1983 was funded by a research grant from the Social Science Research Council. I am also grateful to the Horniman Trust for its support.
2 There is a significant urban population in the towns situated on the two largest islands; it includes a large proportion of Fiji-born Indians, the descendants of indentured labourers brought to Fiji by the British to work on sugar plantations. Today they form over half the country's population. There was no Indian community in Gau at the time of my fieldwork.
3 In Fiji, kinship terms used to describe immediate relations by blood or marriage are extended by use of a classificatory principle, e.g. I call my mother's sisters by the term for 'mother' and my father's brothers by the term for 'father'; the children of anyone I call mother or father are my 'brothers' and 'sisters'. I call my mother's brother by the term for 'father-in-law' and my father's sister by that for 'mother-in-law'; their children are my 'cross-cousins'. If my mother calls someone 'sister', then I call that person 'mother'; if she

calls someone 'cross-cousin' I call that person 'father' and so on. All marriages are by definition between cross-cousins. Thus, even if no such relation can be traced before marriage, the in-marrying wife from a distant island learns to address her husband's kin as she would have done had they been known to be cross-cousins prior to marriage.

4 Seniority means, for example, that the oldest of a set of siblings ranks above the others, whose status is in accord with their relative age.

5 All relations of equality in Fiji are 'joking relationships', i.e. equality is given by the fact that one can speak with familiarity, joke, tease, etc., with the opposite party. The relation between cross-cousins typically obtains *across* households.

6 Note that this is a 'gift exchange' not a 'commodity exchange'. The relation between subject and object in a gift exchange is such that a woman given as 'gift' in marriage retains her subjectivity – her rights cannot be entirely alienated from her. In Fiji the woman's rights in the land of her birth devolve upon her children who are said to be able to 'take what they want without asking' from their mother's brothers.

7 I use the term 'symbolic' to distinguish this spatial construct from that which describes the 'logical' relation between objects on different planes. Symbolic and logical above/below describe a kind of conceptual continuum. If a high chief sits on a chair in a space that is called 'above', he is at once literally and symbolically above others. However, the two notions are *not* conflated; if an invalid sits in a chair in a space that is called 'below', he is literally above others present but symbolically 'below' them. Thus, I am not suggesting here that Fijians see spatial relations in an entirely different way from other people. This is emphatically not the case.

8 Clan affiliation is through the father, but kinship relations are reckoned bi-laterally; thus any child has rights through his or her mother with respect to the mother's natal lineage.

9 Note that the term 'chiefs' can refer either to all members of the chiefly clan *or*, much more exclusively, to the heads of the different clans considered as a group. This group includes the head of the chiefly clan and those of its male members who combine the status of 'elder' with their chiefly rank.

10 This should not be taken to mean that women *never* sit 'above'. If only women are drinking kava, then the highest-status members of the group sit 'above' the *tanoa*; similarly, high-status women visitors to a village will be accorded positions 'above' the *tanoa*, but only if their husbands are not present.

11 For a full analysis of this process, see C. Toren (1988) 'Making the present, revealing the past . . .', *Man* 23: 696–717.

12 See M. Sahlins (1983) 'Raw women, cooked men and other 'great things' of the Fiji islands', in P. Brown and D. Tuzin (eds) *The Ethnography of Cannibalism*, Special Publication, Society for Psychological Anthropology.

PART IV

Editor's introduction

Modern nations, particularly former colonies, use the myth of primitivism whenever they display the arts of their decimated, indigenous minorities as symbols of a national identity. Australia promotes its identity abroad by juxtaposing 'contemporary' images of culture (Sydney Opera House) and 'primeval' images of nature (Ayers Rock, kangaroos, or motifs from Aboriginal art), thus situating itself outside history, conflating its identity *as a nation* with its existence *as a continent*. Equating Aboriginal art – and, by extension, the creators of this art, the Aboriginal peoples themselves – with eternal nature hides current Australian aboriginal struggles over land rights and masks a violent colonial past. In the Americas, each large nation has taken the arts of its suppressed original inhabitants and displayed them as symbols of nationality. The United States circulates signs and tokens depicting and naming its native populations – 'Eskimo Pies', 'Miami', the 'Cleveland Indians', 'Pontiacs'[1] – and allocates a 'national' holiday to celebrating its break with Europe, symbolized by the take-over of native foods (popcorn, turkey, sweet potatoes, cranberries). Edgar Heap of Birds, in 'Don't want Indians, just their names . . .', evokes the bitter mockery of this 'strange white custom' from the native American perspective.

The process of assimilating as a sign what is rejected as historical reality is institutionalized and celebrated in major exhibitions of native American art used to commemorate the bicentennial of the United States and other national events. In the same way, Aboriginal art formed a significant element in the Australian bicentenary celebrations. Passing references, on these occasions, to the tragic consequences for the indigenous peoples of the original white invasion of their territories and subsequent efforts of the whites to subjugate and exterminate them, successfully serve only to locate any 'problem' firmly in the past and to render contemporary peoples and issues invisible.[2] Introduce the living peoples themselves, on their own terms, and 'acknowledge what was done to them and what is today cynically denied them' and these artistic celebrations of national unity would become 'grim farce'.[3]

In comparable ways, individual white artists sometimes

collude unconsciously in perpetuating the process of mythi-
cizing, when they project their desire for the eternal and
changeless on to real other peoples. The burgeoning in recent
years of 'neo-primitivism' in European and American
art – fetishes, masks, sexual symbolism, earth colours, wood-
carving, rough painting, expressive gesture, and other identi-
fiable traits – probably refers more to expressionist sources and
to a desired 'retrieval' of mystical or emotional intensity (with its
supposed origins in a completely imaginary human prehistory)
than to any specific, appropriated 'tribal' artistic tradition.
Neo-primitivism's associated critical vocabulary ('universal',
'vigorous', 'spiritual', 'authentic', 'symbolic', 'potent', etc.) and
eager market of consumers make it a noteworthy and perhaps
perennial artistic tendency. Alongside it exist other kinds of
primitivizing approaches, such as art practices based on confu-
sions of geography with ethnicity; for instance, the assumption
of 'aboriginality' by white artists in Australia described in
'Locality Fails' by Imants Tillers.

Although the intention behind the work of some European
artists is meant to be understood as an act of atonement for
a world destroyed, in speaking 'on behalf of' peoples to whom
they don't belong, whose history they have not suffered, these
artists try to be simultaneously the cowboy *and* the Indian, in
the words of Jimmie Durham's text. Such misrecognition
involves an unconscious eradication of the self-representations
and *living* reality of the people on whose part such artists claim
to speak. Borrowing a suggestion from Nathaniel Tarn, this ten-
dency could be called the 'I-come-to-speak-through-your-dead-
mouths' syndrome.[4] Christopher Pearson's ironic dissection of
certain highly idealized representations of Australian Aborigi-
nals, created by both white and aboriginal artists, indicates that
these supposedly positive Arcadian stereotypes in fact function
to block the emergence of effective contemporary self-represen-
tations.

In Jean Fisher's analysis, 'the problem of reinventing subjec-
tivity within conflicting cultural orders' is a project in which
political issues of cultural self-determination and personal issues
of artistic self-expression merge. 'Without access to the existing
structures of power, strategies of survival and renegotiation are
limited to the manipulation of the rhetorical space of dominant
culture.'

Too often this space is occupied primarily by white artists,
curators, anthropologists, historians, and poets – all claiming to
have access to insights that allow them to articulate the positions
of others. From the perspectives offered by this book, what
has become visible, then, is that the project of rein-
venting subjectivity can justly be described as 'collaborative'

by white artists only when 'we' participate by at last beginning
to recognize, name, depict, and relinquish the interest on our
own investments in the privileges of self-identities formed with
reference to a fantasized, primitivized, colonized 'other'. The
anguish of discovering a 'self' that originates in this transaction
dissolves in the recognition that one can be an active participant
in its re-formation and re-definition, rather than a passive
onlooker doomed to collect interest and suffer guilt.

NOTES

1 'Eskimo Pies': ice-cream on a stick, chocolate on the outside, vanilla
on the inside. 'Miami': a city named after an extinct native nation.
'Cleveland Indians': a baseball team, like the Boston Braves; other
teams are often named after birds or animals. 'Pontiacs': a kind of
automobile named after the great chief of the combined Ottawa,
Chippewa, and Potawatomi peoples who gained the allegiance of all
the native nations east of the Mississippi and organized a resistance
against the opening of Indian lands to white settlers, known as
'Pontiac's Rebellion'; eloquent, scrupulously honest, with remark-
able tactical and organizational skills, both military and diplomatic,
he achieved 'an extended period of unanimity and effective co-
operation among essentially alien tribes' (Frederick J. Dockstader
(1986) 'Pontiac', Encyclopedia Americana, Vol. 22; see also Howard
H. Peckham (1947) Pontiac and the Indian Uprising, Princeton, NJ:
Princeton University Press).
2 Susan Hiller (December 1978) 'Sacred circles: 2000 years of North
American Indian Art', Studio International, London; reprinted
(1979) in Art & Society History Workshop Papers, London.
3 John Pilger (6–13 January 1988) 'Australian white lies', Time Out,
London: 12–13.
4 Nathaniel Tarn (1986) 'Neruda and indigenous culture', Sulfur 15:
169–72; I have used paragraphs 2 and 3 on p. 172 in constructing the
paraphrase.

13 The search for virginity

JIMMIE DURHAM

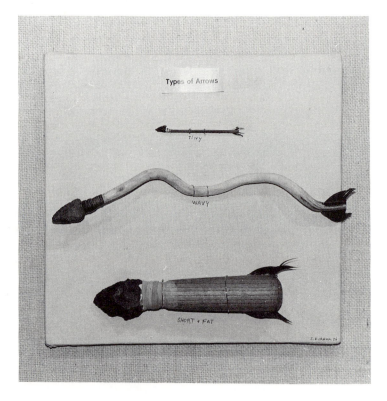

13.1 Jimmie Durham, **Types of Arrows** (1985), 14″ × 21½″ × 2″ (photograph Luis Camnitzer).

AMUSING PERSONAL ANECDOTE

I was actually taught opposites in school. That was in Arkansas, where everything is clear, in about my fifth year in school. (I think I must have been 11 years old by the European system of counting.) I had previously been taught that the correct way to say 'possum' was 'opossum', so I imagined that we probably said 'posits', and I listened to adults to see if I could hear that word and show off my new knowledge.

The teacher said that black was the opposite of white, sweet was the opposite of sour, and up was the opposite of down. I began to make my own list of opposites: the number one must be the opposite of the number ten, ice was the opposite of water, and birds were the opposite of snakes.

But I soon had problems, because if snakes and birds were opposite, where could I put the flying rattlesnake, which we saw every evening as the rattlesnake star? I theorized that in special circumstances things could act like their opposites. If grey is the blending of the opposites white and black then the flying rattlesnake could be seen as a grey bird. That worked out well because our most common bird was the mockingbird, which, everyone knows, likes to eat pokeberries to get drunk — an activity closer to snake behaviour than to bird behaviour. I said to my family, 'What is the opposite of a mockingbird?' 'A mockingbird, ha ha ha.' They didn't get it.

Much later in life some African friends made me study Marx and Engels, wherein I learned that progress is simply a matter of opposites pushing against each other. The cop pushes me, I push the cop; the cop puts me in jail where I have time to plan my next move and strengthen my resolve. My opposite, the cop, is unaware that he has played a part in my development and in the overall scheme of human liberation. I give him a superior smile, which heightens the dialectical struggle.

The moral: dialectically we are far beyond the stage when your folks came over and pushed my folks. We have now reached the stage where I get paid real money for writing these words because some of your artists try to steal our images. Ha, ha, sucker, I win!

WHAT YOU THINK

You think you are the ones who move around and we are the ones who stay put. Even if you catch some of us moving around, physically or mentally, you think we are mockingbirds or anomalies. Explorers and explorees. But you think that way because your sexual affairs are messed up. In your system men and women are opposites and that, primarily, in socio-economical terms. Men are bosses and move-arounders; women are subservient and stay-at-homers. So the guys are all at the pub, and they think, 'Jesus, women are mysterious, there in their houses, Lord luv 'em.' Even after the guys have explored women to their own satisfaction and decide they know everything there is to know about those opposites, in their primitive naivety they extend that system so that England becomes the guy moving around and my folks are seen as the ever-lovably mysterious wife. In that set-up Jews, who are clearly 'others' but who had no choice but to move around, were assigned the role of prostitutes. There were even stories of 'good Jews' similar to those of 'the prostitute with a heart of gold'. Once Israel existed as a country it could become 'one of the guys'.

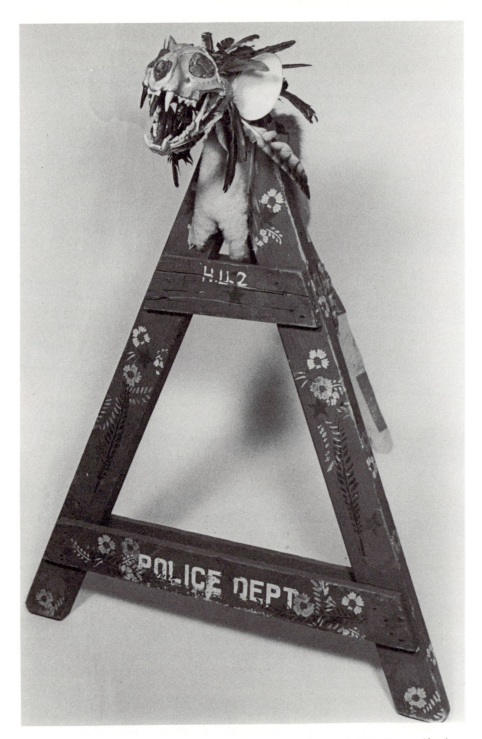

13.2 Jimmie Durham, **Tlunh Datsi** (1984) (photograph Maria Thereza Alves).

How many ways have European artists developed to paint women over the centuries? And then, why have so many gay men accepted the idea (the accusation) that they are somehow like 'women', and assumed 'feminine' attributes which they take right out of the men's textbook? You guys ought to think about that whenever you pose as gypsies or savages, or whenever you tell stories about us savages. Didn't you ever read Genet?

THE SEARCH FOR VIRGINITY

I have been thinking about the Yanomami Indians, even though I know that this is the German artist Lothar Baumgarten's territory. It turns out that humans have been around for at least 3 million years, so let's give 1 million for initial development and consider the last 2 million years. Are there some folk who have remained unchanged for 2 million years? Because that is the only point in time I can imagine when we might all have been primitive. Those unchanged folks: their language and thought-patterns haven't changed, their dance steps haven't changed, their food and their dinner hour haven't changed for a **million years**? Well I'm a little sceptical. Even if we say they haven't changed **much** for a **tenth** part of a million years, we are then making the very odd assumption that the first nine parts of that million years really do not matter.

The Yanomami are now most-favoured primitives. Personally, I've seen so many films and articles about them, and signed so many 'Save the Yanomami' petitions that I'm a little sick of them. But there is something very crazy going on. We know that the peoples of the Amazon forest were once about 95 per cent more numerous than they are at present, that they had extensive intercourse with the Inca Empire, and that they were once brilliant stone-carvers and potters. Now, you would go through some weird changes by losing half your population to smallpox even if you had no direct contact with the rest of the world. It seems to me that as 'Virgin Territory' the Yanomami are pretty battered and used. If us primitives have some primitive wisdom that may be taken home as a souvenir of your visit, I would not trust the virginity of Yanomami wisdom any more than I would that of the Xhosa.

Virginity and primitivity are the same value to you guys, but your reasons for placing value on either concept are pretty silly. You want to be 'first' more out of fear than conquest (although the two go together), and then you want to be 'the only'; and that makes you bored after a while because the whole set-up is too empty. So you have a never-ending search for true virgin territory. 'Untouched Wilderness.' 'Breaking new ground.' 'Thrusting through the barriers to new frontiers.'

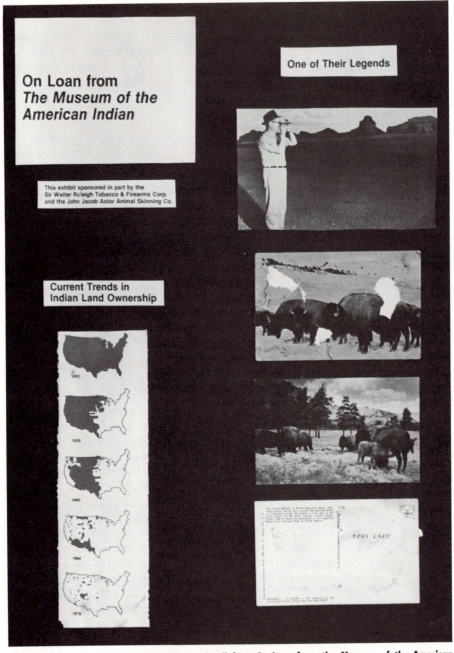

13.3 Jimmie Durham, detail from **On Loan from the Museum of the American Indian** (1985).

WHAT IF GROCERIES WERE THE STANDARD?

Human progress is measured by the technologies of poking and hitting. It is as though we took the worst part of ourselves to be the best. What made the Iron Age the Iron Age? What if there were some much more important developments at the same time which we overlook because the age has been assigned to iron? My folks, then, were in the Stone Age when you guys showed up. But if groceries were the standard, we were in the Maize, Tomatoes, and Beans Age and you were in the Turnips Age. For you, today is the White Bread Age.

POKING, HITTING, BREAKING, AND EXPLORING

Everyone loves the lone cowboy. Free and independent, away from the law, he doesn't have to work. He has that really neat existential loneliness and penetrating gaze. He is a perceptive critic of those who live in the town, and he 'doesn't take no shit off nobody'. Sometimes he must kill evil savages, but the intelligent savages become his friends and he learns their ways while always keeping to himself. What a perfect model for twentieth-century artists. What a perfect way for Jackson Pollock to get the draw on Picasso. But wait, these days artists like to think of themselves as 'shamans'. What if you could be the cowboy *and* the Indian, like Karl May's 'Winnetou'? A perfect set-up for profits both psychological and economical.

It becomes problematic for us savages, however, basically for two reasons; first those cowboy-shaman-artist guys cannot seem to put themselves into even the slightest part of their analysis of a given situation (because they **do** imagine themselves to be lone cowboys). The second reason has causes within the first; the guys believe art to be like an object, so when they think of 'art as a weapon' they imagine it to be like iron—an efficient poker and stabber. So the artist guys say they are 'challenging society' (to a duel?) and as cowboys and explorers and husbands they speak for us and about us. Now, in the first place, that is a bad situation because I want to speak for myself; and in the second place, all Indians and Wives know that Cowboys and Husbands don't know shit from Shinola.

14 Unsettled accounts of Indians and others

JEAN FISHER

Myth hides nothing and flaunts nothing: it distorts; myth is neither a lie nor a confession: it is an inflexion . . . it transforms history into nature. (Roland Barthes)[1]

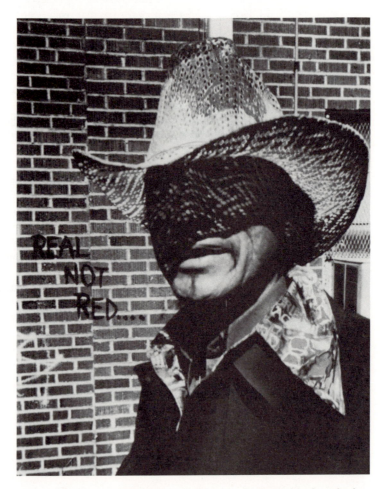

14.1 Richard Ray (Whitman), *Real Not Red* (1985), black and white photograph with acrylic 10″ × 8″.

The story of the white man's invention of the Indian and how this image sustained America's myth of civilization has been ably documented.[2] In order for the myth to be realized, the Red Body was to be drained of its life-blood and transformed into a pale shadow of the colonizer, while providing the transfusion that would revitalize this alien. Native America was to be no more than a punctuation mark at an erased site of difference: a vampirized body, neither living nor dead, haunting the domain of the unspeakable. The unspeakable has, nevertheless, been retranslating itself through the colonial discourse imposed upon it, and another voice has come about. It speaks, not for a revision of 'history', but for a denaturing of dominant myths from within their own representations; it speaks, not as a 'return of the repressed' (what once was), but as a resonance born of the duplicitous effects of colonialism. The following notes and accounts circulate around the discourse of the other, addressing those configurations that map the place assigned by white culture to Native American peoples.

COYOTE INTRODUCES A SOBERING TALE, LAUGHING[3]

The problem of reinventing subjectivity within conflicting cultural orders is outlined in a film text, *Harold of Orange*[4], scripted by Anishinabe writer, Gerald Vizenor. The story-teller in the film introduces us to the satirical tale of Harold Sinseer and his Warriors of Orange, 'tribal tricksters' who, 'word-driven' from the land, are now returning in 'mythic time to reclaim their estate from the white man'.

The Warriors' School of Social Acupuncture is wise to those venous pressure points likely to elicit the liberal sympathies of the white fathers of the foundation whose grants aid the reservation. Seeking imaginative ways to tap into grant money, the Warriors are proposing a fictitious scheme to grow 'pinch' beans and set up reservation coffee-houses in a feint of white gentility. Their trump card is that coffee will assist in the 'sober revolution' to eradicate alcoholism, a goal close to the vampiric puritan heart. In a presentation of the project to the grants committee, Harold initiates a play of parodic decoys designed to disrupt the cultural order of things. Vizenor's 'wordarrows',[5] forged on the forked tongue of white man's history, and aimed by the Oneida comedian/actor Charlie Hill, pierce the rhetoric of prejudice and stereotype, telling how Native Americans were talked out of their proper names, their language, and their land, thereafter infantilized and romanticized into the white man's fictions. But in mythic time an accounting takes place irrespective of histories, and it is here that the Indian is other-wise.

Trickster, the polymorphous disseminator of confusion, plays a game no one can win, least of all Trickster (a most perplexing strategy from the point of view of the anaemic eye). Committee adviser Fanny is owed money by Harold (although he had earlier assisted with her Indian literature research), but she threatens to withhold her support for the Warriors' project should the loan not be repaid. Harold elicits a cheque from the foundation director claiming, as before, that he needs money to bury his grandmother. This apparent deception is set against another official's smug account of the 'acquisition' of tribal artefacts. Typically, Trickster is obliged to relinquish his cheque to Fanny.

Emerging at the core of this exchange of properties is the transference of a debt that repeatedly turns on the unburied grandmother (a question of tradition). The vampirized – and colonized – body likewise arises as a debt (a depletion of blood, of identity) that cannot be discharged since it always creates a further demand. Vizenor's obtuse use of 'estate' therefore suggests more than landed property as understood by white culture; rather, Trickster means to reclaim his 'e-state': his right to cultural difference (speech and self-determination) embodied in the absent figure of the grandmother. Thus, Vizenor establishes for us the rhetorical space within which, in pursuance of a persistent demand, we may approach the coming-into-being of the other and the coming-about of being-other as both an effect and a measure of the untranslatability of language in its movement of exchange between differing cultures.

COYOTE AND SPIDER AT THE MARGIN OF ERROR

Ironically cultural difference would not be a matter for current reflection if monolithic and ethnocentric societies did not perceive themselves as threatened from both within and without. Thus among the challenges posed to dominant cultures are, on the one hand, a breakdown of the illusion of the coherent subject at the centre of knowledge and power and a deterritorialization of the body; and, on the other, liberation movements and their modes of expression by neo-colonized or disenfranchised peoples. The apprehension of white societies is that such movements represent a different socio-political organization and set of ethical values that can no longer be contained by the old colonial model.

In colonial discourses, the cultures of others are typically relegated to the margins of mainstream life as having little to do with its essential progress except as a convenient labour force. In the official history of the United States, Native America has the status of an epiphenomenon, peripheral to the legitimat-

ing narratives of colonization. During the recent 1986 Liberty
celebrations there was a marked silence concerning the debt to
indigenous American peoples. In the narratives of the United
States this debt must be elided, for to acknowledge it would be to
concede the contradictions inherent in the colonial enterprise.
In its continued erosion and erasure of the land and its indig-
enous cultures white America cannot be said to be truly
'American' but the residue of a colonizing European conscious-
ness whose vast vampiric machine of corporate and political
power is the heir to Renaissance expansionism.

The 'discovery of America' is not synonymous with a dis-
covery of its lands and peoples. On the contrary, concealed
under the masquerade of a grand romantic adventure, 'dis-
covery' marks the limits to European civilization as it emerged
from the socio-political and religious conflicts of the late Renais-
sance. Before indigenous peoples discovered the intruders,
America, whether dreamt as El Dorado or the Promised Land,
was a phantasm already forming in European consciousness.
Indigenous peoples were never discovered since, for conquest to
take place, they could not exist as such. What emerged was a
representation, the Indian: a phantasm constructed from a
cacophony of signifiers isolated from their legitimate place in
native schemata, motivated towards proving the inherent
inferiority of native peoples, and destined to justify white claims
to their lands. Indeed the image of the Indian was already in
place before white settlement seriously got under way.
Bernadette Bucher's analysis[6] of the Flemish de Brys's illustra-
tions to the *Great Voyages*, the first compilation of early expedi-
tions, published between 1590 and 1634, shows that the Protes-
tant engravers had already transformed first-hand accounts of
the American peoples into northern Renaissance iconographic
conventions – demons, grotesques, or classical ideals – that can
be correlated with the shifts in Europe's prevailing religious and
nationalistic disputes. As North American settlement gave way
to the less benign aim of conquest, favourable attitudes towards
native cultures were suppressed under the discourse of savagism.
It later remained for rhetoric, first theological and then scienti-
fic, to argue whether indigenous cultures represented a degen-
erate or a prior state of civilization. But in any case, the pro-
nounced sentence was that the Indian was a morally and intel-
lectually inferior human being who, if he could not be civilized,
at best – in his role as Noble Savage – was to be mourned, but
nevertheless sacrificed to the higher ideals of progress. As
became apparent, it was not possible to transport alien desires
and ideals from one place to another, from one body to another,
without perversion of those ideals or violation of the host body.
In order for the myth of civilization to be realized, reality had to

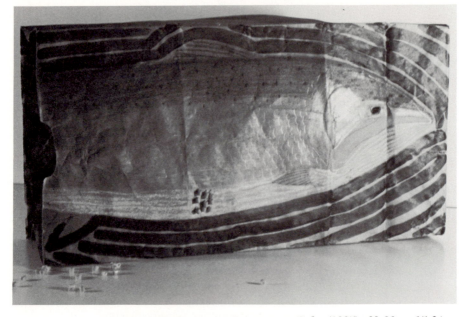

14.2 G. Peter Jemison, *Cattaraugus Coho* (1985), 20.32 × 15.24 × 40.64 cm (photograph Jolene Rickard).

be adjusted to accommodate it. As amongst the first peoples to be colonized by Renaissance expansionism, Native America is at the core of European colonial discourse and the way it subsequently shaped itself in the political psyche of the United States.

Despite its claims to democracy, colonial America had to legitimize its own history at another's expense using many of the terms developed by the monarchical state. A rationalistic view of the world, imbricated with Judaic-Christian moralism and the classical ideal of the hierarchical state, had gradually institutionalized knowledge into discrete disciplines or partitions forming frontiers and enclosures in place of more labile fields of territorial organization. Knowledge itself was ordered according to dualistic principles – good/evil, mind/body, culture/nature, identity/difference – in which the second term was *ipso facto* inferior because it was conceived as the 'is-not' of the first term. The identity of the self was likewise implicated in this web of divisive duplicity. Thus if western subjectivity was formulated on the premisses of an idealized self in reality it was not, it stood in antagonistic relation to the self it dreaded itelf to be. Formed between illusion and reality, it was a self not at one with itself. In this dualistic system there could be a subject, the transcendental 'I', and its object, an 'other', but not another equal subject. Hence the other arose as an effect of a disavowal.

Cultural difference could not be acknowledged as such for to do so would be to accept an untenable equality. What was aimed for, therefore, was the apparent eradication of difference and the creation of homogeneity according to the dominant model. Paradoxically, however, it was by appropriating the signs of difference that the image and power of the selfsame could be secured. The tendency of colonialism to privilege homogeneity through assimilation is symptomatic of western philosophy's desire for equivalence between signified and signifier – a transcendental truth.

By the time America emerged as an independent nation during the eighteenth century, European history had sedimented into a master narrative written from the point of view of this transcendental subject: another form of private property under which all other possible histories were subsumed – a story very different to the consensus that transmitted communal tribal experience. Time was appropriated by the history of this one as surely as space or territory, and the colonized body, were claimed in its name. Within this naturalizing movement, the colonized were rendered anonymous and speechless: 'Since whites primarily understood the Indian as an antithesis to themselves, then civilisation and Indianness as they defined them would be forever opposites. Only civilisation had history and dynamics in this view, so therefore, Indianness must be conceived as ahistorical and static.'[7] For the colonizer to acknowledge an Indian past would be to accept his own position as usurper, and to relinquish his role as the Author of History. We might say that there could be no pre-Columbian history because the 'Indian' was an invention of Columbus: a name born of a fantasy and a navigational error, of a condensation in time and space, and of a transference of meaning on to an alien body which was to be permanently defaced.

SPIDER THROWS THE BOOK AT COYOTE

If, as Pearce maintains, Protestantism formed the image of the Indian from its interpretation of civilization and savagism, what were among its organizing principles? From our perspective, puritanical Protestantism appears as an interdictory theology, superstitious and singularly humourless, preoccupied with distinctions between good and evil, and with redemption from original sin. Since any appeal to sensory pleasure was redolent of popish corruption, Protestantism gave a moralistic priority to the written Word, and by invoking the Hebraic interdiction against graven images, performed an iconoclastic operation on visionary imagination corresponding to its physical destruction of Catholic iconography.[8] Protestantism suppressed much of the

alchemical-mystical thought of Renaissance humanism whose heliocentric models of an holistic universe, incorporating occult knowledges from Hermetic and Cabbalistic traditions, may have found more compatibility with the multidimensional cosmos of Native American thought. Puritans, identifying themselves with the Israelites in the Wilderness, interpreted the world through the Scriptures as they revealed God's purpose, not through an interactive engagement with it; moving west facing east, they translated what they saw through the limited vision of Protestant rhetoric. Thus, Indian hospitality was sent by God's grace to his Chosen, while Indian hostility was Satan's scourge to test their faith, and a justification for the eradication of the indigenous populations from their lands. It could be argued that Protestant cleansing of souls was effected, not through an internal responsibility, but through a transference of guilt and sin on to the body of Native America. Once the people were removed, a virgin land would be free for their own inscription.

The 'civilized' signs apparently lacking in Native American cultures circulate around the interpretation of inscription: the peoples were lacking Scripture (a recognizable writing and the biblical Word of God) and private property (the physical demarcation of territory). Native American traditions of oral and pictographic transmission of history, their principles of communalism against individualism and private property, of absolute equivalence between the body and the land which rendered the latter unthinkable as a marketable commodity, were incomprehensible to the European. For them, the Indian was outside Scripture and the law, and hence illegible and illegal. Because they could perceive no prior text, they could see no grounds for translatability. Without written title to his name, his history, and his territory, the Native American body and its extension, the land, was to be the blank page upon which the colonizer could trace his own master narrative. Armed with the gun and the plough, the pen and eventually the camera, the colonizer was the author of his own myth, outside nature, outside the scene he inscribed and recorded.

Throughout succeeding centuries, Scripture would be invoked to justify dispossession as the natural and divine right of he who worked or made his mark upon the land: 'Those who labour the earth are the chosen people of God';[9] 'Treaties were expedients by which ignorant, intractable, and savage people were induced without bloodshed to yield up what civilised people had the right to possess by virtue of that command of the Creator delivered to man upon his formation;[10] 'But as regards taking the land, at least for the Western Indians, the simple truth is that the latter never had any real ownership in it at all

. . . and let him . . . who will not work perish from the face of the earth which he cumbers.'[11] Any possibility of exchange between white and native cultures was foreclosed by blindness and prejudice. Incapable of perceiving any common ground for translatability, whites presumed indigenous peoples to have no culture, and when they resisted acculturation they were displaced or erased and the land-body occupied. Until the mid-twentieth century it was impossible to consider that the Indian may be 'uncivilizable' because, in his wisdom, he could perceive few advantages in white interpretations of civilization, and learned quickly to recognize the moral turpitude too often at work between the Christian word and deed.

SPIDER MAKES RESERVATIONS AND COYOTE IS RENDERED SPEECHLESS

To a significant extent, white rhetoric was a disavowal of reality. While the earliest explorers in the Americas enthusiastically reported cities, towns, and agriculture, these civilized signs of American life were quickly elided in favour of an emphasis on non-Christian practices.[12] Any positive signs of culture were incompatible with the desire to see the people as backward and savage. That this fantasy was used to support the political rationale for dispossession is illustrated by the 1830 Removal policy towards the Cherokee Nation in Georgia, a people who had long been organized according to principles fully compatible with the Constitution and American commerce. Moreover, Sequoyah, a distinguished Cherokee intellectual, recognizing the power of the written word, had invented a syllabary for the Cherokee language, which subsequently formed the basis of an independent newspaper. We might also add here that it is seldom remembered that the Iroquois League of Peace had been a model of government central to the formation of the United States Constitution.[13]

From the liberalist point of view, removal to territory west of the Mississippi – as yet unsettled by whites – was to protect the tribes and allow acculturation to proceed away from the more deleterious effects of white contact. For those who believed the Indian to be uncivilizable, removal was an effective apartheid that would halt miscegenation, ensure the integrity of white American culture, and enable its westward expansion. With typical rhetorical duplicity, it was argued that Cherokee civilization was the product of mixed-bloods who did not represent the interests of the whole tribe.[14] As a result of the Removal Bill, the Cherokees were to be forcibly transported to where they 'properly' belonged – in the 'wilderness' beyond the 'frontier': a

process of deculturation in contradiction to the ideals of removal.

There appears to be more to this contradiction than the state of Georgia's claim to sovereignty over Cherokee lands. An excess of meaning had erupted at the margins of the colonial discourse that seemed to threaten its core. In so efficiently translating the terms of white culture into those of its own, the Cherokees had accomplished what was inconceivable to the colonizing mind: an integration of cultural difference without loss of identity. However, the Cherokees had not closed a cultural gap but exposed an abyssal difference; a rewriting had taken place which not only transgressed the mythic text but also white claims to authorship.

How was this Indianness, unaccounted for in the colonial text, to be resolved except by transporting tribal America to a remove – and, within a few decades, to reservations – and by inscribing in its place a phantom other it was not? When it was perceived, by the end of the century, that this not-other persisted despite efforts at assimilation, further erasure was attempted by forbidding the use of indigenous languages and ceremonies, by forcing white education, and, through the General Allotment Act of 1887, by breaking up the reservations. The Native American proper name, the sign of an unspeakable and unintelligible difference, did not attract official censure until the dispossession of land was all but accomplished and the body itself confined to reservations. In a ceremony offering American citizenship, Indian identity was to be relinquished by renouncing the tribal name and assuming a given white name.[15]

The erasure of the proper name signifies more than a symbolic eradication of Indian culture since the Name was and is profoundly associated with the identity of its owner. Speaking of this, N. Scott Momaday tells us that 'A man's name is his own; he can keep it or give it away as he likes. Until recent times, the Kiowas would not speak the name of a dead man. To do so would have been disrespectful and dishonest. The dead take their names with them out of the world.'[16] The Kiowa writer reminds us of Jacques Derrida's point that the proper name is untranslatable and hence is outside language.[17] Clearly, in the white mind, assimilation could not be effected until this sign of Indian untranslatability could be removed. The name as sign, dissociated from its tribal origins, could then be displaced into the white man's fantasies: 'A mockery is made of us by reducing our tribal names and images to the level of insulting sports team mascots, brand-name automobiles, camping equipment, city and state names, and various other commercial products produced by the dominant white culture. This strange white custom is particularly insulting when one considers the great

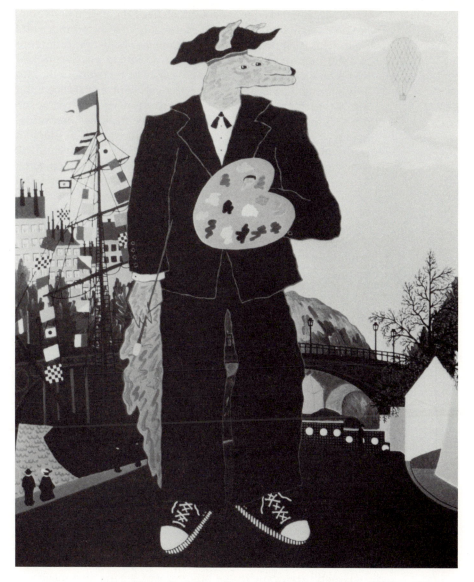

14.3 Harry Fonseca, *Rousseau Revisited* (1985), 182.8 × 152.4 cm
(reproduced courtesy of Elaine Horwitch Galleries, Santa Fe).

lack of attention that is given to real Indian concerns.'[18]

By these strategies, Native America was transferred, not only
from one physical place to another, but also from one linguistic
place to another where notions of 'savagism' could be safely
recycled in the form of a nostalgic 'primitivism' and used as art
or commodity exchange. The means by which white society

physically demarked and deterritorialized the native body may be seen as an actualization of the metaphors inscribing white rhetoric as it circled around the problems of cultural difference and the nuances of translation. If the land-body was the original text whose unfathomable meaning had to be transcribed into white terms, it was also the site of a psychic transference upon which was sedimented those unconscious fantasies characteristic of the colonial discourse of the other. The 'frontier', and subsequently the boundary of the reservation, appear as lines of resistance where the inadequation between the two cultural terms becomes apparent. Relocation and Removal, the placing 'in reserve' (in the 'reservation') under conditions of poverty and neglect, that which carries the sign of an absolute untranslatability, are strategies tracing the failure of white translation. These are configurations that bear witness to Derrida's contention that 'we will never have, and in fact never had, to do with some "transport" of pure signifieds from one language to another, or within one and the same language, that the signifying instrument would leave virgin and untouched'.[19]

COYOTE DOUBLES UP

Native America has had the awesome task of renegotiating its subjectivity through the absence of itself, and the presence of another it feels itself not to be, using the once-alien instrument of its eviction. As *Harold of Orange* discloses, what emerges in this reinscription of an 'original' text through a fantasized other is the unburiable residue of difference, the absent grandmother whose account cannot be settled. None the less, it is the very unresolvability of this debt that holds the capacity for a potentially inexhaustible exchange. It is by way of this elusive demand that the self carries the possibility of transforming itself to meet changing circumstances. According to Paula Gunn Allen:

> A contemporary American Indian is always faced with a dual perception of the world: that which is particular to American Indian life and that which exists ignorant of that life. Each is largely irrelevant to the other except where they meet – in the experience and the consciousness of the Indian. Because the divergent realities must meet and form comprehensible patterns within Indian life, an Indian poet must develop metaphors that will not only reflect the dual perceptions of Indian/non-Indian but that will reconcile them. The ideal metaphor will harmonize the contradictions and balance them so that internal equilibrium can be achieved, so that each perspective is meaningful and in their joining, psychic unity rather than fragmentation occurs.[20]

This complex doubling movement is suggested in a decep-
tively simple photograph by Yuchi/Pawnee artist and poet
Richard Ray (Whitman). *Gina One-Star, Rosebud Sioux* (1972)
presents an image of a young girl reflected in a mirror. The 'two'
girls appear to be identical; the mirroring creates an effect of
difference, and yet one cannot tell which is the 'original' and
which is the reflection. But in any case, as a photographic
image, both girls are at a remove from the real.

The print works of Paiute/Pit River artist Jean LaMarr echo
Allen's sentiments, proposing renewal and wholeness by harmo-
nizing contradictory cultural perceptions. *Lena 1922 and Now*
(1983) is a poignant dual portrait of a woman in youth and in old
age. The border design encompassing her combines roses with a
traditional abstract mountain symbol; suggesting the temporal
and cultural changes that have affected her life. *Vuarneted
Indian Cowboy* (1984) (Figure 14.4) is decked out as a rodeo
rider wearing, as do many of LaMarr's figures, the clothes of
western mythology, but invested with Native American symbols
referring to ancestry and contemporary life. The reflective
designer sun-glasses, a recurrent motif in the artist's work, are
indicators of the dual perception of Native American experi-
ence; but by masking the figure's face, his real identity, they
express, as Allen says, white ignorance of Native American life
beyond the outward signs of 'Indianness'.

The spirit of Jean LaMarr's work seems close to that of the
paintings of Maidu artist Harry Fonseca. Like Vizenor, Fonseca
takes the polymorphous and satirical figure of Coyote as
Trickster (not the only persona in Native American literature,
but one that has emerged as symbolic of Indian relations with
dominant culture), dresses 'him' in contemporary costumes, and
sets him loose in the scenarios of white society. *When Coyote
Leaves the Res* (1983) finds Coyote wearing jeans, a heavily
zippered jacket, and sneakers, swaggering by an urban wall
with an expression of roguish humour. The 'cool' punk style is his
reply to the appropriation of Indian signs by white hippies, and
is a perfect masquerade by which he may mingle with the stereo-
typical identities of the street. But with his ubiquitous sneakers,
Coyote comes softly. In more recent paintings, he has expanded
his territory to invade the white man's own icons. A double
masquerade takes place in *Once Upon A Time 1* as he assumes
the place of Wolf-Grandmother in the tale of Red Riding Hood;
while in *Rousseau Revisited* (1985) (see Figure 4.3), he appro-
priates the persona of the French artist. Fonseca's Trickster, like
Vizenor's Harold, takes up the language of the white man's
game but reverses the direction of play.

The game, on one level, has been a war of words: a rhetoric
of misrepresentations and double talk against a belief in the

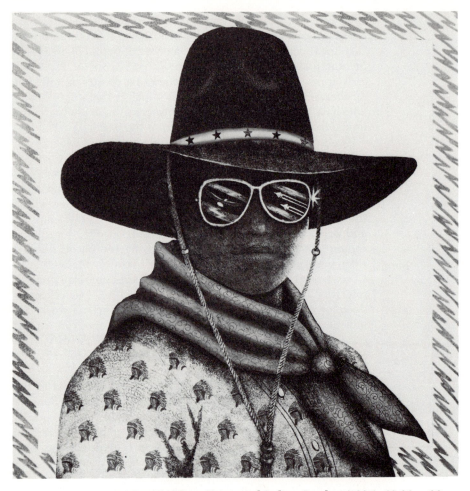

14.4 Jean LaMarr, *Vuarneted Indian Cowboy* (1984), 60.96 × 96 cm
(photograph, Tony Mindling).

sanctity and truth of the spoken contract. 'A word has power in
and of itself. It comes from nothing into sound and meaning; it
gives origin to all things. By means of words can a man deal with
the world on equal terms. And the word is sacred.'[21]

Cheyenne/Arapaho artist Edgar Heap of Birds engages in this
battle using epigrammatic language installations that invade
the rhetorical space of media publicity and advertising slogans.
However, the tone of his address is neither accusative nor imper-
ative but, speaking across time and space, is inscribed with a
compassionate understanding of the relationships between the
world and its peoples. His work often combines Tsistsistas
('Cheyenne') words with English words, or mirror reversals – a

'talking in tongues' and disruption of our habitual modes of reading that question our presumed mastery through language. A predominant theme is the non-place assigned to Native American peoples. *Don't Want Indians* (1982) refers us to the relegation of tribal peoples to the realm of commodity fantasies; while *Possible Lives* (1984) is a reminder of the real people forgotten behind white myths. *In Our Language* (1982) made elegant use of the public address function of the computerized Spectacolor board in Times Square, sending 'messages to New York' of the mistaken identity imposed on his people by the designation 'Cheyenne' (a white corruption of a Lakota word), and of the identity given by his people to the white man, 'Vehoe': an identity based not on racial typologies but on the perceived similarity of his behaviour to Spider in tribal myth. *In Our Language*, as many of Heap of Birds's projects, was a collaboration, emphasizing a bond between the self and its community that is antithetical to western aesthetics' privileging of individual creativity.

COYOTE BOXES WITH HIS SHADOW

Contemporary Native American art does not give us access to the innermost secrets of its people; cultural difference, like Trickster, is elusive and not appropriable except in the most superficial way, as evidenced by the primitivist trends in European art. Rather, contemporary work tends to reveal more about white attitudes. Through the insight of those who have passed through the white looking-glass, we may perceive the movements by which our rhetoric betrays us all, and works to efface the biographical self, turning it into an institutionalized other. Cherokee poet and artist Jimmie Durham, in referring to the Noble Savage stereotype, perhaps echoes the thoughts of those who feel alienated from the source of their own representations: 'One of the most terrible aspects of our situation today is that none of us feel that we are authentic. We do not feel that we are real Indians. . . . For the most part we feel guilty, and try to measure up to the white man's definition of ourselves.'[22]

A laconic commentary on the stereotype of the Indian is presented in the photographs of Richard Ray (Whitman). The artist confronts the turn-of-the-century photography of Edward S. Curtis, whose aestheticized subjects consolidated the myth of the Noble Savage. In accord with prevailing assumptions that the Indian was a 'vanishing race', Curtis set about documenting the authentic Indian uncontaminated by white contact. The absence of such a pure Indian signifier nevertheless compelled him, like other contemporary photographers seduced by their fantasies of the exotic other,[23] to synthesize his fantasy by

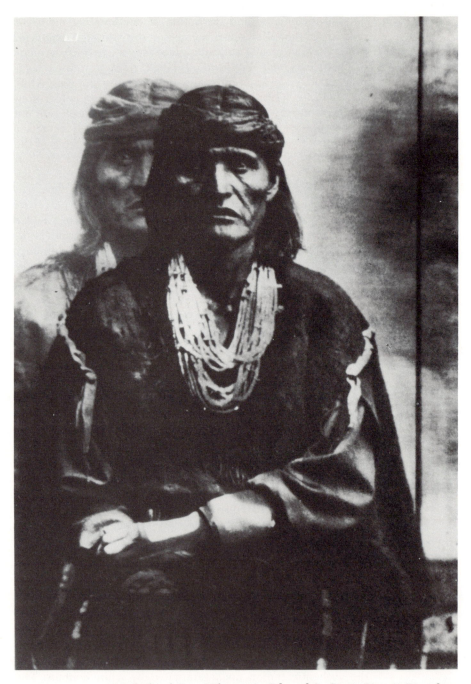

14.5 Richard Ray (Whitman), *Edward S. Curtis Rip-off (Vanishing Americans) .. Hardly ..* (1972), black and white photograph 10″ × 8″.

cropping or retouching signs incompatible with those of 'Indianness', or by adding studio props and costumes bearing little relation to the life of the sitter.[24] To the extent that the sitter has no identity except that donated by the photographer, Curtis manifested an unconscious but none the less arrogant lack of respect for cultural integrity typical of white attitudes couched in liberalist sentiments.

In *Edward S. Curtis Rip-off (Vanishing Americans) . . . Hardly . . .* (1972) (Figure 14.5), Richard Ray steals back a studio appropriation and doubles it to expose Curtis's imaginary Indian surrogate as a pale shadow revealing nothing of the 'real' behind the white image of the 'red'. *Real Not Red* (1985) (see Figure 14.1) is the title of one of the artist's 'Street Chief' series, his contemporary reply to Curtis and to the stereotypical ethnographic portrait where the sitter is presented in a frontal pose, stoical and humourless, evoking the notion of the harsh conditions of 'savagism'. Although Richard Ray's street chiefs are poverty-stricken, they are none the less relaxed human beings whose dignity is not dependent on the false trappings of Indianness. The photographs express the warmth and compassion of shared experience, not the idealized preconceptions of anthropological scrutiny.

Like Richard Ray, Jimmie Durham works to dismantle the stereotypes of Indianness that turn living cultures into mortician's specimens. *On Loan from the Museum of the American Indian* (1985) (see Figure 13.3) presents an archaeology of white misrepresentations in which Native America is presumed to have long since fossilized into a miscellany of falsely identified artefacts, 'legitimating' the theft of its remaining land and water life-support systems. Durham's parodic facsimiles of the ethnological museum exhibit cut swiftly through the voyeuristic colonizer's gaze as it attempts to dispossess the colonized of its identity and replace it with clichés of savagery (*Who's Hair Is This?*) or backwardness (*Types of Arrows*) (see Figure 13.1). Within the multiple facets of Durham's work, however, there is another body that stalks what we have imperfectly called the domain of the unspeakable – of those who cannot be laid to rest because the debt has not been discharged, or the proper words have not been spoken. Durham assembles the discarded remains of nature and consumer society – animal skulls and car parts, feathers and beads, turquoise and plastic baubles. Thonged, beaded, painted, the resurrected skeletal body breathes out an iridescent difference that profoundly unsettles the stereotypic signs of Indianness. Another space takes place where *Tlunh Datsi* (1984) (see Figure 13.2) stands ready to spring, and *Ahwi* (1986) and *Doya* (1986) slowly reveal their silent grimaces. They are 'sound' sculptures – resonances from the dark reaches of an

alien body; and if we do not hear its speech it is because we cannot enter its domain.

Making manifest what is elided from dominant culture is characteristic of the work of Cattaraugus Seneca artist G. Peter Jemison. Little could be more evocative of the waste and neglect of consumer society than the plain brown paper bag. It is a commodity that has little identity except as a transient container for other goods: a boundary that reveals nothing of the nature of its contents. Originating from the pummelled remains of trees, its destination is the garbage can. Jemison reclaims the dignity of this frail remainder, honours its qualities as if it were a Seneca beaded bag or a Lakota parfleche container. Painting and collage breathe life back into its surface, telling stories of the tragic conflict between nature and contemporary culture (*Night Deer*, 1983); of the destructive avarice marking the history of white–Indian contact in the north (*Fur Trade*, 1983); and of the clichéd values propagated through the media (*The Good Guy Rides A White Horse*, 1986). Jemison gives back to the surface – the boundary between inside and outside – an identity in difference, connecting the local and the specific with the universal, infusing meaning into emptiness. *Cattaraugus Coho* (1985) (see Figure 14.2) is more than a beautifully realized image of a fish slipping through water; it is the flow of life, and one imagines that, contained within its body, are stories that, for the people, need no written text.

Another voice resonates in the shadow of the stereotype, and we may hear something of its echo in the work of Tuscarora artist Jolene Rickard. *Shuweeka and Fish* (1985) makes use of the transparency of multiple negative photography, super-imposing the image of a fish on that of a young man. The work bears none of the conventional signs of Indianness reassuring to white observers yet it is ingrained with values specific to place and culture. Filling the picture with the delicate texture of its scales, the fish is not simply a fish but, like all nature – organic and mineral – is imbued with a spirit commensurate with that of man and intimately touches his life pulse. The grain of the fish is that of the man, and to diminish one is also to diminish the other. This connectedness transcends time and space as we understand them; *Tuscarora Mimbres* (1986) reflects the vision of the ancient Mimbres culture of the south-west that, like a wave, continues to carry meanings to the Iroquois peoples of the north. Likewise, the poignant figure of *Lyle and the Stone – Lakota Trail* (1985) (Figure 14.6) draws us into a contemplation of contemporary Native American problems. In these works the artist avoids 'framing' her subjects. In the triptychs, *Giving Thanks I* (1984) and *Hodinausaunee* (1984), images of people, of nature, and of man-made artefacts are both individualistic and

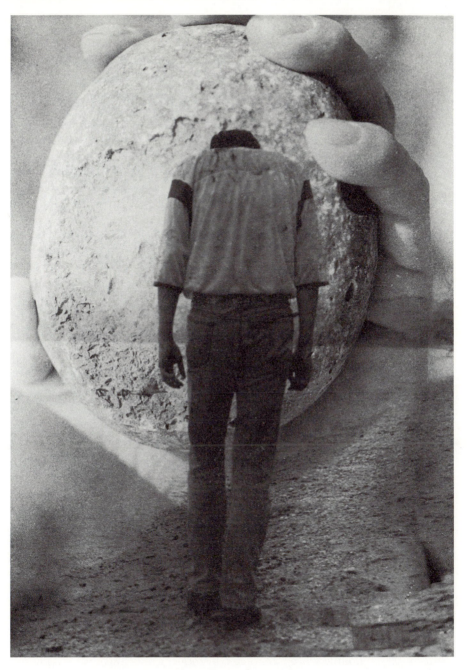

14.6 Jolene Rickard, *Lyle and the Stone – Lakota Trail* (1985), black and white photograph 18.5″ × 12.5″.

a part of a collective whole. 'It is important that I know the people and places and elements I photograph. I do not feel I am taking; rather I am sharing.'[25]

COYOTE FINDS ANOTHER VOICE

Contemporary Native American arts are as diverse as the cultures and circumstances from which they arise, ranging from tribal traditions to modern technologies. Many artists move freely among different practices, disregarding white disciplinary distinctions and modernist purism. It is a case of making connections not setting limits or boundaries; keeping open, as Durham says, the capacity to reinvest and to incorporate new ideas into traditional matrices.[26] Lability and interconnectedness allow subjectivity to be negotiated across changing sets of representations.

The neo-colonial position of Native American peoples nevertheless remains a cause for concern; with limited political support or legal representation, relocation and land loss continue to threaten the well-being of many; the smallpox-infected blankets have been replaced by water and crop pollution from industrial effluents and radioactive waste, threatening life itself. Without access to the existing structures of power, strategies of survival and renegotiation are limited to the manipulation of the rhetorical space of dominant culture.

To speak through the tongue of another is not necessarily to be subjugated by its ideological effects. Where a speaker speaks through a colonial discourse, the lacunae of untranslatability open on to the implications of parody and irony: to a Babelian laughter where puns, displacements, portmanteau words, and other transgressions make apparent language's estrangement from the self and violate its claims to pure and original meaning. This is characteristic of the polyphonic Anglo-Irish writing of J.M. Synge and James Joyce who, like Native Americans, are linked to an oral tradition. It is also the nature of the Anglo-French visual-verbal puns of Marcel Duchamp whose enigmatic references to multidimensional energy flows are closer to the spirit of Native American arts and the alchemical tradition of the Renaissance than to the univocality of modernism. In his contemplation of parody, Mikhail Bakhtin speculates that its double-voiced character introduces into discourse 'a semantic intention that is directly opposed to the original one. The second voice, having made its home in the other's discourse, clashes hostilely with its primordial host and forces him to serve directly opposing aims.'[27]

It is here that we recognize the transgressive ploys of Trickster in *Harold of Orange*. Perceiving the demand yet recogniz-

ing the impossibility of 'a transport of pure signifieds' between disparate languages, Harold capitalizes on this paradox, orchestrating a game of parody and irony in which he is both transgressor and transgressed, translator and translated – always doubled, double-crossed, doubling back, and doubling up with a *double entendre*. But he brings into play Trickster's role as cultural transformer, enabling the transition from one state of being to another, and proposing the reinvention of Native American identities from within the colonial discourse.

In Native American stories, Trickster is a polymorphous persona as adaptable to change in adversity as the classical Western hero is fixed in his tragic search for the Absolute. Trickster's contract with the world is, to use Bakhtin's analogy, dialogical not monological; s/he does not own the world but inhabits it creatively, presenting a life-model that, rather than attempting to resolve the contradictions of life into idealized abstractions, seeks to harmonize them within lived experience. Trickster recalls a property of humanness suppressed by absolutist rhetoric and its desire to eradicate difference and paradox. Trickster reopens the dialogue with those serio-comic and carnivalesque traditions discussed by Bakhtin; traditions that, in literature, present not the monological and authoritative voice that aims to suppress difference, but a polyphonic voice capable of maintaining several full and equal subjects in a kind of 'transcribed speech': 'The author's consciousness does not transform others' consciousnesses . . . into objects, and does not give them secondhand and finalising definitions.'

In orthodox terms, the serio-comic genres are inherently transgressive: accepting man's inability to 'know', they do not seek to embody truth but to test it; motivated towards social change, their strategies include parodic attacks on socio-political hierarchies and prohibitions, and the use of dream, fantasy, and humour. The role of humour as a mechanism to accommodate experienced conflicts, death and renewal, is understood by Native American writers and artists. Vine Deloria Jr, one of the foremost spokespersons on indigenous legal affairs, comments that 'Laughter encompasses the limits of the soul. In humour life is redefined and accepted. . . . Humour has come to occupy such a prominent place in national Indian affairs that any kind of movement is impossible without it.'[28]

Bakhtin's world-view – 'a collectivity of subjects who are themselves social in essence, not individuals in any usual sense of the word'[29] – is perhaps the closest we may come to understanding the *Weltanschauung* of Native American peoples. Resistant to western-style power hierarchies, they remain a collectivity of independent peoples who recognize certain shared truths and experiences, not least of which is the effect of difference as it has

been defined and executed by white society. Within their world-view, where the renewal of the self is traditionally inextricably bound to the well-being of the whole, cultural difference is not a cause for contempt but a source of creativity.

NOTES

Parts of this paper were published as 'The ground has been covered' (with Jimmie Durham) in Artforum International XXVI, 10 (Summer 1988), p. 99, and as 'Autres Cartographies' in Les Cahiers du Musée national d'art moderne, Centre Georges Pompidou: Paris (1989), p. 77.

1 Roland Barthes (1973[1957]) *Mythologies*, London: Paladin, p. 129.
2 See Robert F. Berkhofer Jr (1978) *The White Man's Indian*, New York: Random House, Vintage Books; Roy Harvey Pearce (1971) *Savagism and Civilization*, paperback edition, Baltimore: Johns Hopkins University Press; Charles M. Segal and David S. Stineback (1977) *Puritans, Indians and Manifest Destiny*, New York, Putnam.
3 Coyote and Spider: Coyote, one of several trickster figures in Native American oral traditions, has become emblematic of Native American difference. In this text, Spider refers to the white man, following Edgar Heap of Birds's Cheyenne example. In addition, Black Elk tells of a Lakota holy man, Drinks Water, who dreamed that 'the four-leggeds were going back into the earth and that a strange race had woven a spider's web all around the Lakotas' (as told through John G. Neihardt (1972) *Black Elk Speaks*, New York: Washington Square Press Pocket Books, p. 8).
4 *Harold of Orange*, 1984; 16mm colour film, 30 minutes duration. Directed by Richard Weise, scripted by Gerald Vizenor, and starring Charlie Hill. Distributed by Film in the Cities.
5 Gerald Vizenor (1978) *Wordarrows, Indians and Whites in the New Fur Trade*, Minneapolis: University of Minnesota Press.
6 Bernadette Bucher (1981) *Icon and Conquest, A Structural Analysis of the Illustrations of de Brys's Great Voyages*, trans. Basia Miller Gulati, Chicago: University of Chicago Press.
7 Berkhofer, op. cit., p. 29.
8 Pearce, op. cit.; Frances A. Yates (1966) *The Art of Memory*, Chicago: University of Chicago Press.
9 Thomas Jefferson, 1784, quoted in Pearce, op. cit., p. 67.
10 Governor George Gilmer of Georgia, 1830s, quoted in Berkhofer, op. cit., p. 161.
11 Theodore Roosevelt, 1885, quoted in Frank Bergon and Zeese Papanikolas (eds) (1978) *Looking Far West*, New York and Scarborough, Ontario: New American Library, pp. 38–40.
12 Bucher, op. cit.
13 Joseph Bruchac (April 1984) 'New voices from the longhouse: some contemporary Iroquois writers and their relationship to the tradition of the Ho-de-no-sau-nee', in *Coyote Was Here*, ed. Bo Scholer, *The Dolphin* 9.
14 Berkhofer, op. cit., p. 162.
15 Vine Deloria Jr (1971) *Of Utmost Good Faith*, San Francisco: Straight Arrow Books.
16 N. Scott Momaday (1976) *The Way to Rainy Mountain*, paperback edition, Albuquerque: University of New Mexico Press, p. 33.
17 Jacques Derrida (1985) 'Des tours de Babel', in *Difference in Translation*, ed. Joseph F. Graham, Ithaca/London: Cornell University Press, pp. 165–207.
18 Edgar Heap of Birds (1986) *Sharp Rocks*, Buffalo, NY: CEPA.

19 Jacques Derrida (1981) *Positions*, trans. Alan Bass, Chicago: University of Chicago Press, p. 20.

20 Paula Gunn Allen, quoted by James Ruppart, 'The poetic language of Ray Young Bear', in *Coyote Was Here*, op. cit.

21 Scott Momaday, op. cit.

22 Jimmie Durham (1983) *Columbus Day; Poems, Drawings and Stories about American Indian Life and Death in the Nineteen Seventies*, Minneapolis: West End Press.

23 Malek Alloula (1986) *The Colonial Harem*, trans. Myrna Godzich and Wlad Godzich, Minneapolis: University of Minnesota Press.

24 Christopher M. Lyman (1982) *The Vanishing Race and Other Illusions*, photographs of Indians by Edward S. Curtis, New York: Pantheon Books in association with the Smithsonian Institution Press.

25 Jolene Rickard, artist's statement in (1986) *Ni' Go Tlunh A Doh Ka*, exhibition catalogue, Long Island, New York: Amelie A. Wallace Gallery.

26 Jimmie Durham (1986) essay in ibid.

27 Mikhail Bakhtin (1984) *Problems of Dostoevsky's Poetics*, ed. Caryl Emerson, Minneapolis: University of Minnesota Press, p. 193.

28 Vine Deloria Jr (1969) *Custer Died for your Sins: An Indian Manifesto*, New York: Avon Books.

29 In Bakhtin op. cit., introduction by Waye C. Booth, p. xxi.

15 Locality fails

IMANTS TILLERS

Albert Namatjira was born on 28 July 1902 (Marcel Duchamp's birthday) in Hermannsburg, Central Australia. He was a member of the Aranda Tribe of South Australia and worked as a stockman, camelman, and stationhand at the Mission Station, Hermannsburg. There, after seeing an exhibition by Rex Batterbee and John Gardner in 1934, he attempted, untaught, drawings and pokerwork figures of animals and birds on wood not in the traditional manner of Aboriginal representation but in the style of Rex Batterbee. In 1936 at Batterbee's next visit to Central Australia, Namatjira offered his services as camelboy in return for painting lessons. In imitating Batterbee's subjects, technique, and compositional preferences, Namatjira became the first Aboriginal artist to work in a characteristically non-Aboriginal manner and for this accomplishment achieved a modicum of fame recorded in the 1950 *Who's Who in Australia*.

In this volume, the most remarkable statement (even more remarkable than the Mission Superintendent's observation that Albert is 'happiest if sitting in sand or around a campfire, playing marbles like others of his tribe') is that his *recreation* is given as 'walk-about out bush'.[1] But while in 1950 'walk-abouts' were strictly 'recreational', in the 1970s they became 'avant-garde'. Yet, this was the case for British artists such as Richard Long and Hamish Fulton, rather than for Aboriginal artists.

Today, however, in Australia the obvious distinctions between Long's 'art' and Namatjira's 'hobby' are becoming blurred as more and more contemporary advantages are extracted from an association with 'aboriginality'. In fact the contemporary Australian art scene is now marked by two apparently convergent tendencies: the assimilation of 'traditional' Aboriginal cultural forms into 'contemporary' art and the emergence of 'aboriginality' (in defiance of the dictionary definition) as a ubiquitous quality which is no longer the exclusive domain of 'black' Aborigines.

The change in attitude to 'traditional' Aboriginal art is most forcefully demonstrated by the inclusion of Aboriginal paintings (not as anthropological curiosities but as contemporary works in

their own right) in the recent exhibitions such as the Biennales of Sydney, 1979 and 1982, and *Australian Perspecta*, 1981. This acceptance of Aboriginal art can in part be attributed to the promotional activities of the Aboriginal Arts Board of the Australia Council and those of organizations such as the Papunya Tula Co. which markets 'traditional' Aboriginal paintings done in 'modern' media,[2] as well as the commercial success of private entrepreneurs in marketing ventures such as the *'Gallery of Dreams'* at Hogarth Gallery.

However, the other more subtle and powerful reason for this acceptance is that certain contemporary forms in recent art seem to be convergent with Aboriginal art (and even 'life-style') to the extent that to a non-Aboriginal audience they have the atmosphere of 'aboriginality'. This atmosphere may be evoked through reference to aspects of a primitive life-style – to the look of its rituals, its artefacts, and the natural environment in which they are perceived to occur. Thus in *Australian Perspecta*, 1981, the works of artists who were presumably 'influenced by' or 'had an affinity with' Aboriginal art were installed in the same space as the acrylic paintings of Clifford Possum Tjapaltjarri, Tim Leura Tjapaltjarri, and Charlie Tjapangatti. Ironically the 'aboriginality' of this art could be seen to represent a reciprocal (white) position to Namatjira's 'European' watercolours.[3]

Despite its irrefutable presence, the new sense of 'aboriginality' evades definition and even enunciation. It exists in the local work as a nuance, an inflection. For example, Bernice Murphy alludes to the incipient 'aboriginality' in certain works in the following almost opaque way:

> The recent concern in art with the environment, archaeology and anthropology, and rehabilitation (through performance art) of the mythopoeic consciousness, personal symbols and a sense of generalised ritual is particularly important for the release and enrichment of new imaginative material into the bloodstream of Australian art.[4]

Robert Lindsay in the foreword to his exhibition *Relics and Rituals* (works by fifteen artists) at the National Gallery of Victoria is no more explicit. He suggests:

> It is the power and simplicity of communication which is inherent in totemic objects, archetypal images and tribal rituals, that the artist hopes will cut through the habits of contemporary sophisticated forms of communication. It is the return to fundamentals, the simple realities of life that through magic and mystification may evoke archetypal responses and emotions.[5]

Moreover, this 'strategy of nuance' spans the entire range of
contemporary art production in Australia, from formalist
painting to 'radical' socially engaged work, and even spills into
the related areas of fashion and design. Thus lyrical abstrac-
tionists (or more recently neo-expressionists) desiring the aura of
'aboriginality' shift their palettes (and titles) towards the 'desert'
colours – the ochres, browns, and reds[6] – but otherwise con-
tinue in their internationally derived styles as before. The
socially engaged artist on the other hand accrues 'aboriginality'
by association – by basing a performance, for example, on a
pertinent Aboriginal issue (Land Rights) or by taking part in
a collaborative photographic project with Aborigines. An
'Aboriginal' inflection can be found in the most naive or the most
sophisticated work – it does not matter whether the reference is
serious (supporting their culture) or ironic in tone (exposing our
in-built prejudices).

The reluctance for a more explicit identification with the
Aborigines, for an authentic 'cultural convergence',[7] can in part
be explained by the deep guilt underlying Australian culture.
For the history of white settlement in Australia in relation to the
Aborigines is a story of homicide, rape, the forcible abduction of
children from their parents and the methodical dispossession of
the lands upon which their well-being, self-respect, and survival
have depended. 'Cultural convergence' is attractive as an *idea*
because it offers a painless way to expiate our collective guilt for
this history while simultaneously suggesting an easy solution to
the more mundane but nevertheless pressing problem of finding
a uniquely Australian content to our art in an international
climate sympathetic to the notion of 'regional' art. The reality of
'cultural convergence' which necessitates that political and
economic inequities be rectified first is a less satisfying prospect.
Certainly 'aboriginality' is not a new idea – the Antipodeans
in the 1950s and the Jindyworobak poets in the 1940s as well
as others before them like Margaret Preston (who suggested it
should form the basis of a 'modern' Australian art) were
attracted to it – the difference today is that contemporary art
forms and media particularly in the areas of informal sculpture
and performance can approximate more closely the 'look' of
traditional Aboriginal artefacts, rituals, and environments.

The 'concerned conscience' about the Aboriginal people
which 'aboriginality' might reflect, however, does not often
originate among the Australian-born. Interest in Aboriginal
culture has and continues to come mostly from abroad.[8] (They
do not have to share our guilt.) Thus during the Sydney biennale
European Dialogue, 1979, Australian artists were often dis-
mayed by the interest in and knowledge of Aboriginal culture
shown by visiting artists and critics and the almost aggressive

indifference they displayed to the Australian urban environ-
ment and its culture. Some, like Marina Abramovic and Ulay
even returned later (under a Visual Arts Board grant) to seek out
(with typically Germanic zeal and determination) the Abori-
ginal influence for their own work. Their stay culminated in an
'alchemical' performance at the Art Gallery of New South
Wales: *Gold Found by the Artists*. This work (dealing with their
'survival experience, perception changes, energy and tele-
pathy')[9] together with the attitudes subsequently expressed
about Aborigines,[10] stands as a conspicuous model of a more
'serious', more earnest 'aboriginality' for local artists. Since
'advanced' art in the twentieth century habitually aspires to the
condition of religion, it is little wonder that the spiritual
resource of Aboriginal culture and its esoteric practices should
now be recognized and association with it consciously sought.

Suzi Gablik, in an article for *Art in America*, 'Report from
Australia', emphasized the links to the continent's Aboriginal
past in certain contemporary work. She speaks of Australian
artists being less embroiled in repressive cultural heritages than
their American or European counterparts and thus able to look
sympathetically to nature and even 'able to trace, in a clear,
quiet way, some old paths back to the aboriginal presence'.[11]
Such optimistic remarks (as exhortations to action) clearly
reflect the change in critical attitudes towards 'regionalism', a
word which now has ascendancy over the formerly popular and
derogatory expression 'provincialism'. For today we believe that
'remarkable work is as likely to arise in Cracow, Turin, Düssel-
dorf, Vienna, Paris, London or Amsterdam as in New York'.[12]
Why not Sydney or Melbourne as well? The old Jindyworobak
notion of *environmental value* – the 'slow moulding of all
people within a continent or region towards the human form
which that continent demands'[13] seems ready for a revival and
'aboriginality' is being offered again as an appropriate form.

This widespread though largely unstated hope (or even belief)
in an 'indigenous' Australian art ignores the contemporary
understanding of the nature of the physical world. Just as the
discovery of the special theory of relativity and quantum
mechanics revolutionized our view of the world in the first
quarter of the twentieth century, so Bell's theorem will revolu-
tionize our view in the last quarter. In 1975, Henry Stapp, in a
work supported by the US Energy Research and Development
Administration, wrote:

Bell's theorem is the most profound discovery of science.[14]

Bell's theorem shows that either the statistical predictions of
quantum theory or the *principle of local causes* is false. It does
not say which one is false only that both of them cannot be true.

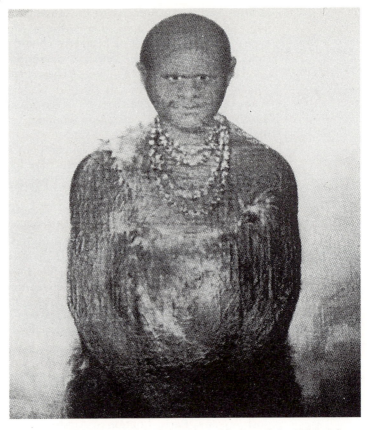

15.1a Benjamin Duterrau, *Tasmanian Aboriginal* (c. 1834) (photograph Marianne Baillieu).

When the Clauser–Freedman experiment confirmed that the statistical predictions of quantum theory were correct it proved that the principle of local causes was false. The important thing about Bell's theorem which makes it relevant to the present discussion is that

> it puts the dilemma posed by quantum phenomena clearly into the realm of macroscopic phenomena . . . it shows that our ordinary ideas about the world are somehow profoundly deficient even on a macroscopic level.[15]

And it does not matter how Bell's theorem is reformulated, it invariably projects the 'irrational' aspects of sub-atomic phenomena into the macroscopic domain. It says that not only do events in the realm of the very small behave in ways which are utterly different from our common-sense view of the world but that events in the world at large, the world of sports cars and

15.1b Tibetans, from Heinrich Harrar (1955) *Seven Years in Tibet*, London: Reprint Society.

freeways (or the world of pristine white walls and spilt drinks) also behave in such ways. Since Bell's theorem *proves* that the principle of local causes fails it is of crucial relevance to the present discussion of a 'local' content in Australian art, 'regionalism' and 'aboriginality'.

The principle of local causes asserts that what happens in an area does not depend upon variables subject to the control of an experimenter in a distant 'space-like separated' area. The principle of local causes is common sense. The results of an experiment in a place distant and 'space-like separated' should not depend on what we decide to do right here. Thus 'local' art inevitably reflects 'local' conditions. 'Local' conditions might include the continuation of an Aboriginal presence in Australia but equally they might include the transference of art information and models from New York to Sydney. For New York and

Sydney are not 'space-like separated' at all: information is transmitted through identifiable channels (i.e. mechanical reproductions in aeroplanes) and thus arrives not mysteriously but by identifiable means. Could it be otherwise!

According to Bell's theorem it *is* otherwise. For the failure of the principle of local causes implies that there can be unexplained connectedness between events in different 'space-like separated' places and that this connectedness allows, for example, an experimenter (e.g. an artist) in one place to affect the state of a system in another remote (apparently unconnected) place. Or this can happen in reverse. Thus to take an almost preposterous example, Böcklin's painting *The Island of the Dead* completed in 1880 in Munich might be the direct (though slightly delayed) result of the successful extermination of the Tasmanian Aborigines by the white settlers,[16] despite the fact that Böcklin would have had no direct knowledge of this catastrophic event. (Like the mother who rose in alarm at the same instant that her daughter's distant automobile crashed into a tree.) Bell's theorem would imply that this is not merely an association nor a matter of 'pure chance':

> the conversion of potentialities into actualities cannot proceed on the basis of locally available information. If one accepts the usual ideas about how information propagates through space and time, then Bell's Theorem shows that the macroscopic responses cannot be independent of far-away causes. This problem is neither resolved nor alleviated by saying that the response is determined by 'pure chance'. Bell's Theorem proves precisely that the determination of the macroscopic response must be 'nonchance', at least to the extent of allowing some sort of dependence of this response upon the far-away cause.[17]

While it is outside the scope of this chapter to pursue the implications of Bell's theorem on contemporary Australian art in any greater detail, it suffices to suggest that the conscious striving after the appearance of 'localness' could be an utterly futile and nonsensical activity except in that it might produce effects (unknown to us) in other, remote 'space-like separated' regions (say in the Carpathian Mountains or the Upper Urals).

The failure of the principle of local causes also invites speculation on the 'distant' origins of 'local' phenomena. How are we to interpret the fact that 'objects' no more convincing than the crude representations in Giorgio de Chirico's paintings occur with an unnatural frequency in the Australian suburban landscape? Does the mere resemblance of these dissociated, displaced 'objects' to those in de Chirico's pictures necessarily imply a causal connection?

15.2a Photograph reproduced in *European Dialogue: A Commentary*, Biennale of Sydney (1979), p. 27.

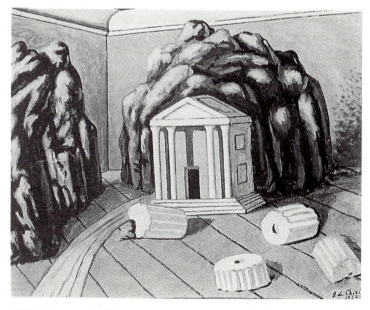

15.2b Giorgio de Chirico: *Temple in a Room* (1927).

In fact these 'objects' can be explained by more conventional and immediate causes. After all they are not so surprising in themselves considering the degree to which Australian experience is mediated by photography and photographic reproduction. For these 'objects' which seem to be the members of an entirely new *species of object* are derived (mutated) from photographs though they are not photographs in themselves. While often resembling houses (master-built project homes) at other times they can resemble the Greek temples of de Chirico's pictures. What is common to these 'objects' is that some essential property seems to be missing. Collaged together from prefabricated components (often neo-classical in their reference) chosen from printed brochures, their visual attributes can be best described as 'flatness', 'frontality', 'sharp focus', 'full colour', 'high resolution', etc. In real life they evoke strong feelings of *déjà-vu* and in the presence of other such 'objects' (e.g. in a street) they seem to partake of a game of 'quotation' and 'cross-reference'. Their most plausible attribute is that of being 'photogenic'. Also since they are entirely derived from photographic representations they have the same qualities of surface, of reproducibility, and they acknowledge the same formal devices of framing and cropping as do photographs themselves.[18]

A conventional and plausible explanation (pre Bell's theorem) of the resemblance between these 'objects' and the images in certain of de Chirico's pictures would point to the fact that 'simulation' (the quintessential quality of Australian life and culture and the means by which these 'objects' arise) is also an abiding interest of de Chirico – particularly in his later work. In these unfashionable works, the melancholy of *places* (of deserted Italian piazzas on autumn afternoons) yields to the melancholy of his own personal metaphysical situation. This is expressed in a twofold strategy of 'simulation': on the one hand 'precise variations' on his early 'metaphysical' works and on the other hand an almost inept imitation of 'traditional' painting and its subject-matter. ('Simulation' invariably allows the simultaneous embrace of apparently contradictory positions since the 'surface' is borrowed from 'elsewhere' and does not necessarily reflect real intentions or meanings.)

De Chirico said 'Pictor classicus sum'[19] (I am a classical painter) and painted classical subjects in the classical manner. He even painted portraits of himself and his wife in seventeenth-century costume. These paintings reflect an almost pathological nostalgia – a 'quixotic' desire to defy the incontrovertible circumstances of his 'time' and 'place' – and there are in this echoes of the recent Australian experience (post 1788). But whereas de Chirico's later work in the intensity of its anguish bears comparison with the work of Francis Bacon or Hermann Nitsch,

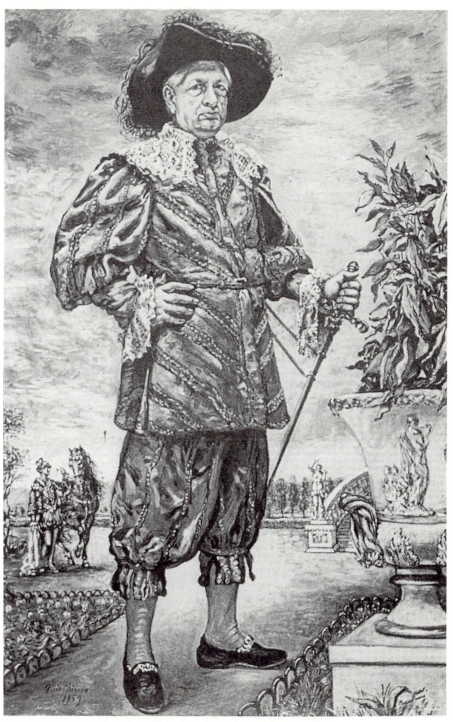

15.3 Giorgio de Chirico: *Self-Portrait in Costume* (1959), 60.25″ × 38.5″ (reproduced in *Art & Text*, 1982).

Australian 'simulation' (except for unintentional, largely archi-
tectural manifestations) is bound to a comfortable mediocrity by
its own tentativeness. We do not yet have a *white* artist who can
declare with conviction: 'I am Aboriginal.'

But while these connections and associations between de
Chirico's interests and the Australian experience conform to the
common-sense view of the world (of the pervasiveness of 'local'
phenomena), how are we to interpret the presence of *this* frag-
ment of 'Melbourne' (*circa* 1929) mapped into the second
sentence of de Chirico's novel *Hebdomeros*:

> And then began the tour of that strange building situated in a
> street that looked forbidding, although it was distinguished
> and not gloomy. As seen from the street the building was
> reminiscent of a German consulate in Melbourne. Its ground
> floor was entirely taken up with large stores. Although it
> was neither Sunday nor a holiday, the stores were closed,
> endowing this part of the street with an air of tedium and
> melancholy, a certain desolation, that particular atmosphere
> which pervades Anglo-Saxon towns on Sundays.[20]

Luckily a world in which 'locality fails' is far more interesting
than the one in which we are limited to our immediate circum-
stances and which we are suffered upon to reflect in our art.

NOTES

Reprinted from Art
& Text 6, Mel-
*bourne, 1982, and
published in this
volume by kind
permission of the
editors.*

1 J. A. Alexander (ed.) (1950) *Who's Who in Australia*, Sydney,
 p. 530.
2 The contemporary 'look' and practicality of these works in contrast
 to the sand-paintings from which they are derived makes them fit
 more easily into the contemporary context.
3 In the biennale of Sydney, *Visions of Disbelief* (1982), an Aborigi-
 nal sand-painting (not 'simulations' of sand-painting as in the pre-
 vious biennale) was given an entire space to itself, thereby endow-
 ing this work with a pivotal significance.
4 Bernice Murphy (1981) *Australian Perspecta* (catalogue), p. 13.
5 Robert Lindsay (1981) *Survey 15: Relics & Rituals* (catalogue),
 National Gallery of Victoria.
6 This is in direct contrast to Aboriginal painters themselves whose
 choice of colours is limited by the local availability of certain pig-
 ments rather than by inherently 'Aboriginal' colour preferences.
 Thus prior to the 1977 exhibition of Papunya art works at Realities
 Gallery in Melbourne, the Aboriginal artists wished to add to the
 intended purchase of acrylics some blue, green, and possibly other
 colours for use in their work. However, they were talked out of this
 by a white artist's advice to stick to their 'traditional' range of pig-
 ments. (See Dismas M. Zika (1981) *Landscape, Some Interpreta-
 tions* (catalogue), Tasmanian School of Art.) The idea of extending
 the colour range could be seen as could be seen as the same kind of
 cultural adaptation as, say, the substitution of readily available
 'galiron' sheets for 'traditional' though scarce stringybark as a
 building material.

7 Bernard Smith (1980) *The Spectre of Truganini*, Sydney: Boyer Lectures, ABC, pp. 44–52.
8 ibid., p. 27.
9 Jennifer Phipps (1981) 'Marina Abramovic/Ulay', *Art & Text* 3: 45.
10 ibid.: 46–50.
11 Suzi Gablik (January 1981) 'Report from Australia', *Art in America*: 29.
12 Nick Waterlow (1979) *European Dialogue: A Commentary* (catalogue), Biennale of Sydney.
13 Les Murray (1977) 'The human-hair thread', *Meanjin*, Aboriginal issue, 36, 4:569.
14 Henry Stapp (1975) 'Bell's Theorem and world process', *Il Nuovo Cimento* 298: 191.
15 Henry Stapp (1971) 'S-Matrix interpretation of quantum theory', *Physical Review* D3: 1303ff.
16 Truganini, the last of the original Tasmanian Aboriginals, died in 1876.
17 Stapp, 'S-Matrix interpretation', op. cit.
18 See Paul Taylor's catalogue essay in (1982) *Eureka: Artists from Australia*, London:Institute of Contemporary Arts and Serpentine Gallery.
19 (1968) *De Chirico*, New York: Harry Abrams p. 13.
20 Giorgio de Chirico (1964) *Hebdomeros*, London: Peter Owen, p. 10.

16 Aboriginal representation and kitsch

CHRISTOPHER PEARSON

> If there is one person more damaging to the position of Aboriginal Australians than the racist, it is the person who idealizes them and romanticizes them. (Stewart Harris)[1]

> The West has gone very far in replacing difference with sameness, in supplanting other, contrasting modes of thought and act, in changing what had once been exotic for westerners into pale and tawdry reflections of itself. (S. W. Mintz)[2]

On the façade of Adelaide Gaol, on the left side of the arch over the main gate, there is a remarkable piece of sculpture. Placed just above eye-level, charcoal-coloured against the white of the wall, it represents an Aboriginal woman in torment. The face of the grotesque is miserably contorted; so much so as to have given rise to prison lore that it is the death mask of someone hanged there, and that the snake writhing around her neck was a noose. But, in the nineteenth century, when there was an 'Aborigines' Location' or reserve beside the gaol, it was a practical image of punishment; a warning that needed no translation.

In spite of its historical function and the fact that some Aboriginal prisoners now find it a galling sight, that sculpture is one of the relatively few representations of Aboriginal people that is not offensively kitsch. It has a matter-of-fact quality. Although it owes something to neo-Gothic fantasy and prevailing conventions on the depiction of savages, it is also clearly the work of someone who had looked closely at Aborigines and understood terror and pain. Its potency raises questions. Why are so many contemporary pictorial, cinematic, and literary representations of Aborigines so lacking in power and so bad? Why are the most 'sympathetic' usually the worst? What kind of effect does kitsch have on the images that its subjects have of themselves?

As well as raising those questions, I think the grotesque offers two important clues to their answers. Its matter-of-factness is

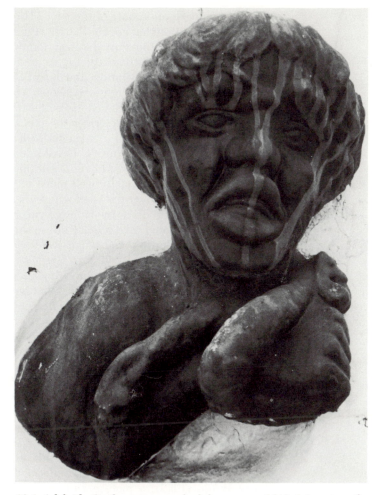

16.1 Adelaide Gaol, grotesque of a lubra anon., 1840–1 (courtesy the author).

one of them. There is no suggestion that the artist used Aborigines as an opportunity to wear his heart on his sleeve or to 'make a statement' which was principally about himself and his feelings. However we might judge what we imagine his racial attitudes to have been, they are not readily discernible and certainly not focal. The image is free of mawkishness and any sense of personal guilt. It is a blunt, truthful warning that addresses its audience directly, delivered with more confidence than most modern sensibilities can muster.

While the purpose it served has a sort of edifying tactlessness, its technical gaucherie is also instructive. Its roughness suggests that the man who made it had had little formal training and that

he may have been an inmate of the gaol.[3] He belongs within a semi-skilled tradition that goes back to the First Fleet. Governor Phillip's illustrator, the Port Jackson Painter, distinguished himself – although insufficiently for us to be certain of his name – by ignoring convention and 'painting what he saw'. Previous depictions of Aborigines by people who had never seen them had cast them as noble savages with sable Grecian forms and faces. Bernard Smith describes the Port Jackson Painter's portraiture as 'naive realism . . . tinged with kindly sentiment and a hint of amused superiority. He did not, it would seem, dislike the Aboriginals nor did he represent them idealistically.'[4]

That description fits equally well much of the best work on the subject produced over the last forty years at the tail end of that tradition, most of it by elderly, rural naive painters. Aboriginal people may take offence at the slightly patronizing element in Henri Bastin's *Aboriginal Ballets* (as he persisted in referring to corroborees) or at Sam Byrne's bluntness. But to do so is to miss the most important thing about both painters. 'The pictures have a quirky integrity that makes many more ostensibly sympathetic paintings, including much of the work of Drysdale and David Boyd, look phoney.'[5]

Drysdale is widely considered the most successful painter of Aboriginal subjects. Geoffrey Dutton, for example, sees him as 'the modern artist who towers above all others in the strength of his paintings and drawings'.[6] Bernard Smith takes a less enthusiastic view of Drysdale's excursions into 'that dangerous iconographic territory' and remarks that 'it cannot be said, in all conscience, that he has come through it unscatched'.[7] Smith identifies the problem with the early 1950s studies as an unhappy compromise between realism and classicism. There are other tell-tale failures in the manipulation of visual codes. *Mount White* (1953), a picture Dutton greatly admires, is a portrait of an Aboriginal mother and child which contrives to make the mother in particular look like a Red Indian. The picture is eloquent testimony that Drysdale saw those particular subjects through an alien filter, a precursor to the 'Bury My Heart at Wounded Knee/Give Me Back My Dreaming' School presently in fashion, which is as misleading and irrelevant as the Greek heroic mould.

Of the later Melville Island studies, Smith remarks: 'Here it is the romantic, hallucinatory and somewhat surrealist side of his work which is predominant.' The problem for Drysdale, and for just about everyone else attempting to deal with Aboriginal subjects, was a problem of poise – what to make of the ethics of the situation, what to make of one's interpretative role and, sometimes almost as an afterthought, what to make of the subjects themselves. There was no available style, or combina-

tion of styles, that solved all those problems and rang true consistently, uncontaminated with idealizations.

In an interview with Dutton, Drysdale explained:

> The way he sits with his feet in certain positions, his hands and feet are anatomically the same as yours, but they comport themselves with a certain difference, all this, all these sorts of things are intriguing, they become part if you like, and yet they're not part of a landscape, they do stand out. It might be his landscape, certainly on one hand but on the other he is man, and to me this strange primitive quality is the same thing as in the landscape, it is part of the trees and the rocks, and the river, it's man in this as he virtually was. This I know sounds terribly romantic![8]

It doesn't just sound romantic, it *is* romantic. It comes close to a complete reversal of the pathetic fallacy: man scarcely distinguishable from nature, man 'as he virtually was' in the Dreamtime or before the Fall, man as 'a strange primitive quality' homologous with trees and rocks. They are debilitated and debilitating ways of perceiving other human beings, and as a description of traditional Aboriginal perceptions of human relationships to land they are simplistic to the point of caricature. Even the suggestion that 'his hands and feet are anatomically the same' as Dutton's suggests a failure to notice inconvenient difference. Drysdale was right to feel the need to apologize at the end of his stumbling articulation of that sort of warmed-over romanticism. It does not wholly mar his work because the best of it is based on fresh, closely observed responses to actual experiences and people. In less able artists' work, those misconceptions are usually crippling and painful to behold. Art, quite as much as the third-rate history and anthropology which Professor Tatz holds to blame, is responsible for what he identifies as 'a mental straitjacket for whites and blacks: a physical prototype, head-banded, bearded, loin-clothed, sometimes ochred, one foot up, a clutch of spears, ready to hunt or exhibiting eternal mystical vigilance . . . a pristine, pure, before-the-white-man-came-and-buggered-everything, idealised type'.[9]

There are some roughly parallel problems in the literary depiction of Aborigines. The earliest Australian-born poet to express a distinctly Australian view was William Charles Wentworth. He was studying at Cambridge in 1823 when the subject of the Chancellor's Prize for poetry, 'Australasia', was announced, and he tried his hand. He was judged the runner-up to a more skilful versifier called Praed, who had relied on descriptions of New Zealand and reports about cannibal Maoris for his information, and classical Greece for much of his imagery. Praed began a tradition of misrepresenting Aborigines

as literally bloodthirsty which was strong enough to create a durable market-interest in cannibalism[10] and one on which Daisy Bates was able to trade most successfully even in the 1920s and 1930s:

> . . . the revel in the wood.
> The feast of death, the banqueting of blood.
> When the wild warrior gazes on his foe
> Convulsed beneath him in a painful throe,
> And lifts the knife, and kneels him down to drain
> The purple current from the quivering vein.

Those revels aside, Praed apostrophized Australasia by suggesting what 'fabling fancy' might have found:

> If the Muse of Greece had ever strayed
> In solemn twilight through thy happy shade . . .
> Among thy trees, with merry step and glance,
> The Dryad then had wound her wayward dance,
> And the cold Naiad in the waters fair
> Bathed her white breast and wrung her dripping hair.

These classical wraiths were, as Brian Elliot put it, 'the first of a long line of exotics who went on haunting the bush, in the rasher moments of many native-born poets, for the best part of a century'.[11]

Wentworth, in contrast, described its actual inhabitants as 'enthusiasts free' and 'pure native sons of savage liberty'. They may have been a cross between the sectarian enthusiasts the Church of England so deplored and Rousseau's noblemen of Nature, but at least they also bore some resemblance to their actual subjects. But here, as in so many other respects, Australians were long dependent on recognized versions with British imprimaturs for their perceptions of local realities.

In the 1830s, carved wooden 'blackboys' were popular in the grander colonial houses. They were modelled on Regency blackamoors and usually served to hold curtains gathered and parted during the day. The image sums up neatly enough the generality of fictional roles in which Aborigines have since been cast, as decorator objects in a wearisome succession of tableaux. For examples of crassness one need not dwell on the distant past; despite its moments of subversive wit, Peter Corris's *White Meat* is a ham-fistedly ingratiating tribute to the fact that, even in thrillers, the noble or picturesque savage is not dead.

There are, of course, honourable exceptions. Herbert's *Capricornia*, Stow's *To The Islands* and Mather's *Trap* all develop substantial Aboriginal characters, and *Trap* made a heroic, largely successful attempt at black comedy. But it wasn't until Alf Dubbo, in Patrick White's *Riders in the Chariot*, that Aus-

tralian fiction gained a thoroughly satisfactorily realized, major Aboriginal character.

Ironically, Dubbo's aboriginality is almost peripheral to White's central novelistic purpose; in literature almost as much as in the visual arts it seems that the subject has been most effectively dealt with when approached obliquely, since it is no longer open to most of us to approach it unselfconsciously. Attempts to grapple with it head-on, particularly in poetry and fiction, have mostly been embarrassingly bad and more conspicuous for their sincerity than their art. Even a poet of the order of Judith Wright has often failed to achieve an adequate poise, and her prose *Cry For The Dead* is a work of Arcadian sentimentality.

A song by Goanna Band encapsulates the problem of poise:

'Round about the dawn of time
The Dreamin' all began
'nd proud people came
They were lookin' for the Promised Land
– Runnin' from the heart of darkness
– Searchin' for the heart of light
(. . . I think we've found paradise . . .)
But they were standin' on Solid Rock
Standin' on Sacred Ground
Livin' on borrowed time
'nd the winds of change
Were blowin' cold that night!
They were standin' on the shore one day
Saw the white sails in the sun
Wasn't long before they felt the sting
White man – White law – White gun
Don't tell me that it's justified
'cause somewhere someone lied.
(Shane Howard 1982. © Uluru Music)

In its innocent way, this song, 'Solid Rock', brings together a number of important themes: failure to come to terms with historical reality and an ill-thought-out sense of white collective guilt ('cause somewhere someone lied), the noble savage (proud people came), primally pure spirituality versus brutal materialism (Solid Rock, Sacred Ground, White law, White gun) and the Arcadian conflation of pre-contact Australia with western millennial fantasy (the Promised Land, paradise).

I raised the question at the beginning of this chapter: why are the most 'sympathetic' representations of Aborigines usually the worst? Part of the answer often lies in the quality of the sympathy itself, exemplified by this song. Appearances notwithstanding, it isn't really a song about Aboriginal history at all. It

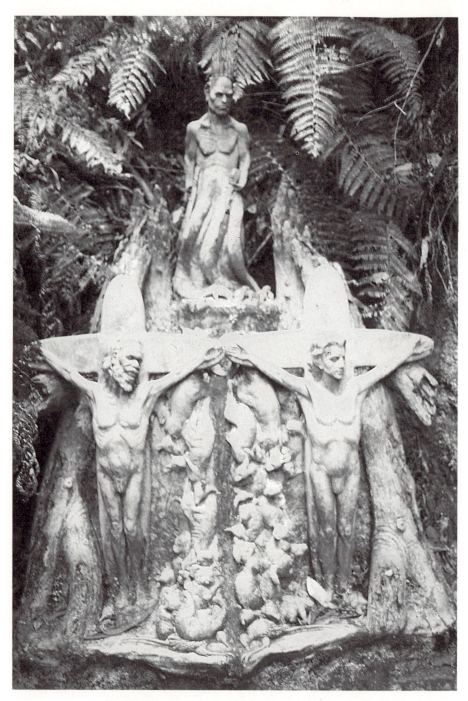

16.2 William Ricketts, *The Spiritual Form of William Ricketts,*
outdoor sculpture, Dandenongs, Australia.

is an alienated, urban teenagers' lament for a missing sense of legitimate belonging in the country, and a lament for something cosmic and mystical with which to identify. It appropriates a dimly conceived notion of Aboriginal spirituality as a talisman of its author's identity as a caring individual and his authority as the voice of conscience. The sympathy is a combination of self-concern and confusion. The guilt we are invited to share (if it is not simply a way of putting down the previous generation and disowning western civilization) is a refinement of generalized, bourgeois bad faith.[12]

The tendency to recruit Aboriginal culture into breast-beating exercises in schlock-mysticism is a hallmark of recent Australian cinema, Peter Weir's *The Last Wave* being the most spectacular example. Again, in *Storm Boy*, David Gulpilil is called upon to exhibit a lot of 'eternal mystical vigilance', in the role of Fingerbone. Even James Lawrenson, who plays the role of Boney in the police drama serial on TV, is a part-time plainclothes noble savage. It may take another twenty years before the makers and consumers of mass media entertainment come to terms with post-contact history sufficiently for an indigenous version of *F Troop* to be produced.

Despite obvious differences of quality, there is a kind of continuum between Drysdale's and Wright's work, Shane Howard's song and Peter Weir's movie. What links them is a highly romantic conception of the role of 'the Artist', particularly the notions of assuming vicarious suffering and the guilt of others on one's own shoulders and attempting to articulate the national conscience. While they exhibit differing degrees of sophistication in doing so, it remains a common stumbling-block. Such notions are prone to blunt sensibility and subvert reason. I suspect that all four of them, like many Australian contemporary artists and writers, would subscribe to George Steiner's classic dictum that 'men are accomplices to that which leaves them indifferent'. It is a logically indefensible proposition, no matter how high-sounding.

The most extreme form of this romantic conception of the role of the artist can be seen in the work of William Ricketts. Inspired by Blake's example and by Blake's *The Spiritual Form of Nelson* especially, he has created a number of sculptures exposing what he calls 'the spiritual form of William Ricketts' (that is, sculptures of himself). In one group, he and an allegorical Aborigine are being crucified side by side, the crosses decorated with tjuringa motifs, while the spirit of white conquest presides above them, gun in hand. In another, an Aboriginal spirit elder with angel's wings confides to him the secrets of the Dreamtime. All this would be merely laughable if it weren't for the fact that his sanctuary in the Dandenongs is a

place of pilgrimage for some Aboriginal people and for the counter-culture. What the hippies see there is a reassuring western mediation that has turned the once-exotic into 'pale and tawdry reflections of itself. What Aboriginal people find in it. I don't know, and nor perhaps do they, but I think they have reason to resent it.

Because kitsch is omnipresent, it is often assumed to be harmless, particularly since its effects are often difficult to judge. The carved blackboys of the 1830s may seem merely picturesque now, but consider a more recent analogue. In the 1940s, etched glass mirrors depicting a lone Aborigine with a spear enjoyed a vogue in suburban living-rooms and front bars. The clouded figure interrupts reflection in a small degree to remind us of a splendid, irrelevant warrior whom we superseded in an empty land. Cosy surroundings and our own faces fill the remaining vacuum.

The wooden blackboys, in their Regency costumes, were there to serve, in a suitably humble capacity, in imitation of their betters. The opaque, white figure in the mirror serves to underpin a comparable world-view. The mirror is a stylized map of the continent, it represents a reassuring lie and, again, it is a pale and tawdry reflection of ourselves.

Protracted exposure to a dominant culture's images of Aborigines has inevitably prompted many of them to internalize the roles and act accordingly. 'Coon songs' borrowed from negro tradition and taught to Aborigines on reserves and missions in the 1920s remained popular at sing-alongs well into the 1960s. A representative verse suggests the dimensions of the process:

> Oh! the monkey and the nigger
> Were sitting on a rail
> The only difference I could see –
> The old black nigger 'ad no tail.

Gary Killington, describing an ethnic music session at which the song was sung and then discussed, says 'there was absolute silence until one person commented in a quavering voice, showing-obvious emotional distress, ' "Is that what we have been singing all these years?" '[13] Pernicious in its effects as this sort of rubbish is, I do not see that it is much worse than the Arcadian fantasy versions that have replaced it. Both deny Aborigines the range and diversity of fully human beings.

Western representations of Aborigines by Aboriginal artists are remarkably rare. The illustration to the front page of the Kimberley Land Council Newsletter (see Figure 16.3b) suggests the extent to which Professor Tatz's stereotype has been internalized. To gauge the impact of white kitsch on Aboriginal artists' self-images, it would be necessary to dwell at length on

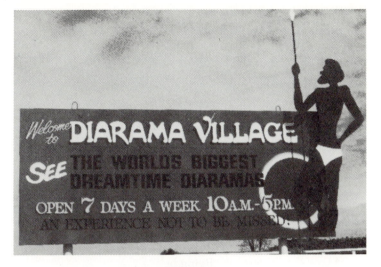

16.3a 'Welcome to Diarama Village'.

KIMBERLEY
LAND
COUNCIL
NEWSLETTER

16.3b Kimberley Land Council Newsletter.

the increasing level of self-conscious kitsch often apparent in their work. A prophetic overview of the impact achieved in Paris[14] and Berlin by various visiting Aboriginal artists and exhibitions comes from Edmund Carpenter:

> We have called primitive man forth from his retreat, reclothed him as a Noble Savage, taught him to carve the sort of art we like and hired him to dance for us at lunch. . . . It's as if we feared we had carried too far our experiment in rationalism, but wouldn't admit it and so we called forth other cultures in exotic and disguised forms to administer all those experiences suppressed among us. But those we have summoned are generally ill-suited by tradition and temperament to play the role of alter ego for us. So we recast them

accordingly, costuming them in the missing parts of our psyches and expecting them to satisfy our secret need.[15]

Two brief literary examples of Aboriginal self-definition may serve to illustrate my argument. The first quotation comes from Marnie Kennedy's poem, 'Our history', first published in the Aboriginal journal *Identity*:

> Once we were wild and free
> as free as the birds soaring high in the breeze.
> God meant us to have this rich land
> but fate dealt us a big dirty hand.
> He knew we would not destroy our land
> but live as free as the birds soaring high in the breeze . . .
> Yes, once we were free.
> Now there are chains on our necks to our knees.
> Yes, once we lived in paradise.
> Now it's living hell.
> We were beaten into submission
> and the chains cannot be broken.
> Thanks to Captain Cook
> who came for a look.

The notion of 'chains on our necks to our knees' has resonance of the kind of bondage, scrubbing roads, popularized by David Bowie in the film clip accompanying *Let's Dance*. But it seems restrained compared with the romantic excesses in the following passage from Boolidt Boolitba's foreword to Jan Roberts's *Massacres to Mining*:

> The sweet scent of eucalypt and earth. The sounds of life, love and laughter. All this and peace, borne on the winds that kiss this land. A land with gifts beyond men's wildest dreams and with beauty such as has never been seen. Populated with a people who have learned to live within the beauty, harmonising with and becoming a part of it. A people possessing all the beauty, within themselves, that the land around them has – no more, no less – for they are a part of the land and all things are part of the people. All things – tangible and intangible, animate and inanimate.
>
> Then, for some unknown reason and in the most sadistic way imaginable, all this ends when fools come to the shores of this utopia and rape and destroy. Steered by greed, lust and many more concepts as totally alien to this land as the aliens themselves.
>
> The horror is far more horrendous than the world has ever and will ever see for in this land all the evil that could ever be perpetrated has been perpetrated in excess on the land and her people.[16]

There is, of course, some short-term political advantage to be gained from Arcadian rhetoric of this kind, particularly in mobilizing public opinion and support overseas, where its implausibility is less immediately apparent than in Australia. But the Aboriginal people who have been persuaded to believe it have been deprived of a more potent weapon – an authentic account of their history.

NOTES

Reprinted from Art & Text 14, Melbourne, 1984, and published in this volume by kind permission of the editors.

1 S. Harris (1979) *It's Coming Yet*, Aboriginal Treaty Committee, p. 74.
2 Alfred Metraux (1972) *Voodoo in Haiti*, New York: intro. S. W. Mintz, p. 6.
3 I am indebted to Don Langmead, architectural historian and biographer of G. S. Kingston, who designed the gaol, for the information that this grotesque and a companion piece were ordered between December 1840 and June 1841. The identity of the sculptor is unknown.
4 B. Smith (1971) *Australian Painting 1788–1970*, 2nd edn, Oxford: p. 55.
5 Two of the most memorable naive images are Bastin's *Hommage à Rousseau* and David Fielding's municipal park scene, *Noble Savage as Garden Ornament*. While both pictures salute Le Douanier, Fielding's plaster Aborigine is also an explicitly ironic tribute to Jean Jacques. It is as much a perspective on the contemporary consumers of naive art as on the unselfconscious suburban racism that used to delight in such objects. In encapsulating the tradition, he ends it.
6 G. Dutton (1974) *White on Black*, London: Macmillan, p. 62.
7 B. Smith, ibid., p. 251 (both quotations).
8 G. Dutton (1974) *Russell Drysdale*, 2nd edn, London: Thames & Hudson, pp. 91–2.
9 C. Tatz (1979) *Race Politics in Australia*, Armidale: UNE Publishing Unit, p. 86.
10 There is small amount of evidence to suggest that cannibalism was occasionally practised in the area Bates wrote about. Infanticide victims and, more rarely, adults appear to have been eaten in times of severe drought. See, for example, W. Hilliard (1976) *The People In Between*, Seal, p. 1107. Bates's claims on the matter were sensationalistic and mostly wanton inventions.
11 I have relied heavily in this section on the work of Brian Elliott in (1967) *The Landscape of Australian Poetry*, Cheshire, pp. 52–5. For an overview of sorts see J. J. Healy (1978) *Literature and the Aborigine in Australia*, University of Queensland Press.
12 On the question of the part played by white guilt in Australian art, see Imants Tillers's chapter, 'Locality Fails'.
13 G. Killington (1982) 'Similar yet distinctive', BA Hons thesis, Adelaide, p. 10.
14 See Jill Montgomery 'Australia: the French discovery of 1983', *Art & Text* 12–13, Melbourne.
15 Edmund Carpenter (1976) *Oh What a Blow That Phantom Gave Me*, London: Paladin, pp. 94–5.
16 J. Roberts (1982) *Massacres to Mining*, intro. B. Boolitba, Dove.

17 Born from sharp rocks

Edgar Heap of Birds

BORN

FROM

SHARP

ROCKS

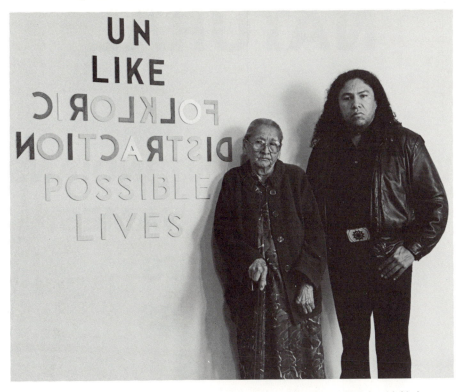

17.1 Lightning Woman and her grandson Edgar Heap of Birds with his language installation **Possible Lives** (photograph David Priest).

The native arrow-points of the past were worked and formed to become sharp and strong weapons. These sharp rocks were responsible for the defence and welfare of the tribe. As weapons of war the sharp rocks of the Tsistsistas (Cheyenne) people were used for two separate purposes, as defence of attack weapons against man and as tools of preservation through hunting game animals.

Today one may still discover actual Tsistsistas arrow-points on the surface of the earth. In touching these weapons I have found clues as to the useful current-day defences and preservation tactics that can serve living Native Americans.

At this time the manifestation of our battle has changed. The white man shall always project himself into our lives using information that is provided by learning institutions and the electronic and print media. Through these experiences the non-Indian will decide to accept or reject that the Native Americans are a unique and separate people with the mandate to maintain and strengthen indigenous rights and beliefs. Therefore we find that the survival of our people is based upon our use of expressive forms of modern communication. The insurgent messages within these forms must serve as our present-day combative tactics.

NATURAL

WE DON'T WANT INDIANS

JUST THEIR NAMES

MASCOTS

MACHINES

CITIES

PRODUCTS

BUILDINGS

LIVING PEOPLE

As a native artist, these insurgent messages delivered through art must present the fact that Native Americans are decidedly different from the dominant white culture in America. The world-view which we hold is a creation of our circular awareness and sole self-determination.

Countless times our combative measures through art are misrepresented or corruptly undertaken by the non-Indian. Too often the white man masquerades as the native artist, creating many self-serving images. Regretfully when the true Native American art is finally accepted the style turns out to be that which fulfils the comfortable fantasy held by the non-Indian. It must be understood that the dominant white culture is not in a position to instruct the essence of the native outlook but can only learn.

The word installation entitled 'Don't Want Indians' exposes the prevailing attitude of America to its native peoples.

Over the last 400 years the dominant white culture has attempted to crush the lives of Indian people, rendering many entire tribes extinct, through brutal wars and governmental policies.

Today Indian people must still struggle in order to survive in America. We must battle against forces that have dealt us among the lowest educational opportunities, lowest income levels, lowest standards of health, lowest housing conditions, lowest political representation and **highest** mortality rates in America.

Even as these grave hardships exist for the living Indian people, a mockery is made of us by reducing our tribal names and images to the level of insulting sports team mascots, brand-name automobiles, camping equipment, city and state names, and various other commercial products produced by the dominant white culture.

This strange white custom is particularly insulting when one considers the great lack of attention that is given to real Indian concerns.

In 'Don't Want Indians' the pinkness of the words **mascots, machines, cities, products**, and **buildings** is a symbol for the true colour of the Anglo-American (which is much more pink than white) and also alludes to the pink, cool, and uncaring attitude that the majority of America feels toward the serious crisis that faces the American Indian.

At the bottom of the word installation the words **living people** are presented in yellow-green to give the sense of the living, vital, and **growing** American Indian. Such colour is found throughout the Cheyenne Sundance earth renewal. The yellow-green cottonwood and willow trees spring forth from the rivers, creeks, and streams of the American plains. These trees grow fresh and strong from the water each spring.

Water and growth are the true concepts that represent the American Indian and give life to all things.

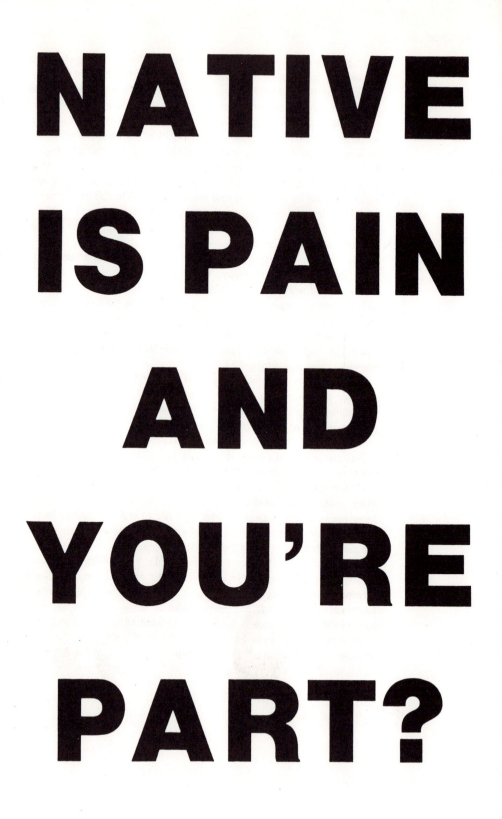

'I am part Indian, I believe that my great, great-grandmother, or was it my grandfather; well, one of them was a full-blooded Cherokee.'

A real Indian person must listen to this ridiculous claim made daily by members of the dominant white culture. White people are so excited by any remote blood-line reference that they may share with a Native American, once they have met one. This trace of affinity that the white person wishes to share with a Native American always vanishes once the real native returns to his or her home. Then the white person, briefly Indian, turns immediately back into the fold of the dominant white culture. While for a few moments there was a willingness on the part of the white person to share in the values and cosmos of the native person, never is there a reciprocal offer made by the white person to share their privileges.

In America, adequate education, job skills, medical treatment, health, food sources, and proper housing are privileges reserved for the white culture. A sharing of the gifts that come with being of the white heritage does not take place, while a sharing of our gifts through our earth awareness is expected.

For myself, as a headsman of the traditional Cheyenne Elk Warrior Society, it has become very difficult to appreciate the attributes of being part Indian. The warrior society members from the Cheyenne and Arapaho reservation, where I live, are always asked to be present at the many funerals that are conducted here. The warriors and chiefs are asked to support the familes of the deceased. We offer them a positive force in their worst of all days. During the burial service, as I walk down the line of family members touching the hand of each grieving person, their powerful pain is shared with me. Too often the cause of death is a broken heart or broken spirit. This condition drives many young native individuals, often under the age of 30, to a deadly accident or death by a disease related to alcoholism or other substance abuse. Many times these casualties of this modern culture are my childhood friends.

The circumstances that break the spirit and cause death are the simple lack of sharing in the privileges that are the possessions of the dominant white culture. Jobs, education, medicine, housing, and food — a lack of these things will lead to a lack of human dignity. When your human dignity is used up there is **nothing** left.

Today the criterion of Indianness is suffering the pain of our culture, which is experienced in our traditional way 'together'. A true Indian cannot claim to be native one day and not native the next. The mark of being of the native experience cannot be measured by a blood fraction.

NAH-KEV-HO-EYEA-ZIM
(WE ALWAYS COME BACK ON PURPOSE)

Translated into the Tsistsistas (Cheyenne) language by my grandmother, Lightning Woman.

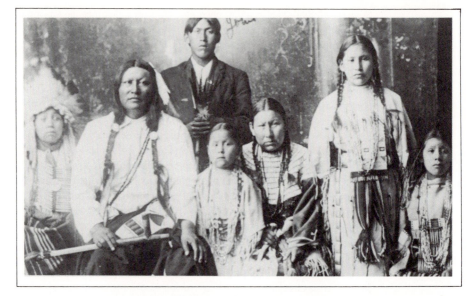

17.2 The Blackwolf—Heap of Birds family, pictured soon after the turn of the century: (left to right) Howling Water—Guy Heap of Birds; Black Wolf—Alfrich Heap of Birds (father); Many Magpies—John Heap of Birds; Blue Wing—Helen Heap of Birds; Soar Woman—Grace Big Bear (mother); Owlet Woman—Ruth Heap of Birds; Red Paint Woman—Esther Heap of Birds. Black Wolf was a headsman of the traditional Tsistsistas Elk Clan and the great grandfather of Edgar Heap of Birds.

Notes on contributors

Rasheed Araeen was born in Pakistan, but has lived in London since 1964. He is an artist and writer, and is the author of *Making Myself Visible* (Kala Press). A retrospective of his work was held at the Ikon Gallery, Birmingham, 1987. He is editor of *Third Text* and curated the exhibition 'The Other Story: History of Afroasian Artists in Britain', held at the Hayward Gallery in Dec.–Jan. 1989/90.

Black Audio/Film Collective was established in London in 1983. The collective has worked on a range of projects from industrial videos to feature documentaries, including *Expeditions*, a tape-slide on race and colonial iconography, and *Handsworth Songs*, a 16mm film documentary on race and civil disorder in 1980s Britain, winner of seven international awards, including the British Film Institute Grierson Award in 1987. The collective also works in media education and as a media consultancy. It is currently producing features and documentaries for Channel Four Television.

Guy Brett is the author of *Kinetic Art* (Studio Vista, 1968) and *Through Our Own Eyes: Popular Art and Modern History* (GMP/Heretic, 1986). He was formerly art critic for the London *Times*, and the Visual Arts editor of the London weekly *City Limits*, and has contributed extensively to the art press since the early 1960s. He has written interpretive essays on Lygia Clark, David Medalla, Helio Oiticica, Susan Hiller, Rasheed Araeen, as well as texts on popular art in Chile, China, and Africa. He lives in London.

Lynne Cooke is an art historian and art critic who teaches at University College London. She was written widely on contemporary art, and sculpture in particular, and has organized exhibitions including *In Tandem: The Painter-Sculptor in the Twentieth Century* for the Whitechapel Gallery, London, in 1986.

Annie E. Coombes is a lecturer in the History of Art and Cultural Studies at Birkbeck College, London University and a co-editor of *The Oxford Art Journal*. She has published articles in *Art History*, *The Oxford Art Journal*, *Art Monthly*, and

Women's Review, and has lectured widely in America and Europe.

Kenneth Coutts-Smith was born in Copenhagen in 1929, of British parents, and spent most of his youth in Britain. He trained as a painter and studied with Leger, Szabo, and Picasso in the 1950s and continued to paint throughout his life. His better-known contribution to art was as a critic and historian, as co-founder and associate editor of *Art and Artists* in 1965 and author of *The Dream of Icarus* and *Dada* (both published in 1970). He moved to Canada in the 1970s where he lectured, wrote, and researched on the sociology of art, Inuit art, and the demise of the avant-garde, amongst other things. He died in 1981, in Toronto, of cancer.

Jimmie Durham is a Cherokee artist, poet, and political activist, who was born in Arkansas in 1940. During the 1970s he was the United Nations representative for the American Indian Movement. From the mid-1980s he was editor of the New York-based *Art and Artists* newspaper, during which time he was also involved in gallery exhibitions of his sculpture, in co-curating shows of Native American art, and in solo performances in several New York theatre venues, including La Mama Theater, Franklin Furnace, and P.S.122. His work has recently been shown in Matt's Gallery, London and Orchard Gallery, Northern Ireland. Durham's essays and his book of poems, *Columbus Day* (West End Press, 1983) have been translated into several languages. He currently lives and works in Cuernavaca, Mexico.

Jean Fisher is an artist, a regular contributor to major international art magazines, and has written numerous critical essays on the work of British, Irish, and American artists. Her specialities are contemporary art and cultural studies. She has co-curated exhibitions in New York and London devoted to extending the debate on cultural difference to include the particular situations of contemporary Native American artists. She lives in New York and London, and is currently teaching Fine Art at Goldsmiths' College, University of London. She is also associate editor of the quarterly journal *Third Text*.

Edgar Heap of Birds was born in Wichita, Kansas, in 1954, and is a Cheyenne Arapaho artist. He studied at the California College of Arts and Crafts, at the Tyler School of Art, Temple University, Philadelphia; and the Royal College of Art, London. He has lectured extensively in universities where he was artist-in-residence. An important part of his work is curating touring exhibitions of contemporary Native American art. An exhibition of his recent work was shown at Matt's Gallery, London in 1988.

Susan Hiller is an artist whose work is exhibited internationally. She lives and works in London.

Signe Howell is professor of Social Anthropology at the University of Oslo where she also is director of the University's Ethnographic Museum. She studied at the universities of London and Oxford and has previously taught in the Department of Social Anthropology at the University of Edinburgh and at Ecole des Hautes Etudes en Sciences Sociales, Paris. She has conducted ethnographic fieldwork among a hunter-gatherer society in Malaysia and in an eastern Indonesian society. Among more recent publications are *Society and Cosmos: Chewong of Peninsular Malaysia* (1989[1984]), and an edited volume *Societies at Peace: anthropological perspectives on peace and violence* (1989). She has a longstanding active interest in contemporary art.

Anna Howells studied anthropology at London University and is presently involved in a medical research project in London.

Jill Lloyd is an art historian and critic specializing in twentieth-century German art. She studied in London and Berlin and currently lives and works in Paris, where she co-directs the magazine *Art International*. She is the author of *German Expressionism: Primitivism versus Modernity*, published by Yale University Press in 1991.

David Maclagan was born in 1940 and currently lectures on art and psychotherapy at Sheffield University and Birmingham Polytechnic. After reading history at Oxford, he studied painting at the Royal College of Art and taught for ten years in art colleges before training in Art Therapy at Goldsmiths' College, University of London (1979–80). He worked for five years in a therapeutic community under the National Health Service. He has written articles on myth, imagination, and psychopathology, and has carried out research on Antonin Artaud, Adolf Wölfli, and Grace Pailthorpe. He is the author of *Creation Myths* (Thames & Hudson, 1977).

Daniel Miller is a lecturer in Material Culture within the Department of Anthropology, University College London. He has conducted fieldwork both as an archaeologist and as an anthropologist in Indonesia, the Solomon Islands, India, and London, and is currently working in Trinidad. His most recent book develops a theory of the nature of consumption as a social process and is published as *Material Culture and Mass Consumption* (Basil Blackwell, 1987). Other publications include *Domination and Resistance*, edited with M. Rowlands and C. Tilley (Allen & Unwin, 1988); *Artifacts as Categories*

(Cambridge University Press, 1985), and *Ideology, Power and Prehistory*, edited with C. Tilley (Cambridge University Press, 1984).

Christopher Pearson is editor of *The Adelaide Review*, the largest circulation arts magazine in Australia. His other journal articles in this field include an analysis of millenarianism in the Land Rights Movement and Black Power politics. They are to be found in the 1982 and 1983 issues of *Labour Forum* (Australia).

Desa Philippi was born in Hamburg, Germany in 1960 and studied Art History at the universities of London and Leeds. Based in London, she is now a freelance writer and associate editor of *Third Text* magazine.

Imants Tillers is an artist who lives and works in Sydney. He exhibits regularly in Sydney, New York, and Zurich. His work has been included in several exhibitions, notably *Documenta 7* in Kassel, 1982, and *Avant Garde in the Eighties* at the Los Angeles County Museum, 1987. In 1986 he represented Australia at the Venice Biennale and his work also featured in the television series *State of the Art: Ideas and Images in the 1980s*, shown in England and West Germany. He has recently finished a commission for the Dome of the Federation Pavilion in Centennial Park, Sydney. A survey of his work from 1978 to 1988 was shown at the Institute of Contemporary Arts in London, 1988.

Christina Toren has a PhD in social anthropology from the London School of Economics and Political Science. Her research on symbolic space and the construction of hierarchy in Fiji combines anthropological methods and theory with those of cognitive psychology, in which she gained her first degree from University College London. Her interests centre on the relation between individual cognition and social processes. She lectures in the Department of Human Sciences, Brunel University.

Index